The Art of
Plant Evolution

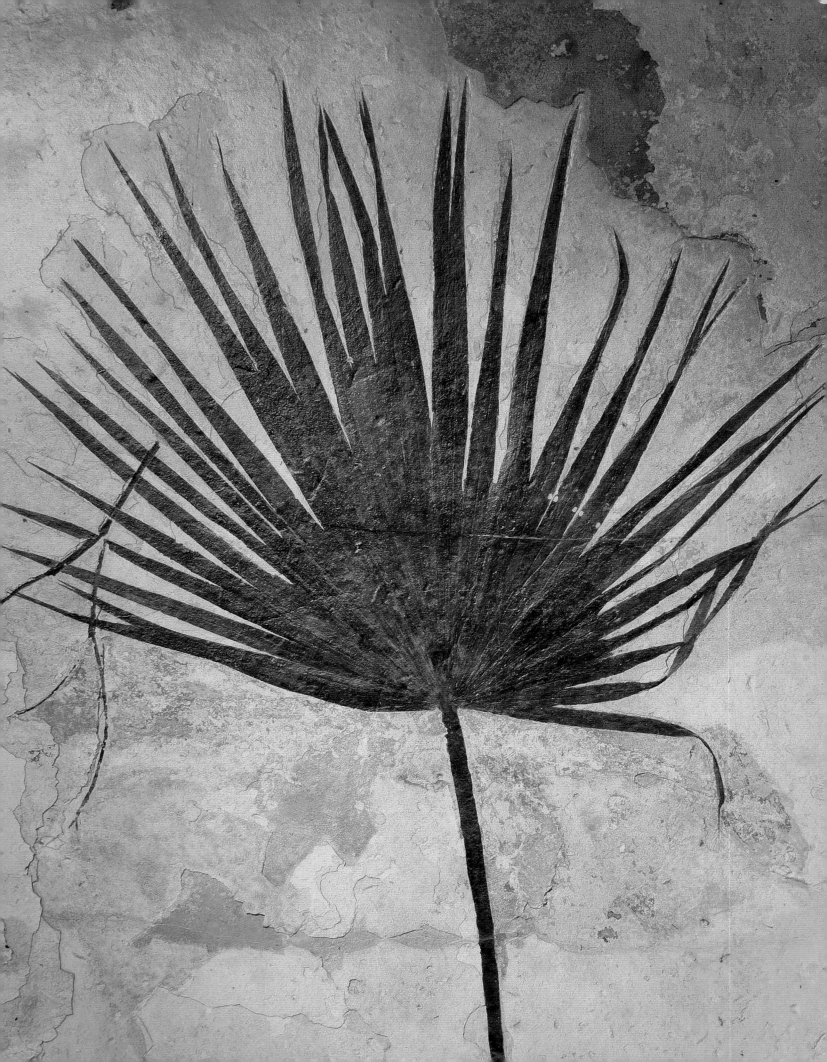

The Art of
Plant Evolution

W. John Kress and Shirley Sherwood

Kew Publishing
Royal Botanic Gardens, Kew

First published in 2009
Softback edition reprinted in 2013 by
Royal Botanic Gardens, Kew
Richmond, Surrey, TW9 3AB, UK
www.kew.org

Distributed on behalf of Royal Botanic Gardens, Kew in North America
by the University of Chicago Press, 1427 East 60th St, Chicago, IL 60637, USA.

Hardback ISBN 978 1 84246 421 2
Softback ISBN 978 1 84246 417 5

British Library Cataloguing in Publication Data
A catalogue record for this book is available from the British Library.

Front cover: Bryan Poole, *Heliconia bihai* with female hummingbirds
Back cover: Rosie Sanders, Tom Putt apple, *Malus* cultivar
Cover flap: Vicki Thomas, *Haemanthus nortieri*
Frontispiece: Fossil palm frond, 50 million years (Eocene), Wyoming, USA. © Smithsonian Institution. Reproduced with kind
permission of the Department of Paleobiology, National Museum of Natural History, Smithsonian Institution, USA

Commissioning Editor: Gina Fullerlove
Copyeditor: Michelle Payne
Production: Lloyd Kirton
Design and layout: Jeff Eden
Publishing, Design and Photography, Royal Botanic Gardens, Kew

For information or to purchase all Kew titles please visit
www.kewbooks.com or email publishing@kew.org

Kew's mission is to inspire and deliver science-based conservation worldwide, enhancing the quality of life.
Kew receives half of its running costs from Government through the Department for Enviroment, Food and Rural Affairs (Defra).
All other funding needed to support Kew's vital work comes from members, foundations,
donors and commercial activities including book sales.

The paper used in this book contains material sourced from responsibly managed and sustainable
commercial forests, certified in accordance with the FSC® (Foresty Stewardship Council), and manfactured
under strict environmental systems, the international 140001standard, EMAS (Eco-Management and
Audit Scheme) and the IPPC (Integrated Pollution Prevention and Control) regulation.

Printed and bound in Italy by Printer Trento S.r.l

Contents

Foreword

Sir Ghillean Prance

Botany and art have a long history together, but this book brings a new dimension to the mix by adding evolution. The Shirley Sherwood Collection of botanical art at Kew is a wonderful resource and it is good to see it used in this way to present an interpretation of plant science and evolution. Today, when so many apparently rational people are questioning the facts of evolution, it is most important to show that it is incontestable. Here we have an experienced evolutionary botanist and an art collector and author combining to demonstrate evolution in a format that is easy to understand. You will also enjoy the many interesting facts that are given about the plant species that are illustrated here and the biographical details about the individual artists. The paintings are by so many of the leading botanical artists of today.

This book is right up to date because the arrangement of it is in accordance with the latest molecular details from DNA of the Angiosperm Phylogeny Group. This group of the leading evolutionary plant scientists has produced a classification that represents much more closely the pathway of evolution and so as you read you will be guided through the most modern system of evolutionary classification of the plant kingdom. The pathway of evolution is made thorough by the inclusion of fossils and of lower plants such as algae and mosses. Quite apart from the teaching on evolution I found it a real pleasure to browse through these pages because of the superb quality of the carefully selected drawings. They represent the selected plant families well but they are also a first rate sample of contemporary botanical art.

This beautiful book is a fine way to celebrate both the 150th anniversary of the publication of Charles Darwin's *On the Origin of the Species* and the establishment of the Shirley Sherwood Gallery at Kew. The gallery will greatly enhance Kew's ability to place botanical art in public view.

Professor Sir Ghillean Prance FRS, VMH
Scientific Director, The Eden Project

Preface

Shirley Sherwood

This book is based on an exhibition at the Royal Botanic Gardens, Kew that has been some years in gestation. In 2002 I mounted a show in Denver Art Museum from my collection of contemporary botanical art. There were eight large galleries to fill through Denver's cold winter and we hung 180 works. Dr John Kress came over to Denver from the National Museum of Natural History at the Smithsonian, Washington, to select works for a Smithsonian exhibition in 2003, which almost immediately followed the Denver show. He decided to emphasise the scientific element of botanical art by arranging the works in an evolutionary sequence. It was a great success with half a million visitors going into the show from the Museum's famous entrance hall displaying Henry, the famous African elephant posturing defiantly.

But there had been no time to prepare and publish a book or catalogue in the six weeks between the Denver and Smithsonian shows. We wanted to repeat the exhibition in more detail in the UK at the new Shirley Sherwood Gallery, especially in 2009 as it is the year of Darwin's bicentennial and 150 years after he published *On the Origin of Species*. And for Kew's exhibit we compiled this book which describes the paintings and the brief biographies of the artists that executed them, as well as updating and including the most recent steps in the understanding of plant evolution. We also wanted to add plant fossils to the exhibition to give more visual, concrete evidence of the story of evolution.

The choice of species and the choice of paintings have been made in the following way: all the works in the Shirley Sherwood Collection, some 700, were sorted into plant orders. We chose 44 orders with 116 families and 134 species to give a wide evolutionary sequence. Generally one painting was selected to represent one family. The choice was difficult as in some groups, like the orchids, there were so many good 'candidates', so occasionally we added extra works. The final selection was made on artistic merit. This meant that the painting chosen was a beautiful plant portrait or an arresting work of art – but it was not necessarily a botanical illustration displaying <u>all</u> the plants' specific identifying features. Nevertheless all the drawings and paintings chosen are scientifically accurate and most have been executed by trained botanical artists. In total there are works from 84 artists from 18 different countries.

So this book deliberately attempts to serve both science and art. The choice of painting was mostly mine, firstly because I had actually added it to my collection and secondly because I selected it for its artistic merit from other works of the same family when we were choosing illustrations for the book. The sequence of plant evolution was developed by John Kress whose knowledge of taxonomy has been influenced by the new analyses of plant DNA during the last ten years. To make it easier for the non-specialist to understand we numbered the sequence of species as they appear in the book.

There have been great strides recently to unlock the more subtle secrets of plant evolution with detailed DNA analysis occasionally altering the previously

accepted taxonomic position of a species or family, particularly of flowering plants. The *Tree of Plant Evolution* shown on page 15 was devised using the latest classification, in order to simplify and explain the new scheme. The earliest plants are found towards the base of the trunk while the most elaborate, more recently developed flowering plants are at the top. Fungi are depicted at the base of the tree as they are now considered to be more akin to animals than plants.

The history of life can be traced in the fossil remains of ancient organisms found embedded in successive layers of rock of different ages. Many sequential step-like changes have occurred over more than three billion years. We illustrate this link by showing plant fossils of distantly related specimens of today's flora.

For the exhibition we chose plant fossils from the major resources of the Natural History Museum, London. We could display only a tiny fraction of what is held in massive storage compartments in this iconic building. These were initially selected by Paul Kenrick, Professor of Palaeobotany at NHM, in an attempt to link a particular fossil with a contemporary plant portrait. The fossil photographs in this book come from the National Museum of Natural History, Smithsonian Institution, USA.

The fossils illustrated include examples of Araucaria needles and cones, with the leaves mirroring foliage from the newly discovered prehistoric Wollemi pine. Also shown is a ginkgo fossil, giant ferns, cycad-like leaves, a palm frond and well-preserved walnuts. Perhaps the most beautiful fossil exhibits are the net-veined leaves of poplar and acer with the venation exquisitely defined and perfectly preserved.

I was surprised to realise when discussing 'The Art of Plant Evolution' that many of my non-scientific friends had never really considered the evolution of plants. They were of course aware of the theory of animal evolution and the

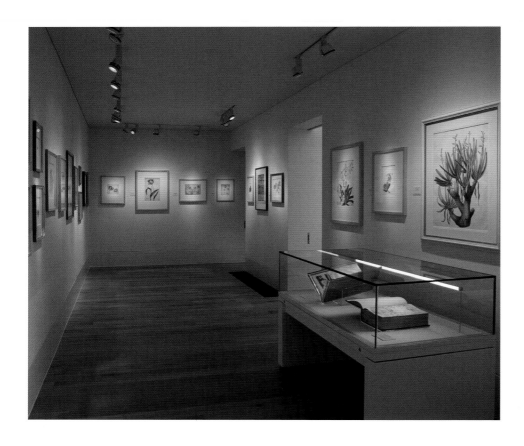

The Shirley Sherwood Gallery of Botanical Art at the Royal Botanic Gardens, Kew opened in April 2008.

descent of man, but looked rather non-plussed as they realised that plants also evolved from simpler forms. Plants are not so obviously arresting as animals — indeed among the mass of new publications celebrating Darwin's bicentennial this year, there are very few books for the layman on plant evolution.

Darwin's bicentennial has been triggering some rather unexpected controversy. It seems very strange that so long after the publication of *On the Origin of Species*, in 1859, there should still be heated debate challenging the whole basis of Darwin's proposition of evolution by natural selection and attempting to re-affirm the biblical and other religions' explanation of the origin of the world's denizens. Creationism is particularly prevalent in the States where as many as half the population either believe that God made the world in six days and rested on the seventh or seriously challenge the concept that man could have had an ape-like ancestor. In some 29 states evolution is not taught as the essential basis of school biology lessons. The general view in the world of education is that, as there is no scientific basis for creationism or intelligent design, neither should be taught in science lessons, but only discussed in religious study. So it is still a hot subject.

While the tree of plant evolution has been undergoing some revisions, mainly through the new tool of DNA analysis, botanical art has also been changing. There has been a huge increase in public interest and the number of botanical artists painting today has expanded enormously. Not only are there far more artists than when I started collecting nearly 20 years ago, but the overall standard is higher and some of the work produced today can be compared very favourably with the best from the past.

This new 'golden age' has been triggered by botanical painting classes all over the world, some excellent 'how to paint' books and the rising interest in endangered species and the environment. Much dedicated work has gone into new florilegia where artists paint plants from a particular garden, recording how they looked in life alongside a dried specimen. Exhibitions and juried shows have also been important in giving an idea of what can be achieved. I have been particularly enthusiastic to demonstrate, through my collection, how widespread this 'golden age' is, by buying work from all over the world. Now there is a wonderful opportunity to show good work from past and present in the Shirley Sherwood Gallery at Kew, with several different exhibitions each year, including work from archives that has never been displayed before.

The Shirley Sherwood Gallery opened its doors in mid-April 2008 with an exhibition designed to show works from the archives of Kew matched with contemporary works from the Shirley Sherwood Collection in an exhibition called 'Treasures of Botanical Art: Icons from the Shirley Sherwood and Kew Collections'. Some of the matches of old and new paintings were so subtle that visitors began to play games of guessing which work was the older one before looking at the captions. Over 60,000 people visited the Gallery from late April to the end of December 2008, showing great appreciation for the exhibitions and the new, unique venue, which is the only gallery in the world that is purpose-built to show watercolours of botanical art.

Art meets science

When botanists first encounter a plant, their first question is, 'what species is this?' And the second question is usually, 'what is it related to?' Botanists are not the only ones interested in knowing the name of a plant. For thousands of years in cultures all around the world people have had an inclination to name, and in many instances classify, plants and animals. Despite this, it was not until the time of Carl Linnaeus, the Swedish father of modern botany who lived in the eighteenth century, that a system of naming and classifying plants based on a scientific methodology was established. Although for the most part the naming conventions established by Linnaeus have not changed, our ideas on the natural classification of plants have grown considerably as our understanding of genetics, diversification and the origin of species has developed – especially with the discovery of DNA and our new ability to read its sequence.

On the other hand, when artists first encounters a plant, their reaction may be quite different to that of the botanist. The artist may not ask any questions about the species at all, but rather look at a flower as an individual of nature with its own unique features of colour, texture, form, size, and proportion. Their first question may be 'how do I capture the essence of this flower on my canvas?' Or perhaps 'how do I create a work of true beauty that may equal or surpass nature itself?' The representation of the natural world by artists has a long history and the evolution from realistic rendition to symbolic representation has cycled back and forth for centuries. The development of photography and most recently digital graphic capabilities have had considerable impact on artists' capability to portray nature.

When looking at a flower the artist sees form, the botanist sees function; the artist sees colour, the botanist sees pollinators; the artist sees the structural

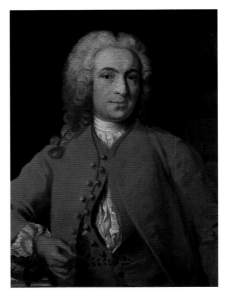

Carl Linnaeus, 'father' of modern botany.
© The Linnean Society of London

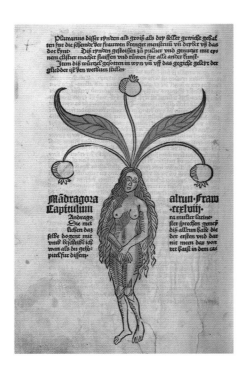

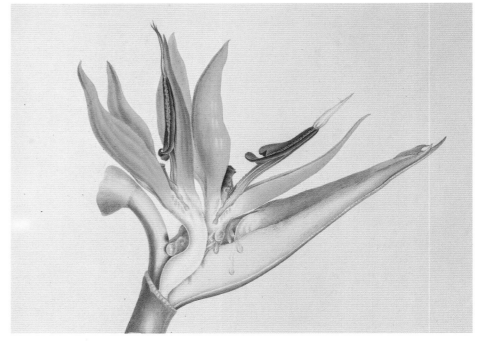

DNA barcoding of plants: *Fritillaria melagris*, native to the UK, and part of its barcode, with the four DNA nucleotide bases represented by different coloured lines. There are about 100 species of *Fritillaria*; short sequences of DNA can be used as a species identification tool and also to determine evolutionary relationships.

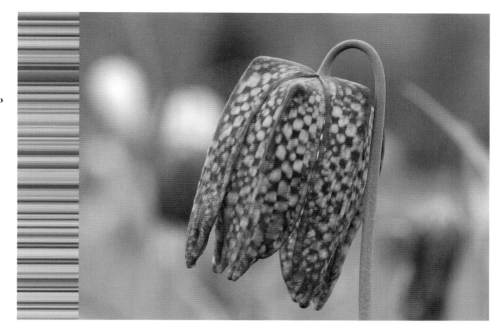

Far left: **A female mandrake in fruit, hand coloured woodcut. From** *Hortus Sanitatis*, **printed by Peter Schoffer in Mainz in 1491; the illustrations are a mixture of science and myth.** KEW COLLECTION

Left: *Strelitzia*. **Detail of hand coloured lithograph by Francis Bauer, b. Austria 1758–1840.** KEW COLLECTION

relationship among the parts, the botanist sees characteristics for determining evolutionary relationships. The field of botanical illustration has developed in part to bring these two disciplines together: the artists' desire to capture the essence of nature through colour and composition and the botanists' preoccupation with naming and classifying species. Beginning in the 1700s the early practitioners in the field of botanical illustration, icons such as Ehret, Redouté, and the Bauer brothers, combined extreme precision with exquisite technique to define a high standard for all future artistic work. Today this precision and beauty is continued through the efforts of many contemporary botanical artists.

The Art of Plant Evolution furthers the tradition of connecting botany and art by tracing the evolution of plants, primarily flowering plants, giving the latest classification concepts alongside plant portraits by contemporary botanical artists. During the last twenty years, the ability to sequence the building blocks, or nucleotides of the DNA molecule (**d**eoxyribo**n**ucleic **a**cid) of both plants and animals has provided scientists with a new and important tool for determining evolutionary relationships among species and higher categories of classification. Now, for the first time, we can trace the origin and diversification of plants during the last 300 million years with some confidence, without relying solely on a rather incomplete fossil record. New DNA sequence-based data on the origins and diversifications of plant groups has given botanists fresh insights into relationships among land plants, including mosses, ferns, gymnosperms (conifers and relatives), and angiosperms (the flowering plants).

Each painting has been chosen according to the artistry, skill, accuracy, and botanical insight of the individual illustrator. Coincidentally or intentionally, by intense observation, the artists have portrayed various critical features for identifying and understanding a species relationship to other species. The book places each artist's botanical observations within the conceptual realm of plant evolution and modern classification. Our hope is that readers will gain a new understanding of the botanical world and plants evolutionary interrelationships, while acquiring an enhanced appreciation of botanical artists' ability to portray the delicate beauty of nature.

Natural selection and the origin of species

All life has descended over time as a result of a series of genetically heritable changes. This process of change, which connects all forms of life to one another, is called evolution. Change can be rapid and occur in a matter of a few generations, as seen today in the development of pesticide resistance in weeds and insects, or change can be gradual resulting in the evolution of complex characters, such as the human eye and the orchid flower. Described as 'descent with modification' by Charles Darwin in his book *On the Origin of Species*, evolution is a scientifically well-established fact. Like gravity, evolution is a scientific theory based on repeated observations, experiments, measurements and discoveries, which makes evolution the most logical and thoroughly-tested explanation for the diversity and continuity of life on Earth.

Evolution requires firstly that individuals in a population of the same species differ from one another in various characteristics; secondly, that these characteristics are inherited from generation to generation; and, finally, that individuals with some of the characteristics survive better and produce more offspring than individuals with other traits. Natural selection is the process by which variation in characteristics among individuals leads to change from generation to generation and eventually to the evolution of entirely new species. The beneficial variations that spread throughout a population are called adaptations. Certain variations may help an individual survive and reproduce, especially if the environment is changing. Individuals with advantageous traits will produce more offspring; individuals without the traits will produce fewer offspring and may eventually become extinct. Over time, as the genetic composition of the entire population changes, a new species will originate. The evolution of one species into many is called diversification. In addition to natural selection, evolution can work in other ways such as through genetic mutation and random changes in gene frequencies called genetic drift. One of the most well-studied and thoroughly documented cases of evolution, adaptation and speciation

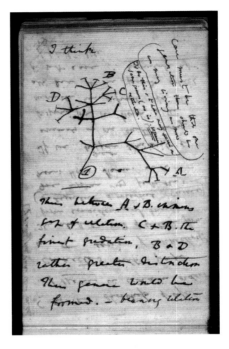

Darwin's famous sketch of an evolutionary tree, from his private notebook B on the 'transmutation of species', 1837.

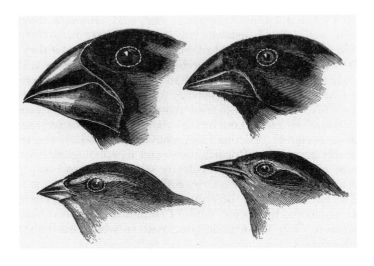

'Darwin's Finches'; beak diversity in the ground finches of the Galápagos Islands. One of the most famous examples of evolution and speciation through adaptation of beak type believed to be related to the seed available for the finches to feed on. From the *Journal of Researches into the Natural History and Geology of the Countries Visited During the Voyage Around The World of HMS Beagle*, revised edition Henry Colburn, 1845.

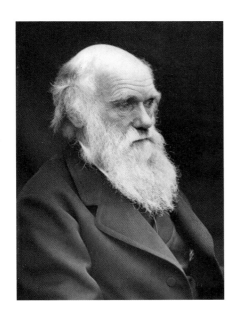

Charles Darwin, b. Shrewsbury, England 1809–1882. His book *On the Origin of Species* expounded the theory of evolution through natural selection.

has focused on a group of birds first observed by Darwin in the Galápagos Islands: the ground finches.

Natural selection and the theory of evolution was a revolutionary idea when Charles Darwin and Alfred Russell Wallace proposed it in the 1850s. Other competing theories for explaining the origin and diversification of living forms have not withstood scientific testing and therefore have been rejected by the scientific community and the populace at large. Since the publication of *On the Origin of Species* in 1859, biologists have tested his concept of evolutionary change through the process of natural selection.

When the theory of evolution and natural selection was first proposed, the actual mechanisms of inheritance and genetics were not yet known. The field of genetics, which began in the early twentieth century, and later the discovery of the helix structure of DNA and the molecular basis of inheritance greatly expanded our understanding of the processes of evolution. This new knowledge paved the way for exciting advances in plant taxonomy and classification.

The success of Darwin's ideas in surviving the many challenges and experiments conducted by scientists during the last 150 years has now firmly established evolution, with a solid genetic basis and mathematical underpinning, as the central theory of organic change and the origin of life. The Theory of Darwinian Evolution, which continues to be refined by thousands of scientists working around the world, is the basis for the entire field of modern biology. Today it is one of the most important concepts in science and probably in the history of human thought.

A letter from Darwin dated 17 Oct 1879, to Sir Joseph Hooker, second public director of the Royal Botanic Gardens, Kew, requesting some seeds. Hooker provided Darwin with many seeds and plants for his experiments. Darwin is said to have written more letters to Hooker than to any other correspondent and the two shared a close relationship in both their professional and private lives.

KEW COLLECTION.

Plant evolutionary relationships and a natural classification

Science is a complex field and many non-scientists often find it difficult to follow. On the one hand the theory of evolution is quite simple, requiring only three steps: variation among individuals in characteristics, inheritance of those characteristics, and differential survival of individuals possessing those characteristics. On the other hand, the results of evolution, especially if traced over long periods of time, can be quite complicated to comprehend. The intricate branching diagrams, which taxonomists use to represent this evolutionary history, are often confusing and difficult to understand by those unfamiliar with the details and terminology. In this and subsequent sections we attempt to make this complex subject simpler by explaining the basis for these diagrams and defining unusual terminology.

Understanding how evolution works through such processes as natural selection and speciation has greatly helped botanists to develop a logically organised and 'natural' system of plant classification. In *On the Origin of Species*, Darwin proposed that evolutionary relationships should be incorporated into classification and provided an example 'tree of life' in this publication (see below). In fact, his branching diagram, which demonstrates the origin of species from varieties over fourteen thousand generations, is the only illustration in the entire first edition of his most famous book.

The metaphor of a branching tree to show the diversification of life from a single beginning, or trunk, has been used over and over again for a hundred years. Botanists have employed such branching diagrams to indicate the close and distant relationships of groups of plants, whether these plant groups are species,

C. E. Bessey's 1915 'bubble-tree' illustrating the evolution of the flowering plants (see page 16). From The Phylogenetic Taxonomy of Flowering Plants, *Annals of the Missouri Botanical Garden*, Vol 2: 109–164.

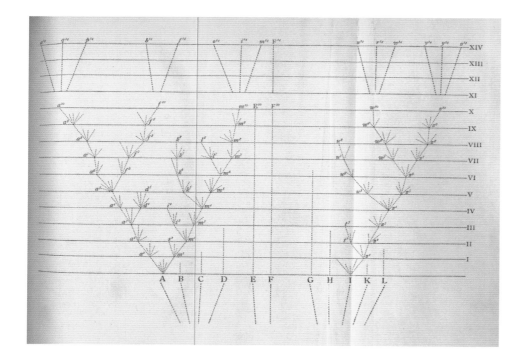

Darwin's original tree of life from *On the Origin of Species*. This shows how lines of descent (from the bottom towards the top) differentiate in a bifurcating (forking) manner over hundreds of generations, eventually becoming the source of new species.

Tree of Plant Evolution

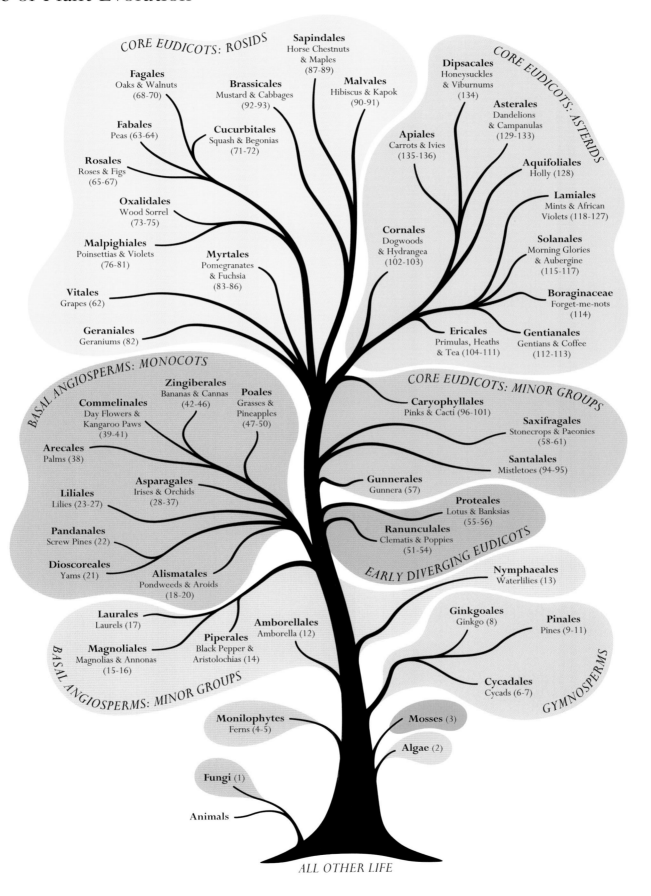

CORE EUDICOTS: ROSIDS

Sapindales
Horse Chestnuts
& Maples
(87-89)

Fagales
Oaks & Walnuts
(68-70)

Brassicales
Mustard & Cabbages
(92-93)

Malvales
Hibiscus & Kapok
(90-91)

CORE EUDICOTS: ASTERIDS

Dipsacales
Honeysuckles
& Viburnums
(134)

Asterales
Dandelions
& Campanulas
(129-133)

Fabales
Peas (63-64)

Cucurbitales
Squash & Begonias
(71-72)

Apiales
Carrots & Ivies
(135-136)

Aquifoliales
Holly (128)

Rosales
Roses & Figs
(65-67)

Oxalidales
Wood Sorrel
(73-75)

Lamiales
Mints & African
Violets (118-127)

Malpighiales
Poinsettias & Violets
(76-81)

Myrtales
Pomegranates
& Fuchsia
(83-86)

Cornales
Dogwoods
& Hydrangea
(102-103)

Solanales
Morning Glories
& Aubergine
(115-117)

Vitales
Grapes (62)

Boraginaceae
Forget-me-nots
(114)

Geraniales
Geraniums (82)

Ericales
Primulas, Heaths
& Tea (104-111)

Gentianales
Gentians & Coffee
(112-113)

BASAL ANGIOSPERMS: MONOCOTS

Zingiberales
Bananas & Cannas
(42-46)

Poales
Grasses &
Pineapples
(47-50)

Commelinales
Day Flowers &
Kangaroo Paws
(39-41)

CORE EUDICOTS: MINOR GROUPS

Caryophyllales
Pinks & Cacti (96-101)

Saxifragales
Stonecrops & Paeonies
(58-61)

Arecales
Palms (38)

Asparagales
Irises & Orchids
(28-37)

Santalales
Mistletoes (94-95)

Liliales
Lilies (23-27)

Gunnerales
Gunnera (57)

Pandanales
Screw Pines (22)

Proteales
Lotus & Banksias
(55-56)

Dioscoreales
Yams (21)

Ranunculales
Clematis & Poppies
(51-54)

Alismatales
Pondweeds & Aroids
(18-20)

EARLY DIVERGING EUDICOTS

Nymphaeales
Waterlilies (13)

Laurales
Laurels (17)

Amborellales
Amborella (12)

Ginkgoales
Ginkgo (8)

Pinales
Pines (9-11)

Piperales
Black Pepper &
Aristolochias (14)

Magnoliales
Magnolias & Annonas
(15-16)

BASAL ANGIOSPERMS: MINOR GROUPS

Cycadales
Cycads (6-7)

GYMNOSPERMS

Monilophytes
Ferns (4-5)

Mosses (3)

Algae (2)

Fungi (1)

Animals

ALL OTHER LIFE

genera, families or orders of plants. In 1915 the American botanist Charles Edwin Bessey used inflated, bubble-like branching diagrams to illustrate relationships among the major groups of flowering plants, indicating not only their position with respect to each other, but also how one group had originated from another in a series of advances moving from the most primitive to the most advanced. These 'trees' were based on the morphological features that characterised each plant group, such as plant habit, leaf shape, and flower structure. Sometimes these branching diagrams have been translated directly, though more often indirectly, into a written classification.

Today plant taxonomists use a great variety of characters to devise and organise their classifications, which are based on evolutionary principles and hence deemed 'natural.' Morphological features, such as roots, stems, buds, leaves and flower parts, anatomical traits, embryological and pollen characters, as well as chemistry and chromosome number have all been included in developing a classification of the modern-day plant. Often, if fossils of a particular plant group are known, they are used to provide estimates of the timing of various branching events on the evolutionary tree. Of all the evidence now available for constructing evolutionary trees and classifications, over the last decade DNA sequence data has played the most important role.

Once all of the sources of character information are gathered, the taxonomist must analyse the data in a method consistent with evolutionary theory. A phylogeny is an evolutionary chronicle of how species descended from a common ancestor and is usually illustrated as a branching tree called a cladogram. Cladograms are built by grouping species according to characters that have uniquely evolved from their common ancestor. Groups of plants that have evolved from a single common ancestor are called monophyletic. Non-monophyletic groups are not accepted as valid in a classification by taxonomists and therefore are rejected as not being 'natural.' By pairing the most closely related species in a bifurcating series of branches, the modern *Tree of Plant Evolution* has been built by taxonomists. Most scientists prefer to represent these evolutionary relationships as complicated, repeatedly branching diagrams. However, these cladograms can also be portrayed as an imaginary 'tree' in order to make the information easier for non-specialists to interpret. As new information on plant evolution is made available, the tree is constantly being refined and updated. The world's leading experts on plant classification have banded together during the last decade to produce a unified classification of plants based on the most up-to-date information, including DNA data. This cohort of scientists is called the Angiosperm Phylogeny Group (APG) and the most recent classification, called APG III, was released in 2009. The tree used in this book follows APG III, the most current consensus view on plant phylogeny.

The *Tree of Plant Evolution* has also been translated into an evolutionary classification that exactly reflects the branching patterns of a cladogram. Therefore, one could, if desired, reconstruct the evolutionary tree from the classification and vice versa. An ever-changing, but ever-improving, classification is a tribute to the many botanists who have shared their combined knowledge about the evolution of the rich diversity of plants in the world today. This classification (APG III) is the basis upon which the paintings in *The Art of Plant Evolution* are organised.

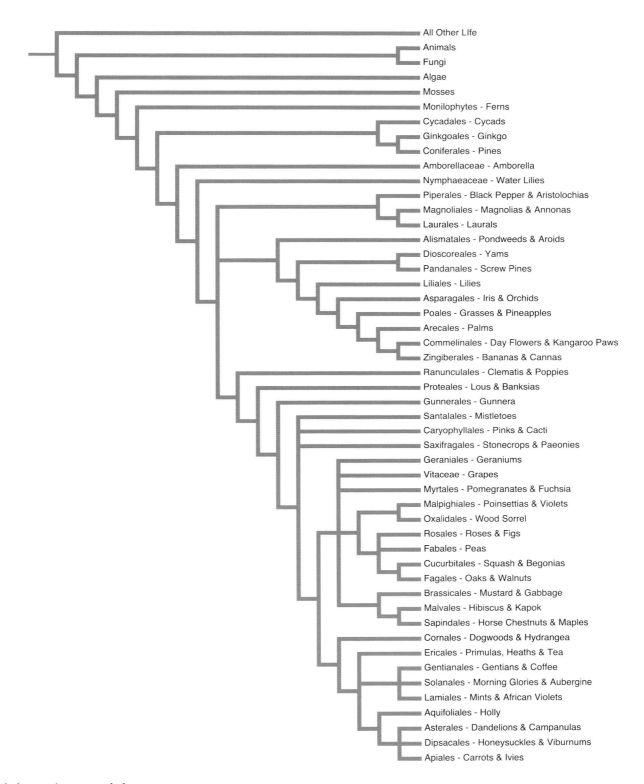

All Other LIfe
Animals
Fungi
Algae
Mosses
Monilophytes - Ferns
Cycadales - Cycads
Ginkgoales - Ginkgo
Coniferales - Pines
Amborellaceae - Amborella
Nymphaeaceae - Water Lilies
Piperales - Black Pepper & Aristolochias
Magnoliales - Magnolias & Annonas
Laurales - Laurals
Alismatales - Pondweeds & Aroids
Dioscoreales - Yams
Pandanales - Screw Pines
Liliales - Lilies
Asparagales - Iris & Orchids
Poales - Grasses & Pineapples
Arecales - Palms
Commelinales - Day Flowers & Kangaroo Paws
Zingiberales - Bananas & Cannas
Ranunculales - Clematis & Poppies
Proteales - Lous & Banksias
Gunnerales - Gunnera
Santalales - Mistletoes
Caryophyllales - Pinks & Cacti
Saxifragales - Stonecrops & Paeonies
Geraniales - Geraniums
Vitaceae - Grapes
Myrtales - Pomegranates & Fuchsia
Malpighiales - Poinsettias & Violets
Oxalidales - Wood Sorrel
Rosales - Roses & Figs
Fabales - Peas
Cucurbitales - Squash & Begonias
Fagales - Oaks & Walnuts
Brassicales - Mustard & Gabbage
Malvales - Hibiscus & Kapok
Sapindales - Horse Chestnuts & Maples
Cornales - Dogwoods & Hydrangea
Ericales - Primulas, Heaths & Tea
Gentianales - Gentians & Coffee
Solanales - Morning Glories & Aubergine
Lamiales - Mints & African Violets
Aquifoliales - Holly
Asterales - Dandelions & Campanulas
Dipsacales - Honeysuckles & Viburnums
Apiales - Carrots & Ivies

A phylogenetic tree or cladogram
illustrating the 'branches' or evolutionary
relationships of plants. Taxonomists build
cladograms by grouping species using
characters that have uniquely evolved
from their common ancestor.

How do we know about plant evolutionary relationships? Evidence from fossils

Evidence for evolution and the relatedness of all organisms by descent from a common ancestor can be found by looking at the similarities between organisms: in shape and anatomy, genetic make up, development (from embryo to adult), location and the fossil record.

Fossils are a rich source of evidence demonstrating how species have changed over time since the very beginning of life 3.2 billion years ago. Fossils tell us that most of the diversity of life has lived in the past and only a tiny fraction of that diversity is present today. The notion often expressed by non-scientists that the fossil record is too imperfect to discern evolutionary patterns is a basic misconception. Some of the most important fossils that contribute to an understanding of the evolution of life represent transitional forms of ancient plants and animals that are intermediate between groups and that look very different in today's world. For example, fossil mammals have been found with whale-like skulls and distinctive hind legs, which show that the ancestors of whales were mammals that walked on land. Over the last 150 years paleontologists have found a very large number of such fossils representing important intermediate forms of life.

Fossils offer solid geologic evidence for the age of various plant lineages. The Wollemi pine from Australia is a good example of a living fossil. This plant, called *Wollemia nobilis*, is a member of the primitive conifer family Araucariaceae, which first appeared in the fossil record during the Jurassic period over 160 million years ago. In 1994 a small population of living Wollemi pine plants was discovered in a remote canyon in the Blue Mountains of New South Wales. Fossil leaves nearly 90 million years old are very similar to the leaves of the plants found in Australia. The fossil evidence and the discovery of the living plants suggest that these conifers have been in existence for possibly one hundred million years.

The origin and form of the earliest plants with flowers have been a mystery since before the time of Charles Darwin. This long-standing mystery made the finding of a fossil of the oldest flowering plant, *Archaefructus liaoningensis*, one of the most important discoveries in our understanding of plant evolution. In the mid-1990s in northeast China, American and Chinese paleontologists found a series of fossils of a small plant with fruits that completely enclosed their seeds, a characteristic that defines all flowering plants alive today. This 125 million year-old Upper Jurassic fossil represents one of the first flowering plants to appear on the Earth and has provided scientists with a snapshot of the structure and form of these very early angiosperms.

New fossils, such as *Archaefructus liaoningensis*, are frequently being found by botanists around the world. Each new discovery provides another piece of evidence to add to the growing body of knowledge about plant evolution and classification.

A. Moss, 71 million years (Cretaceous), Wyoming, USA.

B. Osmundaceae, fern, 71 million years, (Cretaceous), Wyoming, USA

C. Pteridophyte, fern, 71 million years (Cretaceous), Wyoming, USA

D. Cycadaceae, gymnosperm, 71 million years (Cretaceous), Wyoming, USA.

E. Gingko, gymnosperm, 160 million years (Jurassic), Oregon, USA

F. Araucariaceae, gymnosperm, 71 million years (Cretaceous), Wyoming, USA

G Wollemi pine, gymnosperm, 160 million years (Jurassic)

H. *Archaefructus liaoningensis*, angiosperm, oldest flowering plant, 125 million years (Upper Jurassic), China.
COURTESY DR DAVID DILCHER.

I. *Platanus wyomingensis*, early eudicot, 50 million years (Eocene), Colorado, USA

J. *Populus cinnamomoidea*, angiosperm, 50 million years (Eocene), Colorado, USA

K. Juglandaceae, walnut, core eudicot, 43 million years (Eocene), Oregon, USA

G. © JAIME PLAZA, BOTANIC GARDENS TRUST, SYDNEY, AUSTRALIA

ALL OTHER IMAGES ABOVE © NATIONAL MUSEUM OF NATURAL HISTORY, SMITHSONIAN INSTITUTION

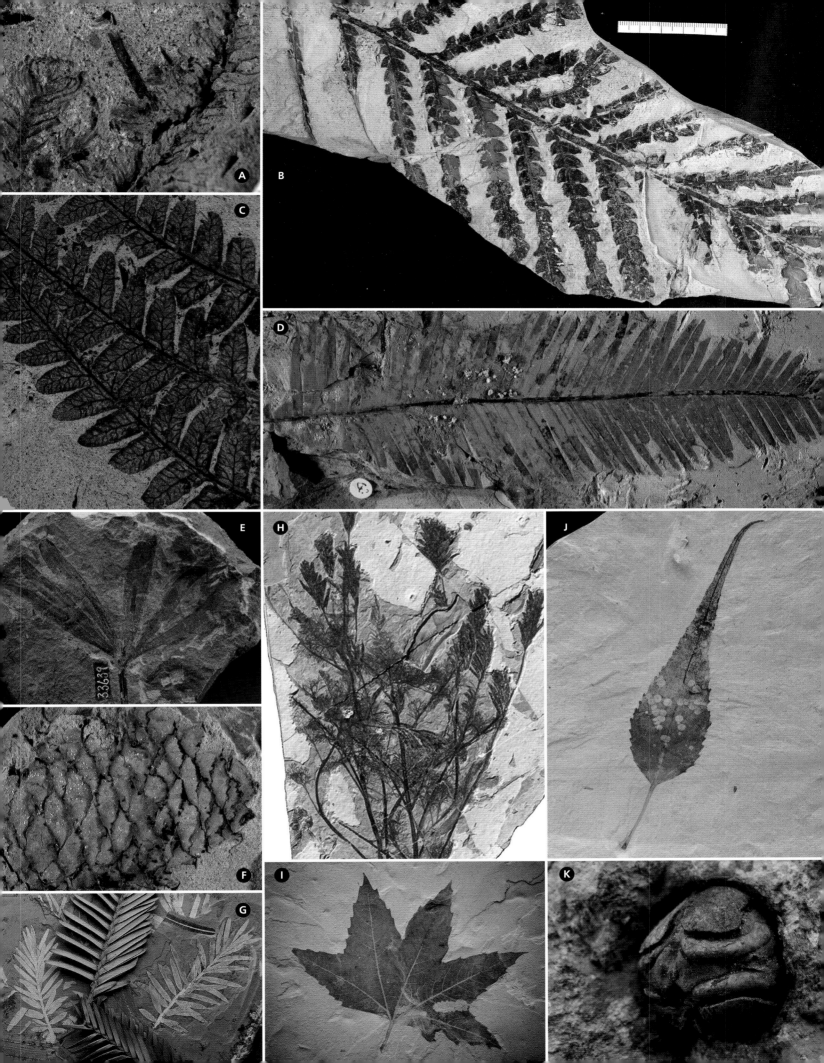

How do we know about plant evolutionary relationships? Evidence from DNA sequence data

The information contained in the DNA of plants and animals provides the genetic blueprint for constructing proteins – the building blocks that control all functions of life. Although the structure of the DNA molecule, which carries this genetic information, was only discovered a little over a half-century ago, analyses of the sequences of the nucleic acids that make up DNA have radically expanded our knowledge of the evolutionary process.

The application of DNA sequence data to our understanding of the evolutionary relationships of plant groups has been of the greatest significance to taxonomists, as it enhances our capability to devise natural, phylogenetic classifications. Fundamentally, DNA data are no different from other types of characters for interpreting evolutionary patterns. The basic advantage is that greater amounts of such sequence data are now available and in most cases easier to interpret than morphology, anatomy, and plant structure. For example, each DNA character, called a base pair or nucleotide, can be only one of four possible discrete kinds. Whereas, for each hair type or leaf type or flower type, plants may have numerous different kinds, making plant characters often more difficult to correctly interpret than DNA characters. Over the last decade taxonomists have come to rely almost entirely on sequence data for constructing meaningful phylogenetic trees and classifications. In many cases these classifications match previous work; in some cases they have proven radically different.

Three basic compartments of genetic information, called genomes, are found in plant cells. These compartments are contained in the chloroplast, the mitochondrion and the nucleus, and each differs in size, rates of change and patterns of inheritance.

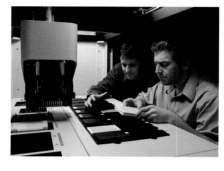

DNA sequencing laboratory at the Smithsonian, USA. © Smithsonian Institution.

Genetic analysis in the Jodrell Laboratory, Royal Botanic Gardens, Kew.

DNA sequencing plays a major role in plant species identification and determining evolutionary relationships. © Smithsonian Institution.

Work-flow diagram showing the generation of DNA sequence data for use in plant taxonomy. DNA is extracted from plant tissue collected from the field and from herbarium samples. This is then sequenced and analysed; vast amounts of data are compared and used to help to classify plants according to their evolutionary relationships.

COURTESY OF IDA LOPEZ

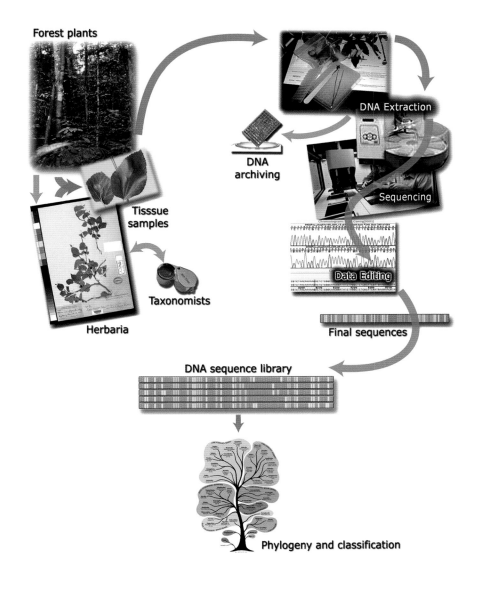

Forest plants

DNA Extraction

DNA archiving

Sequencing

Tisssue samples

Taxonomists

Data Editing

Herbaria

Final sequences

DNA sequence library

Phylogeny and classification

A computer generated model showing the structure of DNA. The molecule is composed of two strands, twisted into a double helix. Each strand consists of a sugar-phosphate backbone (yellow-red-brown) attached to nucleotide base pairs. There are four different nucleotide bases: guanine, cytosine, thymine and adenine. Guanine always pairs with cytosine, thymine always pairs with adenine (shown between the backbones in blue/purple and orange/green). The patterns of arrangement of the base pairs encode genetic information.

© PASIEKA / SCIENCE PHOTO LIBRARY

Botanists use DNA sequence data from each of these genomes to interpret phylogenetic relationships and often the data from the different genomes can be compared and combined to best understand how the plants have evolved.

Until now sequence data from one or more genes have been used for analysing the relationships of a particular group of plants. As DNA sequence technology has expanded, the ability to generate large amounts of data has greatly increased and the lab work has become less expensive. For this reason it is becoming more common to sequence entire genomes and not just a few genes. The major challenge ahead is to devise appropriate facilities for analysing and storing these massive amounts of DNA sequence data.

The *Tree of Plant Evolution* used in this book is based on a series of analyses of three primary genes used separately and combined together. Where appropriate, information on other types of characters has been incorporated into the analyses as well. It is not unlikely that some details about these evolutionary relationships of plants will change as new data are incorporated in the years ahead. However, the current phylogenetic tree and associated natural classification (APG III) provide a well-supported pattern of how plants evolved over the last four hundred million years from a single common ancestor to possibly 400,000 species alive today.

Co-evolution between plants and animals

Plants have evolved and adapted, not in isolation from, but most often in harmony with the animals that eat them, pollinate their flowers, and disperse their seeds. A major goal of biologists studying evolution is to understand the processes that shape these adaptations of organisms to their environment. One of the most important studies of this type was undertaken by Charles Darwin with his classic observations in the Galápagos Islands of beak variation among species of ground finches and the relationship of their beak structure to the food available to the birds on each island.

Another type of plant-animal interaction, that between flowers and the animals that pollinate them, has provided many striking examples of such adaptations between species. When both partners evolve together, such as plants

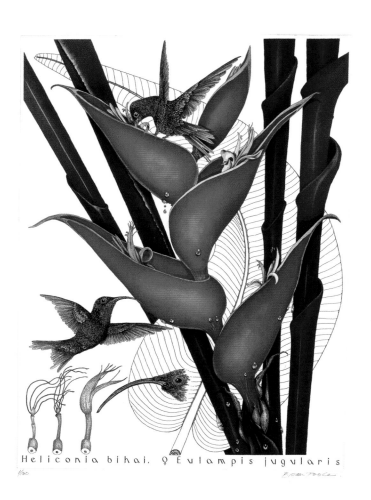

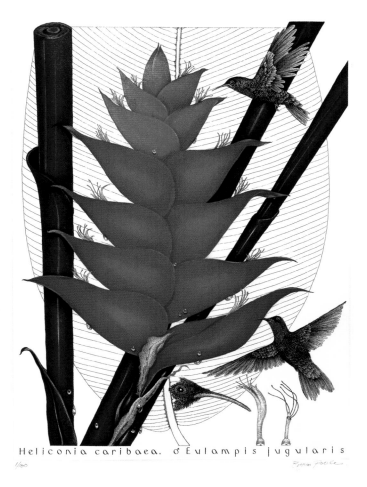

Heliconia bihai **with female hummingbirds** (above and front cover) **and** *Heliconia caribaea* **with male hummingbirds** (right) **as illustrated by Bryan Poole, b. Invercargill, New Zealand 1953. An example of co-evolution.**

and their pollinators, the process is commonly called co-evolution, which is defined as the reciprocal adaptive change between two or more interacting species, often occurring over millions of years. It has now been demonstrated that co-evolution caused the interaction between certain plants and their pollinators, plants and the animals that eat them (called herbivores), the algae and fungi that live together as lichens, as well as leaf-cutter ants and the fungi that they cultivate in their underground gardens.

Growing on the arc of volcanic islands in the eastern Caribbean Sea are two native species of *Heliconia*. These large herbs with banana-like leaves and brightly-coloured red, yellow, orange, and green floral displays are pollinated by a handful of local hummingbirds. Although worldwide there are nearly 200 species of heliconias, the two species in the Caribbean are unusual. One species, *Heliconia bihai*, which also occurs in northern South America, has mostly red and orange bracts with a yellow stripe along the margin and green flowers. The second species, *Heliconia caribaea*, is only found in the Caribbean islands and has similar green flowers, but the bracts can range from pure yellow in some individual plants to pure red in others.

In the centre of the Caribbean island-arc lies the country of Dominica, where an absolutely unique interaction between the two species of heliconia and a single species of hummingbird is found. The hummingbird, called the purple-throated carib or *Eulampis jugularis*, is jet black with iridescent blue wings and a vivid red-violet gorget (throat). The special aspect of this species of hummingbird is that the two sexes are markedly different from each other: the males possess large bodies and short, straight bills, while the females have much smaller bodies and long, curved bills.

The distinctive nature of this bird-plant interaction is that each sex feeds differently: males only visit one of the two plant species, *Heliconia caribaea*, taking nectar from the short straight flowers that are the same size and shape as the males' bills. The females mostly visit *Heliconia bihai*, the second species of plant, to take nectar by probing the long curved flowers that fit the females' similarly-shaped bills. In the process of visiting the flowers to take nectar, both the male and female hummingbirds pollinate the specific species of *Heliconia* that fits their beaks.

This system, one of the most precise plant-animal relationships found in nature, only occurs on these Caribbean islands and nowhere else in the world. The plants and their hummingbird pollinators are absolutely stunning works of evolution in their colour, form, and behaviour. Some ecologists have referred to these unique birds as 'Darwin's hummingbirds' because of the similarity of the diversity of the hummingbird's bills to the beaks of Darwin's finches in the Galápagos Islands, where the theory of evolution through natural selection was first formulated. In the islands of the eastern Caribbean an ecological interaction between heliconias and their hummingbird pollinators illustrates Darwin's theory of evolution in action.

The current classification of the major groups of plants

The currently accepted evolutionary tree for plants has been carefully built by taxonomists over the last ten years and is based on a plethora of plant features and traits. DNA sequence data have provided the core characters for reconstructing the phylogenetic relationships among the major groups of land plants with morphological, anatomical, and chemical traits adding critical interpretations for particular taxa. Yet no single type of character has proven successful in defining the entire tree of plant evolution. To assist the reader in navigating around the tree, we introduce the major groups, or lineages, of plants below, taking a brief look at how they are phylogenetically related to each other, and at some of the characters by which they are recognised.

Fungi. Although fungi have traditionally been considered plants and within the field of botany, scientists now agree that these organisms are not plants at all. Lacking the ability to photosynthesize and possessing a distinctive type of cell wall, they are most closely related evolutionarily to animals. We have placed fungi at the base of the tree of life, as an off-shoot from the animal branch, as a reminder that fungi are not plants and share more features with animals than they do with plants.

Algae. The term 'algae' refers to several groups of unrelated photosynthetic plants that are primarily aquatic. These groups include red algae, brown algae, diatoms, dinoflagellates, and green algae. Each group is distinctive in the type of pigment used for photosynthesis and in its characteristic life cycle. Green algae are most closely related to land plants and share numerous structural and chemical features with them. Green algae and land plants share a common ancestor that dates back to 1 billion years ago.

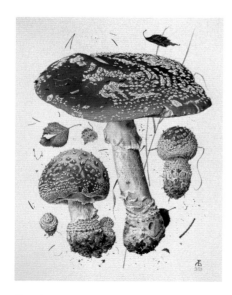

Fungi: *Amanita muscaria* **Algae:** *Laminaria* **sp.**

Mosses. Mosses have traditionally been associated with liverworts and hornworts in a group called 'bryophytes', which sits at the base of the *Tree of Plant Evolution*. It is now agreed that these three types of plants are not monophyletic, and hence not a natural group. Mosses are probably the group most closely related to all other land plants, with which they share a specialised reproductive structure. However, additional data suggest that our ideas on relationships among the mosses, liverworts and hornworts may change as more information is accumulated.

Monilophytes. The ferns and some of their traditional allies (e.g. horsetails) are now grouped together in a single group called the monilophytes. The club mosses have been excluded from this group on the basis of DNA sequence data and because they have a different leaf structure than the ferns. The monilophytes and the club mosses are the first branches on the *Tree of Plant Evolution* whose members possess water-conducting cells, or vascular tissue, in the stems. Like mosses, they reproduce by spores rather than seeds, the latter being typical of the more specialised gymnosperms and angiosperms.

Gymnosperms. The evolution of seeds (made up of the young embryo, some nutritive tissue, and an outer protective covering) was an important step in the proliferation of plants on land. Gymnosperm, like bryophyte, is a term that comprises a number of different groups of plants that are related by the possession of seeds, but do not form a monophyletic lineage. In gymnosperms the seeds are 'naked' and not enclosed within a fruit wall. The living gymnospermous groups include conifers, ginkgos, and cycads, all of which, like the monilophytes, have a well developed vascular system. Botanists do not agree on the evolutionary relationships of the various groups of gymnosperms, or on which of group is most closely related to the flowering plants. Perhaps some missing links between the gymnosperms and the angiosperms became extinct long ago.

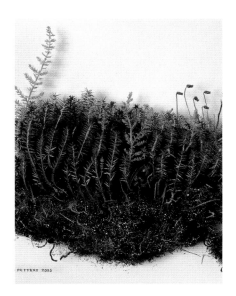

Moss: *Polytrichum commune*

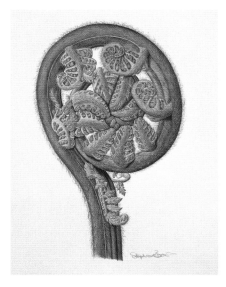

Monilophyte: *Dicksonia antarctica*

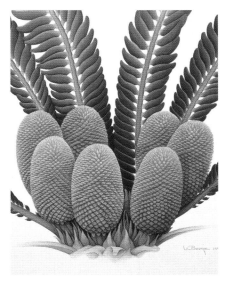

Gymnosperm: *Encephalartos woodii*

Angiosperms. An explosive diversification of plant species began 135 million years ago and continues to this day in the flowering plants (angiosperms). The innovation which stimulated this rich diversity was the evolution of the flower that combined a closed chamber to protect the seeds (called a carpel), a much reduced group of cells to facilitate fertilisation, and a unique nutritive tissue to provide for the developing embryo (called endosperm). The evolution of the flower and the coincident adaptation of many different animals for pollinating them was the origin that led to the over 300,000 species of angiosperms that are estimated to live on the Earth.

One of the most important contributions of DNA sequence data over the last decade has been to our understanding of the evolutionary relationships within the angiosperms. As will always be true in the field of plant taxonomy, new data may change or refine our ideas about phylogeny and classification. However, in the first years of the 21st century, most botanists have accepted the basic patterns of relationships among the major divisions of flowering plants as worked out by an assemblage of botanists called the 'Angiosperm Phylogeny Group'. The major groupings within the flowering plants are generally referred to by the informal names basal angiosperms, monocots, early diverging eudicots, and core eudicots, which include the caryophilids, saxifragids, rosids, and asterids.

The term *basal angiosperm* is applied to the earliest diverging lineages of flowering plants which together do not make up a monophyletic group. There is no single character that is shared by all these disparate lineages and they are simply grouped together at the base of the phylogenetic tree by being excluded from the rest of the flowering plants. For hundreds of years, many botanists recognised two major groups within the angiosperms called monocotyledons ('monocots') and dicotyledons ('dicots'). We now know that the monocots are a monophyletic group embedded in the basal angiosperms, but the dicots are not a monophyletic group. *Amborella*, a small shrub from New Caledonia, is the

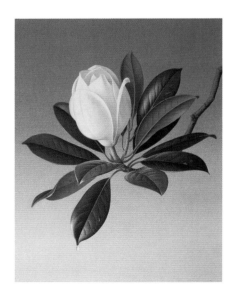

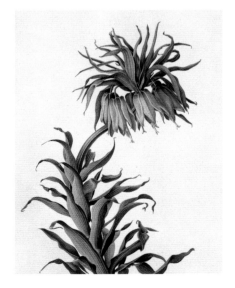

Basal angiosperm: *Magnolia grandiflora* Monocot: *Fritillaria imperialis*

most primitive angiosperm. Other plants, such as water lilies, laurels, magnolias, tulip trees, and black pepper are included in the basal angiosperms.

The **monocots** are the largest monophyletic group in the basal angiosperms with nearly 60,000 species. Monocots account for nearly one-quarter of all flowering plants. They are distinguished from other angiosperms by possessing a single seedling leaf (called a cotyledon), a diffusely scattered vascular system, and floral parts in whorls of three (although this feature is also present in several other basal angiosperms), as well as several specialised cellular characteristics. Monocots probably originated between 125 and 140 million years ago. Twelve major lineages are recognised within the monocots, including pickerel weeds and aroids, screw pines, onions and orchids, lilies, palms, gingers and bananas, day-flowers, and the grasses and bromeliads.

The remaining flowering plants are all contained within a monophyletic group called the **eudicots**, which has been identified primarily by DNA sequence data, but also defined by the presence of pollen grains with three distinctive grooves. It is easiest to consider the eudicots as being made up of several entities: the early diverging eudicots, the caryophilids, the saxifragids, the rosids, and the asterids. Similar to the basal angiosperms, the *early diverging eudicots* are composed of several different and unrelated lineages that do not form a monophyletic group. These lineages include the poppies, buttercups, proteas, plane trees, and lotus. The number of species contained in each of these plant groups is generally quite small with rarely more than 1,000 species per family.

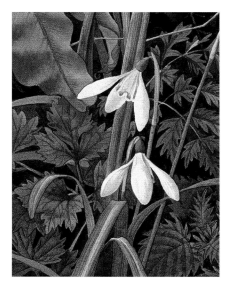

Monocot: *Galanthus nivalis*

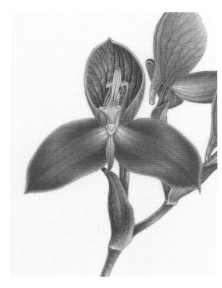

Monocot: *Disa uniflora*

The *core eudicots* make up the main component of what was formerly called the dicots. The *caryophilids*, which are characterised by a special set of pigments called betalains, are a monophyletic group, and include carnations, cacti, Old World pitcher plants, and buckwheat. Many of the caryophilids are especially adapted to extreme environments, such as deserts or nutrient-poor and high-saline soils. The second group of core eudicots, the *saxifragids*, have only recently been recognised as a phylogenetically related group. Plants, such as the witch hazels, stone crops, gooseberries, and paeonias, were formerly not thought to be related at all until DNA data clearly and strongly placed them together. It is still not exactly clear how the saxifragids are related to the caryophilids and other groups in the core eudicots.

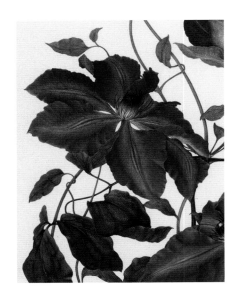

Early diverging eudicot: *Clematis*

The *rosids* contain a very large number of species, perhaps one-third of the angiosperms, and are very diverse in form and geographic distribution. Like the saxifrigids, the rosids contain many plants that formerly were not thought to be related to each other and the complexities of relationships within the group are now being intensely studied. DNA sequence data are the prime evidence for combining these very different types of plants into a single large group, including eucalypts, crepe myrtles, fuschias, poinsettias, willows, carambolas, beans, roses, figs, oaks, mustards, mallos, and oranges.

With nearly 80,000 species, the *asterids* are as diverse and speciose as the rosids. However, unlike the rosids, this group is characterised by a number of specialised features, such as fused petals, unique chemical compounds (for instance, iridoids and alkaloids) and a distinctive ovule structure, in addition to the DNA sequence data. Within the asterids, botanists are in general agreement about the evolutionary relationships among the major subgroups, for example, uniting the heaths with primulas, brazil nuts, and camellias, grouping gentians with potatoes, African violets and mints, and classifying hollies with carrots, viburnums, and asters.

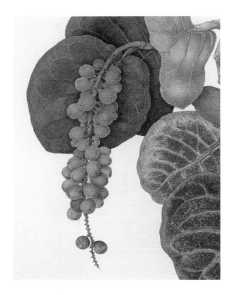

Core eudicot: *Coccoloba uvifera*

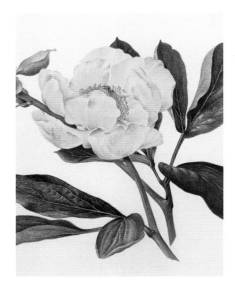

Core eudicot: *Paeonia mlokosewitschii*

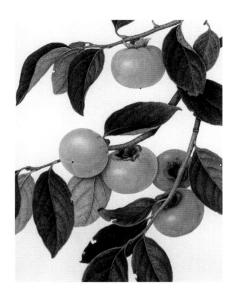

Asterid: *Diospyros kaki*

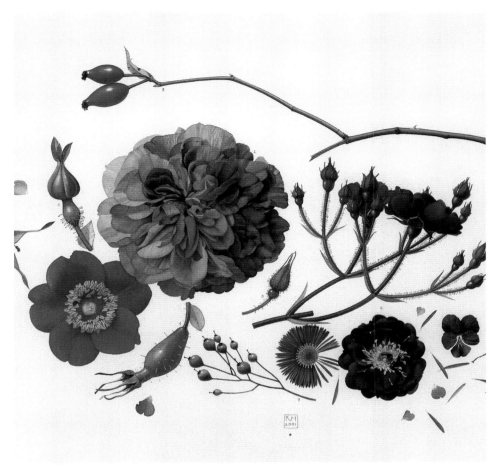

Rosid: *Rosea* **cultivar**

This short synopsis of the major evolutionary groups of land plants serves as an entryway into the additional information that is provided for each of the plants illustrated in *The Art of Plant Evolution*. Included here in total are 134 species in 116 plant families divided among 44 plant orders, illustrated by 84 artists. Although this set of species, families, and orders is by no means exhaustive for the plant world, it is representative and will provide the reader a sufficient overview of diversity. Many taxonomists from many institutions have contributed to the information contained here about the diversity of plant life found on Earth, where on the planet these plants live, how they are related to each other, and how they have evolved over the last two hundred million years.

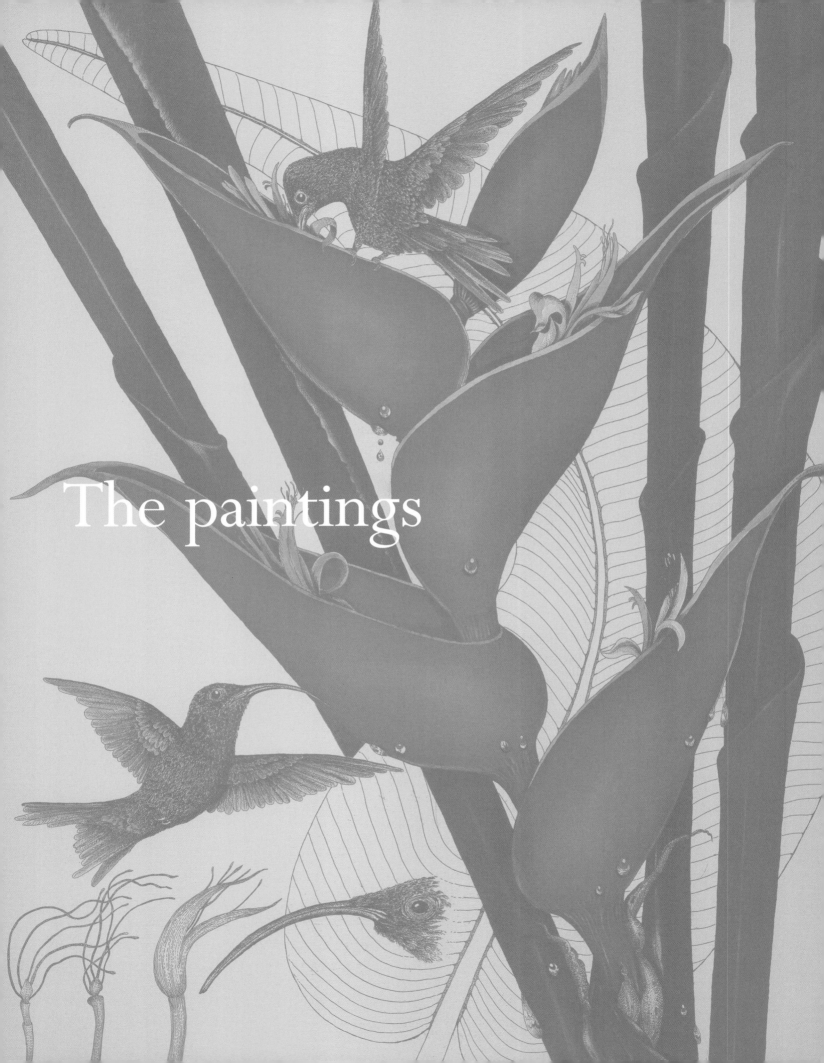

The paintings

Taxonomic arrangement of the paintings[*]

Plant Group and Order	Plant Family	Artist	Painting Name	Botanical Name	Painting
I. Fungi					
	Amanitaceae	Alexander Viazmensky	*Amanita muscaria*	*Amanita muscaria* (L.) Lam.	1
II. Algae					
	Laminariaceae	Susannah Blaxill	Seaweed	*Laminaria* sp.	2
III. Mosses					
	Polytrichaceae	Yanny Petters	Moss	*Polytrichum commune* Hedw.	3
IV. Monilophytes					
Ferns	Dicksoniaceae	Stephanie Berni	Australian tree fern	*Dicksonia antarctica* Labill.	4
	Aspleniaceae	Kate Nessler	Walking fern	*Asplenium rhizophyllum* L.	5
V. Gymnosperms					
Cycadales	Zamiaceae	Leslie Carol Berge	Cycad (female cones)	*Encephalartos ferox* G. Bertol.	6
	Zamiaceae	Leslie Carol Berge	Cycad (male cones)	*Encephalartos woodii* Sander	7
Ginkgoales	Ginkgoaceae	Manabu Saito	*Ginkgo biloba*	*Ginkgo biloba* L.	8
Pinales	Pinaceae	Brigid Edwards	Douglas fir	*Pseudotsuga menziesii* (Mirb.) Franco	9
	Pinaceae	Ann Farrer	Cedar of Lebanon	*Cedrus deodara* (Roxb.) G. Don	10
	Araucariaceae	Bronwyn van de Graaff	Wollemi pine	*Wollemia nobilis* W.G. Jones, K.D. Hill & J.M. Allen	11
VI. Angiosperms					
Amborellales	Amborellaceae	Alice Tangerini	*Amborella trichopoda*	*Amborella trichopoda* Baill.	12
Nymphaeales	Nymphaeaceae	Pandora Sellars	Blue water lily	*Nymphaea capensis* Thunb.	13
Piperales	Aristolochiaceae	Rosália Demonte	*Aristolochia gigantea*	*Aristolochia gigantea* Hook.	14
Magnoliales	Magnoliaceae	Paul Jones	*Magnolia grandiflora*	*Magnolia grandiflora* L.	15
	Annonaceae	Alvaro E. X. Nunes	Custard apple	*Annona crassifolia* Mart.	16
Laurales	Calycanthaceae	Betty Hinton	*Idiospermum australiense*	*Idiospermum australiense* (Diels) S.T. Blake	17
Alismatales	Araceae	Coral Guest	Cheese plant	*Monstera deliciosa* Leibm.	18
	Araceae	Margaret Mee	*Philodendron muricatum*	*Philodendron muricatum* Schott	19
	Butomaceae	Dasha Fomicheva	Flowering reed	*Butomus umbellatus* L.	20
Dioscoreales	Dioscoreaceae	Camilla Speight	*Dioscorea elephantipes D. discolor*	*Dioscorea elephantipes* Engl. and *D. discolor* R. Knuth	21
Pandanales	Pandanaceae	Noboru Isogai	*Pandanus tectorius*	*Pandanus tectorius*	22
Liliales	Melanthiaceae	Lawrence Greenwood	*Trillium decumbens*	*Trillium decumbens* Harb.	23
	Colchicaceae	Pandora Sellars	Glory lily	*Gloriosa rothschildiana* O'Brien	24

Vertical side labels: Fungi and Lower plants · Gymnosperms · Basal Angiosperms: Minor Groups · Basal Angiosperms: Monocots

Plant Group and Order	Plant Family	Artist	Painting Name	Botanical Name	Painting
	Philesiaceae	Coral Guest	*Lapageria rosea* and *L. rosea* var. *albiflora*	*Lapageria rosea* Ruiz & Pav. and *L. rosea* var. *albiflora* Hook.	25
	Liliaceae	Rory McEwen	Crown imperial	*Fritillaria imperialis* L.	26
	Liliaceae	Coral Guest	*Lilium regale*	*Lilium regale* E.H. Wilson	27
Asparagales	Orchidaceae	Francesca Anderson	Vanda 'Fuchs Blue'	*Vanda* sp.	28
	Orchidaceae	Carol Woodin	*Disa uniflora*	*Disa uniflora* P.J. Bergius	29
	Orchidaceae	Kate Nessler	Clamshell orchid	*Prosthechea cochleata* (L.) W.E. Higgins	30
	Orchidaceae	Angela Mirro	*Phragmipedium kovachii*	*Phragmipedium kovachii* J.T. Atwood, Dalström & Ric. Fernandez	31
	Iridaceae	Celia Hegedüs	Stinking iris	*Iris foetidissima* L.	32
	Xanthorrhoeaceae	Bronwyn Van de Graaff	Grass tree	*Xanthorrhoea australis* R. Br.	33
	Alliaceae	Vicky Cox	White onion and skin	*Allium cepa* L.	34
	Alliaceae	Vicki Thomas	*Haemanthus nortieri*	*Haemanthus nortieri* Isaac	35
	Alliaceae	Susan Ogilvy	Snowdrops	*Galanthus nivalis* L.	36
	Asparagaceae	Kate Nessler	*Hyacinthus orientalis*	*Hyacinthus orientalis* L.	37
Arecales	Arecaceae	Jessica Tcherepnine	Coconut	*Cocos nucifera* L.	38
Commelinales	Commelinaceae	Beverly Allen	Blue ginger	*Dichorisandra thyrsiflora* J.C. Mikan	39
	Haemodoraceae	Christina Hart-Davies	Kangaroo paw	*Anigozanthos manglesii* D. Don	40
	Pontederiaceae	Pandora Sellars	*Pontederia cordata*	*Pontederia cordata* L.	41
Zingiberales	Strelitziaceae	Patricia Villela	Strelitzia augusta	*Strelitzia nicolai* Regel & Körn.	42
	Heliconiaceae	Paul Jones	Heliconia bougainville	*Heliconia solomonensis* W.J. Kress	43
	Musaceae	Bryan Poole	Banana flower and fruit	*Musa* x *sapientum* L.	44
	Cannaceae	Susan Ogilvy	Canna leaves	*Canna indica* L.	45
	Marantaceae	Dianne McElwain	Prayer plant	*Maranta leuconeura* E. Morren	46
Poales	Bromeliaceae	Etienne Demonte	*Billbergia sanderiana* and *Hylocharis cyanus*	*Billbergia sanderiana* E. Morr.	47
	Bromeliaceae	Alvaro E. X. Nunes	Bromeliad	*Bromelia antiacantha* Bertol.	48
	Juncaceae	Ann Farrer	*Juncus maritimus*	*Juncus maritimus* Lam.	49
	Poaceae	Ann Schweizer	*Phyllostachys viridis*	*Phyllostachys viridis* (R.A. Young) McClure	50

Basal Angiosperms: Monocots

Plant Group and Order	Plant Family	Artist	Painting Name	Botanical Name	Painting
Early Diverging Eudicots					
Ranunculales	Papaveraceae	Brigid Edwards	Oriental poppy	*Papaver orientale* L.	51
	Papaveraceae	Brigid Edwards	Poppy seed head 1999	*Papaver somniferum* L.	52
	Lardizabalaceae	Seiko Kijima	*Akebia quinata*	*Akebia quinata* (Houtt.) Decne.	53
	Ranunculaceae	Josephine Hague	*Clematis* 'Elsa Spath'	*Clematis* cv. Elsa Spath	54
Proteales	Nelumbonaceae	Beverly Allen	Yellow lotus	*Nelumbo lutea* Willd.	55
	Proteaceae	Celia Rosser	Saw banksia	*Banksia serrata* L.f.	56
Core Eudicots: Minor Groups					
Gunnerales	Gunneraceae	Sue Herbert	Small gunnera leaf	*Gunnera manicata* Linden ex Delchev.	57
Saxifragales	Paeoniaceae	Jeanne Holgate	Paeonia	*Paeonia mlokosewitschii* Lomakin	58
	Grossulariaceae	Jill Coombs	Gooseberry	*Ribes uva-crispa* L.	59
	Saxifragaceae	Jean-Claude Buytaert	Pickaback plant	*Tolmiea menziesii* Torr. & A. Gray	60
	Crassulaceae	Ellaphie Ward Hilhorst	*Crassula coccinea*	*Crassula coccinea* L.	61
Core Eudicots: Rosids					
Vitales	Vitaceae	Kate Nessler	Wild grapes	*Vitis vinifera* L.	62
Fabales	Fabaceae	Pauline M. Dean	Jade vine	*Strongylodon macrobotrys* A. Gray	63
	Fabaceae	Yuri Ivanchenko	August (pea)	*Pisum sativum* L.	64
Rosales	Rosaceae	Rosie Sanders	Tom Putt apple	*Malus* cultivar	65
	Rosaceae	Regine Hagedorn	Roses 1	*Rosa* cultivar	66
	Moraceae	Pamela Stagg	Four figs	*Ficus carica* L.	67
Fagales	Fagaceae	Regine Hagedorn	Acorns from the Jura	*Quercus robur* L.	68
	Juglandaceae	Jakob Demus	Walnuts	*Juglans nigra* L.	69
	Betulaceae	Elizabeth Cameron	Purple filbert	*Corylus maxima* 'Purpea' Mill.	70
Cucurbitales	Cucurbitaceae	Anne Ophelia Dowden	Squash blossom 1978	*Cucurbita pepo* L.	71
	Begoniaceae	Lizzie Sanders	Begonia	*Begonia socotrana* Hook. f.	72
Oxalidales	Oxalidaceae	Alvaro E. X. Nunes	*Averrhoa carambola*	*Averrhoa carambola* L.	73
	Elaeocarpaceae	Margaret Saul	Blue quandong	*Elaeocarpus angustifolius* Blume	74
	Cephalotaceae	Christina Hart-Davies	Australian pitcher plant	*Cephalotus follicularis* Labill.	75
Malpighiales	Euphorbiaceae	Jenny Phillips	*Euphorbia obesa*	*Euphorbia obesa* Hook. f.	76
	Passifloraceae	Vicki Thomas	*Adenia hastata*	*Adenia hastata* Schinz	77
	Salicaceae	Brenda Watts	Goat willow	*Salix caprea* L.	78
	Violaceae	Paul Jones	Violet	*Viola* sp.	79
	Clusiaceae	Margaret Mee	*Clusia grandiflora*	*Clusia grandiflora* Splitg.	80
	Podostemaceae	Manabu Saito	Koemaroe-njannjan	*Mourera fluviatilis* Aubl.	81
Geraniales	Geraniaceae	Ellaphie Ward Hilhorst	Pelargonium	*Pelargonium tetragonum* L'Hér.	82

Plant Group and Order	Plant Family	Artist	Painting Name	Botanical Name	Painting
Core Eudicots: Rosids					
Myrtales	Lythraceae	Ann Schweizer	Pomegranates	*Punica granatum* L.	83
	Onagraceae	Siriol Sherlock	Fuchsia	*Fuchsia* cv. 'Corallina'	84
	Myrtaceae	Jenny Phillips	*Corymbia ficifolia*	*Corymbia ficifolia* (F. Muell.) K.D. Hill & L.A.S. Johnson	85
	Melastomataceae	Margaret Ann Eden	*Medinilla magnifica*	*Medinilla magnifica* L.	86
Sapindales	Sapindaceae	Pauline Dean	Horse chestnut	*Aesculus hippocastanum* L.	87
	Rutaceae	Andrew Kamiti	*Calodendrum capensis*	*Calodendrum capensis* Thunb.	88
	Meliaceae	Barbara Pike	Klapperboo	*Nymania capensis* Lindb.	89
Malvales	Malvaceae	Alvaro E. X. Nunes	*Pseudobombax tomentosum* (fruit)	*Pseudobombax tomentosum* (Mart. & Zucc.) Robyns	90
	Malvaceae	Alvaro E. X. Nunes	*Pseudobombax tomentosum* (flower)	*Pseudobombax tomentosum* (Mart. & Zucc.) Robyns	91
Brassicales	Tropaeolaceae	Damodar Lal Gurjar	Nasturtium tropaeolum	*Tropaeolum majus* L.	92
	Brassicaceae	Katherine Manisco	Savoy cabbage	*Brassica oleracea* L.	93
Core Eudicots: Minor Groups					
Santalales	Balanophoraceae	Rosália Demonte	*Langsdorffia hypogaea*	*Langsdorffia hypogaea* Mart.	94
	Loranthaceae	Helga Crouch	Mistletoe	*Phoradendron* sp.	95
Caryophyllales	Polygonaceae	Katherine Manisco	Sea grapes	*Coccoloba uvifera* L.	96
	Nepenthaceae	Mariko Imai	*Nepenthes truncata*	*Nepenthes truncata* Macfarlane	97
	Caryophyllaceae	Elisabeth Dowle	Pike's pink	*Dianthus* hybrid	98
	Amaranthaceae	Susannah Blaxill	Beetroot	*Beta vulgaris* L.	99
	Aizoaceae	Barbara Oozeerally	Ruschia	*Mesembryanthemum graniticum* L. Bolus	100
	Cactaceae	Arthur & Alan Singer	Cactus wren on saguaro	*Carnegiea gigantea* (Engelm.) Britton & Rose	101
Core Eudicots: Asterids					
Cornales	Cornaceae	Katie Lee	Dogwood	*Cornus florida* L.	102
	Hydrangeaceae	Brigid Edwards	Hydrangea	*Hydrangea* sp.	103
Ericales	Lecythidaceae	Margaret Mee	Cannonball tree	*Couroupita guianensis* Aubl.	104
	Ebenaceae	Kimiyo Maruyama	*Diospyros kaki*	*Diospyros kaki* Thunb.	105
	Primulaceae	Brigid Edwards	Primulas	*Primula* sp.	106
	Primulaceae	Francesca Anderson	*Cyclamen persicum*	*Cyclamen persicum* Mill.	107
	Theaceae	Jinyong Feng	*Camellia chrysantha*	*Camellia chrysantha* (Hu) Tuyama	108
	Sarraceniaceae	Mariko Imai	*Sarracenia purpurea*	*Sarracenia purpurea* L.	109
	Actinidiaceae	Elisabeth Dowle	Kiwi fruit & prickly pear	*Actinidia chinensis* Planch. and *A. deliciosa* (A. Chev.) C.F. Liang & A.R. Ferguson	110

Plant Group and Order	Plant Family	Artist	Painting Name	Botanical Name	Painting
	Ericaceae	Lawrence Greenwood	*Rhododendron falconeri*	*Rhododendron falconeri* Hook. f.	111
Gentianales	Gentianaceae	Marjorie Blamey	Gentian	*Gentianella quinquefolia* subsp. *occidentalis* (A. Gray) J.M. Gillett	112
	Apocynaceae	Ann Farrer	*Allamanda cathartica*	*Allamanda cathartica* L.	113
No Order	Boraginaceae	Lizzie Sanders	*Trichodesma scotti*	*Trichodesma scotti* Balf.f.	114
Solanales	Convolvulaceae	Josephine Hague	Morning glory	*Ipomoea purpurea* (L.) Roth	115
	Solanaceae	Susannah Blaxill	Aubergine	*Solanum melongena* L.	116
	Solanaceae	Brigid Edwards	Cape gooseberry	*Physalis peruviana* L.	117
Lamiales	Gesneriaceae	Josephine Hague	Studies of streptocarpus	*Streptocarpus* spp.	118
	Plantaginaceae	Sylvia Peter	'Rat's tail' spitzwegerich	*Plantago lanceolata* L.	119
	Plantaginaceae	Diana Lawniczak	Speedwell	*Veronica persica* Poir.	120–121
	Lamiaceae	Anelise Scherer de Souza Nunes	*Origanum dictamnus*	*Origanum dictamnus* L.	122
	Lamiaceae	Vicki Thomas	*Plectranthus zuluensis*	*Plectranthus zuluensis* T. Cooke	123
	Paulowniaceae	Tai-li Zhang	*Paulownia elongata*	*Paulownia elongata* S.Y. Hu	124
	Orobanchaceae	Mariko Imai	*Aeginetia indica*	*Aeginetia indica* L.	125
	Acanthaceae	Ann Farrer	*Thunbergia grandiflora*	*Thunbergia grandiflora* Roxb.	126
	Bignoniaceae	Christabel King	African tulip tree	*Spathodea campanulata* P. Beauv.	127
Aquifoliales	Aquifoliaceae	Jenny Phillips	Holly	*Ilex* sp.	128
Asterales	Campanulaceae	Rosane Quintella	*Physoplexis comosa*	*Physoplexis comosa* Schur	129
	Menyanthaceae	Sara Anne Schofield	Bog bean	*Menyanthes trifoliata* L.	130
	Asteraceae	Marilena Pistoia	Dandelion	*Taraxacum officinale* F.H. Wigg.	131
	Asteraceae	Brigid Edwards	Artichoke flower	*Cynara scolymus* L.	132
	Asteraceae	Johann F. Dietzsch	Woolly thistle	*Cirsium eriophorum* (L.) Scop.	133
Dipsicales	Adoxaceae	Margaret Stones	*Viburnum rhytidophyllum*	*Viburnum rhytidophyllum* Hemsl.	134
Apiales	Araliaceae	Diana Lawniczak	Ivy	*Hedera helix* L.	135
	Apiaceae	Viet Martin Kunz	Sand thistle	*Eryngium maritimum* L.	136

Core Eudicots: Asterids

* Angiosperm Phylogeny Group (2009). An update of the AGP classification of families and orders of the flowering plants. *Botanical Journal of the Linnean Society*, in press.

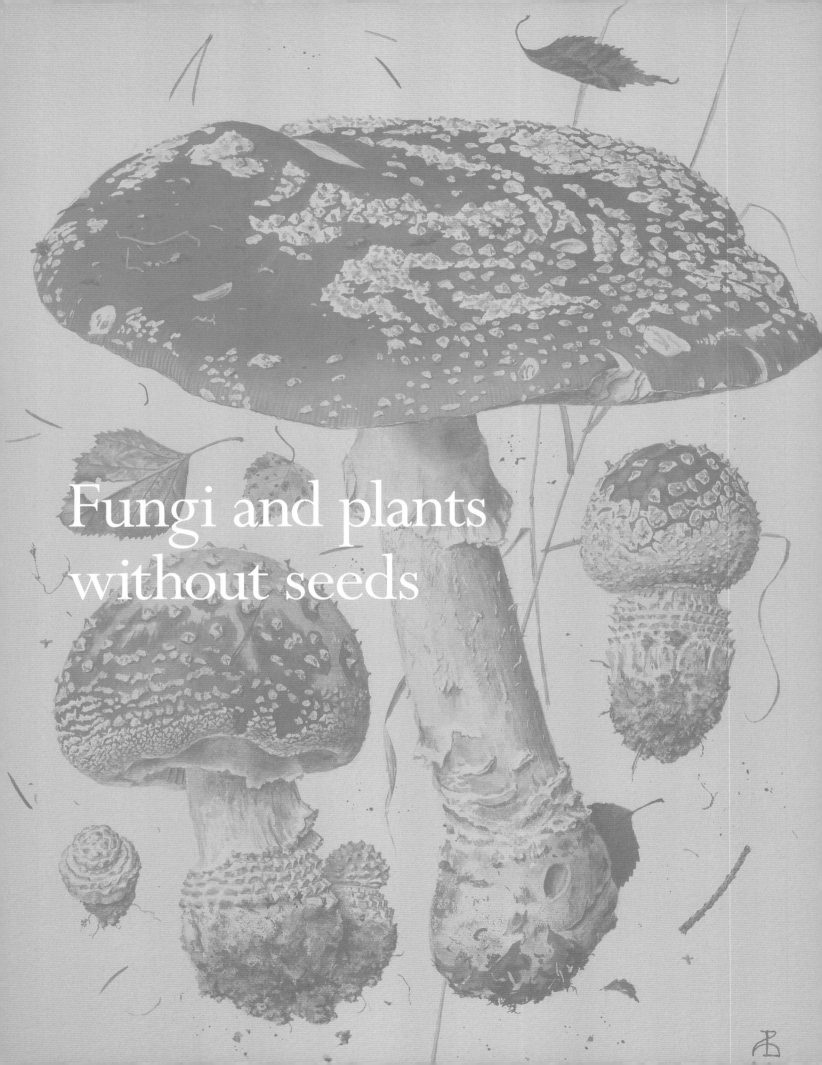

Fungi and plants
without seeds

Fungi and plants without seeds

This section groups together the fungi, which at one point were thought to be plants but are now considered not to be akin to them, with several lineages of early evolving plants, including the algae, the mosses, and the monilophytes (ferns and relatives). These early lineages are similar in that they reproduce by spores and evolved before the development of seeds, which are only found in gymnosperms and angiosperms.

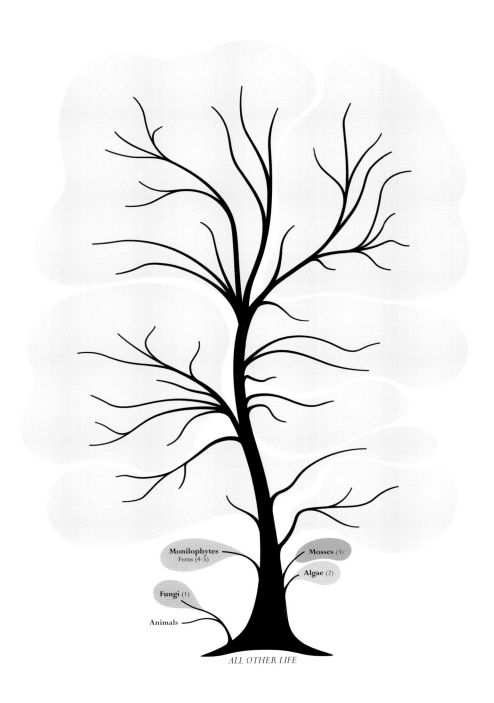

Monilophytes
Ferns (4-5)

Mosses (3)

Algae (2)

Fungi (1)

Animals

ALL OTHER LIFE

I. Fungi

Although fungi have traditionally been considered plants and within the field of botany, scientists now agree that these organisms are not plants at all. Lacking the ability to photosynthesize and possessing a distinctive type of cell wall, they are most closely related to animals. Fungi have been put at the base of the *Tree of Plant Evolution* as a reminder that they are not plants and share more features with animals than they do with plants. However, fungi in the form of mycorrhizae have an exceedingly important symbiotic association in mineral nutrition with the roots of many plant species, especially trees.

1. *Amanita muscaria* – Amanitaceae

Alexander Viazmensky, b. Leningrad (St Petersburg), Russia 1946

Watercolour on paper, 380 mm x 280 mm
Signed with hieroglyphic AV in old Russian

Alexander Viazmensky paints both fungi and landscapes. Each summer he ventures deep into the woods near St Petersburg for his fungi, visiting secret spots for his trophies. Since 1997 his lively style has become more detailed and clearly outlined, although he retains his customary clutter of leaves, pine needles and strands of grass which discreetly indicate where he found the toadstool.

Alexander Viazmensky's work is held at the Royal Horticultural Society's Lindley Library and he produces excellent prints of his work which can be seen in the Grand Hotel Europe, St Petersburg. He taught at the Minnesota School of Botanical Art Master Classes in 2004 and 2006 and had illustrations in the *Red Data Book of Nature of St Petersburg*. He had a solo show in 2007 as part of the XV Congress of European Mycologists and taught an enthusiastic class at the American Society of Botanical Art in 2008.

This previously unpublished portrait of *Amanita muscaria* was executed in 2003. The classic toadstool or 'magic mushroom' has hallucinogenic properties and is widely pictured in folklore.

Amanita has over 400 described species worldwide and is one of the largest genera of basidiomycetes. The fruiting bodies of the species *Amanita muscaria* are found in summer and autumn in coniferous and deciduous forests from lowland elevations up to the subalpine zone in both temperate and subtropical regions. The Latin musca means fly and was applied to this species because of the mushroom's ability to attract and in some cases poison these insects. The same compounds that poison flies are also toxic to humans and the mushrooms have been used as inebriants and as hallucinogens by indigenous peoples in different parts of the world. Based on DNA sequence data generated from specimens collected in different regions of the northern hemisphere scientists have found distinct geographic races that correspond to Eurasia, to Eurasian subalpine zones, and to North America. This type of regional differentiation is not unexpected in such a widespread species.

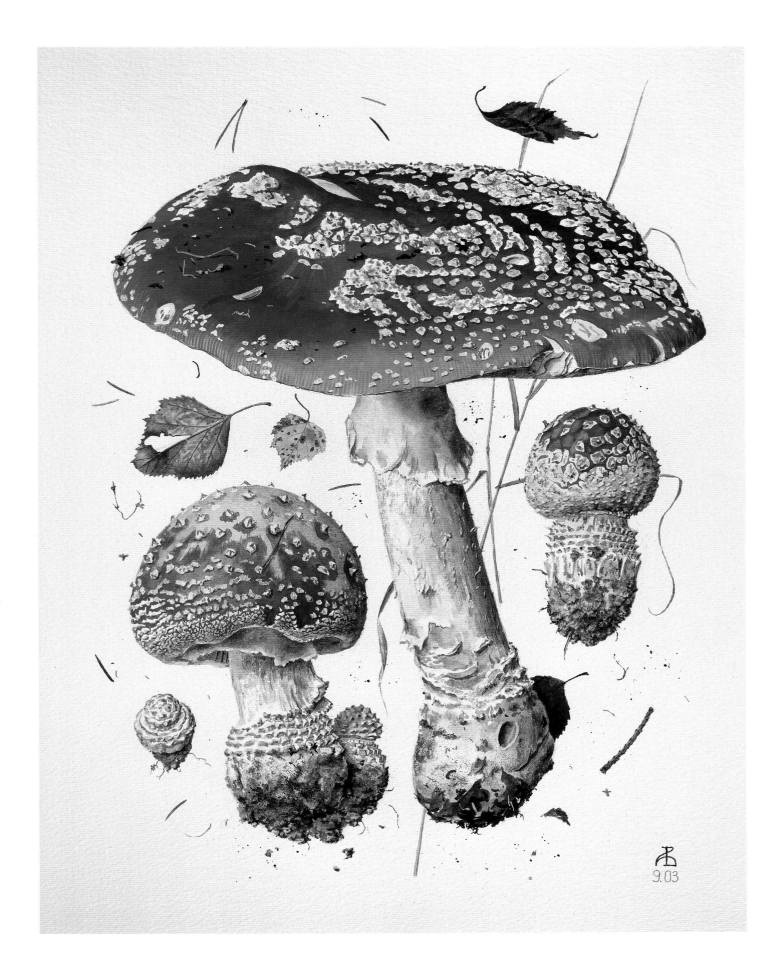

II. Algae

The term 'algae' refers to several groups of unrelated photosynthetic plants that are primarily aquatic. These groups include red algae, brown algae, diatoms, dinoflagellates, and green algae. Each group is distinctive in the type of pigment used for photosynthesis and in its characteristic life cycle. Green algae are most closely related to land plants and share numerous structural and chemical features with them. Green algae and land plants share a common ancestor that dates back to 1 billion years ago.

2. Seaweed: *Laminaria* sp. — Laminariaceae

Susannah Blaxill, b. Armidale, New South Wales, Australia 1954

Watercolour on paper, 460 mm x 650 mm
Signed *Susannah Blaxill 2002*
Commissioned

Susannah Blaxill was born in Australia but trained and worked for a period in England, with exhibitions at the David Ker Gallery, London in 1991 and at Spink in 1994, after she had returned to Australia.

Her painting of seaweed took several months to complete after much initial positioning, producing the most arresting and subtle work with dense, amazing depths of painting tones.

There is no doubt at all that Susannah is one of the great contemporary botanical artists and yet another example of the strength of botanical art in Australia, alongside such artists as Paul Jones, Jenny Phillips and Celia Rosser.

The major groups of seaweeds are green algae (Chlorophyta), brown algae (Phaeophyta), and red algae (Rhodophyta). Although all are called 'algae,' they are only related by the aquatic habitats in which they occur and do not form an evolutionarily monophyletic group. Green algae are most closely related to land plants, and use the same pigments for photosynthesis. The three groups also differ in their basic reproductive cycles and growth forms. Brown algae are almost exclusively marine and only three genera of brown algae occur in fresh water. The plant shown here is a brown algae that was found at a small beach called Scotts Head on the northern coast of New South Wales in Australia. The painting is not detailed enough to be able to distinguish the actual species, but the plant is most likely in the genus *Laminaria*, which contains about 45 species. The word laminaria is derived from Middle English and refers to the ash made by burning brown algae. This ash provides potash used in soap making.

III. Mosses

Mosses have traditionally been associated with liverworts and hornworts in a group called 'bryophytes,' which sits at the base of the *Tree of Plant Evolution*. It is now agreed that these three types of plants are not monophyletic, and hence not a natural evolutionary group. Mosses are probably the group most closely related to all other land plants, with which they share a specialised reproductive structure. However, additional data suggests that our ideas on relationships among the mosses, liverworts and hornworts may change as more information is accumulated.

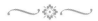

3. Moss: *Polytrichum commune* – Polytrichaceae

Yanny Petters, b. Dublin, Ireland 1961

Oil painting on glass, 440 mm x 440 mm
Signed *Yanny Petters 2003*

Yanny Petters studied graphics at the College of Marketing and Design, Dublin and became an apprentice sign-writer for pubs for four years, during which she became fascinated with painting on glass.

This study of moss from a peat bog is painted on glass in the same way that the Chinese paint their 'inside-out' perfume bottles, with the finest details first. It is an unnervingly realistic and solid slab of bog. Yanny achieves extraordinary '3D' effects and has had a number of commissions for County Wicklow National Park using plants from peat bogs.

The mosses, and their close relatives the liverworts, represent some of the first plants to leave the watery habitats occupied by algae and move onto land hundreds of millions of years ago. In general they do not have water and nutrient conducting tissue like that found in the stems of the more advanced land plants, and are therefore generally smaller in overall stature. The upright and leafy gametophyte, as illustrated in the painting, is the most dominant phase in the moss life cycle, while the sporophyte, which is the dominant vegetative body in all other land plants, forms a single unbranched stalk terminated by a sporangium. The name 'Polytrichum' means 'many hairs' and refers to the trichomes or hairs found on the sporangium. Unlike most other mosses, relatives of this particular moss have evolved relatively well-developed internal conducting systems; these have evolved independently of the xylem and phloem found in ferns, gymnosperms, and angiosperms. Two specialised groups of cells are found in the centre of the stems: hydroids, which conduct water, and leptoids, which conduct the products of photosynthesis. The independent evolution in unrelated plants of structures that have the same or similar function is called convergent or parallel evolution.

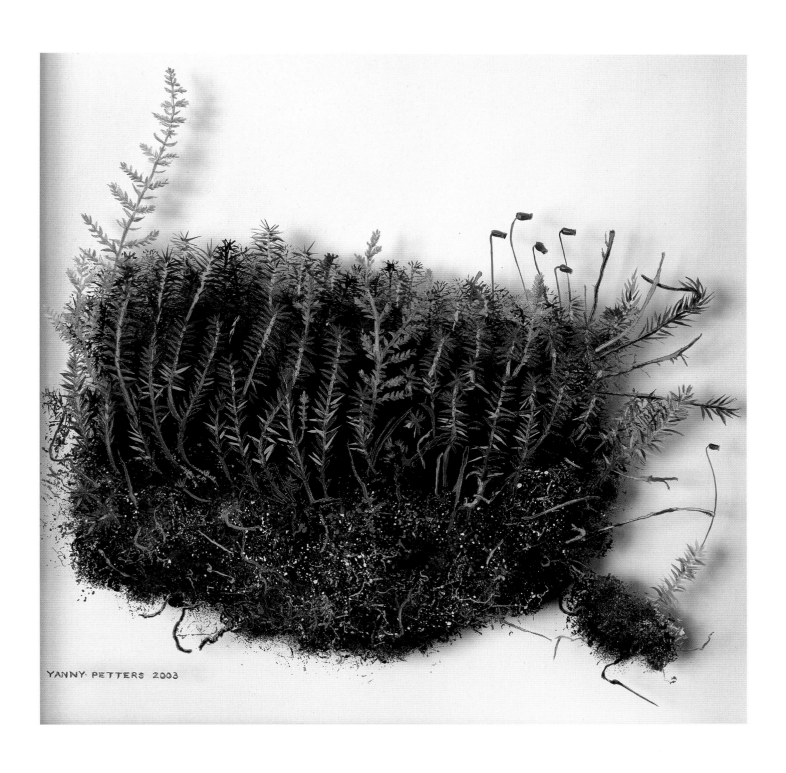

YANNY PETTERS 2003

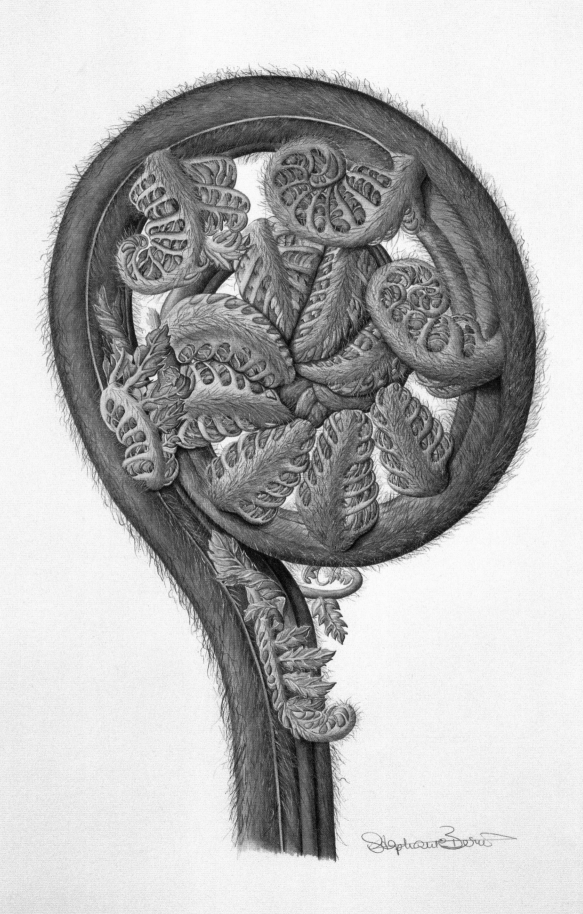

IV. Monilophytes

The ferns and some of their traditional allies (e.g. horsetails) are now grouped together in a single group called the monilophytes. The club mosses have been excluded from this group on the basis of DNA sequence data and because they have a different leaf structure from that of the ferns. The monilophytes and the club mosses are the first evolutionary branches on the *Tree of Plant Evolution* whose members possess water-conducting cells, or vascular tissue, in the stems. Like mosses, they reproduce by spores rather than by seed, the latter being typical of the more specialised gymnosperms and angiosperms.

4. **Australian tree fern:** *Dicksonia antartica* — Dicksoniaceae

Stephanie Berni, b. Bristol, England 1949

Watercolour on pencil, 290 mm x 200 mm
Signed *Stephanie Berni*

Stephanie Berni enrolled at the English Gardening School in her mid-forties and became one of many British artists trained by Anne-Marie Evans at the Chelsea Physic Garden. She has two paintings in the Hunt Institute, and is contributing to the *Highgrove Florilegium*, an initiative by The Prince of Wales Trust to record the plants in his garden. Stephanie has shown in a number of London Galleries including, in 2004, the Ebury Galleries, where this intense painting of a fern frond was acquired.

This dramatic painting of a large crosier unfurling was an immediate candidate for the book cover of *A New Flowering: 1000 years of Botanical Art*, particularly so as in the gallery next to this exhibition in the Ashmolean Museum was a magnificent bishop's crosier, one of Oxford's treasures. Possibly the early design of a bishop's crosier was inspired by an unfolding fern.

The ferns are the most ancient group of land plants alive today that possess a true vascular system made up of phloem, which conducts the sugars produced by the leaves, and xylem, which conducts water and nutrients taken up by the roots. Unlike the mosses, in which the gametophyte is the dominant plant body, in ferns the green leafy shoots represent the sporophyte. Ferns reproduce by spores, which grow in a specialised structure on the backs of their leaves. The tree ferns are the largest of all ferns and are found in New and Old World tropical wet montane cloud forests as well as some south and north temperate areas, such as New Zealand, southern South America, India, China, and Japan. The tree ferns have long been in the fossil record dating back to the early Jurassic or Cretaceous periods. The genus *Dicksonia* was named in 1788 by Charles-Louis L'Heritier de Brutelle, an amateur French botanist, in honour of James Dickson, a prominent nursery man of the time. Due to forest clearing, the species *Dicksonia antarctica* is now believed to be locally extinct in its native New Zealand.

5. **Walking fern:** *Asplenium rhizophyllum* – Aspleniaceae
(formerly called *Camptosorus rhizophyllus*)

Kate Nessler, b. St Louis, Missouri, USA 1950

Watercolour on vellum, 225 mm x 205 mm
Signed *Nessler*

With her recent exhibitions in the Park Walk Gallery, London, Kate Nessler has confirmed her position as one of today's most important botanical artists. She has had seven solo shows there since 1995.

There are now thirteen Kate Nessler paintings in the Shirley Sherwood Collection, collected since she showed at the Royal Horticultural Society where, in the early 1990s, she was awarded three gold medals. Kate's recent works are all on vellum, which has had an impact on her style, making her more introspective and detailed. Although still showing some classical portraits of garden flowers in her show in 1999, she was moving into more intense studies of plants in their natural surroundings. Her introspective painting of a dried-up shuck of corn received much attention in the recent 'Treasures of Botanical Art' exhibition in the Shirley Sherwood Gallery.

The small painting of the walking fern (*Asplenium rhizophyllum*) is on vellum. It is beautifully composed and rather fun.

This species of the true ferns derives its common name, walking fern, from the uncommon practice of sending out arching fronds that form young plantlets at the tips. These plantlets touch the ground, take root, and grow into mature plants. Occasionally it is possible to see two or three generations of a single plant all 'walking together' over a limestone rock face. This fern is native to North America from the sub-arctic in Canada southwards to North Carolina and westwards. The closest relative of *Asplenium rhizophyllum* is *Asplenium ruprechtii* or Ruprecht's walking fern of eastern Asia. This long distance between such close evolutionary relatives is true of many species pairs of ferns, gymnosperms and flowering plants. One explanation of such disjunctive geographic distributions is that a common ancestor of the two species was found on both continents over one hundred million years ago, when the land masses were together as a single super-continent. As the continents diverged over time so did the species until one became two: one species in Asia and its closest relative in North America.

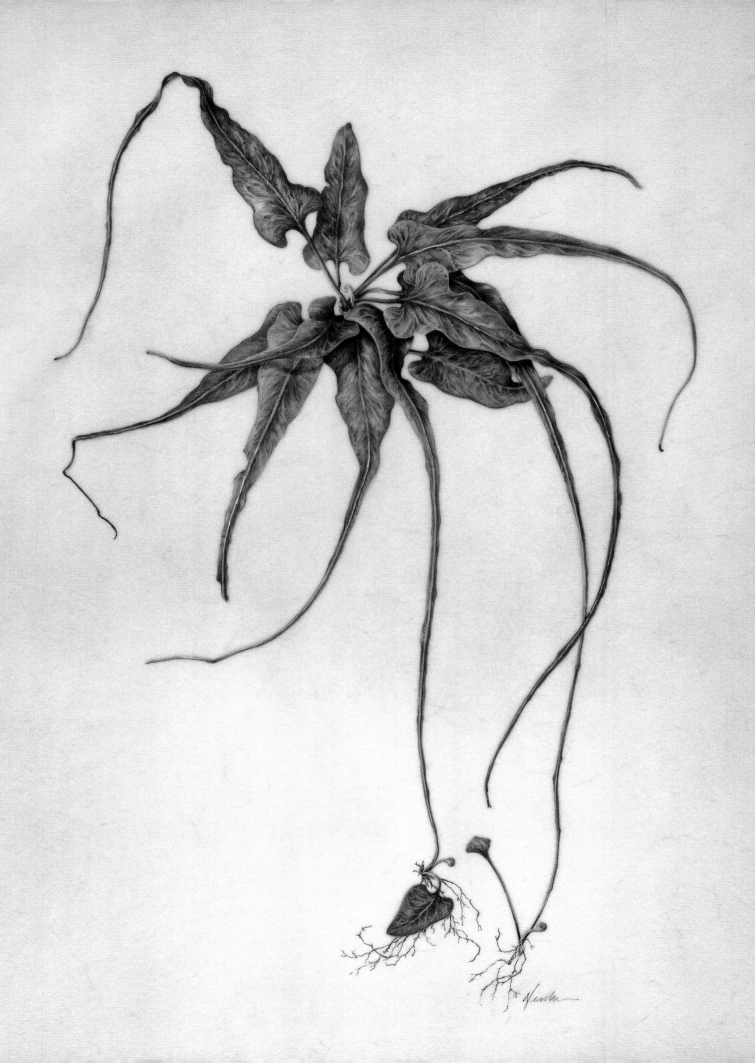

Gymnosperms

V. Gymnosperms

The evolution of seeds (made up of the young embryo, some nutritive tissue, and an outer protective covering) was an important step in the proliferation of plants on land. Gymnosperm, like bryophyte, is a term that comprises a number of different groups of plants that are related by the possession of seeds, but do not form a monophyletic evolutionarily coherent lineage. In gymnosperms the seeds are 'naked' and not enclosed within a fruit wall. The living gymnospermous groups include conifers, ginkgos, and cycads, all of which, like the monilophytes, have a well-developed vascular system. Botanists do not agree on the evolutionary relationships of the various groups of gymnosperms, or on which group is most closely related to the flowering plants. Perhaps some missing links between the gymnosperms and the angiosperms became extinct long ago.

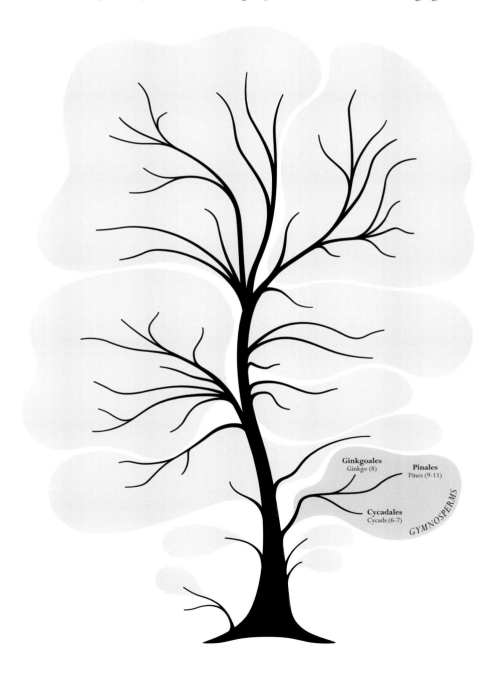

Ginkgoales
Ginkgo (8)

Pinales
Pines (9-11)

Cycadales
Cycads (6-7)

GYMNOSPERMS

Cycadales

Cycads, which are often mistaken for palms or tree ferns because of their short, squat trunks and feathery leaves, are found mostly in tropical and subtropical habitats. Today less than 135 species are known to be living and many of them are rare and endangered in their native habitats. Cycads were most abundant and diverse during the Mesozoic era, which began about 250 million years ago and ended with the extinction of the dinosaurs 65 million years ago.

6. Cycad (female cones): *Encephalartos ferox* – Zamiaceae

Leslie Carol Berge, b. Taunton, Massachusetts, USA 1959
Watercolour on paper, 570 mm x 760 mm
Signed *L C Berge 1998*

Leslie Berge is from an artistic and musical family of French origin; she was educated at the American College in Paris. Her first degree was in art history, painting and drawing in 1981 from Bennington College, Vermont, followed by an MA in Illustration at the Art Institute of Boston, with an emphasis on children's books. She has been a freelance artist since 1981, and exhibited in the 7th International Exhibition at the Hunt Institute in 1992. Later she visited South Africa where she enjoyed the different South African flora, in particular the most important collection of cycads in the world, growing in Kirstenbosch, the famous botanical garden on the slopes of Table Mountain.

Leslie's dramatic 1998 painting of the female cones of the cycad *Encephalartos ferox* was chosen to decorate a ceramic plate by Wedgwood for a special series commemorating the Shirley Sherwood Collection.

Cycads are dioecious, which means that male and female cones are borne on separate individual plants. Both male and female cycad cones are typically very large and sometimes brightly coloured. Likewise, seeds are generally large and in modern species usually have a fleshy and colourful seed coat, presumably to attract animals including birds, bats, and opossums to disperse them. Cycads, which evolved in the Carboniferous or early Permian period about 280 million years ago, all share several evolutionarily unique characteristics, including the loss of the ability to produce branches in the axils of leaves, a special vascular pattern in the stems, and the production of 'coral-like' roots that contain symbiotic nitrogen-fixing cyanobacteria (blue-green algae). Cycads also produce poisonous compounds called cycasins, which may be an important evolutionary defence against bacteria and infecting fungi. Due to wide horticultural interest many species of cycads are now rare in the wild. Conservation organisations have pushed to limit the commercial cycad trade and to list rare species as threatened and endangered in international treaties. They are microchipped in the wild so stolen plants can be identified.

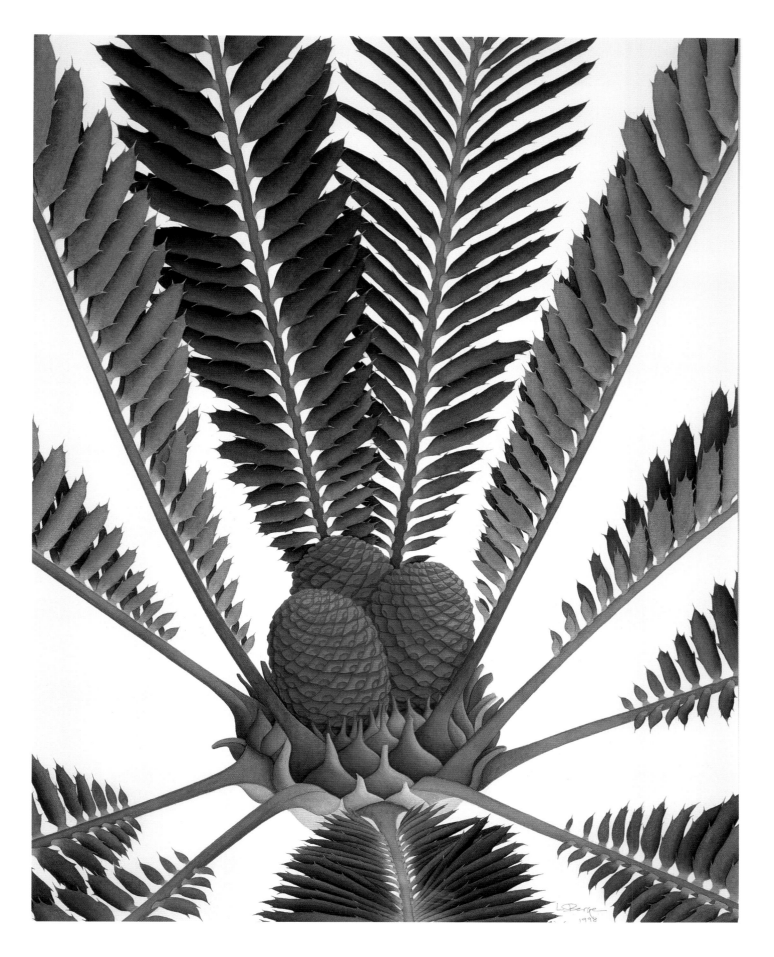

7. **Cycad (male cones):** *Encephalartos woodii* – Zamiaceae

Leslie Berge, b. Taunton, Massachusetts USA 1959

Watercolour and pencil, 700 mm x 510 mm
Signed *L C Berge 1999*

Leslie Berge entered another cycad, *Encephalartos woodii* for Longwood's Flora 2000, Delaware. This painting looks like a giant nest where a goose has laid a cluster of golden eggs, a far cry from Longwood Garden's normal elegant image, but appropriate, nevertheless, as Longwood has one of the few specimens of this highly-endangered cycad. Only one male specimen has ever been found in the wild, near Durban. Tempting as they look, both cycad fruit and pollen can be very poisonous in some species.

Male cycad cones produce abundant, powdery pollen that at first suggests that wind pollination, such as found in most other gymnosperms, is responsible for reproduction in these plants. However, scientists have shown that wind pollination plays only a minor role whereas insects, especially beetles, are the primary agents for transporting pollen. For this reason beetles are thought to be some of the earliest pollinating insects to evolve. Cycads are composed of two families with 10 or 11 genera and 130 species. Cycadaceae contains only the genus Cycas; Zamiaceae contains the remaining genera, including *Encephalartos*. Cycadaceae is distributed in South-East Asia, southern China, Malaysia, tropical Australia and various islands of the western Pacific, with a disjunct species in Africa and Madagascar. The Zamiaceae are found in the American tropics, Africa and Australia. Cycads belonging to the genus *Encephalartos* were first described by Johann Georg Christian Lehmann in 1834. The generic name is derived from the Greek 'en', meaning 'in', 'cephale' meaning 'head,' and 'artos,' meaning 'bread,' apparently because the local people of Africa, where this genus is native, make a type of flour from the starchy seeds.

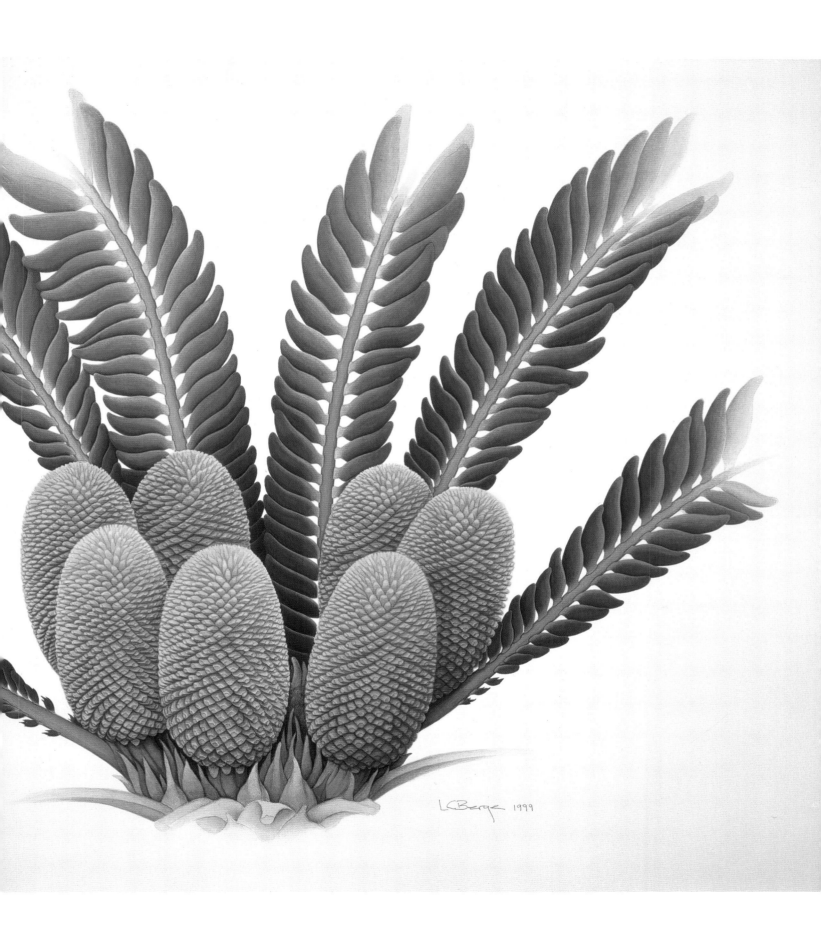

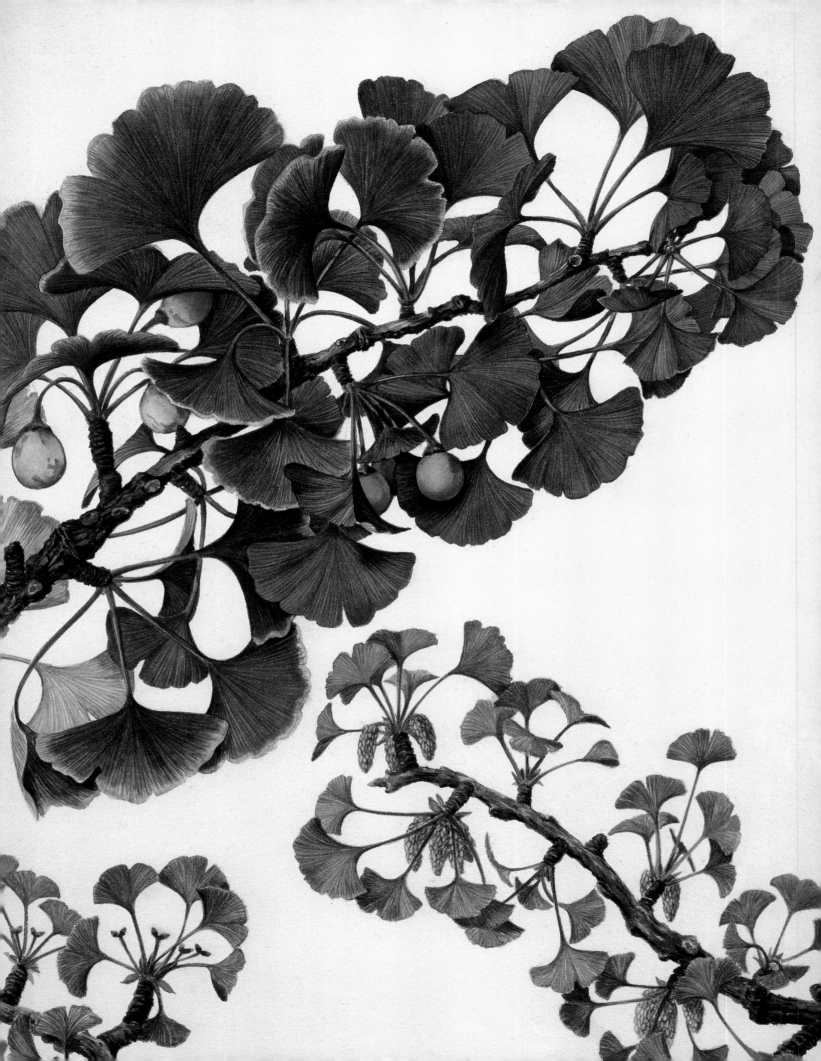

Ginkgoales

This order of gymnosperms is well represented in the fossil record with leaves of many different forms but contains only a single living species, *Ginkgo biloba*. The ginkgos, which are commonly cultivated as ornamentals around the world, are rare in their native habitats in China. Like cycads, ginkgos are dioecious. The fan-shaped leaves have very distinctively branching veins and turn a bright yellow in the autumn before they fall from the branches. Ginkgos have apparently changed very little since they evolved hundreds of millions of years ago.

8. *Ginkgo biloba* – Ginkgoaceae

Manabu Saito, b. Tokyo, Japan 1929
Watercolour on paper, 510 mm x 357 mm
Signed *M. Saito Aug '71*

Although Manabu Saito was born in Japan, he has spent most of his life in the United States and became an American citizen in 1968. He now lives in Stillwater, New Jersey and has recently been spending his winters in Tucson, Arizona painting a series of Sonoran Desert flora, mostly cacti, in their winter (non-flowering) forms.

He has an impressive list of titles, having produced all the 127 plates showing 1,563 species for *Wildflowers of North America, a Guide to Field Identification* by Frank D. Venning (1984) following a previous project of colour plates showing 230 species of cacti for *Cacti, a Golden Guide* (1974).

Manabu's first one-man exhibition was in 1968, and he has had an annual show at the Zyt Gallery, Los Altos, California since 1980. He showed at the Hunt Institute in 1977, at the 4th International Exhibition. Recently, he has contributed to the Brooklyn Florilegium Society.

This painting of the lovely Ginkgo tree shows every stage from early spring to fruiting.

Similar to pines, ginkgos have separate male and female reproductive structures. However in this gymnosperm these structures are borne on separate plants. The male pollen is produced in the cones, which hang down and release the gametes to be dispersed by the wind. The female gametes are borne in pairs of cones reduced down to single fleshy ovules. Although many species have male and female reproductive structures produced by separate plants, ginkgos are one of the few plants with distinctive sex chromosomes in which ovulate plants bear two X chromosomes and pollen-producing individuals have X and Y chromosomes. The evolutionary significance of this organisation is still debated. The first representatives of ginkgos appear in the fossil record in the Permian period, and fossils nearly identical to the leaves of *Ginkgo biloba* extend back nearly 200 million years. During the Triassic and early Jurassic periods, extinct relatives of modern ginkgo were widespread, diverse, and attained their peak of evolutionary development. Following such abundance, this lineage of plants began its decline and all species except for *Ginkgo biloba* have gradually become extinct.

Pinales

Approximately 600 species of conifers, all woody trees and shrubs, are alive today. They diverged from other gymnosperms over 300 million years ago. The leaves are usually needle-like although some can be broad, such as in the species of the Podocarpaceae found in the southern hemisphere. Members of two of the most species-rich families of the Pinales, the Pinaceae and the Araucariaceae, are illustrated here.

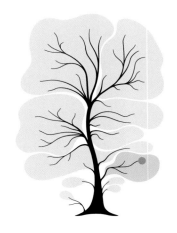

9. Douglas fir: *Pseudotsuga menziesii* – Pinaceae

Brigid Edwards, b. London, England 1940

Watercolour over pencil on vellum, 250 mm x 180 mm
Signed *Brigid Edwards 1993*

One of the most important of today's botanical artists, Brigid Edwards was inspired by the works of the Bauer brothers and Ehret and started painting plants in the mid-1980s. She has been a trail blazer and has exhibited her work widely; a beautiful study in the Shirley Sherwood Collection of two magnolia leaves, the mature one separated from an old leaf by a fruit placed between them, was in the 1990 Summer Show of the Royal Academy, a regrettably rare honour for botanical artists today.

In 1994 Brigid was part of a group show at the Kew Gardens Gallery (where this painting was acquired) and she has had major exhibitions at the Thomas Gibson Gallery, London (1995 and 1997), and the William Beadleston Gallery, New York (2000). In 2006 she surprised everyone in the botanical art world by showing a series of much enlarged insects at Thomas Gibson Fine Art. There are 14 botanical studies by her in the Shirley Sherwood Collection.

This memorable painting is a favourite work; the colour, texture and apparent simplicity of execution are superb. By magnifying the cone she has made this work much more arresting.

Pseudotsuga means 'false hemlock' because the leaves somewhat resemble those of the true hemlock *Tsuga*. The species was first observed on Vancouver Island almost 200 years ago by Archibald Menzies, for which it is named. The species is distributed in the north-west United States and British Columbia. On the coast of the Pacific Ocean where Douglas firs reach their maximum size, trees may attain 100–110 metres in height and be 4–5 metres in diameter; some individuals are known to be more than 1,000 years old. Taxonomists now agree that there are only four species in the genus *Pseudotsuga*, although 22 species have been described in the past. *Pseudotsuga* is one of the many genera with species that are found in either western North America or in eastern Asia, indicating a long evolutionary history dating back to the time when North America and Asia were joined as a single continent. Conifers, such as *P. menziesii*, reproduce by seeds, which were an evolutionary innovation that evolved in the ancient ancestor of all gymnosperms and angiosperms. However, unlike the more advanced flowering plants, gymnosperms produce 'naked' seeds without a protective coat.

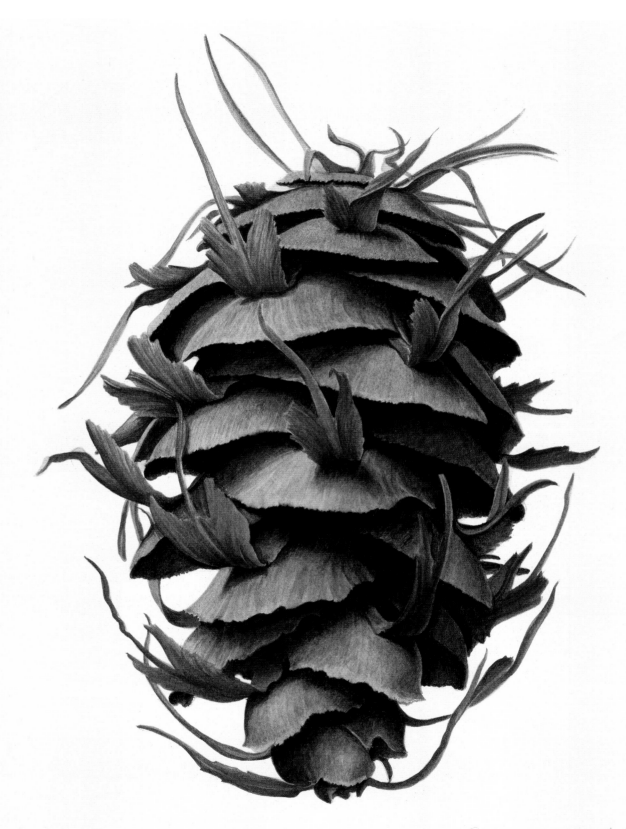

Brigitte Edwards 1993

Pseudotsuga menziesii × 2½
with acknowledgements to Professor William Horton

10. Cedar of Lebanon: *Cedrus deodara* – Pinaceae

Ann Farrer, b. Melbourne, Australia 1950, works in England

Watercolour on paper, 550 mm x 680 mm
Signed *Ann Farrer 91/92*
Commissioned

Annie Farrer took a degree in English and history of art at Manchester University. In 1977 she was awarded a Churchill travelling scholarship which took her to Kashmir and Ladakh to draw the illustrations for *Flowers of the Himalaya* with text by O. Polunin and A. Stainton (1984). She often travels to the Himalaya having led treks there for over 15 years: she may have inherited this passion for far-away places from her relative, the famous botanical explorer, Reginald Farrer (1880–1920) who travelled widely in China and Burma and introduced many plants into Western gardens.

Annnie painted this remarkably detailed branch of cedar of Lebanon from a specimen taken from a mature tree in a garden in Oxfordshire. It is a maze of pine needles with beautifully executed cones dripping with resin.

Pinaceae, the pine family, contains ten genera and 220 species. Two types of cones are produced: male cones in which the tiny pollen is contained, and female cones which produce the seeds. Both types of cones are borne on the same tree. This type of mating system with separate male and female cones assures that gametes are dispersed between plants leading to cross-fertilisation. Cross-fertilisation results in more natural variation in a population, which is the source of variety upon which evolution through natural selection works. The seeds of pines are primary components of the diets of many species of birds, squirrels, and other rodents in natural forests and these trees play a key role the functioning of the ecosystem. The Pinaceae, including pines, spruces, firs, hemlocks, and larches, is almost entirely limited in geographic distribution to the northern hemisphere. Cedars are found in North Africa, the Near East, Cyprus, and the Himalaya. The generic name 'cedrus' is derived from 'kedros', the ancient Greek name for these trees, and the species name 'deodara' is the local name in North India.

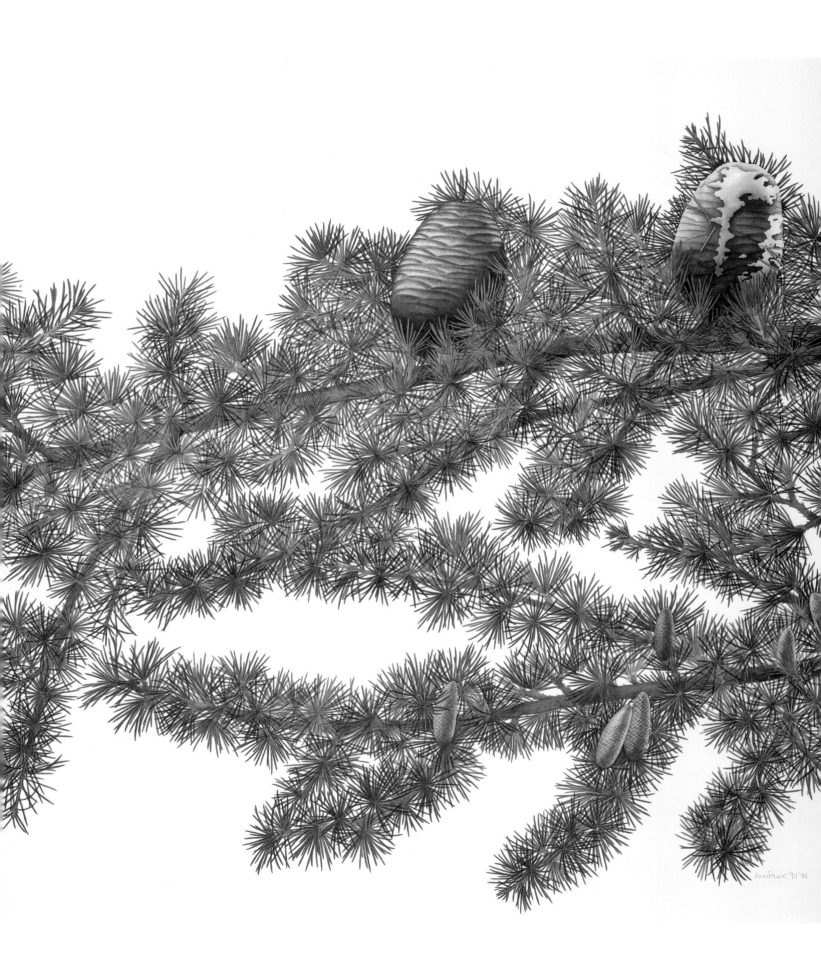

11. **Wollemi pine:** *Wollemia nobilis* – Araucariaceae

Bronwyn Van de Graaff, b. Australia 1964

Watercolour on paper, 580 mm x 483 mm
Signed *B Van de Graaff*
Commissioned

Bronwyn Van de Graaff lives at Avoca Beach near Sydney and is a professional artist and a lawyer, having graduated from the University of Sydney in 1989. She showed in the annual Botanica in Sydney in 2000–2003 and in the Botanical Art Society of Australia over the same period.

In 2003 she was commissioned to paint the recently discovered prehistoric Wollemi pine for Lilianfels, an Orient-Express Hotel, which is situated on a ridge overlooking the Blue Mountains only a few miles from where the Wollemi pine was found. Her painting, one of the first of the new discovery, hangs in the main room.

It shows the male and female cones which are formed at the end of the downward flowing branches. Each year the buds at the tip of the branches burst into a mass of tangled young leaves that gradually change from a vivid yellow-green to the darker adult foliage.

The Araucariaceae family contains three genera with 40 species, and is restricted to the Southern Hemisphere from South-East Asia to Australia, New Zealand, and southern South America. Evolutionary relationships among the species within the 200 million year-old family had long been contested until an analysis using DNA sequence data provided clear insights into the ancient history. It is now generally agreed that all three genera are monophyletic and that *Wollemia* is the most primitive. The Araucariaceae is most diverse in New Caledonia where 5 species of *Agathis* and 13 species of *Araucaria* are endemic. These 18 species show very low genetic differentiation suggesting that they evolved very rapidly, perhaps due to the unique New Caledonian soils. Living plants of *Wollemia*, which before 1994 was known to science only as a 150 million year-old fossil, were discovered by an avid hiker in a rainforest gorge in the Wollemi National Park, 125 miles west of Sydney in the Blue Mountains of Australia. *Wollemia nobilis*, named after the wildlife officer who found it, is one of the world's rarest trees with only 43 adults known, all containing exactly the same DNA.

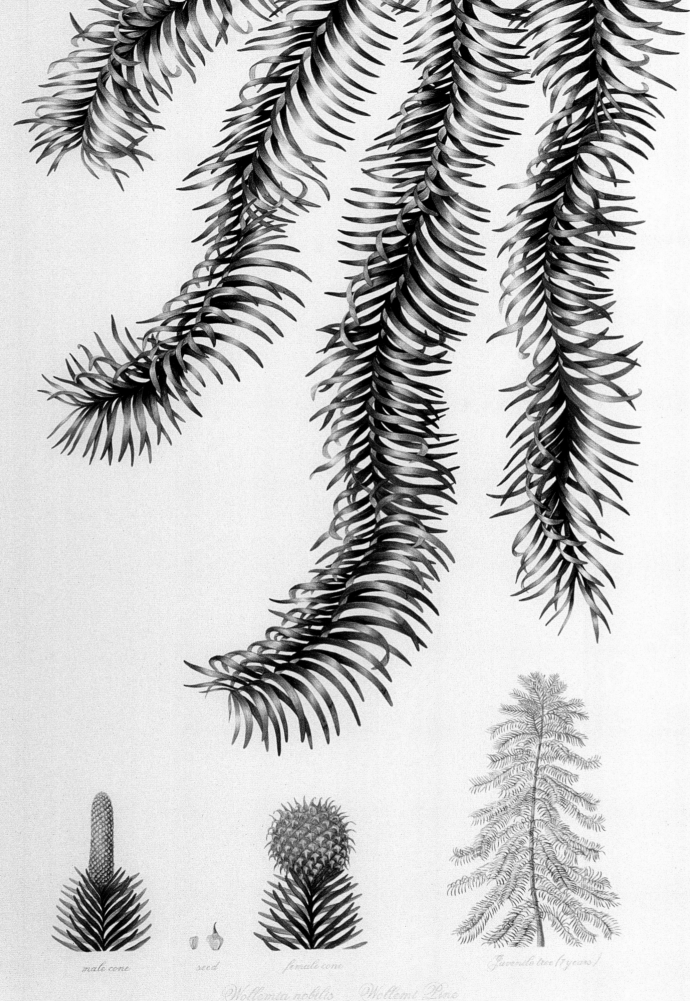

male cone seed female cone Juvenile tree (7 years)

Wollemia nobilis *Wollemi Pine*

Angiosperms
Basal angiosperms: minor groups

VI. Angiosperms

An explosive diversification of plant species began 135 million years ago and continues to this day in the flowering plants (angiosperms). The innovation which stimulated this rich diversity was the evolution of the flower that combined a closed chamber to protect the seeds (called a carpel), a much reduced group of cells to facilitate fertilisation, and a unique nutritive tissue to provide for the developing embryo (called endosperm). The evolution of the flower and the coincident adaptation of many different animals for pollinating was the origin that led to the over 300,000 species of angiosperms that are estimated to live on Earth. The major groupings within the flowering plants are generally referred to by the informal names basal angiosperms, monocots, early diverging eudicots, and core eudicots, which include the rosids, and asterids.

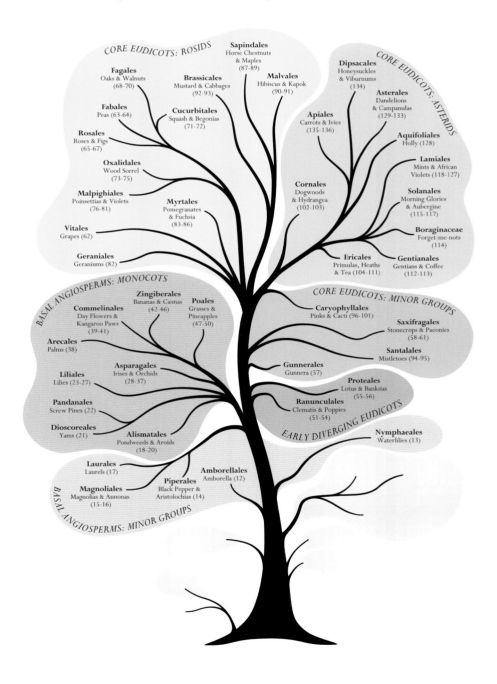

Basal Angiosperms

The term basal angiosperms is applied to the most early diverging lineages of flowering plants which together do not make up a monophyletic group. There is no single character that is shared by all these disparate lineages and they are simply grouped together at the base of the phylogenetic tree by being excluded from the rest of the flowering plants. *Amborella*, a small shrub from New Caledonia, is the most primitive angiosperm. Both *Amborella* and the water lilies (Nymphaeaceae) form separate, distinctive lineages from the orders of this group. Other plants, such as laurels, magnolias, tulip trees, and black pepper are included in the basal angiosperms.

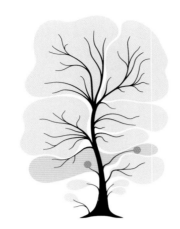

Amborellales and Nymphaeales

Along with several other species, plants in the Amborellales and Nymphaeales (water lilies) are the most ancient extant angiosperm lineages and retain some features of the earliest angiosperms in their wood structure, flower organisation and pollinators. These plants evolved before all other flowering plants and were so different from other angiosperms that it was difficult to classify them into any order. Each is now placed into a separate order of its own.

12. *Amborella trichopoda* – Amborellaceae

Alice Tangerini, b. Takoma Park, Maryland, USA 1949

Pen and ink on Denril vellum, 430 mm x 323 mm
Signed *A. R. T. 2008*
Commissioned for this book

Alice Tangerini has been the staff illustrator at NMNH Smithsonian since 1972, specialising in grasses, composites and gingers. Her output has been consistent and huge, usually executed in pen and ink. She is expert at resuscitating dried specimens under the microscope for detail, something that was necessary with the illustration of *Amborella* shown here.

She has lectured and exhibited widely in the US and travelled to Hawaii and Guyana to draw living specimens. She is also responsible for curating the extensive collection of botanical illustration in the Smithsonian. Alice has received the Distinguished Service Award (1999) from the Guild of Natural Science Illustrators and the Award for Excellence in Scientific Botanical Art (2008) by the American Society of Botanical Artists. Her work is a superb testimony to botanical illustration, a benchmark for other scientific illustrators.

This fine example of a line drawing was created from some small scraps of preserved herbarium material. *Amborella*, although important in the evolutionary development of flowering plants, is an unimpressive bush found only in New Caledonia. When Alice was commissioned to draw it for this book, living plants in the US were not available. It is an example of what can be achieved from the most impoverished and meagre material.

The genus *Amborella* holds a special place in the evolution of the flowering plants. Although traditionally classified with the laurels because of its similar flowers and fruits, most botanists now agree that it is not in this family, but represents the most primitive living angiosperm. Long considered to be primitive – as suggested by the poorly-developed conducting elements in the wood, flowers with undifferentiated sepals and petals, numerous stamens, and several distinct 'open' carpels – it was somewhat of a surprise when DNA data demonstrated that it should be at the very base of the evolutionarily tree of flowers. *Amborella* has only a single species, found only on New Caledonia in the South Pacific. This large, isolated island is rich in gymnosperms and basal angiosperms and *Amborella trichopoda* occurs with some of these plants in rainforests along a chain of high mountains. Field observations suggest that, like its close relatives the cycads, the species is pollinated by beetles and other insects.

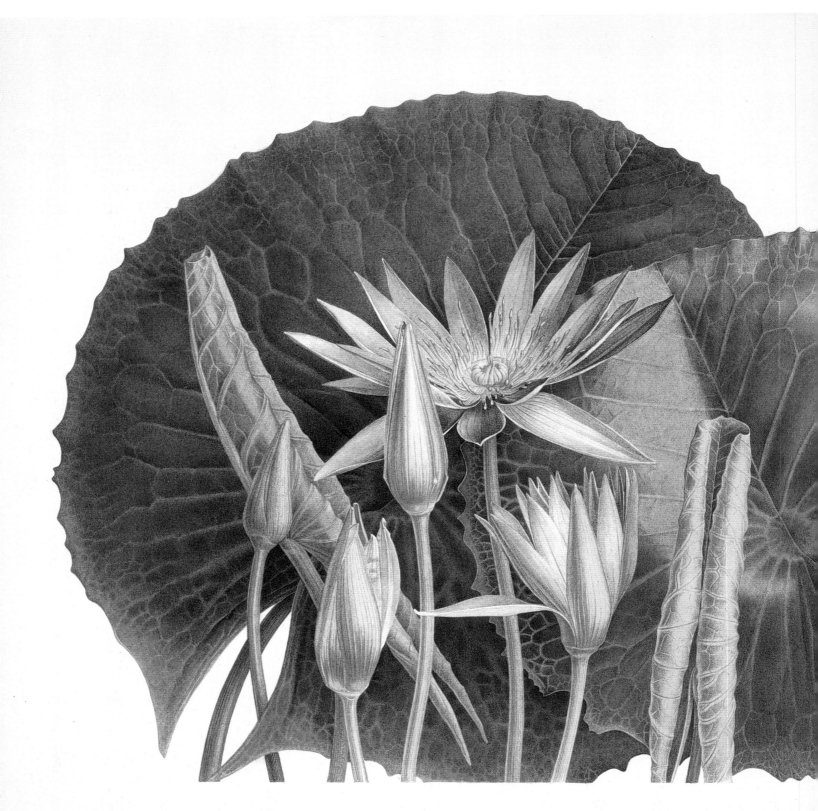

Nymphaea capensis

Pandora Sellars

13. **Blue water lily:** *Nymphaea capensis* – Nymphaeaceae

Pandora Sellars, b. Herefordshire, England 1936

Watercolour on paper, 385 mm x 500 mm
Signed *Pandora Sellars '95*
Commissioned

Initially trained as a designer, Pandora Sellars then studied at the Cheltenham School of Art and Manchester College of Art. She became a teacher and freelance botanical artist, exhibiting widely in Britain and abroad since 1972. She had a successful solo exhibition at the Kew Gardens Gallery in 1990; her work is widely reproduced, and the Royal Horticultural Society awarded her a gold medal. Pandora has done a number of studies of *Arum* species and it became one of her favourite genera while she illustrated the Kew monograph *The Genus Arum* by P. Boyce (1993). Several of her *Arum* studies were on show at the first exhibition in the Shirley Sherwood Gallery.

This painting of blue water lilies, commissioned in 1993, took two years to complete. Pandora visited Wyld Court Nurseries near Newbury and took samples home in a bucket. Initially she painted the flowers from tight bud to exquisite flower. A year later she painted the young and mature leaves as a fan-shaped background. This became the cover of the book *Contemporary Botanical Artists*, and must be one of the best-known works in the Shirley Sherwood Collection.

DNA evidence strongly supports the placement of the Nymphaeaceae as the second of the tree's basal angiosperm groups. In the past water lilies had been considered to be closely related to monocots, but now this evolutionary placement is not believed to be the case. Members of this family, which include 8 genera with 70 species, are found worldwide in freshwater habitats: lakes, ponds, rivers, streams, marshes and canals. Even though the water lilies are considered to be primitive flowering plants they possess many specialised characters that evolved in association with their aquatic habitats, such as stems with air canals and scattered vascular bundles, leaves with mucilage, umbrella-shaped leaf blades, and flowers on long pedicels. Water lilies are all primarily beetle pollinated and have flowers in which the female parts are receptive to gametes prior to the pollen being shed from their own stamens. This facilitates insect attraction and cross-pollination of the flowers.

Piperales

This order is made up of five (possibly six) families, including the Dutchman's pipes, black peppers, and lizard tails. The various members now grouped in the Piperales have not always been considered as closely related, but DNA sequence data provide strong evidence for placing them together as an evolutionary group. Oil cells and two-ranked leaves are found in most of the species of this group. Some species have stems swollen at the nodes where the leaves are attached as well as flowers in whorls of three, which is similar to the monocots.

14. *Aristolochia gigantea* – Aristolochiaceae

Rosália Demonte, b. Niteroi, Brazil 1932

Gouache on vellum, 550 mm x 410 mm
Signed *Rosália Demonte 1985*

The Demonte family live in Petrópolis, the high altitude summer refuge in the mountains behind Rio in the Atlantic Rainforest. Rosália and her sister Yvonne shared a studio next to their house with Ludmyla, one of Rosália's daughters. Rosália's brother Etienne Demonte lived nearby where he painted alongside his two sons. None of them had any extensive formal training and their styles of painting were sometimes very similar. Rosália tended to concentrate on flowers and butterflies, while her daughter paints dramatic pictures of the wild cats of South America.

The extraordinary vine, *Aristolochia gigantea*, grows up a steep bank in Rosalia's garden. The specimen she painted for this dramatic picture, with its huge striking maroon speckled flower (depicted life-size in the painting), was given to her by Roberto Burle Marx, the famous landscape designer who was such a great friend of Margaret Mee (see page 80).

The family Aristolochiaceae contains 7 genera with 460 species, although botanists still differ on the taxonomic boundaries within this family. The plants are generally temperate herbs and tropical or subtropical lianas and shrubs. The aristolochias make up one of the five groups of basal angiosperms in the order Piperales. The flower is structured with the petals, sepals, stamens, and carpels in whorls of three, which suggests that these plants are relatively primitive angiosperms. This led some botanists to formerly believe that they were the closest relatives of the monocots, whose flowers are also in whorls of three. The flowers of *Aristolochia gigantea* are enormous, foul-smelling, and characterised by deep maroon markings. These features serve to attract carrion-loving flies which are deceived into visiting the flowers as a site to deposit their eggs. The pollen-bearing flies become trapped in the inflated portion of the flower and transfer pollen to the stigma before they are allowed to exit. The name of the genus is derived from the Greek words 'aristos' meaning 'the best or most excellent' and 'locheia' meaning 'childbirth' in reference to the use of this plant in ancient herbal medicine to assist in childbirth and abortion.

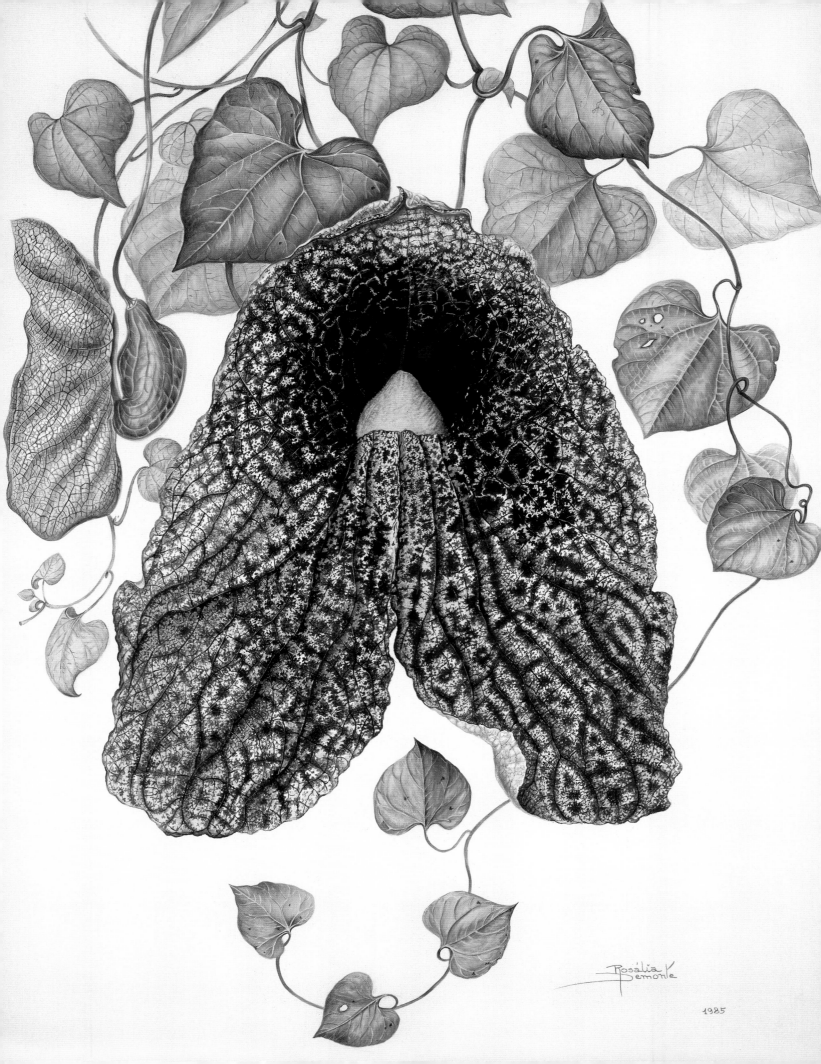

Rosália Demonte

1985

Magnoliales

The six families in this order, including the magnolias, the custard apples, and the nutmegs, have traditionally been grouped together and recognised as evolutionarily-related plants by taxonomists. DNA data also strongly support this close relationship. Numerous vegetative and cellular features, as well as the presence of a fleshy structure surrounding the seeds, are found in all members of the Magnoliales, also suggesting their descent from a common ancestor.

15. *Magnolia grandiflora* – Magnoliaceae

Paul Jones, b. Sydney Australia, 1921–97

Acrylic on paper, 710 mm x 540 mm
Signed *Paul Jones*

Paul Jones lived in Sydney for most of his life and was the best-known flower painter in Australia in the 1990s. Just before his death he wrote an important essay on painting from nature which is published in *A Passion for Plants* (2001). He was particularly interested in camellias and had one named after him.

This large painting is a superb study of *Magnolia grandiflora* in acrylic, painted on a shaded background. He executed it after a journey to Japan and it shows how he was influenced by his visit there. There are several other works with a similar graded background in the Shirley Sherwood Collection including an elegant study of shells, which he collected passionately.

The fossil record indicates that the family Magnoliaceae has a long evolutionary history of over 100 million years and that its geographic distribution in the northern hemisphere was much broader than it is today. The family contains two genera, *Magnolia* and *Liriodendron*, and 220 species. Most of the species in the Magnoliaceae are found in Asia from the Himalaya eastward to Japan and south-eastward through the Malay Archipelago to Papua New Guinea. The rest of the species are native to the Americas, from temperate south-east North America to tropical and subtropical South America, including Brazil. The genus *Liriodendron* contains only two species: one in North America and the other in China; which is another example of the east Asian-North American disjunct distribution pattern that suggests the long evolutionary history of these species. The large conspicuous flowers of *Magnolia* are mainly pollinated by beetles. As in other beetle-pollinated flowers those of *Magnolia* are large in size, white or pink in colour, lack nectar, have an abundance of pollen, and emit a sweet fragrance. Linnaeus named the genus *Magnolia* in honour of the French botanist Pierre Magnol.

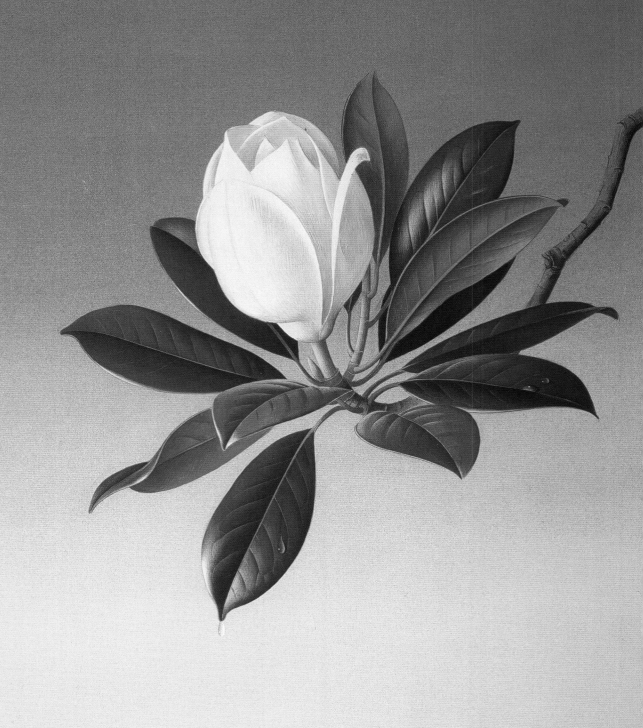

16. Custard apple: *Annona crassifolia* – Annonaceae

Alvaro Evando Xavier Nunes, b. Anápolis, Goiás, Brazil 1945

Watercolour on paper, 378 mm x 537 mm
Signed *Alvaro Nunes 2003*

Alvaro Nunes is still based in his birthplace Anápolis in the state of Goiás but spends long period's away, working in remote areas of Brazil. He is particularly interested in the Brazilian savannah and has painted many of the fruits of native trees from the savannah, Amazonia and the Pantanal. Finding his subjects has involved long journeys of up to eight months to these isolated parts of the country.

He qualified as an architect at the Federal University of Brasilia in 1971 and then worked for the government of Brasilia on local urban projects until 1981. His botanical studies started with a six-month internship in the botanical department of Brasilia Federal University in 1989 where he focused on the flora of the Brazilian savannah. He also attended a painting course taught by Christabel King at São Paulo Botanical Institute in 1993.

The Custard Apple is shown entire and with its fruit broken open to display the segmented interior. Alvaro details the fruit's development in a precise and academic study, yet the fruit's outer and inner surfaces are beautifully painted.

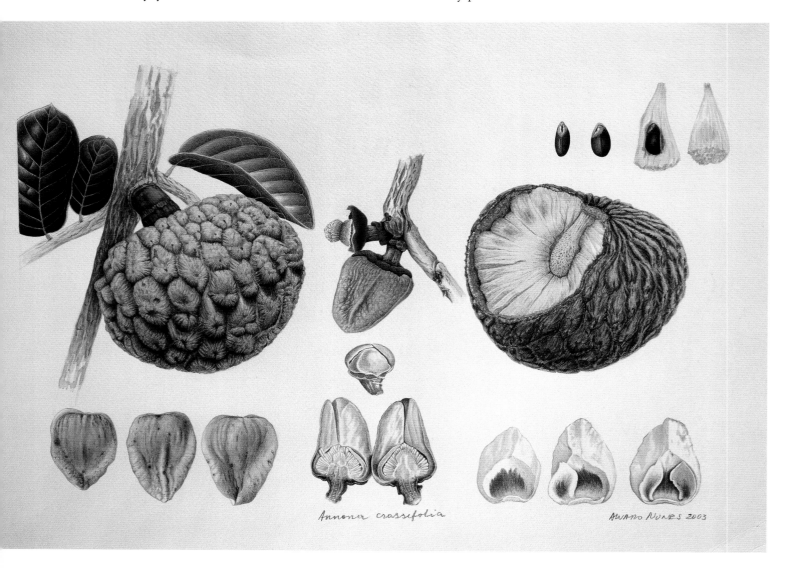

Annona crassifolia

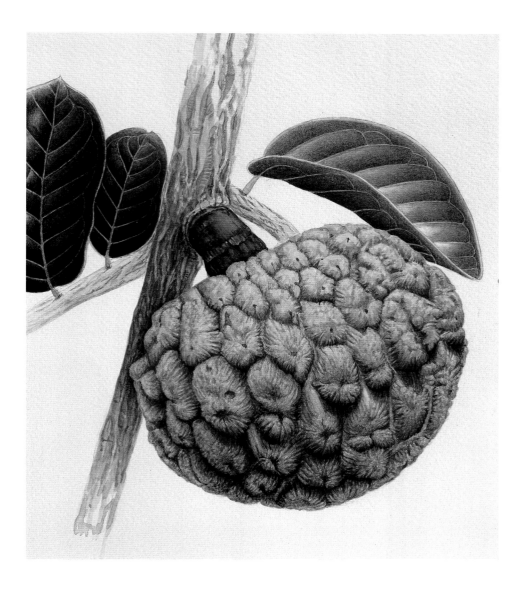

The Annonaceae is one of the six families in the order Magnoliales. The family is composed of trees and shrubs that are pantropical in distribution with the largest concentration of species is in the Asian tropics, but with many species in the Americas and Africa. In total the family contains 128 genera and 2,300 species and is one of the primitive basal groups of angiosperms. The flowers are fragrant and usually with numerous free and spirally arranged petals, stamens and carpels. Like other basal angiosperms the flowers have various characteristics for pollination by beetles, including closed flowers, fruity odours, special food tissues to reward the insects, and fleshy petals. In addition, the flowers of some species of *Annona* produce heat and the beetles remain in the closed, protective flowers overnight where they mate after consuming the food tissues produced inside the flowers. Several species of *Annona* produce edible fruits, called cherimoya, guanabana, soursop, sugar apple, and sweetsop.

Laurales

This order contains seven families, the largest of which is the laurels or avocados. Most of the features that distinguish the members of the Laurales are found in the specialised floral structures, including ovary position and inner stamens that do not produce pollen. This order is most closely related through evolution to the Magnoliales in the basal angiosperms.

17. *Idiospermum australiense* – Calycanthaceae

Betty Hinton, b. Gin Gin, Queensland, Australia 1935

Watercolour on paper, 600 mm x 460 mm
Signed *Betty Hinton*

Betty Hinton has spent her career in Queensland, beginning as a photographer and then emerging as a painter in the late 1970s. In 1980 she was featured in a television documentary entitled *A Big Country* and again in 1990 as a botanical artist in another film entitled *Under Southern Skies*.

In 1992 she embarked on a major project, painting plants from the Daintree Forest Reserve. The tropical rainforest of Daintree (north of Cairns) has a remarkable group of ancient 'plant dinosaurs', remnants left from long ago, most of which are found nowhere else except as fossils. Betty Hinton has produced about forty studies which will eventually be housed in the new library building of James Cook University on Cairns campus.

The idiot fruit (*Idiospermum australiense*) is a tall tree of 15 metres or more and the only way to look at the flowers is through binoculars or by finding someone to climb the tree. Luckily Betty Hinton found two rock climbers who rigged the tree, donned hard-hats and returned in triumph after several exhausting hours, carrying flowering branches which she could paint close up. Her study combined the flowering branches with the fruit on the ground starting to sprout off the forest floor.

The Calycanthaceae is the most evolutionarily primitive family within the order Laurales and is found in eastern Asia, eastern and western North America, and tropical rainforests of northern Queensland in Australia. *Idiospermum australiense* is a rainforest canopy tree restricted to a few small populations in northeast Australia, and is the only southern hemisphere representative of the Calycanthaceae. This species shares characteristics with other large-flowered arborescent basal angiosperms, such as numerous spirally-arranged floral parts and separate carpels. Similar to the other basal angiosperms the flowers are characteristically pollinated by beetles. The most distinctive feature of the species is its enormous embryo without endosperm, but with numerous young leaves, or cotyledons, within the seed, which can weight up to 225 grams. The name for the genus refers to this unique embryo and comes from the Greek 'idios' meaning 'peculiar or different' and 'sperma' in reference to the 'seed.' *Idiospermum australiense* was discovered by timber cutters south of Cairns in the late 1800s but was thought to have become extinct as a result of clearing land for crops. In 1971, the species was rediscovered and is now protected by law.

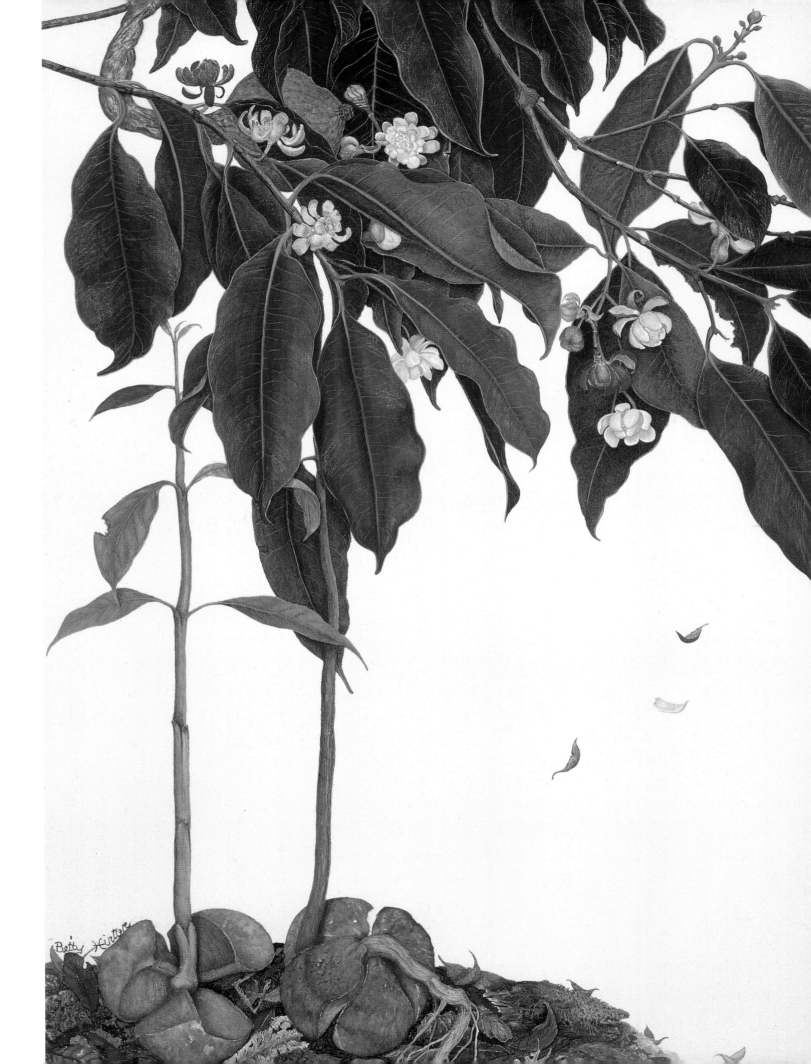

Basal Angiosperms:
Monocots

Monocots

The monocots are the largest monophyletic group in the basal angiosperms with nearly 60,000 species. Monocots account for nearly one-quarter of all flowering plants. They are distinguished from other angiosperms by possessing a single seedling leaf (called a cotyledon), a diffusely scattered vascular system, and floral parts in whorls of three (although this feature is also present in several other basal angiosperms), as well as several specialised cellular characteristics. Monocots probably originated between 125 and 140 million years ago. Twelve major lineages are recognised within the monocots, including pickerel weeds and aroids, screw pines, onions and orchids, lilies, palms, gingers and bananas, day-flowers, and the grasses and bromeliads.

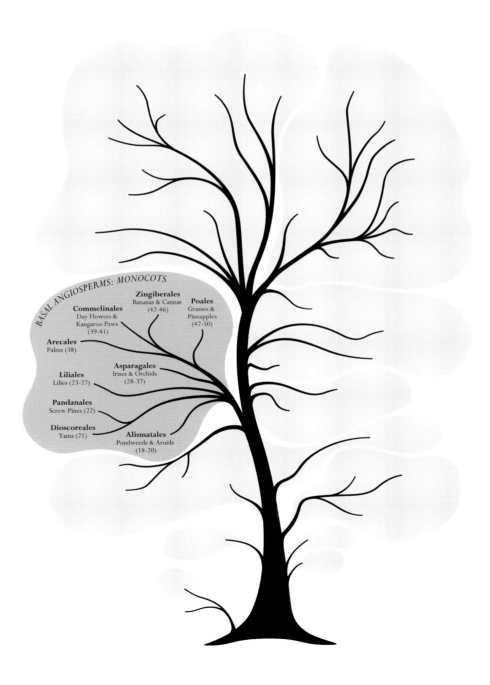

BASAL ANGIOSPERMS: MONOCOTS

Zingiberales
Bananas & Cannas
(42-46)

Poales
Grasses &
Pineapples
(47-50)

Commelinales
Day Flowers &
Kangaroo Paws
(39-41)

Arecales
Palms (38)

Asparagales
Irises & Orchids
(28-37)

Liliales
Lilies (23-27)

Pandanales
Screw Pines (22)

Dioscoreales
Yams (21)

Alismatales
Pondweeds & Aroids
(18-20)

Alismatales

This order includes almost all of the aquatic monocots: those that grow on the surface or completely submerged in ponds, streams, rivers, and the margins of the oceans, such as the water plantains, pondweeds, and sea grasses. The Alismatales also contain the primarily tropical aroids, which usually do not grow in water but are the most closely related plants to these aquatics. This somewhat surprising evolutionary relationship between the aroids and the aquatic monocots has been confirmed by DNA data. The duckweeds, which are the smallest flowering plants in the world, are classified with the aroids.

18. **Cheese plant:** *Monstera deliciosa* – Araceae

Coral Guest, b. London, England 1955

Watercolour on paper, 750 mm x 550 mm
Signed *Coral Guest '97*
Commissioned

Coral Guest was an established artist and teacher by the early 1990s; she has been much influenced by her early training in Japan and at the Chelsea School of Art, London. She paints landscapes as well as her outstanding plant portraits. She has taught at Kew, giving lectures, courses and workshops; in the Nature in Art Gallery, Gloucestershire; in Monet's garden at Giverny and at Harewood House, Leeds.

In 1997 Coral was tutor for one of the first botanical art classes held in an Orient-Express hotel; such classes are now held in Orient-Express hotels around the world. She has been exhibited in all 18 shows organised by Shirley Sherwood. Coral is one of the most important botanical artists working today; her *Painting Flowers in Watercolour – A Naturalistic Approach* (2001) is an excellent teaching book.

She was commissioned to paint a plant portrait of *Monstera deliciosa* in 1997. Grown in an orangery near Oxford, it was sent in a large box to Coral's home in London. Unfortunately the spathe of the flower fell off in transit and she had to wait 6 weeks while another matured before she could complete the work. Initially she struggled with the design, which is extraordinarily bold. The execution is superb and the final result is striking and adventurous.

The Araceae, consisting of 109 genera and 2,830 species, is a family of terrestrial herbs with many small flowers clustered in a spike-like spadix which is enclosed by a cloak-like spathe. Traditionally, the floating duckweeds were placed in a separate family, the Lemnaceae, but DNA data have now shown that they are a part of the aroid family. Members of the Araceae are concentrated in the tropics of the Americas, South-East Asia and Africa although a few reach into temperate zones. One of the most interesting features of the geography of this family is the presence of a number of genera in both the Malay Archipelago or Melanesia and distant tropical America, a distribution separated today by the Pacific Ocean. Members of these genera are all rainforest herbs and long-distance dispersal by water or large animals is probably impossible. Current speculation suggests that these evolutionary patterns reflect a once-continuous distribution during the Cretaceous period when the continents were joined, but strong support for this hypothesis has not been shown. The generic name *Monstera* comes from the Latin 'monstrum' or 'monster' referring to the peculiar perforations of the leaves of many species.

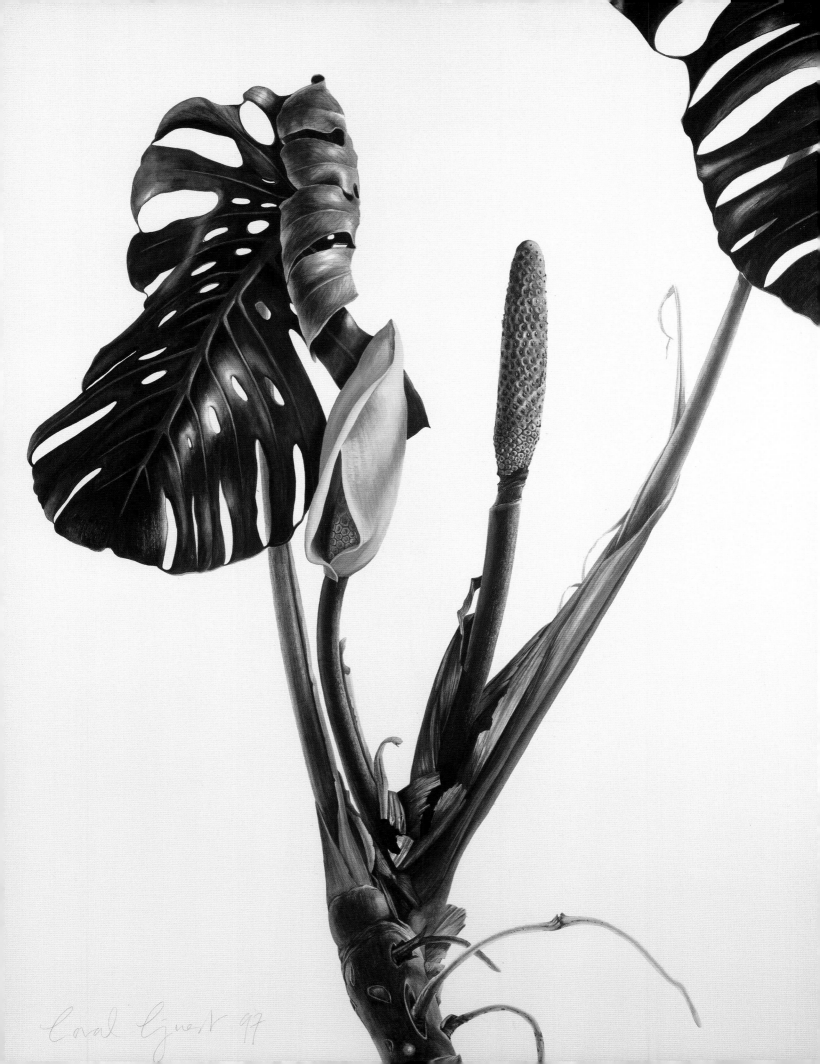

Coral Guest 97

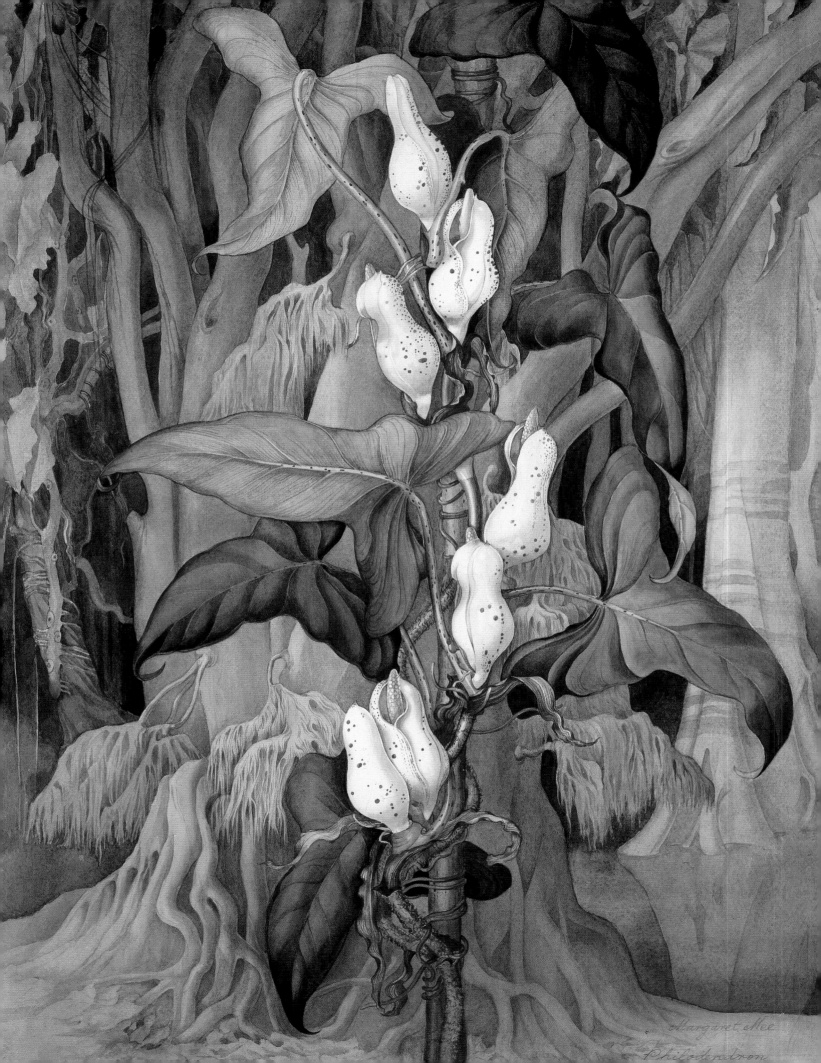

Margaret Mee

Philodendron

19. *Philodendron muricatum* — Araceae

Margaret Mee, England, 1909–1988, worked in Brazil

Pencil and gouache on paper, 640 mm x 470 mm
Signed *Margaret Mee*

Margaret Mee trained as an artist in London at St Martin's School of Art, the Central Art School and Camberwell Art School. She moved to Brazil in the early 1950s, became fascinated with the exotic flora and started organising solo journeys into the rainforest, searching for exciting plants to paint. This seemingly frail, petite woman went on 15 challenging collecting trips into the Amazon, generally with only Indian guides to accompany her. She would sketch specimens *in situ* and then try to get them back to Rio so they could be cultivated (occasionally she lost them when her dugout canoe overturned). She brought back hundreds of valuable plants and four previously unknown species were named after her.

This interesting, complex painting shows the philodendron superimposed on a jungle background. As Margaret Mee became more and more involved with trying to halt the destruction of the Amazonian rainforest she painted a number of works of plants in their rainforest settings, in an attempt to alert a wider audience to this danger. She only did about a dozen of these works with backgrounds but they have been shown in many venues and published extensively. She painted the principal subject first and then created the background later.

Philodendron is the second largest genus in the family Araceae, with 700 species native to the neotropics. The evolution of the pollination system of *Philodendron* and other members of the family is similar in many ways to some of the other basal angiosperms. The spike-like inflorescence, called a spadix, bears many small flowers enclosed in a fleshy bract, called the spathe. Each inflorescence has a 24 hour flowering cycle, beginning with the receptivity on the first night of the female flowers situated at the base of the spadix and finishing with the release of pollen from the males flowers at the apex of the spadix on the second night. These flowers are mainly pollinated by large scarab beetles which are attracted to the inflorescence during the early period when the spadix heats up and emits a strong, sweet odour. The spathe forms an enclosed chamber which, during the first night, the beetles enter, mate in and at the same time pollinate the receptive female flowers. During the following night, the beetles exit the spathe, carrying the pollen just released by the opening male flowers at the top of the spadix.

20. **Flowering reed:** *Butomus umbellatus* – Butomaceae

Dasha Fomicheva, b. Moscow, Russia 1968

Water colour on paper, 250 mm x 225 mm

For ten years Dasha Fomicheva divided her time between Jordan and Russia, working primarily for the Jordanian Royal Family. She earned an honours degree in Stage Design from Moscow Art College in 1986, an MA in painting from Surikoff State Academy, Moscow in 1993 and studied watercolours with Sergey Andriaka, People's Artist of Russia.

Dasha has painted watercolour interiors of the Kremlin Cathedrals for the Kremlin State Museums and landscapes of Petra for the Jordanian Royal Family in 1993 and 1994. She assembled 160 military paintings and drawings of the history of the Hashemite Kingdom for HRH Prince Abdullah; she also paints portraits and lectures in fine art theory. Since 1993 Dasha has exhibited in Moscow, Amman and London, participating in 'Botanical Artists of the World' at the Tryon Gallery in London in 2001.

One project supported by HRH Queen Rania resulted in the publication of *Jordan in Bloom:Wildflowers of the Holy Land* which contained 53 beautiful watercolours by Dasha with a fluent, luminous technique. Her flowering rush shows her easy yet precise technique well. It is delicate and fresh, echoing the ephemeral beauty of the flowers.

The 14 families of the order Alismatales, which diverged very early in the evolution of the monocots, are separated into two main evolutionary groups: the aroids (family Araceae), and the other 13 families. All members of this second group occur in wetland or aquatic habitats and are generally referred to as the 'aquatic monocots.' The family Butomaceae, one of the aquatic monocots, consists of five genera occurring in both temperate and tropical regions. *Butomus umbellatus*, the only species in the genus, is an emergent, aquatic perennial herb indigenous to most of mainland Europe, the British Isles, and temperate western Asia. These plants have 'escaped' their native habitats and invaded North America as a result of dispersal by humans. In many cases this species will displace native aquatic vegetation and once established will increase in population number. This ability to successfully invade new habitats is an evolutionary adaptation which allows some species to take advantage of environments without the natural predators of the native lands where they evolved. The generic name is derived from the Greek 'bous' meaning 'cow' and 'temno' meaning 'to cut' in reference to the sharp-edged leaves that may injure grazing cattle.

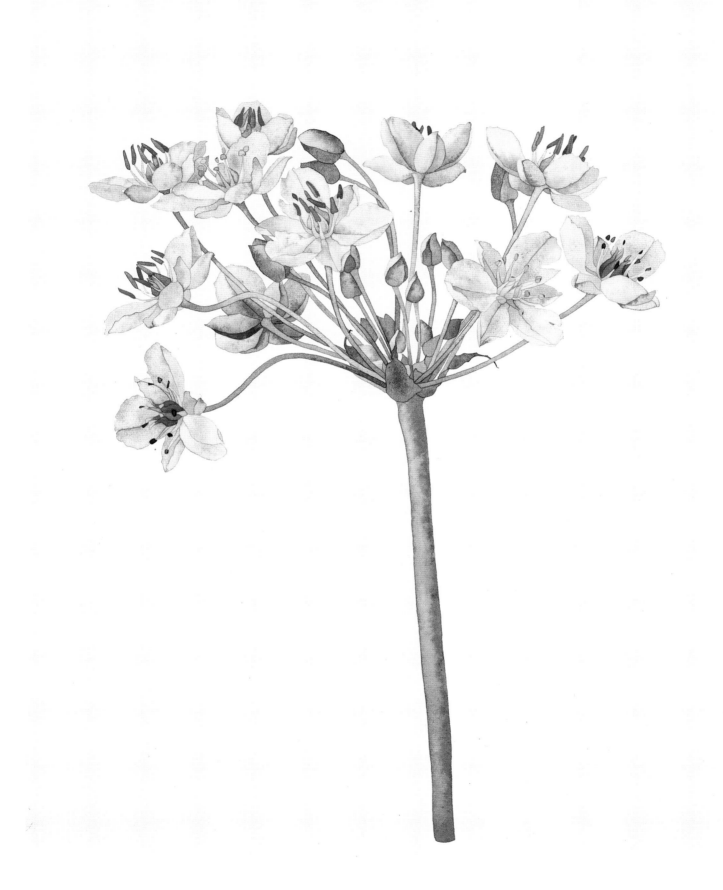

Dioscoreales

Barely one thousand species make up this order, which contains just three families. Within the order the yams are most closely related through evolution to the saprophytic burmannias, a group of tiny of herbs without chlorophyll, which botanists formerly thought were related to the orchids. The net-veined leaves of the yams were cited as evidence for placing these plants with other net-veined monocots, such as catbrier and trillium. However, recent DNA data demonstrated that these close relationships were false.

21. *Dioscorea elephantipes* **and** *D. discolor* – Dioscoreaceae

Camilla Speight, b. Oxford, England 1974

Pen and ink line drawing, 418 mm x 295 mm
Signed *CS 94*

Camilla Speight launched herself as a freelance botanical artist when only 20 years old after a year at Camberwell College of Art in 1992–1993. Her draughtsmanship was quite remarkable and for the first few years she contented herself with exquisite line drawings in pen and ink although she did experiment with colour at one stage.

Initially she worked freelance for Macmillan, and produced the line drawings for a series of RHS manuals and dictionaries published by them. These books covered climbers and wall plants, grasses, orchids and bulbs. She started showing plates of line drawings from 1995 onwards at the RHS, winning a gold medal each time, and was awarded the Garden Writers Guild special award for the RHS *Manual of Orchids*. She started working at the Herbarium, Kew in 1997 but sadly is no longer drawing plants.

This complicated pen and ink study of *Dioscorea elephantipes* shows its deeply corrugated water-storing base, looking uncannily like an elephant's foot, while *Discorea discolor* is shown with its extraordinary blotched heart-shaped leaves.

Botanists long thought that yams, which make up the family Dioscoreaceae, were included in the group of monocots allied to lilies with net-veined leaves. DNA evidence suggested that this evolutionary placement was incorrect and that yams, along with a group of small forest floor plants lacking chlorophyll and the genus *Tacca*, are more closely related to screw pines. Yams are mostly found in tropical forests, but some also inhabit grasslands and semi-desert regions. The family is made up of three genera and over 400 species. All are twining vines with thick, tough underground stems, which contain steroidal sapogenins and alkaloids, most likely as chemical defences against the animals that try to eat them. The genus is named in honour of the Greek physician and botanist Pedanius Dioscorides, author of *De Materia Medica Libri Quinque*. This comprehensive classical herbal prepared by Dioscorides served as the basic botanical text for nearly two millennia until the time of Linnaeus in the eighteenth century.

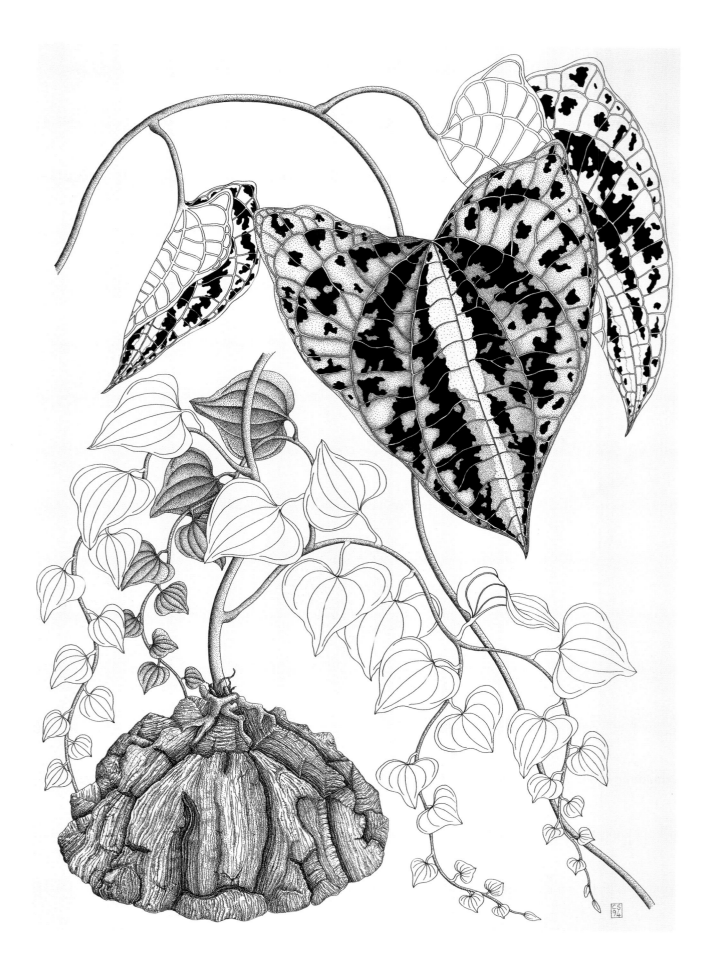

Pandanales

These monocots are almost entirely restricted to tropical habitats and range from small saprophytic forest plants no more than a few inches tall to giant tree-like herbs lining the shores of oceanic islands. Five families make up the Pandanales, including the screw pines and the Panama hat plants, which have long been considered to be related. DNA data are the primary evidence that unite the five families together in this order, as well as uniting the Pandanales with the Dioscoreales.

22. *Pandanus tectorius* – Pandanaceae

Noboru Isogai, b. Gumma, Japan 1935

Watercolour on paper, 1190 mm x 860 mm
Signed *Isogai*

Noboru Isogai graduated as a mechanical engineer from the University of Tokyo in 1959 and worked at Seiko Instruments, Tokyo until 1998. Then he became a teacher in botanical art at the cultural centre at Chiba, where he lives. He is a member of the Seiko Art Association, Japan and the Society of Botanical Artists, UK.

Isogai started showing his work in 1995 in Tokyo and since 1999 has exhibited every year at the Society of Botanical Artists in London and the Agape Gallery, Tokyo.

His *Pandanus tectorius* is a large, beautifully painted watercolour of swirling leaves, notable for its energy and exquisite design.

Formerly taxonomists considered the pandans or screw pines to be evolutionarily closely related to palms (family Arecaceae) or bromeliads (family Bromeliaceae). However, morphological and DNA evidence now suggest that they are not related to palms nor bromeliads at all, but are relatives of the Panama hat plants (family Cyclanthaceae), the vellozias (family Velloziaceae) of Brazil, which was somewhat surprising to botanists, and the yams (family Dioscoreaceae). The evolutionary diversification of the screw pines began about 51 million years before the present time. Today more than 650 species are known to exist. These plants are shrubs and trees, native to the Old World tropics with the flower sexes separated on different plants. The flowers are very different from most other monocots in that they lack any petals or sepals and are often clustered so tightly together that it is difficult to tell one from the next. The fruits form large globular heads of these packed flowers. Pollination varies among the three genera in the family from wind to insects to bats. The name *Pandanus* is derived from the Malay 'pandan' or 'pandang', meaning 'conspicuous' because of the dominance of these plants along the coasts of South-East Asia.

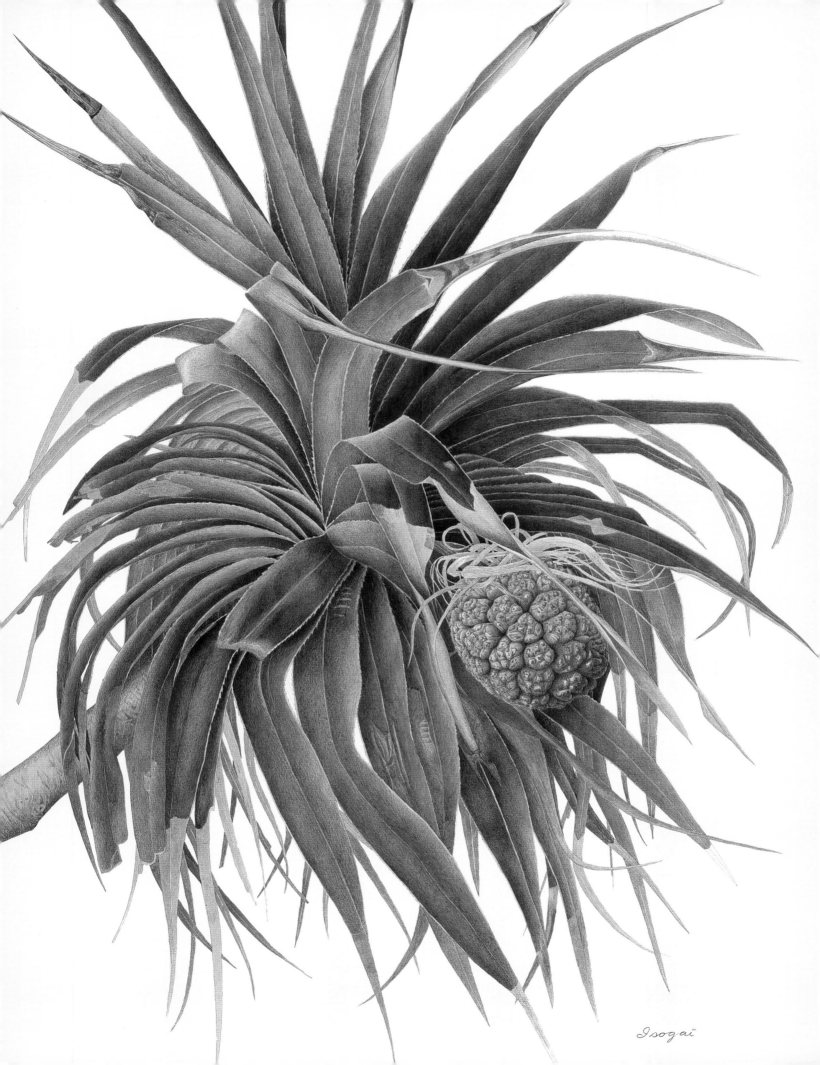

Isogaï

Liliales

In past classifications of the monocots, before the widespread application of DNA data, the order that contained the lilies was thought to include most of the species with a petal-like perianth. This very broad idea of the lilies has now been replaced by a much narrower circumscription of the species, with many taxa now placed in the orders Dioscoriales and Asparagales. The Liliales as defined today contain eleven families, including the true lilies, the frittilarias, the autumn crocuses, the trilliums, catbriers, lapagerias, and alstroemerias; about 1,300 species in all. These plants are similar to each other in having nectaries on the often spotted tepals and anthers that open-up pointing outwards.

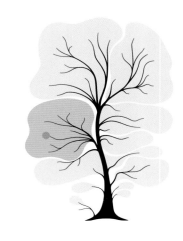

23. *Trillium decumbens* – Melanthiaceae

Lawrence Greenwood, b. Todmorden, England, 1915–1998

Watercolour on paper, 170 mm x 250 mm
Signed *LG*

Before World War II, Lawrence Greenwood worked as a carpet designer, engineering draughtsman and a general manager in industry. He started painting flowers in 1968 and exhibited his work at the shows of the Alpine Garden Society and Scottish Rock Garden Club. He showed 40 paintings at each of the 5th and 6th Rock Garden Conferences held at Nottingham University in 1981 and Warwick University in 1991.

Lawrence produced two kinds of painting. The first was the traditional botanical illustration of a plant set on a white background. The second sets the plant in its habitat, perhaps a woodland plant growing among fallen dead leaves or an alpine species nestling in the rocks and stones of a scree slope: the background was painted in as much careful detail as the botanical subject of the study, as shown in his painting of *Trillium decumbens*.

Those plants traditionally thought to be in a large family that included the lilies, have now been divided into a number of separate families after a more careful analysis of their morphological traits. This reanalysis of the various families was suggested by DNA sequence data. The family Melanthiaceae has been variously classified over the last decade as new information was assimilated. Today the classification is still in dispute and some botanists put the genus *Trillium* into a separate family, called the Trilliaceae, while others include the genus in the Melanthiaceae (as recognised here). Trilliums are found in the temperate zone of the northern hemisphere where they generally occur in forests and in dry, rocky habitats. Fifty species of trillium are currently known to exist although botanists also differ in their interpretation of the number of species in this genus.

24. **Glory lily:** *Gloriosa rothschildiana* — Colchicaceae

Pandora Sellars, b. Herefordshire, England 1936

Watercolour on paper, 280 mm x 370 mm
Signed *Pandora Sellars '90*
Commissioned

Pandora Sellars received the Jill Smythies Award in 1999 from the Linnean
Society in recognition of her outstanding contribution as a botanical artist.
She recently acquired a purpose-built studio and is enjoying teaching students
from Japan, USA and Canada.

Pandora is considered one of the most important botanical artists of all time.
It goes without saying that her work is scientifically accurate, but here is an artist

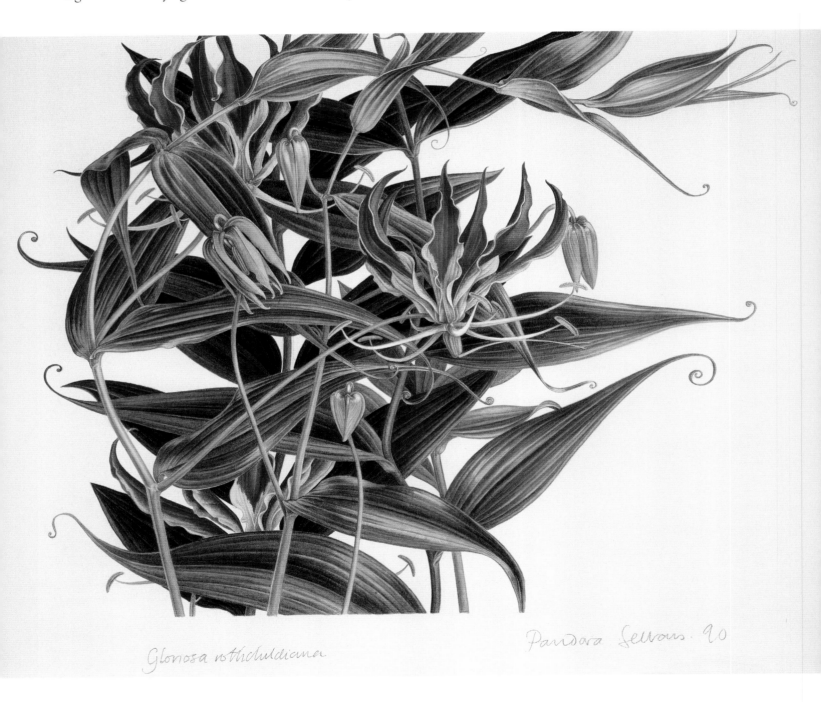

Gloriosa rothschildiana

Pandora Sellars. 90

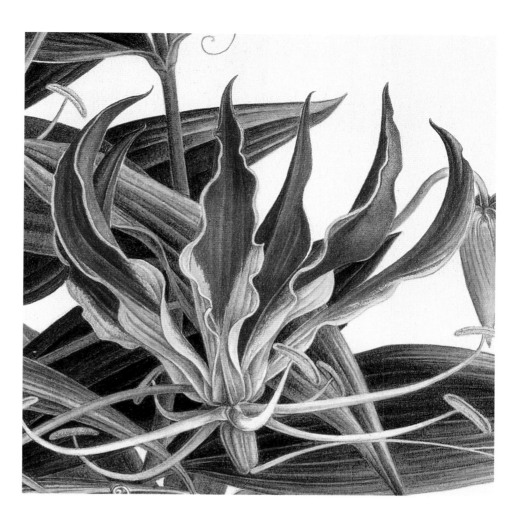

who has transcended the pedantic plant study to paint true works of art. Hers is a subtle approach, restrained and yet surprising. Her paintings always have an immediately recognisable stamp to them and her leaves are probably amongst the most beautiful yet accurate ever painted. The lively tangle of flowers and leaves in the glory lily are very captivating. This work was used on a plate in a special series of porcelain created by Wedgwood to celebrate the Shirley Sherwood Collection.

The Colchicaceae is another family formerly included in the concept of a large 'lily family' and encompasses 13 genera and about 190 species, although some botanists differ in how many species should be placed in this group. These plants are widespread in Africa, Europe, and Asia and extend their distribution to Australia and New Zealand where they are characteristic of Mediterranean-type climates in which the rain mostly falls in the winter months. The members of the Cochicaceae are distinguished from other lilies by their distinctive corms and especially their peculiar chemistry that includes a variety of alkaloids. The conspicuous and colourful flowers of plants in this family attract various insects as their pollinators, including bees, wasps, flies, butterflies, and moths, providing a rich abundance of nectar as a reward to insects visiting the flowers. The genus *Gloriosa* is native to South Africa and Asia, although these plants are now cultivated and naturalised in many tropical areas of the world. The name comes from the Latin 'gloriosus', meaning 'famous and full of glory', referring to the glorious flowers.

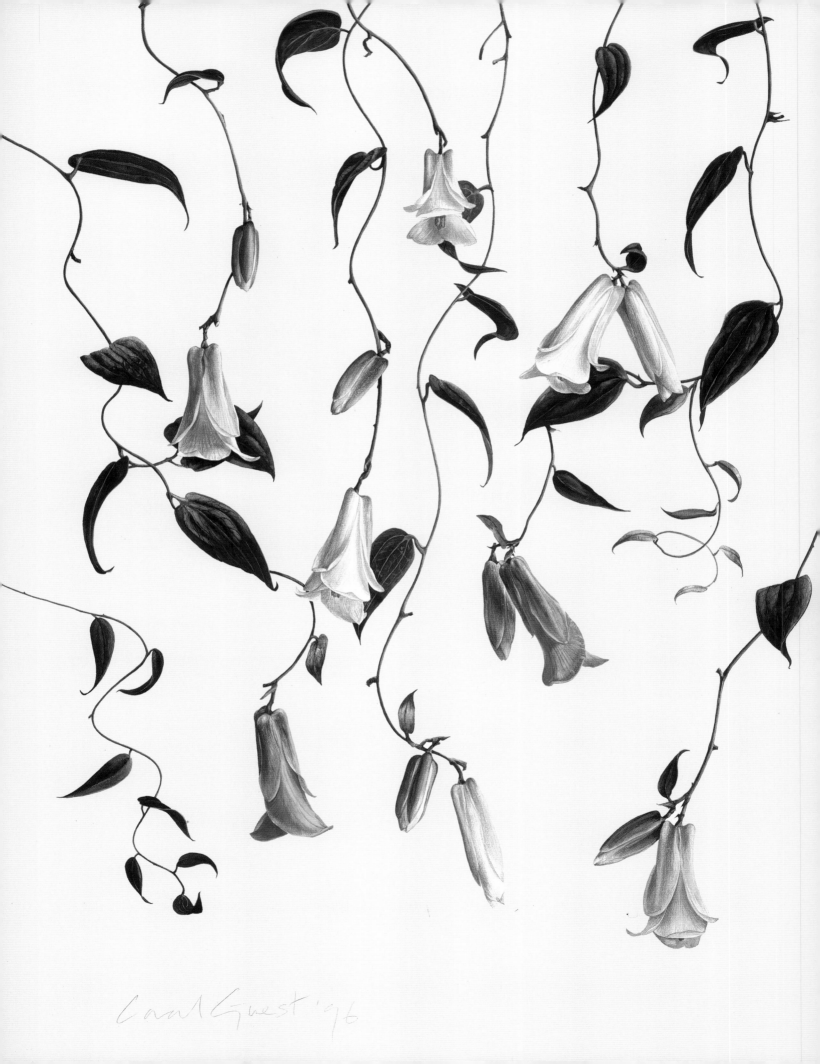

Carol Guest '96

25. *Lapageria rosea* and *L. rosea* var. *albiflora* – Philesiaceae

Coral Guest, b. London, England 1955

Watercolour on paper, 770 mm x 570 mm
Signed *Coral Guest '96*
Commissioned

Coral Guest was commissioned to paint *Lapageria* grown in an orangery near Oxford in Southern England. *Lapageria rosea* is known as the Chilean bell flower and is the national flower of Chile. Surprisingly little grown in Europe, it is a spectacular climber which will grow outside in a very sheltered spot in southern England. It has beautiful, bell-shaped flowers with thick, waxy petals which cascade from the trailing stems. It is tricky to germinate and only occasionally appears in seed catalogues. As it is extremely lime-sensitive, an accidental watering with alkaline tap water can be enough to set the plant back for months, with a very characteristic browning of the leaf tips showing up immediately. Often it will not flower for several years after germination.

This beautiful watercolour shows both white and pink *Lapageria* and the dark glossy leaves suspended on the trailing stems.

The family Philesiaceae comprises only two genera, each with a single species of erect and twining shrubs. They are only found in the forests of southern Chile. DNA sequence data suggest that these two genera are very distinct from other allies of the lilies and most taxonomists prefer to place them in the separate family Philesiaceae. *Lapageria* is the national flower of Chile and depends primarily on two pollinators for successful reproduction: the green-backed fire-crown hummingbird and the giant bumblebee, both of which aid the plant in producing seed. The genus was named after Joséphine Tascher de La Pagerie (1763–1814), who eventually became the Empress Joséphine and wife of Napoleon, but who as a girl lived on the La Pagerie estate in the Caribbean island of Martinique.

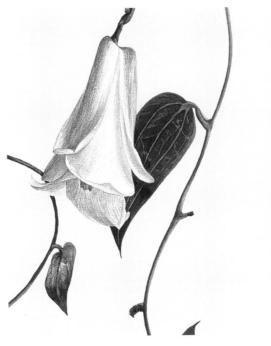

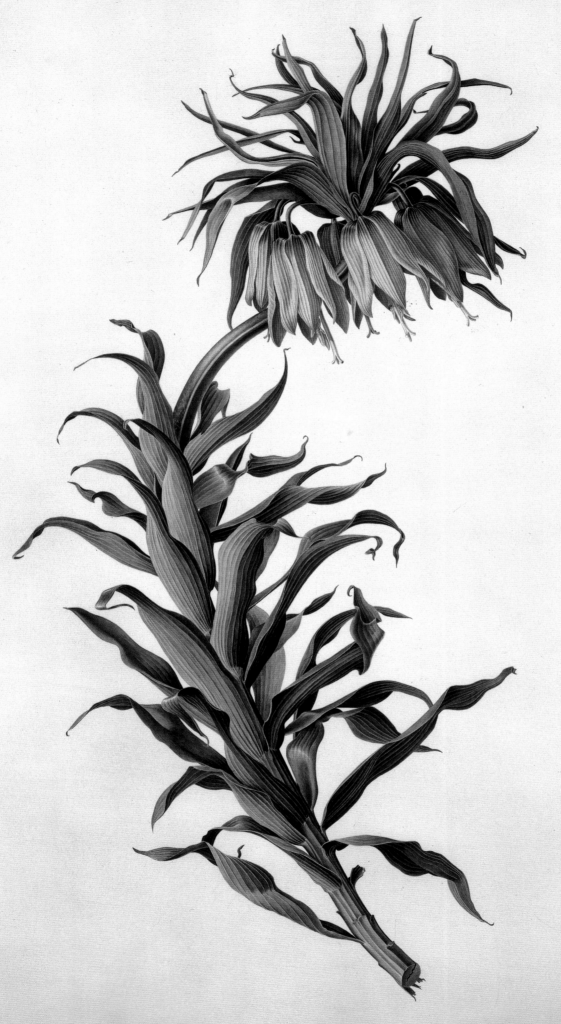

Rory McEwen
1965

26. **Crown imperial:** *Fritillaria imperialis* – Liliaceae

Rory McEwen, b. Berwickshire, Scotland (1932–1982)

Watercolour on vellum, 780 mm x 565 mm

Signed *Rory McEwen 1965*

Rory McEwen's work influenced the development of a number of artists in the Shirley Sherwood collection; Brigid Edwards, Jenny Brasier, Susannah Blaxill and Lindsay Megarrity are examples. They saw the memorial exhibition of his work shown in Scotland and at the Serpentine Gallery, London in 1998.

Rory painted flowers from the age of eight and was encouraged by Wilfrid Blunt, his art teacher at Eton, to look at the works of Redouté and Ehret. Blunt described him as, 'perhaps the most gifted artist to pass through my hands'.

He had no formal training at an art school, but by the time he finished at Cambridge University his illustrations had been published in *Old Carnations and Pinks* by Charles Oscar Moreton (1955). He illustrated *The Auricula* in 1964, and painted many of the plates for Wilfrid Blunt's *Tulips and Tulipomania* (1977). Rory travelled widely, especially in the Far East, and showed his work in Japan and also in a number of modern art galleries including MOMA in New York.

His 1974 exhibition 'True Facts of Nature', at London's Redfern Gallery attracted a great deal of attention. Plants and vegetables were sometimes painted in the same frame, always with the space between them being as important as the objects themselves.

He was much influenced by the past and his studies of the botanical masters like Robert, Redouté, Ehret and Aubriet are reflected in his work. McEwen's tulip was deliberately hung next to Ehret's drawing in the Kew Collection in a recent exhibition at the Shirley Sherwood Gallery (see *Treasures of Botanical Art*, page 56). His work on vellum is particularly noteworthy and encouraged many recent artists to try this medium. The crown imperial *Fritillaria imperialis* is one of his most important works. It is on vellum, a robust plant, with a curved stem and exquisitely painted leaves and flowers.

The taxonomic boundaries of the family Liliaceae have varied enormously over the centuries. In the broad classical sense followed by most past taxonomists, the Liliaceae included between 200 and 300 genera. As currently recognised, the family encompasses only 12 genera and about 500 species. These genera are mainly distributed in the temperate zone of the northern hemisphere, although some are also found in the subtropics. The plants are herbs, usually with bulbs, which help the plants survive the winter months, and contractile roots, which pull the bulbs deeper into the soil to protect them from drying out. The flowers often have variegated patterns on them. The lilies are characterised chemically by the possession of steroidal saponins in their bulbs, stems, and leaves. Fritillarias are distributed across the temperate part of the northern hemisphere, including the drier, harsher areas of Asia Minor and California. The name fritillaria comes from the Latin 'fritillus', meaning 'dice box', which refers to the variegated markings on the flowers of *Fritillaria meleagris*.

27. *Lilium regale* – Liliaceae

Coral Guest, b. London, England 1955

Artists' acrylic on watercolour paper, 1510 mm x 1025 mm
Signed *Coral Guest '07*
Commissioned

In 2007 Coral Guest was commissioned to paint this magnificent portrait of
Lilium regale to make a pair with a wonderful iris painted by her in 2005. The
large iris, 'Superstition', was hung in the new Shirley Sherwood Gallery as one
of the first paintings on entry, deliberately catching the attention of every visitor
to the opening exhibition 'Treasures of Botanical Art'.

Coral grew several lilies herself in large pots, carefully staked them and
painted first the flower, then the stem and leaves life size. When they were
completed she washed the base free of soil to display the roots at the top and
bottom of the corm, which had already divided into several young scaly bulbs.
The bulbs and roots took her another two months to complete.

Her delicate, lush use of colour is outstanding but so also is her capacity to
'hold' such a large composition. This painting and the iris shown previously
make the most remarkable pair of boldly composed and yet sensitively executed
works of art.

The true lilies are perennial herbs of the north temperate zone with scaly bulbs that are
sometimes stoloniferous or rhizomatous. The stems never branch and the flowers are
produced either singly on a stem or in clusters. The large, cup-shaped, usually spreading
flowers come in many colours including white, yellow, orange, red, purple, and maroon
and are typically spotted inside. The strong sweet odours produced by these large
flowers attract the pollinators, usually moths, who transfer pollen between plants. The
genetic variation resulting from these cross-fertilisations produces the raw materials
upon which natural selection acts to produce the evolution of new and novel forms.

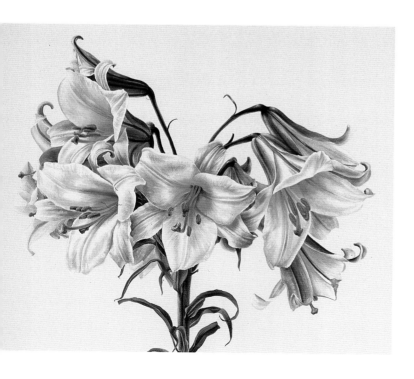

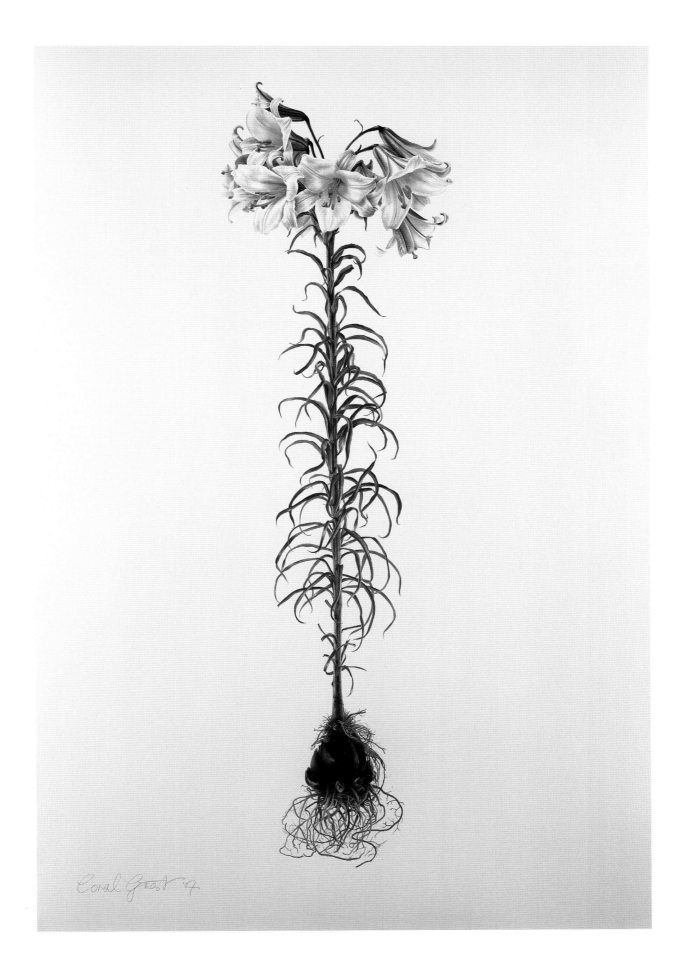

Asparagales

Although the members of this order contain many plants that formerly were thought to be related to the lilies, the Asparagales share a more recent common ancestor with the most advanced monocots, including the day-flowers, the gingers, the bromeliads, and the grasses. Taxonomists are not yet decided on how many different families make up the Asparagales, but some estimate that up to 30,000 species are contained in this order. Most of these species fall within a single family, the orchids. The Asparagales also include the onions, amaryllis, daffodils, iris, agaves and yuccas, hyacinths, asparagus, day lilies, dragon trees, Solomon's seal, and snowdrops. Many of the spring-flowering ephemerals in our temperate forests are members of the Asparagales. All of them possess black seeds and a unique type of nectary in the flowers.

28. Vanda 'Fuchs Blue': *Vanda* sp. – Orchidaceae

Francesca Anderson, b. Washington DC, USA 1946

Pen and ink on paper, 730 mm x 580 mm
Signed *Francesca Anderson for Shirley Sherwood 5/92*

Francesca Anderson has had many solo exhibitions all over the States and for ten years prepared the plates for two books with M. Baldick on the palms of Belize and on Ayurvedic herbs. She has been awarded two gold medals at the RHS, and is a leading light in organising the Brooklyn Florilegium Society. She recently became a Fellow of the Linnean Society. She lives in Brooklyn, New York, and at her farm out on the end of Long Island, where she has created her own nature reserve.

Vanda orchids have been extensively hybridised in Singapore. Anderson's drawing shows the chequered pattern of the flowers which is so distinctive in these hybrids. Her vigorous yet elegant outsized pen and ink studies are full of energy and depth.

Orchids are best known for their conspicuous and complex floral structure. The complexity of these flowers has evolved in response to the varied animals that pollinate them in order to ensure successful reproduction. Bees, wasps, flies, gnats, ants, beetles, hummingbirds and bats have all been observed by botanists as pollinating agents of orchids. The animal, usually an insect, must first be attracted to the flower and then the pollen sack, or pollinia, of the flower must become attached to the insect for transport to another orchid. A variety of attracting and attaching mechanisms have evolved in the orchids, including both visual and olfactory attractants and a type of 'quick-setting glue' for affixing the pollen to the pollinator. The genus *Vanda* is distributed from the southern tip of Australia to India and China. The word 'vanda' is derived from ancient Sanskrit and refers to the resemblance of epiphytic orchids to the evolutionarily unrelated sacred mistletoes growing on oak trees.

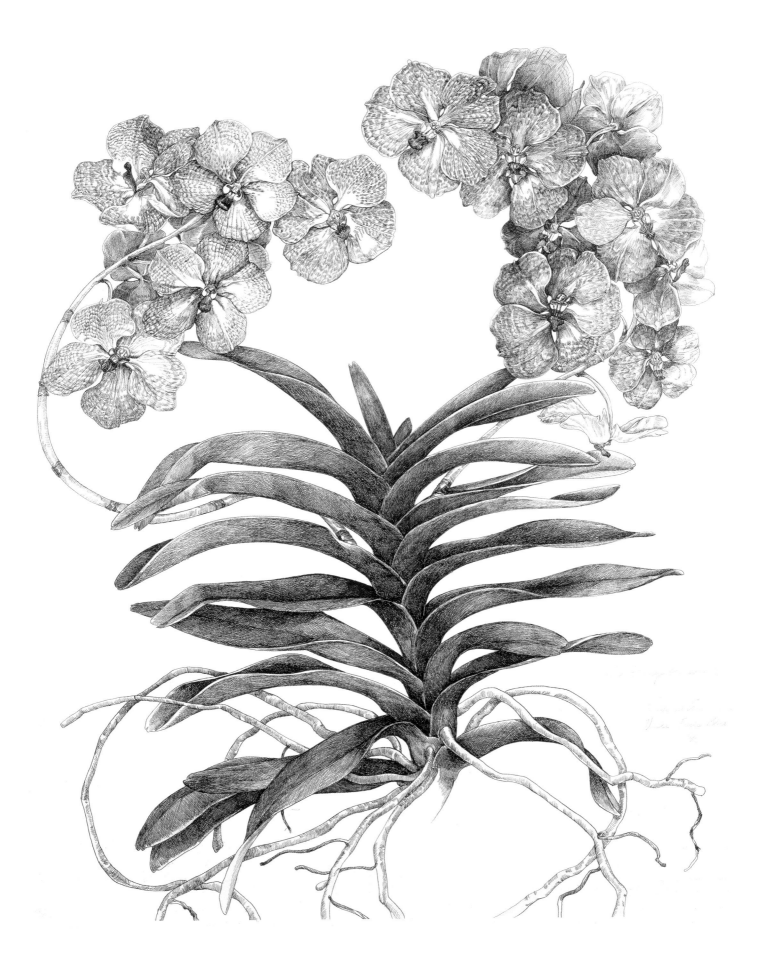

29. *Disa uniflora* – Orchidaceae

Carol Woodin, b. Salamanca, New York, USA 1956

Watercolour on vellum, 710 mm x 470 mm
Signed *C Woodin Disa Uniflora Berg*
Commissioned

In recent years Carol Woodin has become one of the most outstanding botanical artists working in the States. She has concentrated on orchids and started working on vellum, a surface where she achieves an astonishing translucency.

Carol became a full-time botanical artist in 1990 and had two solo exhibitions at the Pennsylvania Horticultural Society, Philadelphia in 1996 and the Buffalo Museum of Science in 1995. She has been involved in many group shows and been awarded a gold medal at the RHS. She won the 1998 Award for Excellence in Botanical Art from the American Society of Botanical Artists, as well as the 'Best of Show' at the National Orchid Society from 1992 to 1996. Her work is held at the Hunt Institute, at Kew and the Niagara Parks Commission, Canada as well as in many private collections. She was awarded a gold medal in 2005 at the World Orchid Conference in Dijon. Currently she is exhibitions co-ordinator for the American Society of Botanical Artists, where she is a very active member.

Disa uniflora is a dramatic orchid which lives under waterfalls on the Cape in South Africa. Every year visitors try to catch a closer glimpse through binoculars of its vivid scarlet flowers high up on the Cape escarpments . Despite its conservation status it is sometimes collected, regardless of the danger to life and limb, and every year there seem to be resultant accidents. However, Carol Woodin got her specimen of *Disa uniflora* from the well-known orchid breeder, Warren Stoutamire of Ohio, USA. It is a vivid portrait with the vellum giving it an added translucency and impact.

Orchids, in the family Orchidaceae, are characterised by often showy, strongly zygomorphic flowers with the pollen usually aggregated into sacks called pollinia that are dispersed as a unit by pollinators. The seeds are numerous, very tiny, and dust-like. The family is monophyletic with all orchids being derived from a unique single orchid ancestor that lived perhaps over 80 million years ago. One of the main evolutionary groups of orchids is the subfamily Orchidoideae, which is easily recognisable by the possession of a single anther, the pollen in pollinia, and fleshy roots. One of the orchids in this group is *Disa uniflora*, found in the Western Cape of South Africa. This species is pollinated by the mountain pride butterfly *Meneris tulbaghia*, which is strongly attracted to the red flowers. The flowers produce a large nectar reward and the elongated pollinia are stuck to the legs of the butterflies and are thereby transported from flower to flower.

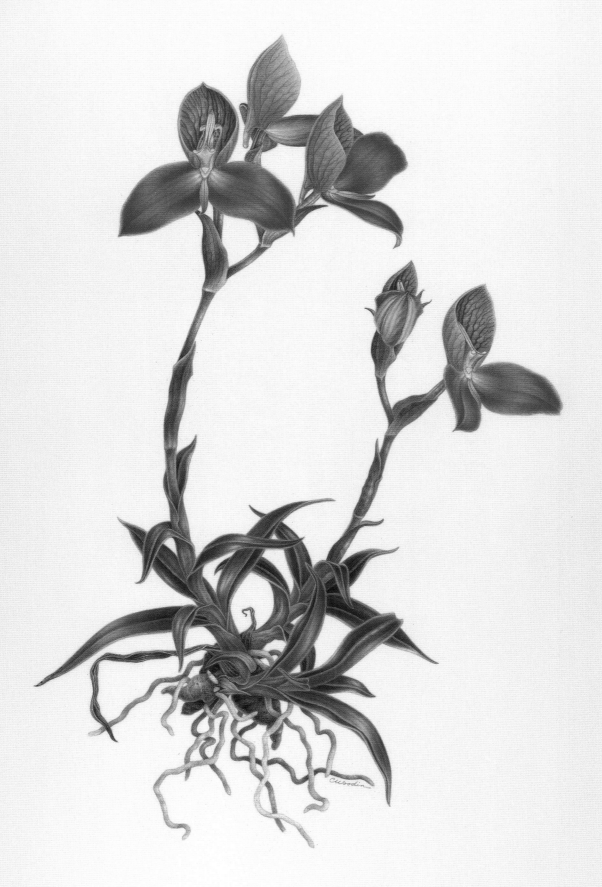

Disa uniflora Berg.

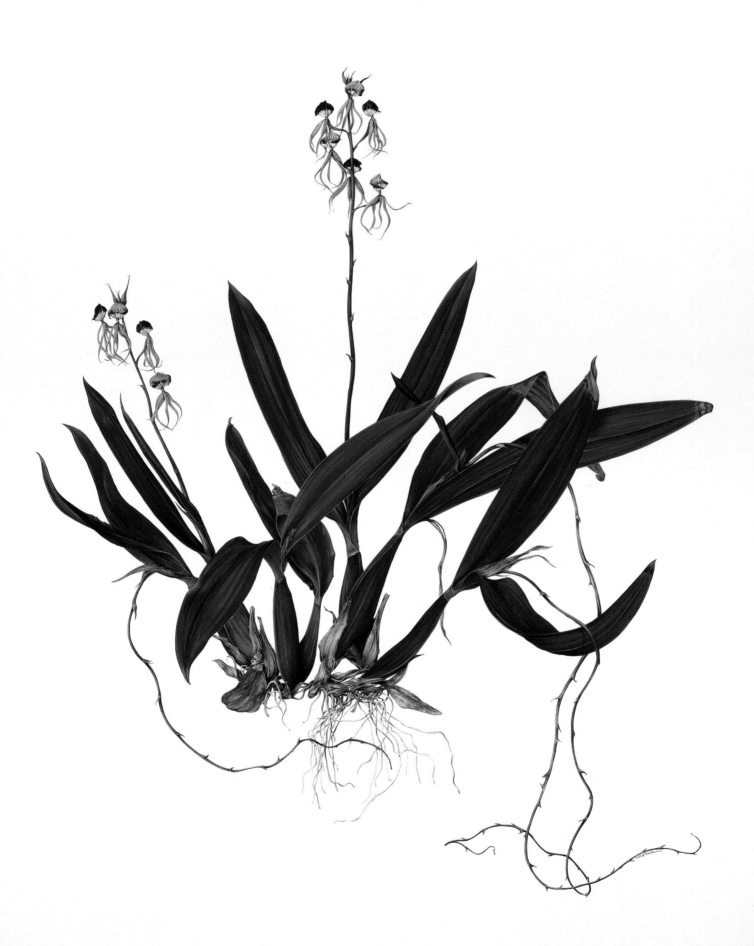

6 August 1995 Newlin
Epidendrum cochleatum
Rult Sp Nursery · Ashland NB

30. Clamshell orchid: *Prosthechea cochleata* – Orchidaceae

Kate Nessler, b. St Louis, Missouri, USA 1950

Watercolour on paper, 845 mm x 685 mm
Signed *Nessler*

Kate Nessler's work is collected in the Morton Arboretum, Lisle, Illinois, USA, the Highgrove Florilegium, Brooklyn Botanical Garden Florilegium, New York and the US National Museum of Women in the Arts, Washington, DC.

This large, dramatic painting is a masterpiece of composition seen from a distance and a miracle of detail seen close up. All the orchid flowers are beautifully drawn, but the excitement is in the trailing stems and roots and the overall design.

The orchids are most closely related evolutionarily to all the other plants in the Asparagales, such as asparagus, onions, irises, and amaryllis. The dust-like seeds of orchids, which lack any type of nutritive cells as found in most other flowering plants, is one of the central traits that distinguishes them from the other members of the order. A single fertilised orchid flower may produce over one million of these extremely tiny seeds, which are usually dispersed by wind. When the seeds reach an appropriate habitat, they must form an intimate ecological relationship with a particular fungus that provides the nutrients for the developing embryo. This symbiosis between orchid and fungus will persist into the adult phase in some orchids that grow in the soil, but may not continue in those species that grow on the branches of trees as epiphytes. Some botanists think that the relationship between the orchids and their fungal partners has resulted in the evolution of the large number of species in this family.

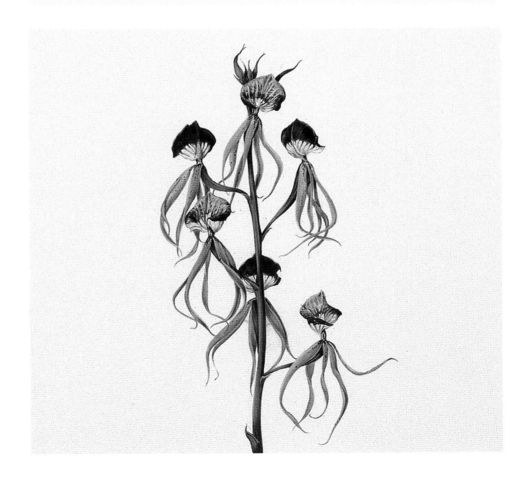

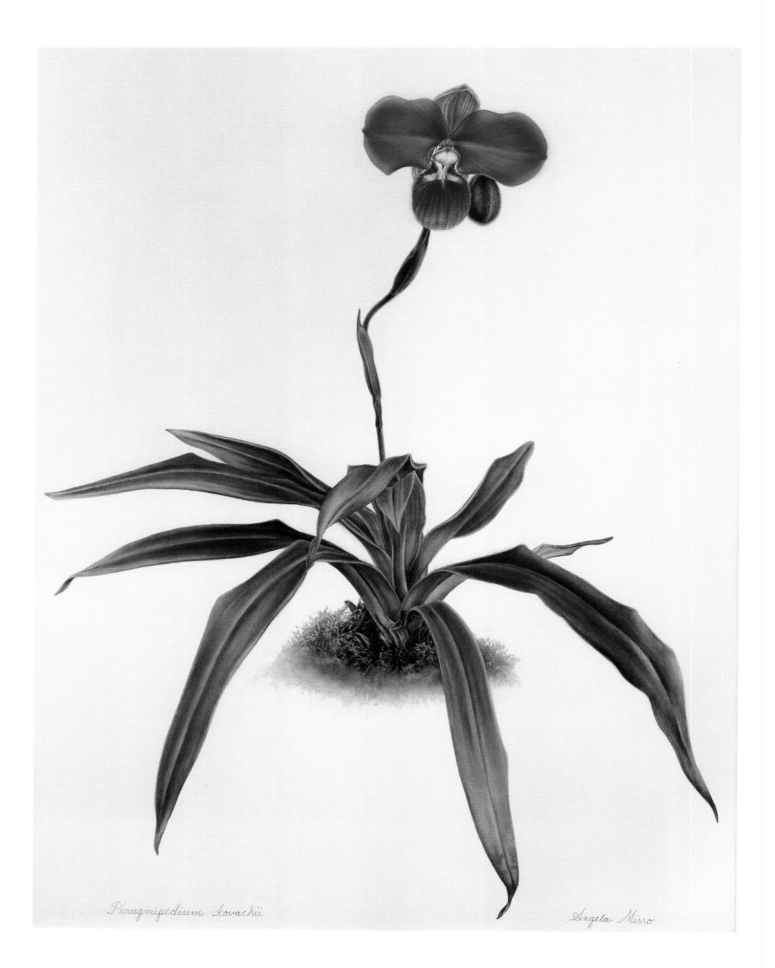

Phragmipedium kovachii

Angela Mirro

31. *Phragmipedium kovachii* – Orchidaceae

Angela Mirro, b. New York, USA 1953

Watercolour on paper, 740 mm x 575 mm
Signed *Angela Mirro*

Angela Mirro went to art school in New York and became a textile designer before turning to painting orchids, which enthral her. She travels to the sites of rare orchids to study them in their natural habitat.

Her work has been widely exhibited in New York, in the International Orchid Show and the National Arts Club, and also in Washington, Miami, Maine, Chicago and abroad in Ecuador and Peru. She has been commissioned to do posters for the New York International Orchid Show each year since 1992.

Phragmipedium kovachii was first collected in 2003 at about 8,000 ft, discovered in a remote site in the north-eastern Peruvian Andes. With some flowers as much as eight inches across and a 'shocking' pink it caused a great stir in the orchid world. Nothing as large or so brightly coloured has ever been found before in *Phragmipedium* species and it came as a complete surprise to the experts.

Angela Mirro became part of the first expedition authorised by the Peruvian authorities to collect five of these truly amazing plants. The mixed group of American and Peruvian orchid specialists had a struggle to reach the rain-sodden mountainside where hundreds of orchids were about to flower. Angela was forced to turn back halfway there but waited in a nearby village until one large hairy bud opened.

This painting was acquired in Lima at the Peruvian Orchid Exhibition where three of the newly collected plants were flowering spectacularly. Vegetative propagation is underway and eventually the plants will be legally available – in the hope that illegal collection will cease to be so attractive, profitable and destructive.

Angela Mirro showed this drawing, the first study of this extraordinary plant, at the Orchid Exhibition. She gave part of her commission fee to the village where she had waited to paint it. It is a good example of the lengths artists will go to paint plants in the wild.

Angela returned to Peru in 2008 to paint a specimen with three flowering heads, two on one stem, which was divided from one of the original plants collected in 2003 and called *Phragmipedium kovachii* 'Laura'.

Charles Darwin remarked that God must have been inordinately fond of beetles, because so many species of this incredibly large insect group inhabit every environment on the planet. He could have said the same thing about orchids, as more species of orchids have evolved and are present today than any other family of plants. Some botanists estimate that the family contains over 20,000 species in 775 genera. The slipper orchids make up one of the core evolutionary groups within the orchids and some botanists recognise this group as a separate family, the Cypripediaceae. These orchids consist of five genera all of which have two anthers and a characteristic slipper- or urn-shaped labellum, and often lack the pollen in sacks. The genus *Cypripedium* belongs to this subfamily. Many orchids are common in their native habitats but some are extremely rare. The distribution of *Phragmipedium kovachii* is limited to a small area of northern Peru where it has been found in only five localities.

32. **Stinking iris:** *Iris foetidissima* — Iridaceae

Celia Hegedüs, b. London, England 1949

Watercolour on vellum, 540 mm x 410 mm
Signed *CNH 95*

Celia Hegedüs was taught painting by her mother, a stage set designer; she trained at the Hammersmith School of Art in 1966 and the City and Guilds, London. She continued to paint while bringing up her family and exhibited at the Royal Academy Summer Show in 1993, 1995 and 1997. She has also exhibited her work at the RHS and gained six gold medals. One of her iris watercolours has been acquired by the Lindley Library and she has had four solo exhibitions at Waterman Fine Art in London.

Among her best works are three iris paintings on vellum acquired for the Shirley Sherwood Collection in 1996, *Iris foetidissima, Iris pseudacorus* and *Iris sibirica*. In each case she has caught the character and essence of the different plants and has created a wonderful translucence with the light penetrating the vellum. *Iris foetidissima* shows bud, flower and fruit contained within a lovely design of flowing, curving leaves dripping with water.

The Iris family, or Iridaceae, encompasses 1,750 species in 78 genera, including such well-known plants as *Gladiolus, Sisyrinchium, Tigridia,* and *Crocus*. This family is widely distributed around the world and occurs in both tropical and temperate regions, with South Africa and tropical America especially rich in species. The evolutionary position of the Iridaceae has been uncertain because of the discordance between evidence from traits of the flowers, leaves and chemistry, and DNA sequence data. Morphological characters, especially the lack of the black pigment in the seeds, place the family within the Liliales, while DNA data place it here within the Asparagales. Characters unique to the irises are particular chemicals, namely calcium oxalate in specialised cells and tannins or various terpenoids, the typical sheath-like leaf blades, and the showy insect-pollinated flowers. Iris is named after the Greek goddess of the rainbow, Iris. The species *Iris foetidissima* is widespread in western Europe and is distinguished from most other irises by the bright red seeds that remain attached to the split-open fruits for many days and are attractive to birds that disperse the seeds in their native habitats.

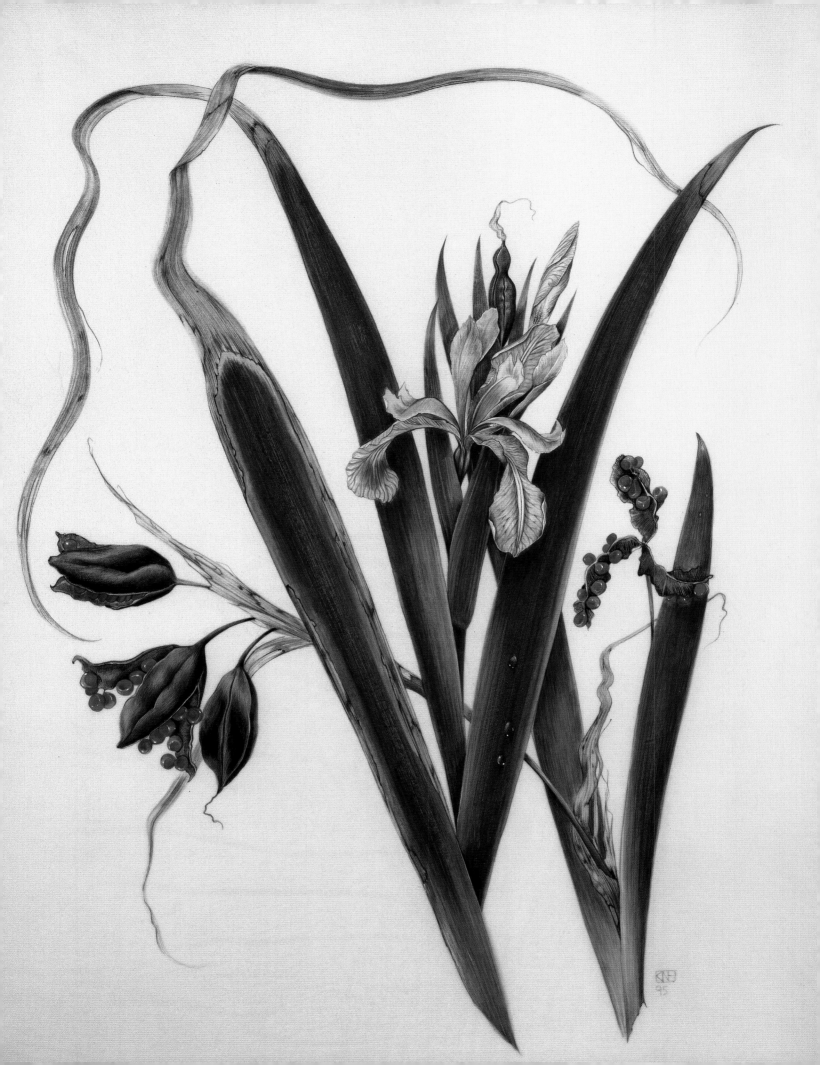

33. Grass tree: *Xanthorrhoea australis* – Xanthorrhoeaceae

Bronwyn Van de Graaff, b. Australia 1964

Watercolour on paper, 580 mm x 463 mm
Signed *B Van de Graaff*

Bronwyn van de Graaff's watercolour of *Xanthorrhoea australis* was shown at the Hunt Institute in 2005 in the 11th International Exhibition and it was acquired the same year by the Shirley Sherwood Collection. This arresting portrait is a clever composition of a difficult subject, with its bizarre black trunk, wildly spiky leaves and spear-like inflorescence. *Xanthorrhoea australis* grows in the eucalyptus forests in the Blue Mountains near Sydney, and the inflorescences have been used as fire sticks by Aborigines. From a distance the plant can look like the figure of a man with an abundant mop of green hair.

Members of the family Xanthorrhoeaceae, which contains ten genera and about 100 species, are restricted to the subtropical and tropical regions of Australia. The plants grow in open eucalyptus forests and heathlands: areas often swept through by fires. These plants have evolved certain adaptations in response to this fiery habitat. As the plant grows, the bases of the leaves remain attached to the fibrous trunk to protect it from the heat of the fires. The plants have also evolved 'woody' palm-like stems to raise the leaves above the level of the fires through a process called 'secondary thickening growth'; a process that is present in only a few groups of monocots. Some species also only flower and fruit after being subjected to a fire. These adaptations allow species of *Xanthorrhoea* to live in these fire-prone environments and also increase their dominance under certain fire regimes. The name 'Xanthorrhoea' is derived from the Greek 'xanthus' (yellow) and 'rhoea' (flowing), and refers to the yellow resin produced by one of the first described species of *Xanthorrhoea*.

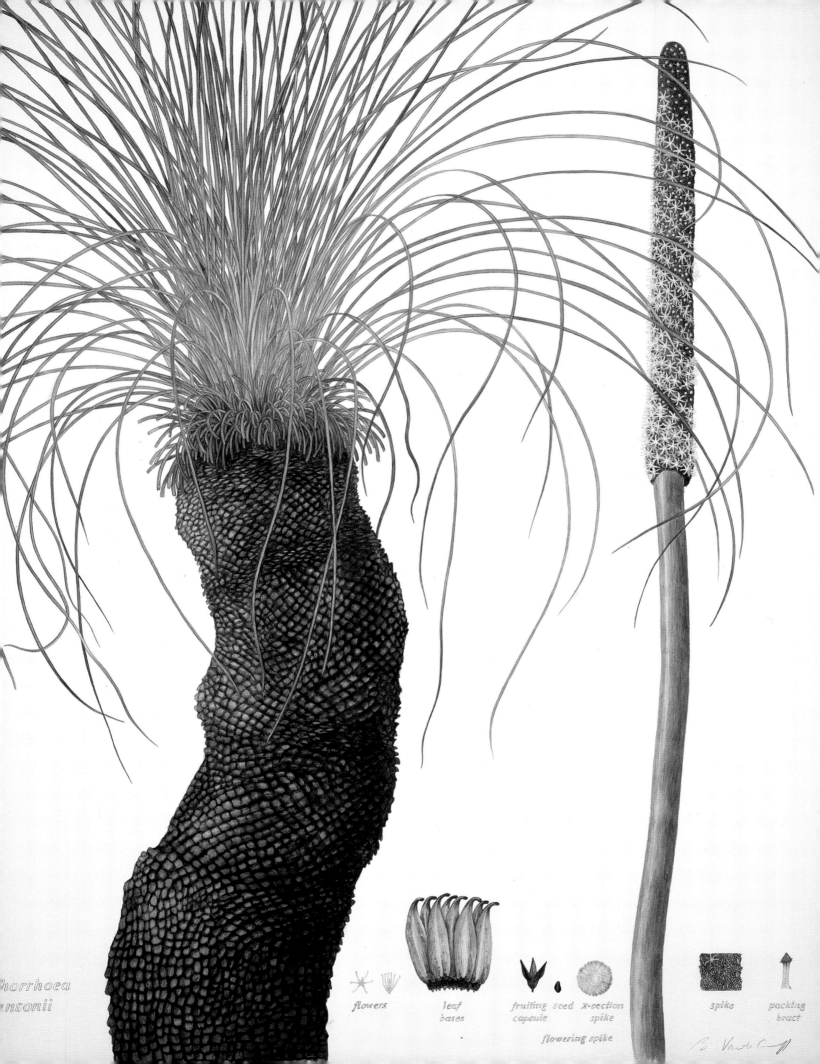

...horrhoea
...nsonii

flowers leaf fruiting seed x-section spike packing
 bases capsule spike bract

 flowering spike

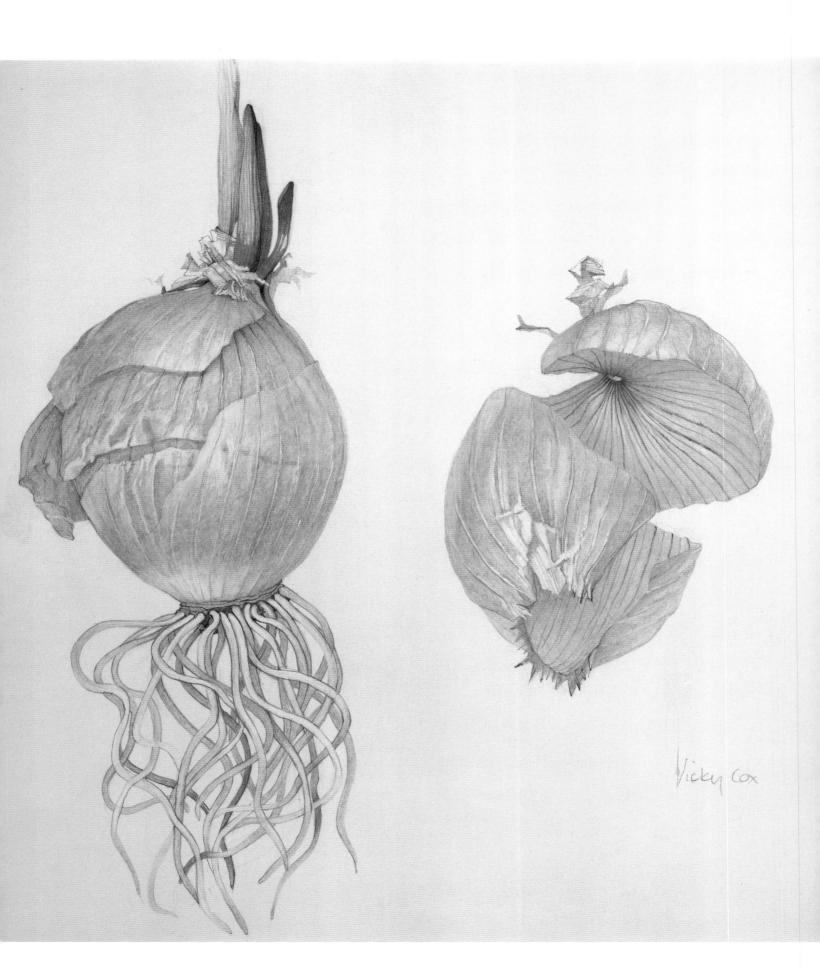

Vicky Cox

34. **White onion and skin:** *Allium cepa* — Alliaceae

Vicky Cox, b. Yorkshire, England, 1943–1999

Coloured pencil on paper, 350 mm x 340 mm

Signed *Vicky Cox*

Vicky Cox trained as an artist in 1968, gaining first class honours at Maidstone College of Art where her tutors included Patrick Proctor and David Hockney. A couple of years later she completed an MA at Birmingham College of Art. From then onwards she was a self-employed artist, doing some teaching and running workshops for both adults and children.

Vicky's plant drawings were mostly done in coloured pencil and she exhibited steadily from 1968 onwards. She was a founder member of the Society for Botanical Artists and was awarded many medals by the RHS. However, she did not only paint or draw plant subjects. She was particularly interested in working from the moving figure in ballet and tai chi, using a very free, loose style in oils, pastels, watercolour and ink.

This work was chosen as a beautiful study in coloured pencil. She has captured the translucency and papery skin to perfection and her roots are full of character.

The insights gained from DNA sequence data have led to many of the larger families related to the lilies being divided up into smaller groups of species with very narrow defining characters and vice versa. The onion family, or Alliaceae, is one example that earlier included 13 genera and 645 species. The onions are closely related to the amaryllis family (Amaryllidaceae) and agapanthus family (Agapanthaceae), but distinguished from them by a few specialised floral traits and some chemical properties. According to the latest classification both the Amaryllidaceae and Agapanthaceae have now been included within a more broadly-defined Alliaceae family. The members of all three of these families are herbs with underground bulbs and an umbel-like inflorescence at the top of a long stem. Garlic and onion have been highly-regarded as important herbal remedies for over a thousand years, as antiseptics, aphrodisiacs, bactericides, digestives, diuretics, sedatives, tonics, and vermifuges. These chemical properties, which have evolved to protect the plant from fungal infection and grazing animals, have been adopted by humans to treat various ailments and infections.

35. *Haemanthus nortieri* — Alliaceae

Vicki Thomas, b. South Africa 1951

Watercolour on paper, 305 mm x 535 mm
Signed *V Thomas 2002*

Vicki Thomas is an attractive and energetic botanical artist and teacher living in
Betty's Bay, in the Cape, South Africa. Her artwork is in collections around the
world, including the *Highgrove Florilegium*, a permanent record of the flora in
HRH Prince Charles's garden in England. Her work has been on exhibition in the
USA and Japan as part of the Shirley Sherwood Collection and in other
prestigious exhibitions in the UK and South Africa.

Vicki is currently working on illustrations for a monograph on *Lobostemon*.
She has had scientific illustrations published in many botanical journals and in
two books dedicated to botanical illustration. She has gold and silver medals from
Kirstenbosch Biennale Exhibitions.

This specimen of *Haemanthus nortieri* has only flowered twice in the last
twenty years at Kirstenbosch. As Vicki mentions in her notes it is rare and comes
from Nardouw Mountains of the North West Cape. Its single leaf is sticky and
collects particles of sand when emerging, which may deter herbivores.

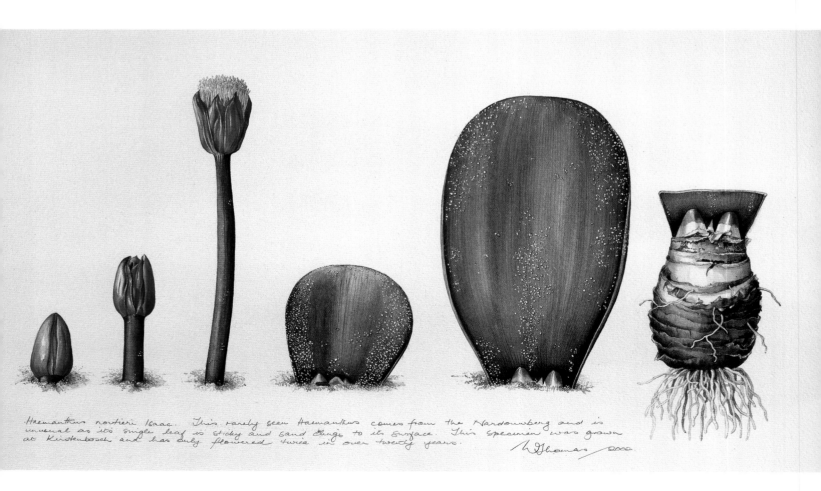

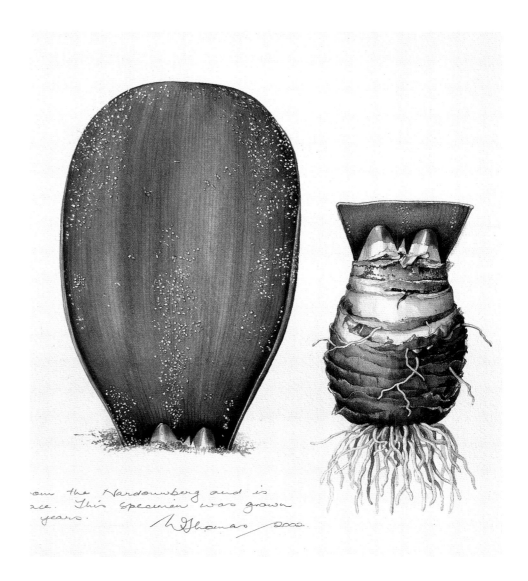

*om the Nardouwberg and is
...ce. This specimen was grown
years.*
M Thomas 2000.

Haemanthus was formerly classified in the segregate family Amaryllidaceae, which is now included in the larger family Alliaceae. Members of the *Amaryllus* group are characterised by the presence of special chemical properties (called 'amaryllid alkaloids'), an ovary positioned below the sepals and petals, as well as DNA sequence. The clusters of flowers are similar in structure to the umbels that are characteristic of onions, but in some cases the clusters are reduced to a single flower. The large, often conspicuous flowers of this family are pollinated by a variety of animals, such as bees, wasps, butterflies, moths, and birds. Members of the *Amaryllus* group in the Alliaceae are widely distributed in temperate and tropical regions, including the Andean Mountains of South America and the Mediterranean region. The genus *Haemanthus* is restricted to South Africa, the southern parts of Namibia and the mountainous zones of Lesotho and Swaziland. The genus takes its botanical name from the Greek 'haima' meaning blood and 'anthos' meaning flower, which refers to the deep red coloured flowers of some species.

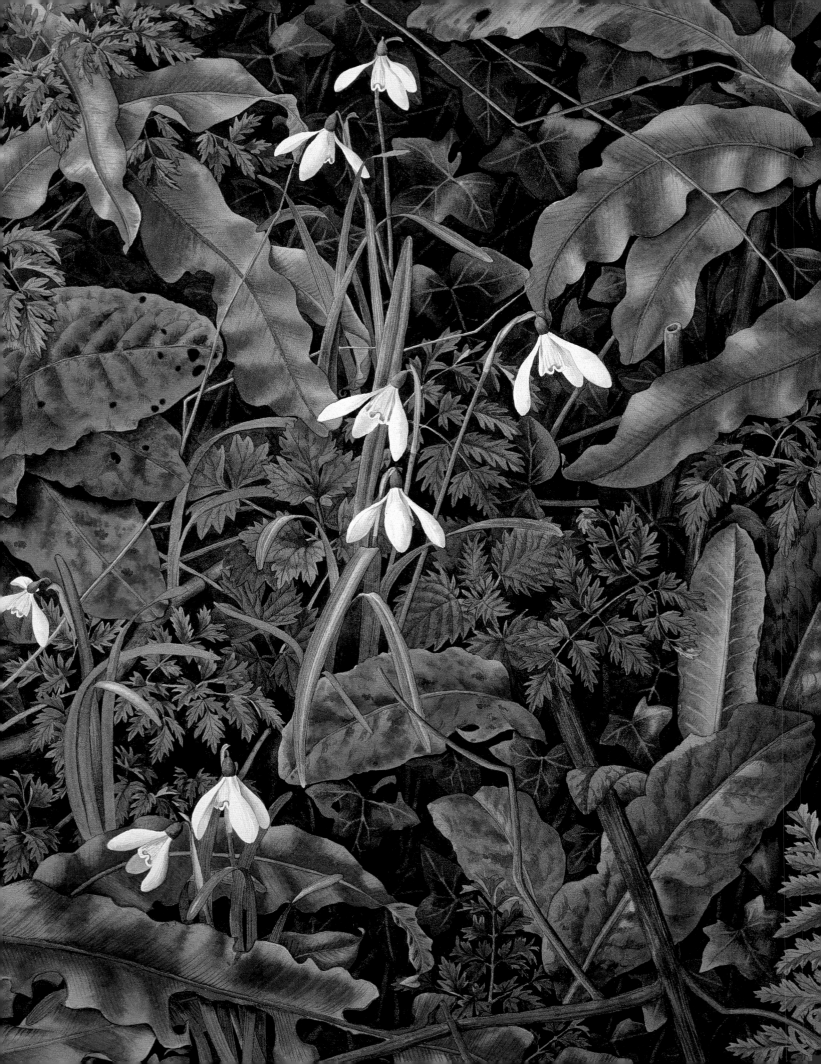

36. **Snowdrops:** *Galanthus nivalis* – Alliaceae

Susan Ogilvy, b. Kent, England 1948

Watercolour on paper, 457 mm x 350 mm
Signed *with monogram 'S' inside O*

Susan Ogilvy has a refreshingly original viewpoint with an unusual sense of design. She has exhibited at the RHS, where she was awarded a gold medal in 1997, and she has had several successful solo exhibitions at Jonathan Cooper's Park Walk Gallery in London, where she has just shown an arresting collection of grass and fern studies interspersed with wild flowers, viewed from above, painted from locations around her home. Inevitably one thinks of Dürer and his 'A Large Piece of Turf'.

Snowdrops are shown emerging from a background of ferns, twigs and grass in the first flush of spring growth. Susan recently painted a series of works from this quadrant showing frosted dandelion leaves as well as densely clustered fern fronds. Several artists have been attempting this kind of study of plants *in situ* from above. This work is so successful that it became one of the greatest favourites in 'Treasures of Botanical Art', a recent exhibition in the Shirley Sherwood Gallery at Kew.

The genus *Galanthus* is native to Europe and Asia with some of the species being the earliest spring-blooming herbs in local habitats, producing their flowers before the snow has completely melted. The flowers are adapted for pollination by bees with the pendent orientation of the flowers protecting the internal sexual organs from damage by adverse weather conditions present in the early spring. This floral construction forces the bee to hang upside-down in order to gather the nectar and pollinate the flower. In addition to the outer whorl of sepals, the shape and position of the inner petal segments form a loose tube around the anthers and style, which provides a secure place for the bee to grasp while it removes nectar with its tongue. Some of the most common plants have evolved flowers with complex structures to ensure successful pollination.

37. *Hyacinthus orientalis* – Asparagaceae

Kate Nessler, b. St Louis, Missouri, USA 1950

Watercolour on paper, 350 mm x 265 mm
Signed *Nessler 1996*

Kate Nessler was involved with the American Society of Botanical Artists from its onset, becoming its President and receiving its most important accolade, the ASBA award of excellence in 1997. She has paintings in the Hunt Institute and the RHS's Lindley Library, and her exhibition 'The Baker Prairie Wild Flower Collection' has travelled in Arkansas in co-operation with the Arkansas Natural Heritage Commission, helping to educate children about their local plants.

This blue hyacinth was painted on paper in 1996 and is a relatively conventional plant portrait, beautifully composed and executed but without the translucency and intensity she later achieved on vellum. She has conveyed the weighty, substantial inflorescence with great skill and the leaves are strong and fleshy.

Until recently the exact evolutionary position of the genus *Hyacinthus* and its relatives within the order Asparagales was unclear. Even DNA data did not initially help in determining the taxonomic position of the hyacinths. However, evidence from floral and chemical traits as well as new DNA analyses suggest that this family be classified in the family Asparagaceae. Hyancinths and their close relatives have a widespread distribution from Europe and Africa to Asia with a few species in the western hemisphere and are most diverse in areas with a Mediterranean-type climate, i.e. a pronounced dry summer and wet, cool winter. The showy, intensely scented flowers are pollinated by a wide range of insects, such bees, wasps, flies, moths, as well as birds. The flowers offer nectar and in some cases an abundance of pollen as a reward to the animals visiting them.

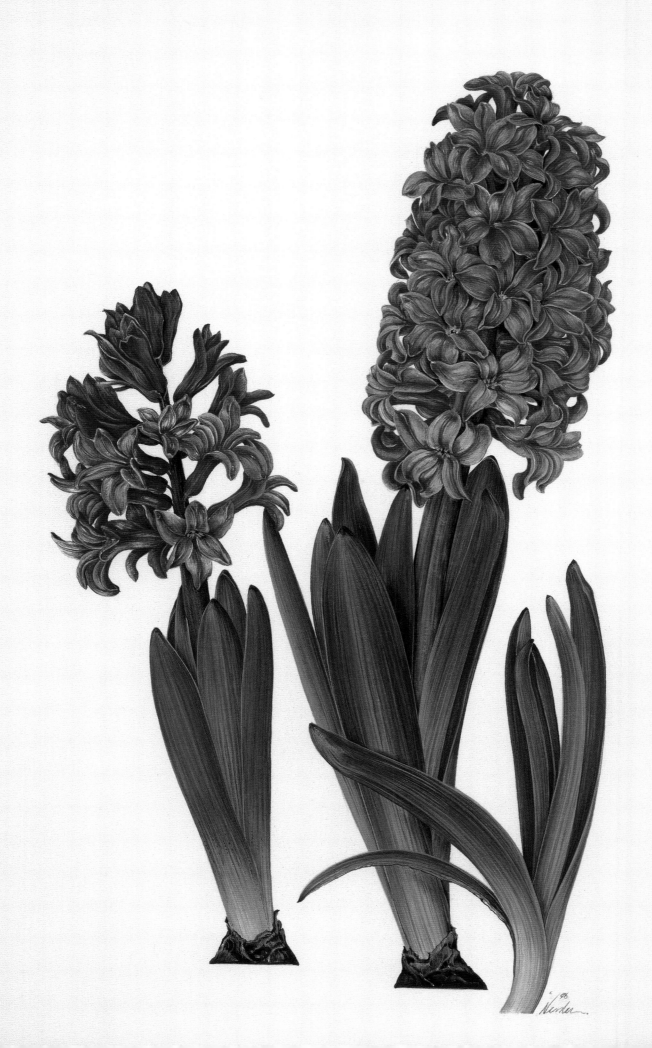

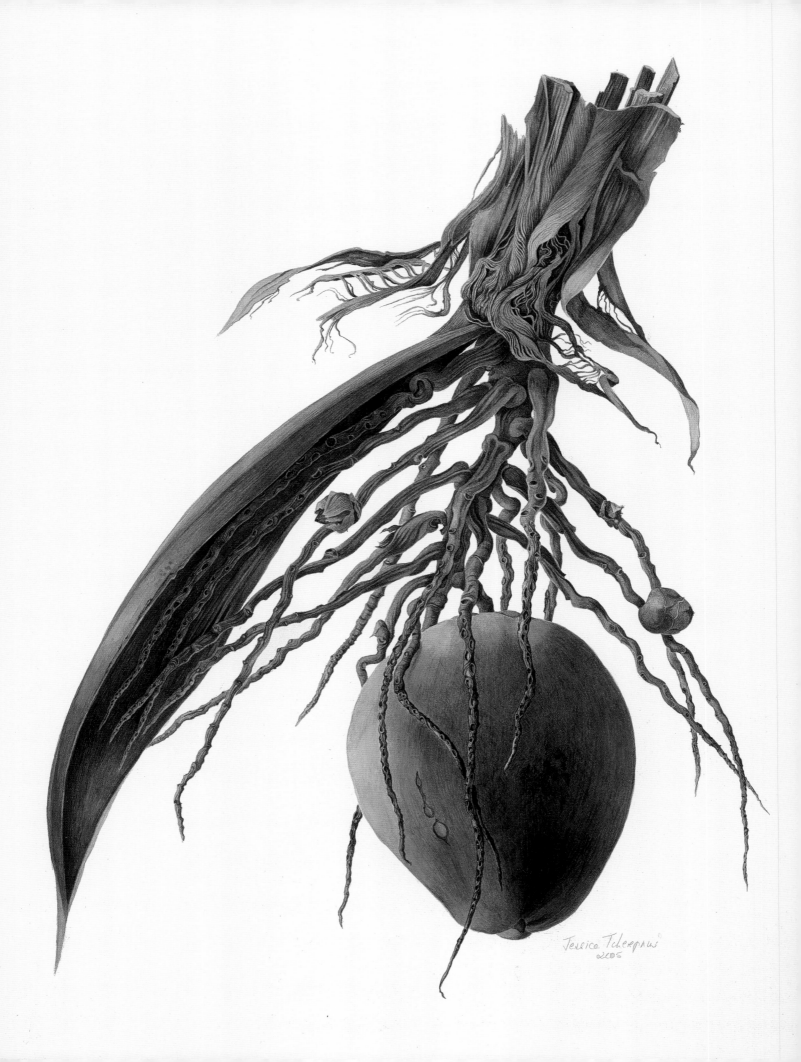

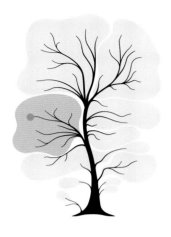

Arecales

This order consists of a single family, the palms, with 2,000 species. Palms are distinctive within the monocots for their 'woody' usually unbranched trunks and were mistakenly allied with the screw pines because of this 'lookalike feature'. They have a unique type of leaf development and unusual pleated leaves. The palms share a number of chemical and cellular traits that indicate they are most closely related to the gingers, day-flowers, bromeliads, and grasses.

38. Coconut: *Cocos nucifera* – Arecaceae

Jessica Tcherepnine, b. London, England 1938, works in USA
Watercolour on paper, 700 mm x 595 mm
Signed *Jessica Tcherepnine*

Jessica Tcherepnine now lives and works in New York although she visits England regularly and shows in London. She studied drawing in Florence where she learned that important facet of botanical art – intense observation.

Her work is held at the Hunt Institute, the Natural History Museum, London the RHS's Lindley Library and the Benois Family Museum, St. Petersburg, Russia, as well as in private hands. She has contributed to the *Highgrove Florilegium* and is a founding member of the Brooklyn Florilegium Society. She is also founding member of the American Society of Botanical Artists and a director of the Horticultural Society of New York.

The RHS has twice awarded her their gold medal. She has had many solo exhibitions regularly from the early 1980s onwards, showing in London, New York, Palm Beach, Florida and Paris. Her most recent exhibition was at Harris Lindsay, London in 2005 where her strong, robust painting of a coconut was acquired for the Shirley Sherwood Collection.

Even before DNA data aided our understanding of evolutionary relationships, the palm family, or Arecaceae, was considered to be a natural, monophyletic group. In the case of palms, DNA sequences have evolved very slowly, which has hampered in part their use in determining the evolutionary history within the palms as well as their relationship to other monocots. Most botanists now think that Arecaceae is most closely related to the families allied to the grasses, gingers, and day flowers. Over 2,775 species and 200 genera make up the palm family. Whereas most species of palms produce flowers and reproduce throughout their lifetime, some species, such as the talipot palms (*Corypha* species) of South-East Asia, grow to be gigantic in size and then have one burst of reproduction, producing millions of flowers and fruits before they die. Most palms are distributed in the tropics. One of the most ubiquitous species is the coconut, *Cocos nucifera*, which is found on the coasts of tropical lands around the world. Whether or not coconuts dispersed naturally or were carried by migrating human populations, such as the Polynesians, is still an unanswered question.

Commelinales

The five families in this order were never associated with each other until DNA data revealed this curious relationship. Very few other traits, except for several chemical characteristics, link them together. The Commelinales consist of less than 800 species, but are found in both the warm temperate and tropical regions of the world. The water hyacinths, day flowers, and kangaroo paws account for most of the species. This order is most closely related to the gingers, banana, and cannas.

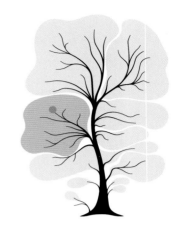

39. **Blue ginger:** *Dichorisandra thyrsiflora* – Commelinaceae

Beverly Allen, b. Australia, 1945
Watercolour on paper, 670 mm x 500 mm
Signed *Beverly Allen 2002*

Beverly Allen started her career as a botanical artist in 1998, having graduated from Sydney University in 1995. Before that she was a freelance graphic designer and illustrator. She is now an important botanical artist in Sydney and has been organising the Royal Botanic Gardens Florilegium Society there.

She exhibits in Botanica, an excellent annual show of Australian artists. She has shown at the Lion Gate Lodge in the Royal Botanic Gardens, Sydney since 1999, where this blue ginger grows luxuriantly in the gardens.

The Commelinaceae is a relatively small family of monocots with about 40 genera and under 700 species, which are found in both tropical and temperate environments. Both floral traits and molecular data support the evolutionary monophyly of this family. The flowers of Commelinaceae members are specialised for bee pollination with modification of the petals and especially the stamens. In some species, the stamens no longer produce viable pollen, but have been adapted to serve as attractants as well as rewards for the visiting bees. In *Dichorisandra thyrsiflora* bees in the genus *Bombus* are able to vibrate the stamens as a means to force the pollen out through the pores in the tips of the anthers. The bees collect the pollen and also pollinate the flowers at the same time. The generic name *Dichorisandra* comes from the Greek words 'dis' (twice), 'chÿri' (separate), and 'andros' (male) in reference to the two lateral stamens that are positioned separately from the group of four central stamens.

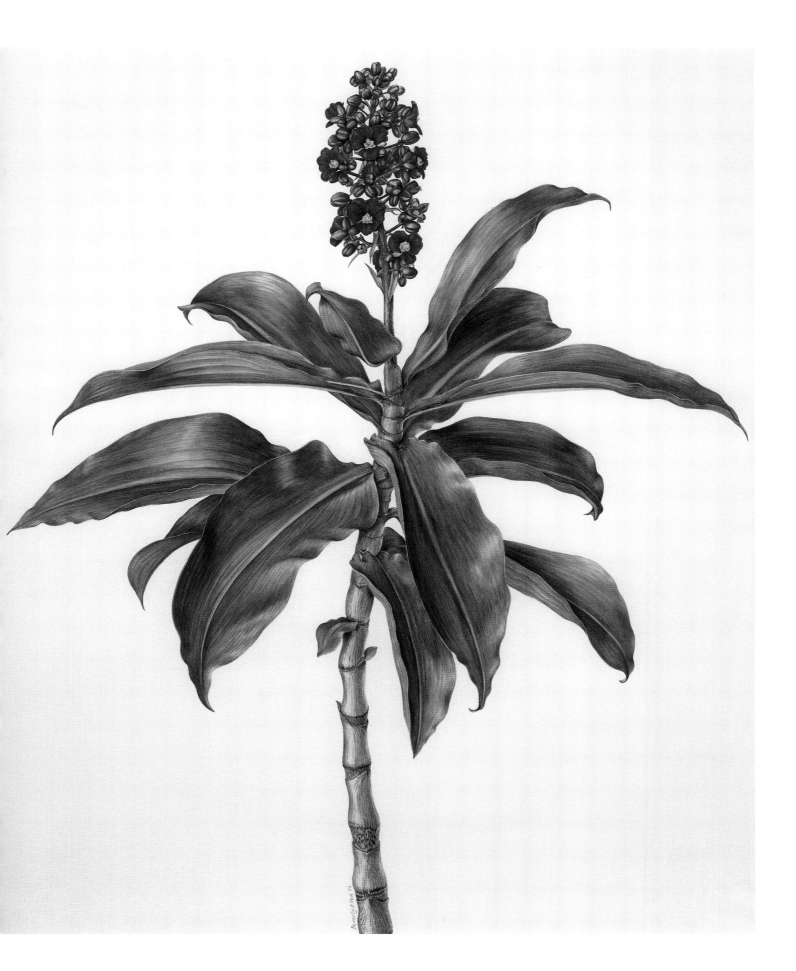

40. **Kangaroo paw:** *Anigozanthus manglesii* – Haemodoraceae

Christina Hart-Davies, b. Shrewsbury, England 1947

Watercolour on paper, 375 mm x 280 mm
Signed *Christine Hart-Davies*

Christina Hart-Davies read fine art and typography at Reading University and then worked for several years on the design and production of educational books. Since settling in Dorset she has become well-known for her precise botanical watercolours.

She has illustrated many books and contributed work to publications such as *Kew Magazine* and the *RHS New Dictionary of Gardening*. Since 2003 she has been working exclusively on paintings for *The Collins Flower Guide*, a major flora of Britain and Northern Europe, due for publication in 2009.

She has three times been awarded the gold medal of the RHS in London for paintings of mosses and lichens. She also holds an RHS gold medal and a World Orchid Conference Bronze for her paintings of Australian and European native orchids.

Her kangaroo paw is particularly notable for its striking design and she is a master of fine detail.

The family Haemodoraceae has a rather broad but uncharacteristic geographic distribution that extends from temperate to tropical Australia, northern South America, Africa, the Atlantic coast of North America, and New Guinea. Similar to all of the families in the order Commelinales, the Haemodoraceae is small with only 13 genera and less than 100 species. All of the members of the Haemodoraceae are considered to be evolutionarily related because of the common presence of specific chemical compounds called arylphenalenones, which are found in no other flowering plants. These pigments produce the orange-red to purple colouration characteristic of the roots and rhizomes of many species in the family. The genus *Anigozanthus* is native to western Australia. The generic name comes from 'anisos' meaning 'unequal' and 'anthos' meaning 'flower,' which refers to the different-sized lobes on the petals.

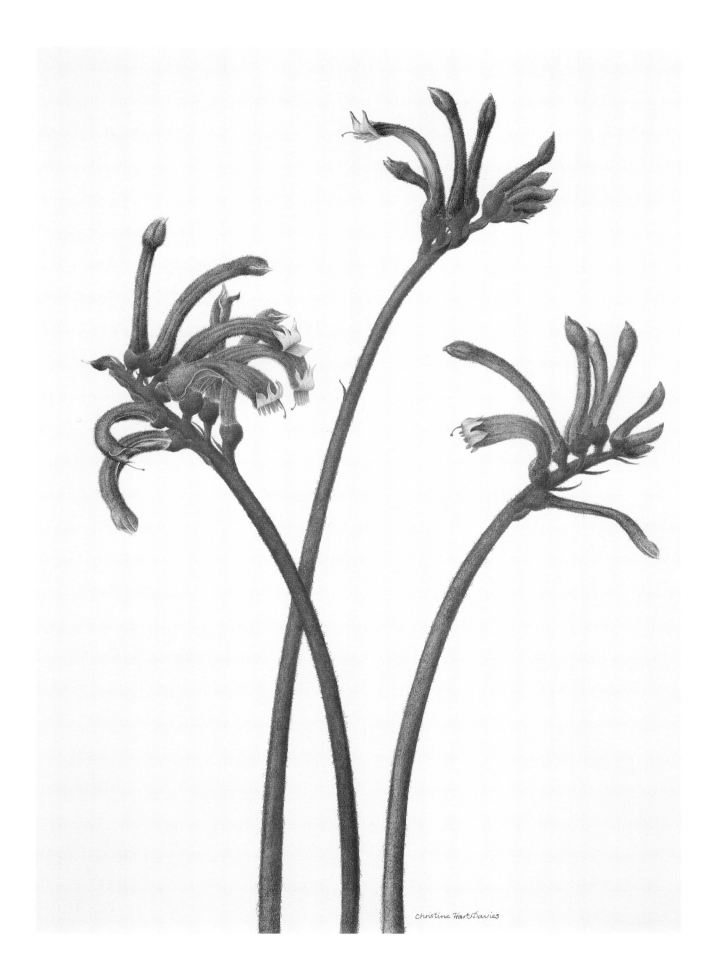

Christine Hart-Davies

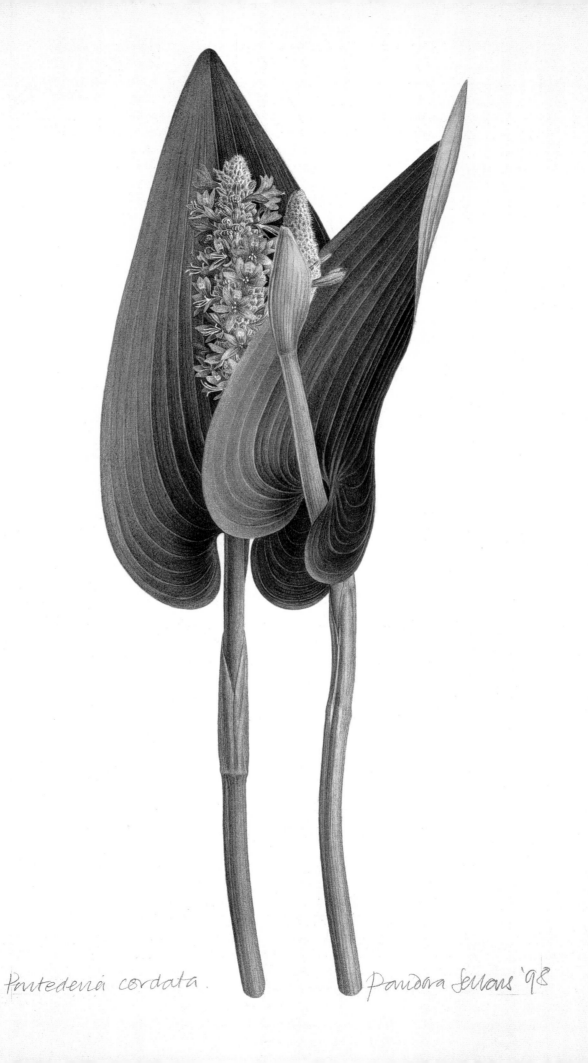

Pontederia cordata. Pandora Sellars '98

41. *Pontederia cordata* – Pontederiaceae

Pandora Sellars, b. Herefordshire, England 1936

Watercolour on paper, 340 mm x 205 mm
Signed *Pandora Sellars '98*

This elegant study of pickerel weed is immediately recognisable as the work of Pandora Sellars. A bud and flower nestle against ribbed spear-shaped leaves. It was chosen for an arresting, stylish poster used in an exhibition in Denver, Colorado in 2002.

It grows vigorously, indeed invasively, in gently running water, its tall blue inflorescences standing well clear of the stream. It will over-winter well in Southern England as well as the southern hemisphere where it is a popular water plant.

All members of the family Pontederiaceae are freshwater aquatic or marsh plants. There are only 35 species contained in seven genera in this family, which are widespread in tropical and subtropical regions although a few grow in the temperate zones. Species in the Pontederiaceae are the only monocotyledons that produce tristylous flowers. This very unique type of floral system, which is only found in two other families of flowering plants (Oxalidaceae and Lythraceae), is characterised by three types of flowers that are all found in a single population of the plants. The three flower types have either short styles with medium or long stamens, medium styles with short or long stamens, or long styles with medium or short stamens. The different forms of flowers ensure that pollen is transferred between different floral types on different plants and that inbreeding is reduced accordingly. It is thought that this unique floral system probably evolved just once within the Pontederiaceae and then was evolutionarily lost several times in those species which do not have it. The genus *Ponterderia* was named in honour of the eighteenth century Italian botanist Giulio Pontedera, who was a physician and director of the botanical garden at Padua.

Zingiberales

Zingiberales are distinguished from their closest relatives, the day flowers and water hyacinths, by several conspicuous characters such as the large broad banana-like leaves attached by long stalks with unique cross-venation in the blade, and the bold, colourful inflorescences with leaf-like bracts containing the flowers. Many cellular features also characterise the Zingiberales. Some of the more evolutionarily advanced species in the order have extremely complex flowers in which the petals and sepals are greatly reduced and instead the anthers become petal-like. Botanists have always thought that the eight families in the order were related, which has been further supported by DNA sequence data. Most of these plants are native to the tropical regions of the earth and many are cultivated as ornamentals.

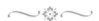

42. **Strelitzia augusta:** *Strelitzia nicolai* – Strelitziaceae

Patricia Villela, b. Rio de Janeiro, Brazil 1952

Watercolour on paper, 560 mm x 760 mm
Signed *P A Villela*

Initially trained at the School of Visual Arts, Rio in the 1970s Patricia Villela re-started her career in the early 1990s by attending the Rio de Janeiro Botanical Institute. Later she was taught by Malena Barretto, Christabel King, Etienne Demonte and Jenevora Searight. She also attended a workshop by Katie Lee in Tuscon, Arizona.

She has been awarded a number of prizes including first place in the Margaret Mee Foundation's Annual Contest in 1996, the Brazilian Bromeliad Society in 1997 and the Mexican Biological Institute in 1998. She has shown at the Hunt Institute, at several bromeliad exhibitions in Mexico and extensively in Rio.

Patricia's work is strong yet subtle. She has a good sense of design and obviously enjoys painting the exotic plants of Brazil. Some of her works have been acquired for the Shirley Sherwood Collection and others to hang in the Copacabana Palace Hotel, Rio. These include bromeliads, strelitzias and heliconias.

Her *Strelitzia augusta*, with its beautiful blue 'carapace' is a striking example of a spectacular species and compared interestingly with the iconic series of *Strelitzia* painted by Franz Bauer (1758–1840), in the opening exhibition of the new Shirley Sherwood Gallery in 2008.

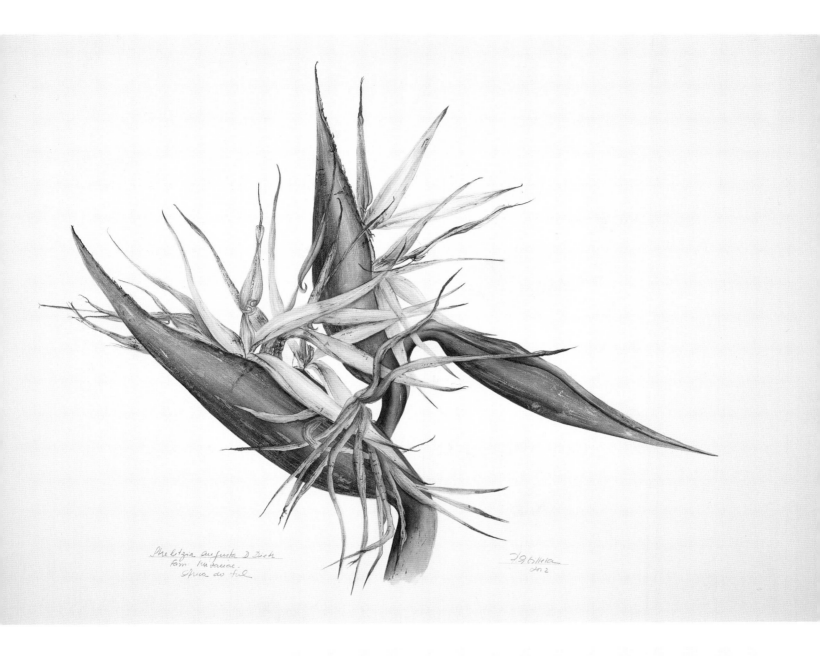

Strelitzia augusta D.Dietr
Fam. Musaceae.
Africa do Sul

Strelitzia is one of three genera in the family Strelitziaceae. The two other genera are *Ravenala* (one species), native to the tropical forests of Madagascar, and *Phenakospermum* (one species) only found in the Amazon region of South America. The broad geographic distribution of these three members of the Strelitziaceae, namely Madagascar, southern Africa, and the Amazon, suggested that these plants may have evolved over 80 million years ago during the Cretaceous period when the continents were close together and plants were easily exchanged between them. However, recent investigations have shown that the three genera more likely were separated about 25 million years ago when the continents were thousands of miles apart. Perhaps seeds of the African members of the Strelitziaceae were carried across the oceans to establish new colonies in South America where the plants evolved into a new species over the millions of years that they were isolated from each other. *Strelitzia* contains five species and is native to South Africa. It was named to honour Charlotte Sophia of the family Mecklinburgh-Strelitz, who was the wife of King George III and a patron of botany.

43. Heliconia bougainville: *Heliconia solomonensis* – Heliconiaceae

Paul Jones, b. Sydney, Australia, 1921–97

Acrylic on paper, 740 mm x 510 mm
Signed *Paul Jones Heliconia bougainville 1997*

There are many paintings of heliconias in the Shirley Sherwood Collection, mainly from Brazilian artists. However, this elegant, pendulous flower stem was unhesitatingly chosen to represent the Heliconiaceae. Paul Jones was not sure of its correct name and just wrote 'Heliconia from Borneo' on it. It was later identified by John Kress (who had in fact named it). It is a beautiful work, with its subtle greens, yellows and oranges, suspended in space, painted in acrylic on paper.

Sometimes he painted on paper of graduated colour, using acrylic on top of the tinted background, as seen in painting number 16, but for other works he used watercolour or acrylic on an uncoloured paper as he has done here.

Heliconias are native primarily to the American tropics, including the Caribbean and nearly 200 species are known. The name *Heliconia* is derived from Helicon, a mountain in southern Greece regarded by the ancient Greeks to be the home of the Muses. This botanical name was used by Linnaeus to suggest the close resemblance between the heliconias and the bananas (genus *Musa*). From DNA data and other evidence, it has been shown that these plants are indeed evolutionarily closely related. For decades ecologists have studied heliconias as a model system for understanding the evolution of pollination systems. In the neotropics, hummingbirds with keen eyesight are the exclusive pollinators of heliconias and are attracted by the bright red, orange, and yellow colours of the bracts and flowers. Several species of heliconias are separated from the American species by thousands of miles and are found in the Asian tropics from Samoa westward to New Guinea and Indonesia. The Asian species of *Heliconia*, including *Heliconia solomonensis*, have evolved green flowers and are pollinated by night foraging nectar-feeding bats. These green species do not require brightly coloured flowers because their bat visitors are colour-blind and do not use colour to locate the plants.

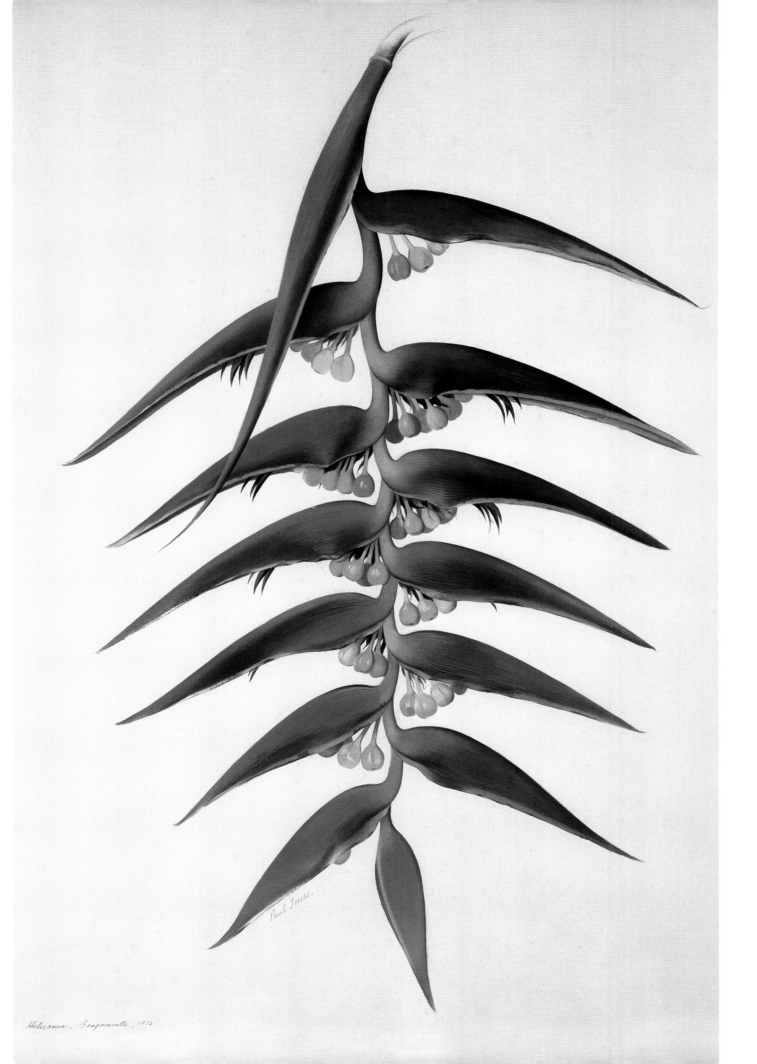

Heliconia, Bougainville, 1972

Paul Jones,

Musa paradisica sapientum.

9/150 Banana Palm – Flower & Fruit. Bryan Poole

44. Banana flower and fruit: *Musa* x *sapientum* – Musaceae

Bryan Poole, b. Invercargill, New Zealand, 1953

Copperplate etching, 530 x 400
Signed *Bryan Poole 9/160*

Bryan Poole studied Politics and Economics in New Zealand at the University of Otago but changed direction later and concentrated on botanical illustration. He moved to England and studied with Dr Christopher Grey-Wilson at the Royal Botanic Gardens, Kew for six years from 1980. He works in London with aquatint etching, woodblock relief printing, egg tempera, watercolour, gouache and pen and ink.

Bryan has re-developed the copper plate technique of Redouté using that artists' *à la poupée* method in touching up the colouring of the etchings. His 'Banana' is a spectacular work with a dramatic stem of fruit balanced with a fainter illustration of a series of maturing bananas curving upward. He saw this specimen in Greece and was fascinated by its strength and vigour which is certainly obvious in the finished work.

The genus *Musa* was first named by Linnaeus in 1753 in his seminal work *Species Plantarum*. The name commemorates Antonius Musa, physician to the first Roman emperor Octavius Augustus. The plant Linnaeus described was the edible banana and he called it *Musa paradisiaca*. Bananas are native to tropical Asia and the islands of the South Pacific, but are cultivated extensively in tropical and subtropical zones around the world. They are the fourth most important tropical crop, but the diversity and taxonomy of these plants are not well known. Most botanists recognise approximately 30 species of wild bananas. The edible bananas, which produce large fruits but no viable seeds, are not species but hybrids of wild species produced by humans. The tiny black spots one sees in the white pulp of the banana fruit are the aborted seeds of the hybrid. Members of the banana family first evolved nearly 80 million years ago, but it is only during the last 8,000 years that these hybrids have been selected by humans as a source of food.

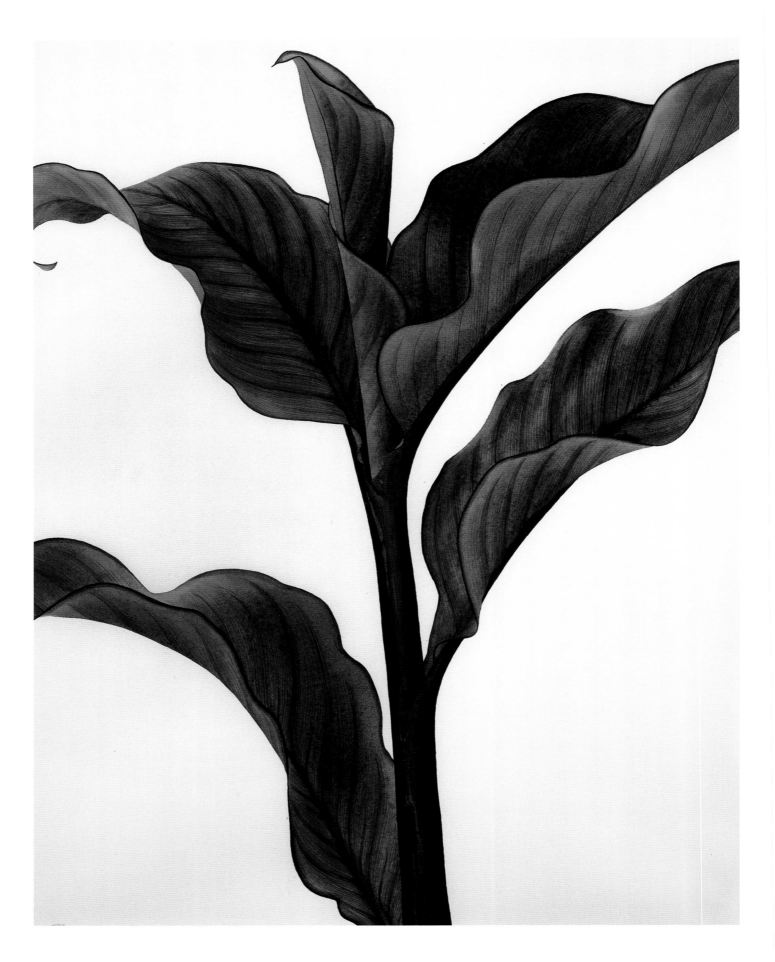

45. **Canna leaves:** *Canna indica* — Cannaceae

Susan Ogilvy, b. Kent, England 1948

Watercolour on paper, 540 mm x 390 mm
Signed *with monogram 'S' inside O*

Susan Ogilvy's portrait of canna concentrates on the strong, dramatic leaves with their prominent red-black veining. This must have been an impulsive painting where the artist was entranced by the velvety texture and drama of the leaves. There were probably no flowers available to do a more complete botanical portrait.

In cultivation cannas are lush-leaved vigorous plants that can dominate flower beds, particularly seen in South Africa. There are some lovely new varieties with glorious colours of yellow, red and cream flushed with the faintest pink. Standing 6 feet high they need to be placed at the back of a border but can also look spectacular in large pots marking a doorway.

The genus *Canna* is native to the New World tropics and subtropics with native species occurring from sea level to slopes of the Andean Mountains of Bolivia. The evolutionarily most closely related group of plants to the cannas is the prayer plant family, the Marantaceae. The common ancestor of these two groups evolved flowers in which five of the six stamens lost the ability to produce pollen and were transformed into petal-like structures. Only one-half of one stamen produces pollen in the flowers of *Canna*. Therefore one of the most peculiar aspects of the evolution of the flowers of *Canna* is that the most conspicuous and colourful parts are not petals, but rather the stamens, which have been modified through time to take over the function of the petals. Some species have pale yellow flowers and are pollinated by hawk moths, whereas others with brightly-coloured red or orange flowers are pollinated by hummingbirds, and one which grows in the mountains of Bolivia has evolved very specialised pale white flowers that are open at night and visited by bats. The name *Canna*, from the Greek 'kanna' meaning a reed, refers to the reed-like appearance of the stems.

46. **Prayer plant:** *Maranta leuconeura* — Marantaceae

Dianne McElwain, b. Canton, Ohio, USA 1949

Watercolour on paper, 760 mm x 570 mm
Signed *Dianne McElwain* © 2002

Educated in art and design (1967–68), Diane McElwain embarked on a career as an artist with a greetings card company, swiftly becoming its art director. In 1975 she became a freelance illustrator and then was inspired to become a botanical artist when she bought the book *Contemporary Botanical Artists* (1996).

As a member of the ASBA she exhibited widely from 2002 onwards, receiving the Talas Award of Merit and the Diane Bouchier Founders' Award, both in 2002, and the Ursus award in 2003. Since then her work, always well designed and of a consistently high standard, has been shown at a number of exhibitions.

This painting of *Maranta leuconeura*, commonly known as the prayer plant, was hung in the 11th exhibition at the Hunt Institute. It is a beautiful design and the wonderfully velvety leaves with their elaborate patterning are superbly executed.

Prayer plants and their relatives in the family Marantaceae are found throughout the tropics of the world, with three-quarters of the species found in the neotropics. Most are small herbs occurring in the understorey of rainforests, but some species in Africa are sprawling vines that form impenetrable thickets. This family is the second largest in the Zingiberales with 31 genera and 500 species. A special feature of prayer plants is the swollen 'pulvinus,' a fleshy swelling between the leaf blade and petiole. The pulvinus causes the leaf blade to turn straight-up during the night, giving the impression that the plants are praying, and is an adaptation to prevent water loss in stressful environments. The small flowers, which are produced in mirror-image pairs, each contain three highly modified stamens which when contacted by an insect cause an explosive release of pollen as the flower actively and momentarily traps the pollinator. This adaptive mechanism ensures that the insect visitor transports pollen from one flower to the next. The name of the family commemorates Bartolomeo Maranta, an 18th century Italian botanist.

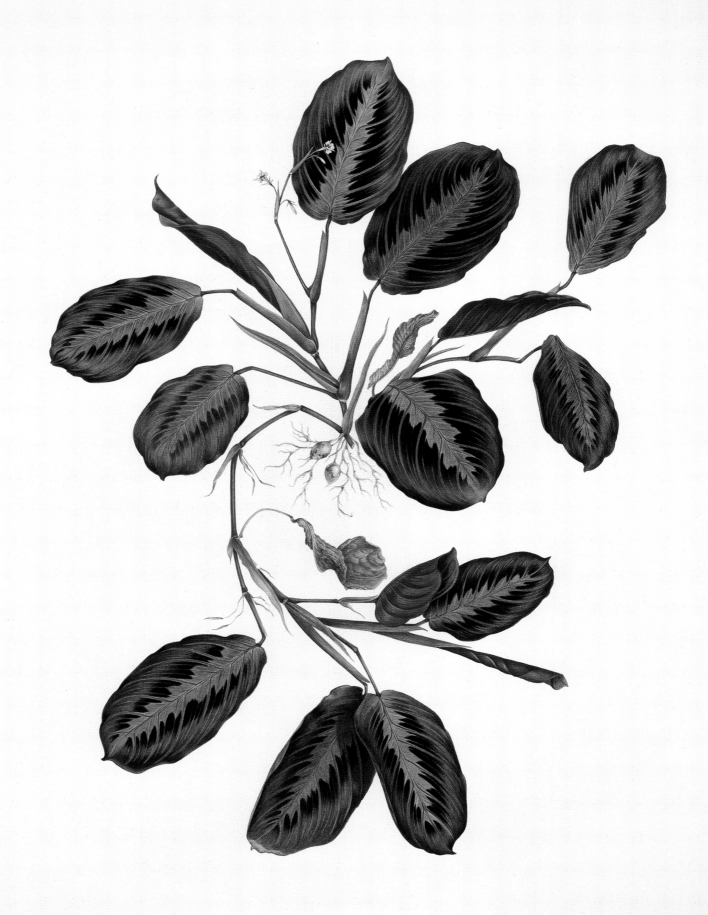

PRAYER PLANT *MARANTA leuconeura* Dianne McElwain #3 ©2002

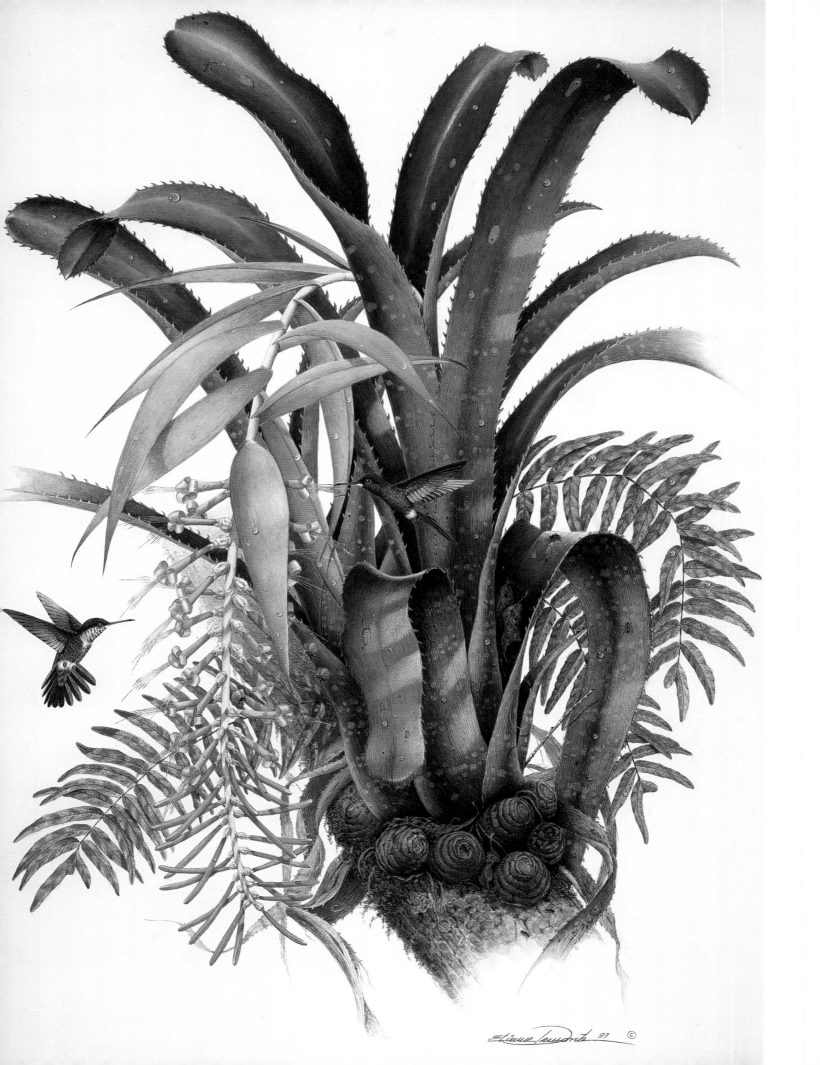

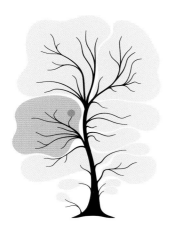

Poales

The Poales are one of the largest orders of monocots with 17 families and nearly 20,000 species. They are found everywhere on earth and all share the character of having silica in their leaves' top layer of cells and branched styles in the flowers. Although some botanists have objected to including so many families in this order, especially the bromeliads and cattails, DNA sequence data provide strong support for incorporating all of them together into a large Poales order. In addition to the grasses, cattails, and bromeliads, the sedges, rushes, pipeworts, yellow-eyed grasses, and restios are also in this group of advanced and specialised monocots.

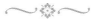

47. *Billbergia sanderiana* and *Hylocharis cyanus* – Bromeliaceae

Etienne Demonte, b. Niteroi, Brazil, 1931–2004

Gouache and watercolour on paper, 700 mm x 480 mm
Signed *Etienne Demonte 97*

Etienne Demonte achieved a great deal for botanical art in Brazil in his lifetime, as well as being a famous painter of birds. He lived in Petropolis, a city above Rio in the cooler Atlantic rainforest, as part of a large family of wildlife painters who were passionate about saving the unique environments of Brazil and triggering conservation through their artistic output and records. He was an influential teacher who inspired many younger Brazilian artists.

From the 1960s onwards he had over two dozen shows in Brazil and he exhibited internationally in Greece, the UK, in Madrid and many other Spanish cities, and in the USA at the Smithsonian Institution in Washington and the Hunt Institute in Pennsylvania. He featured with his sisters in a National Geographic film for an 'Explorer' programme, showing his research and painting in the Bahia region, in the bay of the San Francisco River.

His painting of *Bilbergia sanderiana* & *Hylocharis cyanus* shows all his skill in its composition, and its meticulous and yet romantic evocation of the rainforest.

The Bromeliaceae family is undoubtedly a natural evolutionary group in which all of its members are descendents of a unique common ancestor. They are different from other monocots in the possession of silica bodies in the outermost cells of the leaves as well as special water-absorbing hairs, called peltate scales. Most bromeliads are epiphytic herbs, although some of the largest in size are rooted in the soil. In the past, the Bromeliaceae was thought to be evolutionarily related to pandans (Pandanaceae), pickerel weeds (Pontederiaceae), and even bananas (Zingiberales), but modern DNA data indicate that the family is closely related to a number of other families, including the cattails, sedges, rushes, and grasses. The family contains 51 genera and about 1,500 species, all of which, but one, are native to tropical America. The single non-American species, *Pitcairnia feliciana*, is native to Africa and this curious distribution continues to intrigue botanists today. The genus *Billbergia*, which was named in honour of the Swedish botanist Gustaf Johan Billberg (1772–1844), has 54 species many of which are pollinated by hummingbirds.

48. Bromeliad: *Bromelia antiacantha* – Bromeliaceae

Alvaro Evando Xavier Nunes, b. Anápolis, Goiás, Brazil 1945

Watercolour on paper, 655 mm x 500 mm
Signed *Alvaro Nunes 2006*

Alvaro Nunes participated in botanical drawing workshops in the Federal Universities of Brasilia, Juiz de Fora, Minas Gerais, Goiás and at the 'Swamp-land campus' of the University of Mato Grosso do Sul. His drawings have been published in a number of books including *Fruiteras da Amazonia (Fruit Trees from the Amazon), Peixes do Pantanal (Fishes of the Brazilian Swampland)* and a series of books *Plantar* and *Frutex* all published by Embrapa, the Brazilian Institute for Rural Research.

He has had six one-person exhibitions during the last ten years and has shown in several group shows including the 9th International Exhibition at the Hunt Institute in 1998.

The bromeliad *Bromelia antiacantha* was painted using two plants, one grown in the shade having green leaves, the other grown in the sunshine with magenta and greenish-blue leaf colouration. The work shows a spirited departure from his usual rather sombre style with a spectacular design of criss-crossing leaves looked at from above, in which the flower spikes nestle.

Bromelia is another genus in the family Bromeliaceae with species that are pollinated by hummingbirds. About 48 species of these terrestrial herbs have been named by botanists. *Bromelia antiacantha* flowers from December to February in its native habitats in southern Brazil and Uruguay. During this period the central leaves and bracts subtending the flowers become bright red in colour as a signal to hummingbirds that the flowers are about to open. Several dozen flowers open on each plant per day and offer the three main hummingbird visitors a rich supply of nectar as a reward for pollinating the flowers. Bees also visit the flowers, but not as frequently as birds. Many species of bromeliads and other plants may attract several different types of pollinators even though they have evolved primarily for visitation by only one of them. The genus and family were named after the Swedish botanist Olof Bromel, a physician from Göteborg who lived in the seventeenth century.

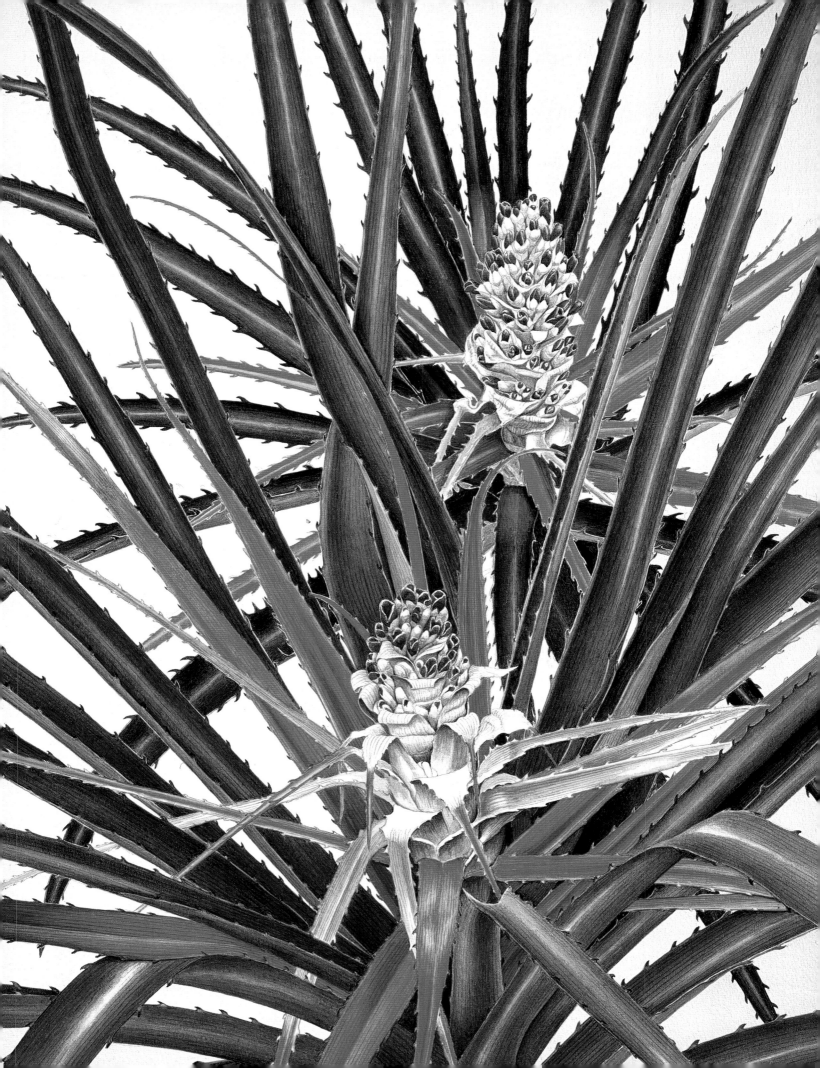

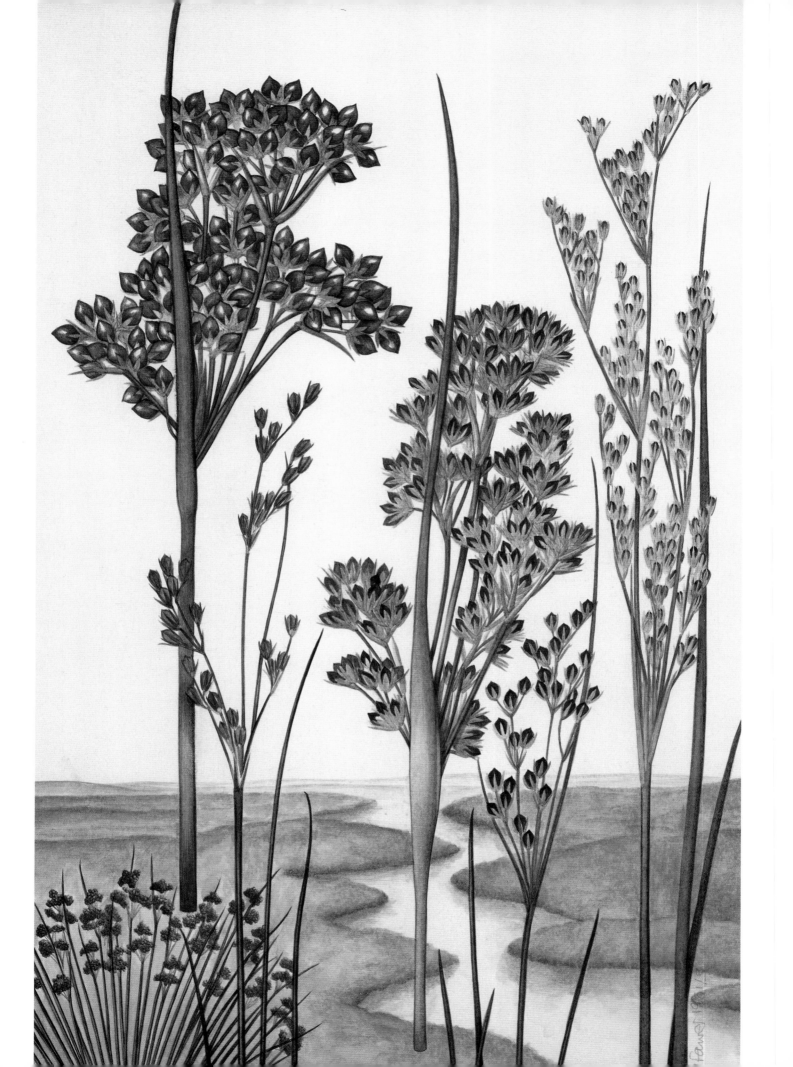

49. *Juncus maritimus* – Juncaceae

Ann Farrer, b. Melbourne, Australia 1950, works in England

Watercolour on paper, 240 mm x 155 mm
Signed *Ann Farrer 1981/3*

Ann Farrer has been awarded six gold medals by the RHS and was the first recipient of the Jill Smythies award by the Linnean Society in London in 1988. She has illustrated many books, including *Grasses of Bolivia*, and now teaches two courses in botanical illustration at Kew each year. She has painted innumerable plates for *The Kew Magazine* (now once more called *Curtis's Botanical Magazine*), *The Plantsman*, and the *The New Plantsman*. Her paintings have been exhibited in the Kew Gardens Gallery, at Lancaster University in the Peter Scott Gallery, at Hortus and at the Hunt Institute's International Exhibition. She is an active member of RHS Picture Committee.

This reed is a painting for the *Collins Guide to the Grasses, Sedges, Rushes and Ferns of Britain and Northern Europe*. It shows marsh and stream flowing away as a background in a rather unusual study for Ann Farrer.

The rushes, reeds, and sedges are grouped together in the order Cyperales. The rushes in the family Juncaceae include six genera and about 400 species. Many features of this family are rather general traits found in many monocots, which make it difficult for botanists to trace its evolutionary history. Members of the Juncaceae mainly occupy cold temperate zones and mountainous regions in damp habitats and some form tiny cushion-like mats adapted to the daily cycles of freezing and thawing in the Andean Mountains of South America. Rushes may superficially look like grasses, but the 3-angled leaves, flowers with petals, and capsular fruits that split apart at maturity are distinctive traits. Unlike their insect- and bird-pollinated distant cousins the bromeliads, the inconspicuous flowers of plants in this family are predominantly pollinated by wind, which propels the pollen from one plant to the next. *Juncus maritimus* is a robust and tough, spreading herb with rigid and erect stems that is distributed along the coasts in the tropics.

50. *Phyllostachys viridis* – Poaceae

Ann Schweizer, b. Cape Town, South Africa 1930

Watercolour on paper, 660 mm x 428 mm
Signed *Ann Schweizer*

Ann Schweizer has a wide range of academic interests. Her first degree was in art and languages from Rhodes University, Grahamstown and she studied fine art practical studies under Maurice van Essche. Later she took another degree at the University of Cape Town in archaeology, followed by further courses in botany and geography. She became a scene painter at the Hofmeyr Theatre, Cape Town for a year and then was resident artist at the South African Museum. From 1963 to the present she has been freelance doing botanical and plant painting; archaeological and ethnological drawing; book illustration and posters; designs for silk-screen printing and – perhaps most unusual of all – drawing a cartoon strip entitled *Travels of William Burchell* for the Botanical Society of South Africa.

Ann has exhibited at the Everard Read Gallery, Johannesburg and recently she has shown mostly botanical subjects in several galleries near Cape Town.

This powerful study of a colourful bamboo led to Ann being commissioned to paint a series of bamboo for a small conference room at the Westcliff Hotel, Johannesburg. She has numerous bamboos growing in her Cape Town garden and enjoys painting them. Her style is easy yet controlled, her use of paint is assured and she is very observant of her subject.

Grasses make up the second largest family of monocots after the orchids. They are easily recognised by their unique single-seeded fruit called a caryopsis, which is responsible for the grains and cereals that provide sustenance to almost every human culture in the world. Botanists all agree that the grass family, or Poaceae, is a well-defined monophyletic group of plants that has evolved unique leaf, flower, fruit, and DNA traits. Classifying the grasses has been greatly aided by insights from the analyses of DNA sequence data. Twelve subgroups have been recognised within the family Poaceae. One of these subgroups includes the bamboos, which are both woody and herbaceous plants, and are almost exclusively found in the tropics. The woody bamboos form an evolutionary group that is separate from the herbaceous species. The flowering cycle of many woody bamboos is unusual in that it can occur across long time spans of up to 120 years. Some unknown biological cue directs every stem of a given population to flower all at once throughout the range of the species, which could cover hundreds of square miles. The plants all flower over the course of a few months, produce a tremendous number of seeds, and then die.

Early Diverging Eudicots

Early Diverging Eudicots

Similar to the basal angiosperms, the early diverging eudicots are composed of several diverse lineages that do not form a monophyletic group. These lineages include the poppies, buttercups, proteas, plane trees, and lotuses. The number of species contained in each of these plant groups is generally quite small with rarely more than 1,000 species per family.

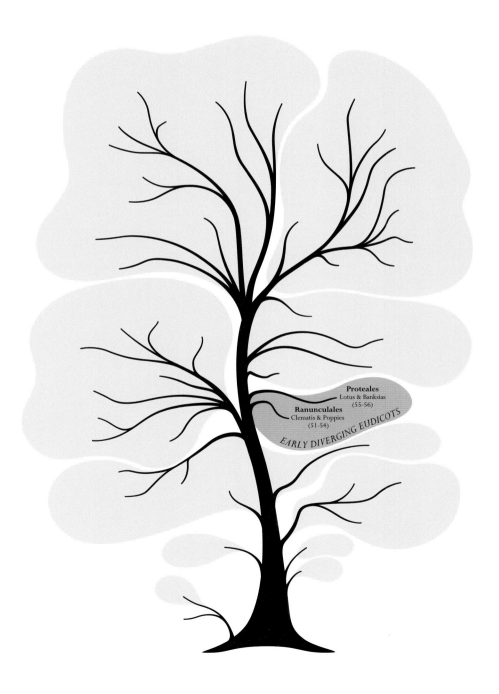

Proteales
Lotus & Banksias
(55-56)

Ranunculales
Clematis & Poppies
(51-54)

EARLY DIVERGING EUDICOTS

Ranunculales

This group of flowering plants includes seven families, which are considered by most botanists to be closely related to each other by evolution. The poppies, buttercups, moonseeds, and barbaries all have specific chemical compounds such as morphines, anatomical features such as surface waxes and nutrient-conducting elements, and seed characters such as abundant endosperm. With nearly 3,500 species these primarily herbaceous plants comprise an important part of our early spring garden flora. The evolutionary relationships among its seven plant families are relatively well-known.

51. **Oriental poppy:** *Papaver orientale* – Papaveraceae
Brigid Edwards, b. London, England 1940
Watercolour over pencil on vellum, 530 mm x 405 mm

52. **Poppy seed head 1999:** *Papaver somniferum* – Papaveraceae
Watercolour over pencil on paper, 381 mm x 305 mm

In the catalogue of her 1997 show at the Thomas Gibson Gallery, Ian Burton wrote: 'The fine painting of the detail on the vellum is uncanny, but when these single objects are arranged and suspended in a contemplative space, they achieve their greatest power, and as a result of this creative act of attention, they have an almost religious intensity… there is a gloriously 'abandoned' Oriental Poppy with papery purple and white petals and hundreds of lovingly counted stamens gathered around a central mandala'.

The startling impact of the poppy flower is balanced by the extraordinary enlarged poppy seed head. They were painted several years apart and Brigid Edwards first saw them hung together in an exhibition at the Ashmolean Museum, Oxford in 2005. These works on vellum are so potent and strong they are unforgettable.

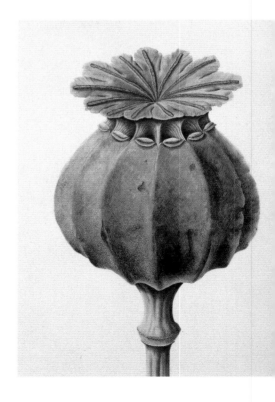

DNA sequence data and floral traits indicate that the poppy family, which includes 40 genera and nearly 775 species, is a natural evolutionary group with all of its members descended from a single common ancestor. Species are native throughout northern temperate regions but a few are found in Central and South America. The large flowers and colourful petals of poppies found in the temperate zone are a sharp contrast to the small clusters of flowers without any petals that have evolved in the genus *Bocconia*, native to the mountains of tropical America. The name *Papaver* comes from the Latin 'pappa', meaning food or milk and referring to the milky latex present in the stems and fruits.

The Papaveraceae have evolved different mechanisms to attract and reward their insect pollinators. Poppy flowers have brightly-coloured petals arranged as an open cup; these attract bees and flies which collect pollen from the exposed stamens. No nectar is produced by these flowers. Other plants in some of the more specialised genera have evolved special modifications of the petals, which are shaped like spurs and produce nectar that is gathered by pollinating bees. Others, such as the genus *Bocconia*, have evolved very inconspicuous flowers lacking petals. These plants rely on the wind to transfer pollen between flowers, facilitated by exposed stamens that hang down and shake their pollen into the breeze.

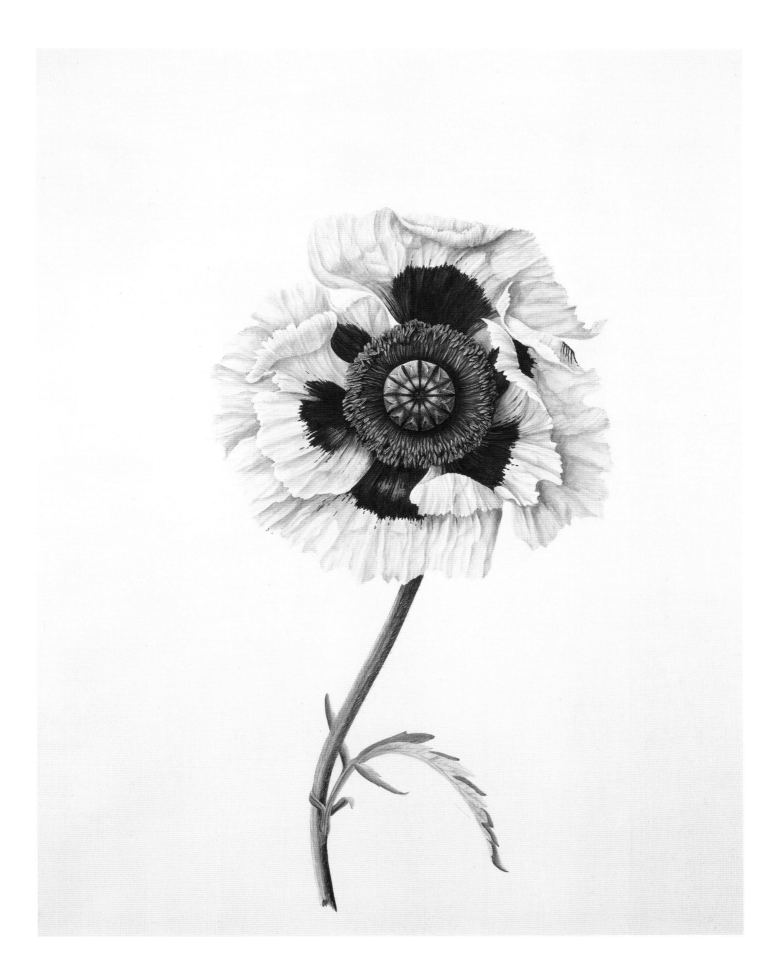

53. *Akebia quinata* – Lardizabalaceae

Seiko Kijima, b. Kobe Hyogo, Japan 1948

Acrylic and pencil on paper, 545 mm x 385 mm
Signed *Seiko*

Seiko Kijima was educated in drama at Tama Art College in 1967–70 and later became a freelance botanical illustrator and instructor, teaching children at Kobe Municipal Arboretum, the Museum of Nature and Human Activities at Hyogo and in the Miracle Planet Museum of Plants. She has shown in numerous group exhibitions in Japan and in the New York Botanical Gardens and the Horticultural Society of New York. In 2001, she was shown in the Hunt Institute for Botanical Documentation.

Seiko works in pencil and acrylic, painting with great delicacy and well thought-out design. Her study of the climber *Akebia quinata* is an example of exquisite detail, which she reproduced on the front of a beautiful catalogue of her work.

Botanists at one time thought that the Lardizabalaceae represented a primitive group of flowering plants that evolved soon after the origin of the angiosperms. Now, as the result of additional evidence from a number of sources, it is believed that these plants have evolved more recently along with the buttercups and poppies. *Akebia* and other genera in the family are climbing vines; some lose their leaves in the winter and others are partially evergreen. Like some of the poppies, the flowers of *Akebia* do not produce nectar and instead provide pollen to reward the pollinating bees. However, this plant has evolved separate male and female flowers with stamens present only in male flowers and pistils only in female flowers. As a result the female flowers have no pollen reward to offer the bees and deceive the insects into visiting them by being larger than the male flowers.

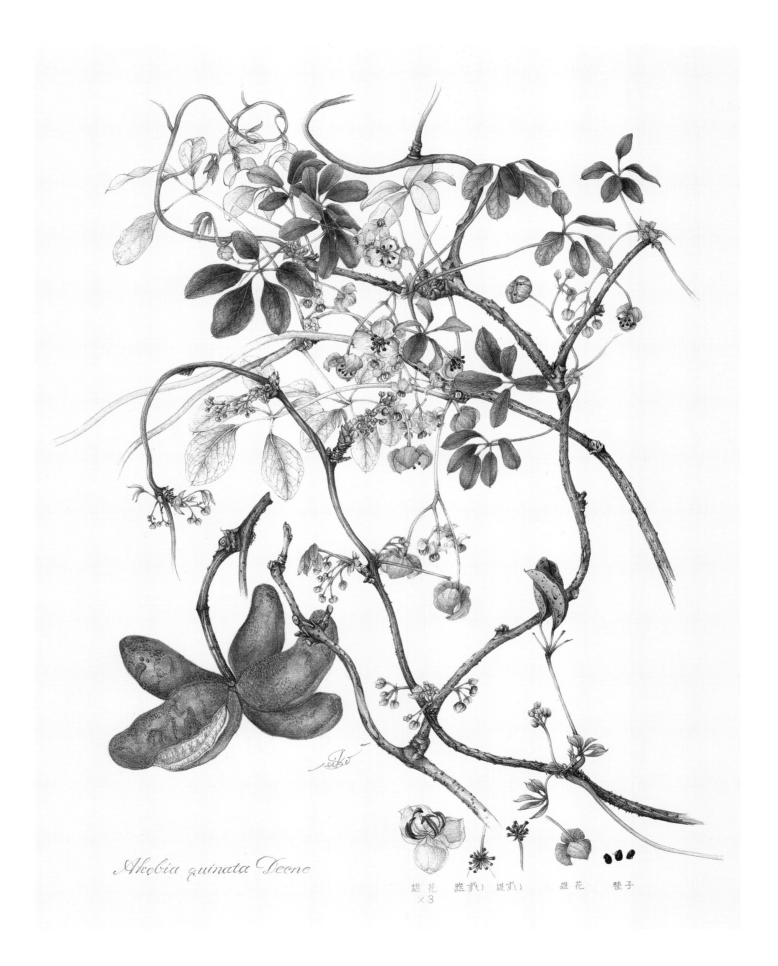

Akebia quinata Decne.

雄花　雌ずい　雄ずい　雌花　種子
×3

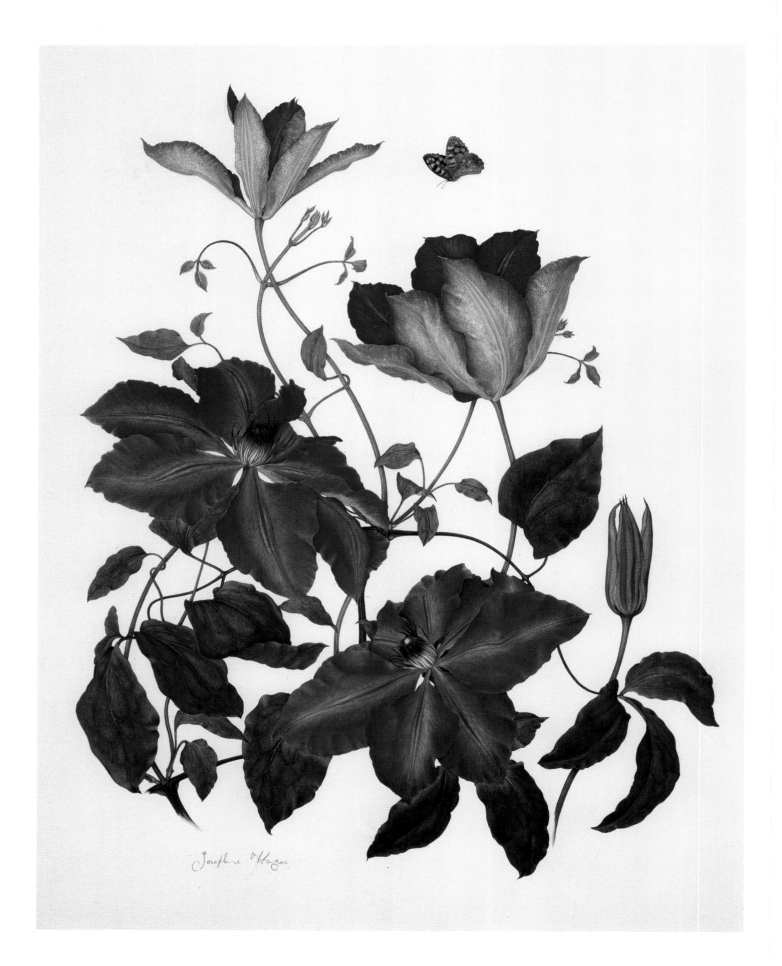

Josephine Hague

54. *Clematis* 'Elsa Spath' - Ranunculaceae

Josephine Hague, b. Liverpool, England 1928

Watercolour on paper, 480 mm x 380 mm
Signed Josephine Hague
Commissioned

Josephine Hague studied textile design at Liverpool College of Art. From 1979 to 1985 she followed a freelance career in textile design and illustration.

Her work has been exhibited in many galleries including at Kew, the National Theatre in London and the Tryon Gallery, London. Between 1984 and 1988 the RHS awarded her four gold medals and in 1993 she was invited to become artist in residence at the Liverpool Museum of Natural History.

Josephine has designed a series of British wildflower ceramic plates for The Conservation Foundation. She exhibited at the Hunt Institute in 1997 and at the National Botanical Gardens of Wales in 2002; and she painted a meconopsis for the Royal Horticultural Society's Lindley Library in 2000. Ness Gardens, the botanic gardens attached to the University of Liverpool, provides many of her subjects.

Clematis 'Elsa Spath' was a commission that indulged the recent enthusiasm for clematis. Her treatment of the powdered white bloom on the outside of the petals is masterly and all her colour tones are true and convincing.

Before DNA data were used to understand the evolution of plants, botanists used various features of the stems, leaves, and flowers to designate which ones were primitive and ancient, and which ones were more advanced and recently evolved. Among the floral features considered to be ancestral characters was the possession of numerous stamens and pistils, as found in the flowers of buttercups, clematis, and other species in the order Ranunculales. For this reason these plants were at one time thought to be some of the most primitive flowering plants. This contention is no longer believed to be true and it is now thought that the numerous stamens and pistils have evolved in response to the diverse array of pollinators which visit the flowers. The Ranuculaceae is classified in the eudicots and the earliest fossils of this family are 70 million years old.

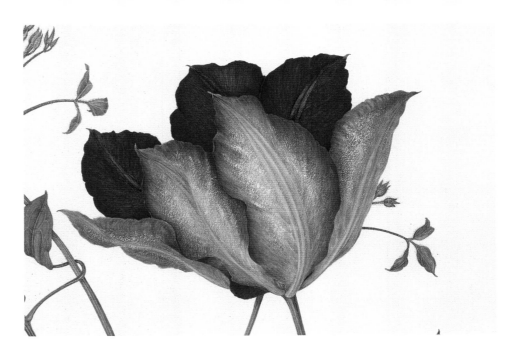

Proteales

The three main components of this interesting group of plants, the proteas, the sycamore or plane trees and the aquatic lotus flowers, were never thought to be related until DNA sequence data provided solid evidence that these plants evolved together. The non-DNA features that link them all together are somewhat obscure, although some characters of the flowers and leaf margins as well as fossils link the plane trees and proteas. The species in the Proteales gave rise to the great diversity of the 'core eudicots' described in the next section.

55. **Yellow lotus:** *Nelumbo lutea* – Nelumbonaceae

Beverly Allen, b. Australia, 1945

Watercolour on paper, 770 mm x 1240 mm

First seen as a scan on email this large painting came as a surprise when it was eventually shown at Botanica in Sydney Botanic Gardens. However, the yellow lotus nearby in the Garden are indeed a magnificent sight and just as large as she had painted them.

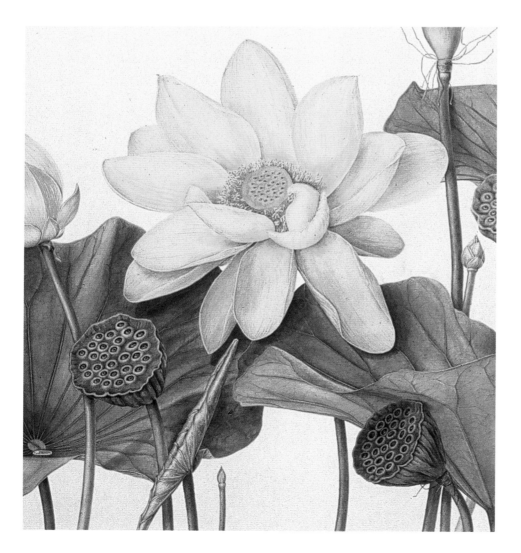

Beverly has exhibited widely in Melbourne as well as Sydney, in New York, Washington and in the Hunt Institute, Pittsburg. After being awarded a gold medal by the RHS her work was selected for Kew and the Lindley Library.

Her lotus was shown in Japan in 2006 in the Sompo Japan Museum of Art, Tokyo and in the first two exhibitions at the new Shirley Sherwood Gallery at Kew. This magnificent painting shows every stage from bud to fruit in a remarkable composition of flowers and leaves standing out of the water.

Plants that grow exclusively in water have evolved in different groups of flowering plants. Aquatics occur in the monocot orders Alismatales (sea grasses and pondweeds) and Commelinales (pickerel weeds) as well as the Nymphaeaceae (water lilies) in the basal angiosperms. Because of its aquatic habit the yellow lotus, or *Nelumbo*, was at first considered to be a close evolutionary relative of the water lilies, which superficially resemble it. It was surprising to most botanists when DNA data and some features of the roots suggested that the lotus was more closely related to sycamore trees and had evolved the aquatic habit separately from the water lilies. This evolutionary position of *Nelumbo* is now generally accepted by botanists. The large flowers of yellow lotus contain many sepals, petals, and stamens, and the numerous carpels are embedded tissue that form a massive cone-shaped disc at the base. *Nelumbo* is derived from the Sri Lankan name for the lotus plant, 'nelumbu' or 'nelun.'

56. Saw Banksia: *Banksia serrata* – Proteaceae

Celia Rosser, b. Melbourne, Australia 1930

Watercolour on paper, 760 mm x 560 mm
Signed *with her monogram and Celia Rosser 1995*
Commissioned

Celia Rosser can certainly claim her place in history as one of the world's most important botanical illustrators through her remarkable work on the Australian genus *Banksia*. These paintings have been reproduced in three superb monographs by Monash University: Volume I published in 1981, Volume II published in 1988 and the long anticipated Volume III in 2000. She became Science Faculty Artist at Monash University, Melbourne, Australia in 1970, started her monumental work there on the banksias in 1971 and has been painting them ever since. Every time the end was in sight another new species was found, so the last volume contains portraits and descriptions of four extra species, bringing the total in all three volumes to seventy-six.

This original painting of *Banksia serrata*, commissioned for the Shirley Sherwood Collection, has been shown all over the world from Kew to Tokyo and from Sydney to Stockholm, including the Scottish National Gallery of Modern Art in Edinburgh. Celia came to the opening in Edinburgh, which happily coincided with her Linnean Society award. It has recently been displayed in 'Down Under' in an exhibition in the new Shirley Sherwood Gallery at Kew, which was designed to show the work and style of the Australian and New Zealand artists, rather than to be a display of their local flora.

Celia paints on very 'corrugated' paper, amazing other botanical artists with the detail and complexity of her watercolours on such a rough surface. She took four months to paint this banksia working by daylight lamps in the evenings.

In 1768 when Captain James Cook mounted his great exploring expedition to the South Pacific, he brought along Joseph Banks, then a young botanist. Along with other naturalists and artists on the voyage, Banks collected specimens and recorded the plants encountered on the many islands they visited. One of the most interesting plants he found was a member of the genus *Banksia*, which was later named after him. Species of *Banksia* occur in the tropical and warm temperate regions of Australia. They are small trees or shrubs with large clusters of flowers that produce abundant amounts of nectar, attracting birds, small marsupials and rodents to the flowers as pollinators. The Proteaceae, though utterly dissimilar in flower and vegetative traits to the Nelumbonaceae (lotus) and Platanaceae (sycamore or plane trees), have been shown with modern DNA evidence to be evolutionarily closely related to these families.

Core Eudicots:
Minor Groups, Rosids, Asterids

Core Eudicots

The core eudicots make up the main component of what was formerly called the dicots. The caryophilids (order Caryophyllales), which are characterised by a special set of pigments called betalains, are a monophyletic group, and include the carnations, cacti, Old World pitcher plants, and buckwheat. Many of the caryophilids are especially adapted to extreme environments, such as deserts or nutrient-poor and high-saline soils. The caryophilids are most closely related to the asterids. The second group of core eudicots, the saxifragids (order Saxifragales), have only recently been recognised as a phylogenetically related group. Plants such as witch hazels, stone crops, gooseberries, and paeonias were formerly not thought to be evolutionarily related at all until DNA data clearly and strongly placed them together. It is still not exactly clear how the saxifragids are related to the caryophilids and other groups in the core eudicots. Several other groups of plants, such as the orders Santalales and Gunnerales, are unplaced on the core eudicots.

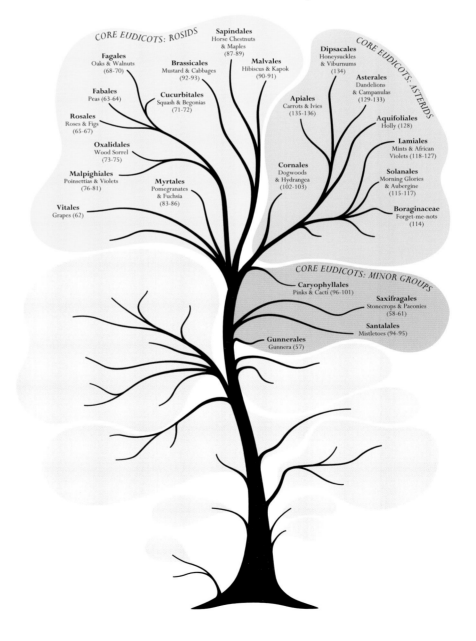

Gunnerales

This small order has evolved at the base of the rest of the 'core eudicots.' Only two families and less than 50 species are contained within it. The strange flowers of *Gunnera*, which have only two petals, two sepals, two stamens, and two carpels are quite different than most of the other core eudicots which have flower parts in fives or sometimes fours. The Gunnerales have proven critical in assisting botanists' understanding of how flowers have evolved.

57. **Small gunnera leaf:** *Gunnera manicata* – Gunneraceae

Sue Herbert, b. Darwen, England 1954

Watercolour on paper, 1520 mm x 1215 mm
Signed *Sue Herbert 2002*
Commissioned

Sue Herbert was trained at Blackpool College of Art and Technology and Sunderland College of Art. She has shown in a number of group exhibitions in London, including the Tryon & Swann Gallery in 1998.

A few years ago this gunnera was commissioned and the picture's development was photographed at several stages. The plant has enormous leaves, as much as six feet across, and grows near water. To celebrate the Millennium some were planted behind a solid stone seat, where they became green, living 'umbrellas', part of a large water garden project.

Sue prepares the leaf for painting by flattening and drying it under a carpet (it is too big for a conventional flower press). Covering the large area of her drawing with watercolour takes several weeks as she builds up layer upon layer. She is wonderfully skilled at 'holding' such a large watercolour in detail.

Her leaves compliment Ruskin's quotation 'If you can paint <u>one</u> leaf you can paint the world', although it is doubtful that Ruskin was contemplating painting such an enormous subject.

Although the leaves of some species of *Gunnera* are quite large (several metres across), the flowers are quite small. Despite their small size, the flowers produce large amounts of pollen and rely upon the wind to transfer the pollen between plants. The production of such an abundance of pollen means that *Gunnera* is well-represented in the fossil record from about 65 million years ago until the present, which has allowed botanists to trace its geographic and evolutionary history. Today *Gunnera* is widely distributed, especially in the southern hemisphere. DNA sequence data have shown that this plant is a member of the most advanced flowering plants, the eudiots, and allied with the genus *Myrothamnus* even though the two genera are quite different in most aspects of their appearance. *Gunnera* was named by Linnaeus in honour of the Norwegian clergyman and botanist Johan Ernst Gunnerus, who lived from 1718–1773.

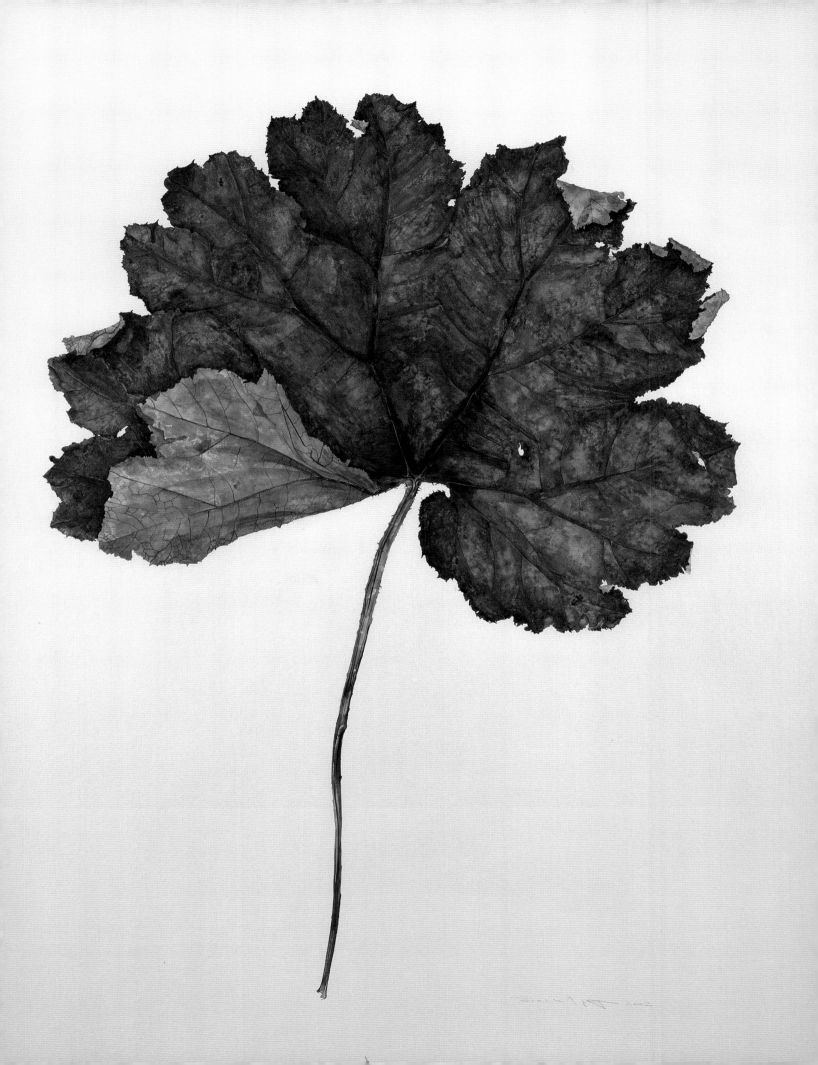

Saxifragales

The 12 to 13 families now classified as members of this order were never considered to be closely related to each other by earlier botanists. Only critical data obtained from DNA sequences have served to indicate the evolutionary relatedness of these plants. The Saxifragales include witch hazels, stone crops, saxifrages, sweet gums, paeonies, gooseberries, and a number of lesser known plant families. Some flower features, such as the bi-partite carpel, fruit traits, including the woody capsules, and leaf characters are shared by members of this order.

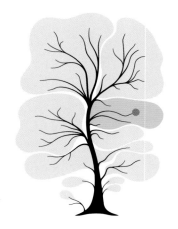

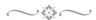

58. **Paeonia:** *Paeonia mlokosewitschii* — Paeoniaceae

Jeanne Holgate, b. London, England 1920

Watercolour on paper, 240 mm x 340 mm

Signed *Jeanne Holgate*

During World War II Jeanne Holgate joined the Women's Auxiliary Air Force and attained the rank of flight officer. She taught herself flower painting and became an official artist to the RHS from 1954 to 1966. The Society has over five hundred of her orchid paintings. She was awarded four gold medals and won the silver trophy for the best scientific exhibition with her work on orchids at the 4th World Orchid Conference.

Jeanne moved from England in 1966 and began her connection with Longwood, one of the most important and impressive gardens in the United

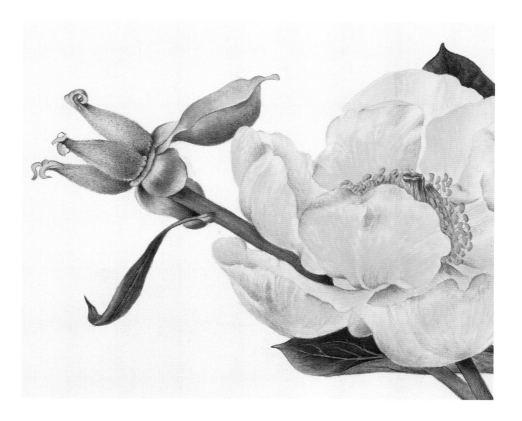

States, but she continued to have one-person shows at Sotheby's and the British Museum in London and all over the United States, while the Hunt Institute held a retrospective of her work in 1973.

In 1972 she was commissioned to paint 'The Flowers of America', showing each state's flower emblem. This was a mammoth task, resulting in an 'elephant' limited portfolio. To complete it she travelled over 45,000 kilometres (28,000 miles) from Maine to Hawaii and from Alaska to New Mexico, taking over four years in the process. Jeanne's works are held in many collections including those of HM Elizabeth the Queen Mother, the Hunt Institute, the British Museum and the University of North Carolina, and is illustrated in *The Art of Botanical Illustration* by Wilfrid Blunt and William T Stern (1994) with a wonderful portrait of a pale pink magnolia. She is a founder member of the Guild of Scientific Illustrators and was elected a Fellow of the Linnean Society in 1991.

When questioned about *Paeonia mlokosewitschii* she particularly remembered painting the red veining in the stem and along the leaves, something that is distinctive to the plant and quite beautifully observed.

The evolutionary position of the genus *Paeonia* in the classification of the flowering plants has been a long-standing debate among botanists. Because its flowers have many stamens and separate pistils, some taxonomists have thought that *Paeonia* were closely related to the buttercups in the family Ranunculaceae, while others placed them near the magnolias. Currently most DNA evidence suggests that paeonies should be classified with crassulas and gooseberries in the order Saxifragales. The family consists of a single genus with large conspicuous flowers. Because some of the species are claimed to have significant medicinal value, the name Paeonia follows the classical Greek name Paeon, who was the physician of the gods.

59. Gooseberry: *Ribes uva-crispa* — Grossulariaceae

Jill Coombs, b. Horsham, England 1935

Watercolour on paper, 250 mm x 190 mm
Signed *Jill Coombs '93*

Jill Coombs studied ceramics, textile design and illustration at West Sussex College of Art. For several years she worked as a freelance artist for the Royal Botanic Gardens Kew, preparing illustrations for the floras of Iraq, Qatar, Egypt and Tropical East Africa.

In the mid-eighties she was Orchid Artist for the RHS. She designed their 1990 Chelsea Plate, and has been awarded three gold medals. She has illustrated *Plant Portraits* by Beth Chatto and *Herbs for Cooking and Health* by Christine Grey-Wilson. She has also prepared illustrations for *Curtis's Botanical Magazine* and *The Crocus* by Brian Mathew.

In 1994, together with two other artists, she was invited by the Royal Botanic Gardens Kew to stage an exhibition of botanical watercolours at the Kew Gardens Gallery, where this gooseberry painting was shown. This elegant little study shows the translucent, hairy fruit to perfection, both on the thorny branch and dissected at the bottom of the page.

The gooseberries are either placed in their own separate family, the Grossulariaceae, or sometimes included in the family Saxifragaceae. DNA data place both of these families in the order Saxifragales, but there is some debate among botanists as to whether this order should be classified in the early diverging eudicots or closer to the rosids. The Grossulariaceae includes one or two genera and are mostly native to the northern hemisphere in mountainous areas. Those gooseberries that are found in the southern hemisphere occur in the high Andean Mountains south to Tierra del Fuego.

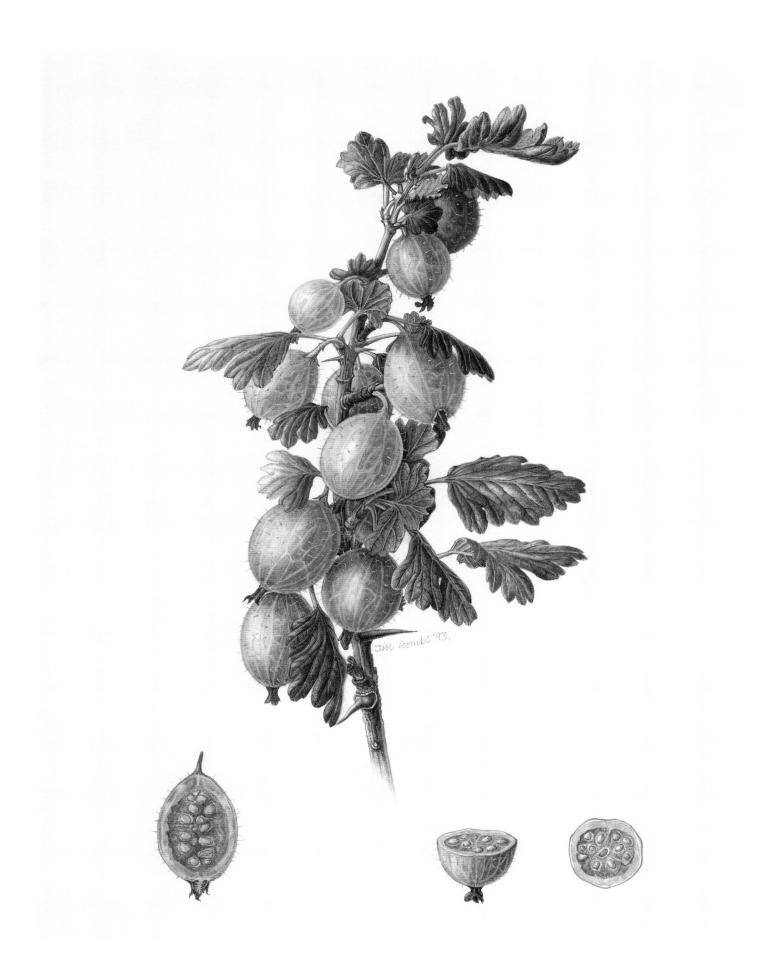

60. Pickaback plant: *Tolmiea menziesii* — Saxifragaceae

Jean-Claude Buytaert, b. Zwartberg, Belgium 1944

Drypoint etching, 495 mm x 654 mm
Signed *Jean Buytaert 1986*

A master of dry-point etching, Jean Buytaert is a full-time sculptor, painter and graphic artist living in Antwerp. He has been professor of both botanical drawing and graphic arts and has had one-man shows in Antwerp, in the Arboretum, Kalmthout and at the Russian Artists' Association in St Petersburg in 1995. He has been commissioned by Queen Paola of Belgium and shown at the Hunt Institute and is represented in the Frick Art Museum in Pittsburgh, among many other collections.

His dry-point etching of *Tolmiea menziesii* was exhibited at the Hunt Institute's 7th International Exhibition in 1992. This is a strange plant with new leaves springing from the centre of mature ones.

In the past taxonomists included a diverse array of plants in the family Saxifragaceae, including both herbs and woody shrubs. DNA sequence data have provided solid evidence, in conjunction with some features of the flowers and leaves, to divide this family into a number of evolutionarily separate groups. Some species, such as the shrubby gooseberries, are placed in a separate family, but still closely related to the Saxifragaceae. Others, such as the hydrangeas, are more closely related to species in the asterids and are not related to plants in the order Saxifragales at all. The genus *Tolmiea* has always been included in the Saxifragaceae, but the flowers of the single species in the genus, *Tolmiea menziesii*, are quite different from other members of the family. In its native habitat, which extends from Alaska south to northern California, tiny fungal gnats gather nectar with their long tongues and pollinate the flowers.

61. *Crassula coccinea* – Crassulaceae

Ellaphie Ward-Hilhorst, , b. Pretoria, South Africa 1920–1994

Watercolour on paper, 370 mm x 305 mm
Signed *E Ward H 1993*

Ellaphie Ward-Hilhorst started her career as a botanical artist in 1973. She must certainly be placed among South Africa's greatest botanical artists and her work is recognised much further afield. She had a prodigious output, producing 800 plant portraits, mostly in watercolour, during her 24 years as an active botanical artist.

She also produced some larger paintings for commissions and she showed at the Hunt Institute, the Everard Read Gallery in Johannesburg and in 'Art meets Science', a South African touring exhibition. She was awarded the Botanical Society of South Africa's Cythna Letty Gold medal and a gold medal at the RHS for her *Haemanthus* paintings. She was well represented in the most recent edition of *The Art of Botanical Illustration* by Wilfrid Blunt and William T Stearn (1994).

Ellaphie's *Crassula coccinea* is a robust masterpiece of dozens of vivid scarlet flowers on a beautifully painted stem of encircling succulent leaves. She had collected it on the top of Table Mountain where its form is more compact than at sea level.

Her work can be compared in quality with succulents painted by Ferdinand Bauer (1760–1826) for the *Flora Graeca* (from 1786) and with an elegant cotyledon painted by Peter Brown (fl.1758–99) in Kew.

When unrelated groups of plants possess the same adaptations to a particular environment biologists refer to this similarity of features as 'convergent evolution', because the plants have converged in their characteristics through separate evolutionary pathways. Members of the family Crassulaceae in the order Saxifragales, which are found throughout the world in hot, dry and rocky habitats, have converged on a very similar set of traits to those found in a number of families in the order Caryophyllales, such as species in the Cactaceae and Aizoaceae families, which inhabit the same type of environment. All of these plants have succulent leaves and/or stems to store water in times of drought and photosynthesize in the same special way to prevent water loss during the day. The Crassulaceae is not closely related to the Cactaceae evolutionarily, but natural selection as a result of the extreme habitats where they live has led to the evolution of the same features.

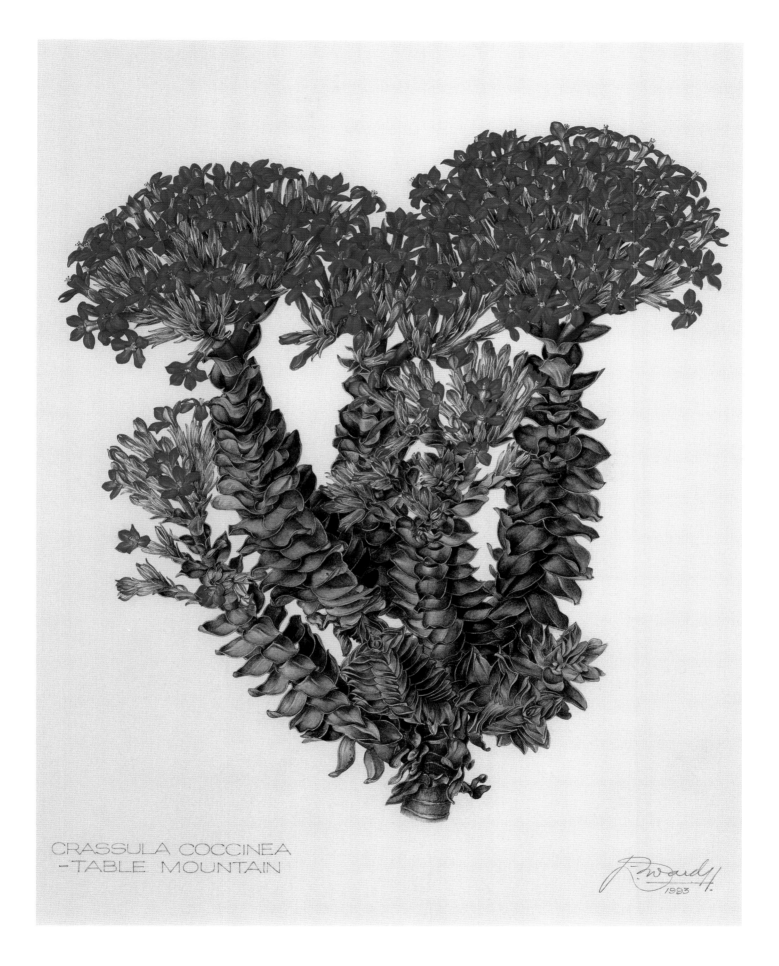

CRASSULA COCCINEA
-TABLE MOUNTAIN

Rosids

The rosids contain a very large number of species, perhaps one-third of the angiosperms, and are very diverse in form and geographic distribution. Like the Saxifragales, the rosids contain many plants that formerly were not though to be related to each other and the complexities of relationships within the group are now being intensely studied. DNA sequence data are the prime evidence for combining these very different types of plants into a single large group, including the grapes, eucalypts, crepe myrtles, fuschias, poinsettias, willows, carambolas, beans, roses, figs, oaks, mustards, mallos, and oranges. This exceptionally large group of flowering plants can also be divided into two smaller groups called the eurosid I, comprising the beans and close relatives, and the eurosid II, including the mallows and their closest relatives. The Geraniales and Myrtales, as well as the isolated grape family, the Vitaceae, are not placed in either of these two main groups.

Vitales

The exact evolutionary placement of the grapes in the classification of the eudicots was for a while somewhat uncertain. Most data, especially DNA sequence evidence, suggested that the Vitaceae should be placed in the rosids, but its exact relatives were unclear and for that reason, the family was not classified into a particular order in the rosids. Recently, additional data have clearly shown that the grapes are somewhat isolated in the rosids, so they have been designated as their own order, the Vitales, which contains only the single family Vitaceae.

62. **Wild grapes:** *Vitis vinifera* — Vitaceae

Kate Nessler, b. St Louis, Missouri, USA 1950

Watercolour and body colour on vellum, 279 mm x 152 mm
Signed *Nessler '07*

This small study is a particular favourite and was chosen by Kate Nessler as the cover for a catalogue in 2003 at an exhibition in Jonathan Cooper's gallery, where she has shown many times. Kate found the wild grapes in a hedgerow near her farm in Arkansas and painted its utter simplicity with great feeling. It is a tiny jewel of a work, a special quiet treasure.

> Within the family Vitaceae, the taxonomic boundaries among the genera are also unclear. This is due to the multiple times that various features of the flowers and leaves have evolved, resulting in species which are not always closely related to each other sharing similar features. The grapes, probably because of their cultivation by humans for so long, have evolved important ecological interactions with various pathogens. Cultivated grapes in Europe became extremely susceptible to both fungal and insect pests in the past century and were threatened with extinction at one point. This threat almost destroyed the wine industry in Europe until it was discovered that American varieties of grapes were not as susceptible to these pathogens.

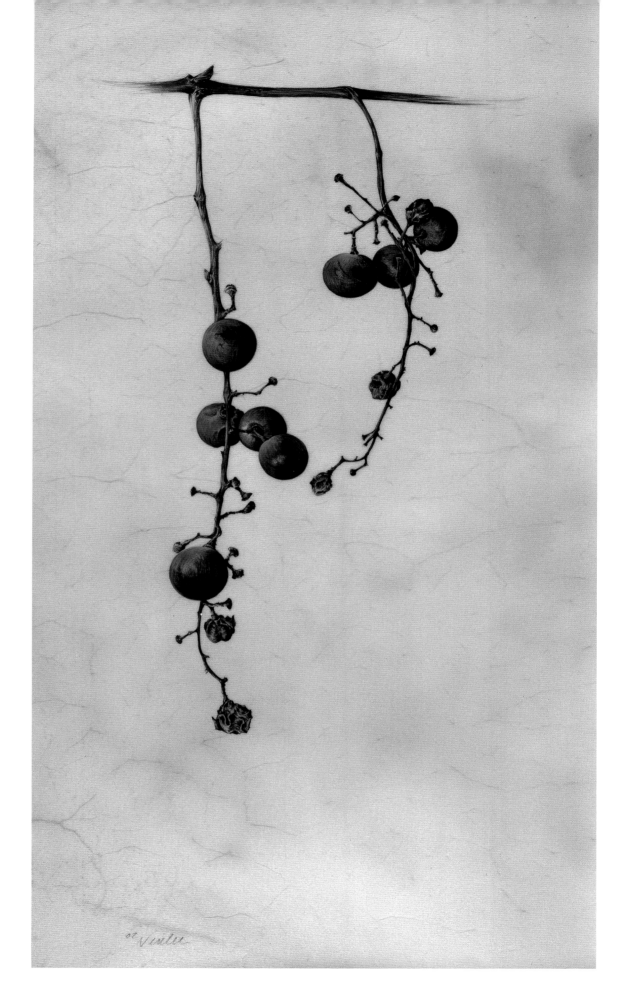

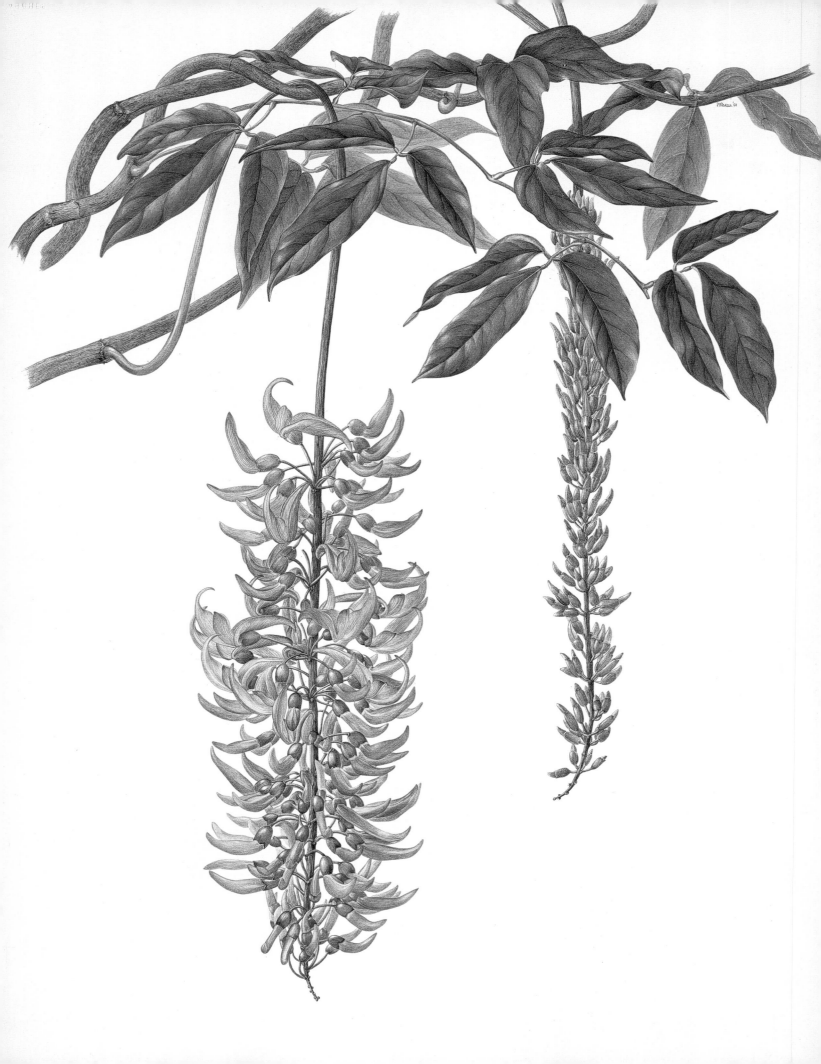

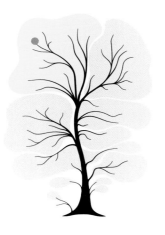

Fabales

Only four families are recognised within this order. The largest family, the Fabaceae or bean family, accounts for most of the nearly 19,000 species so far described in the Fabales. The large green embryo contained with the seed is one of the few traits, besides DNA similarities, that evolved in the common ancestor of the species of this order. The other large group of species in this order is found in the milkwort family, or Polygalaceae. The legumes are second in importance to the grasses with respect to providing nutrition to human populations.

63. Jade vine: *Strongylodon macrobotrys* — Fabaceae

Pauline M. Dean, b. Brighton, England 1943–2007

Watercolour on paper, 680 mm x 465 mm
Signed *P M Dean '01*

Pauline Dean exhibited her meticulous watercolours over a long period. She started in 1987 after being trained as a registered nurse but she had no formal training as a botanical artist. She died recently after a long, courageous struggle with cancer.

In 2004 she published her beautifully illustrated biography, *Pauline Dean — Portfolio of a Botanical Artist,* which shows many of her paintings, mostly of plants growing at Wisley. In 2006 she was invited to the International Exhibition and Conference on Botanical Illustration for Tropical Plants at the Queen Sirikit Botanic Garden in Chang Mai, Thailand where examples of her work were shown and she gave an illustrated talk on botanical painting.

She painted the Jade vine at Wisley. This is an extraordinarily difficult climber to paint with its long pendulous inflorescence of flowers coloured an unreal, 'electric' blue. She felt she had caught the colour of the hanging flowers, before they fell and turned purple on the ground.

The legumes have always been recognised as a very closely related group of species, but taxonomists differ on whether it should be classified as one family or three families. Based on evidence from DNA sequence data, many modern botanists believe that the evidence best supports the recognition of a single family, the Fabaceae. Legumes are the second most economically important family of plants because of their widespread use as a source of protein and their ability to enrich nutrient-poor soils as a result of their ecological relationship with a specific type of bacteria. The Fabaceae is the third largest family of flowering plants with 630 genera and over 18,000 species, which are distributed on every continent around the world except Antartica. *Strongylodon macrobotrys* is a tropical liana. The size and colour of the flowers and their arrangement on long pendent inflorescences is suggestive of pollination by bats.

64. August (pea): *Pisum sativum* – Fabaceae

Yuri Ivanchenko, b. Sverdlovsk (Ekaterinburg), Russia 1961

Watercolour on paper, 378 mm x 278 mm
Signed *Ivanchenko 1997 August* (in Russian)

Yuri Ivanchenko studied at the Repin Institute of Painting, Sculpture and Architecture in the Graphic Faculty from 1985–91 in what is now St Petersburg. He has showed in Moscow, St Petersburg and in Geneva, generally in group exhibitions. His work is held in the Museum of Modern Art, Moscow.
His solo exhibition at Colnaghi, London in 2003 contained a series of paintings celebrating the seasons by month. This still life called 'August' is of a pea struggling up the wall of a shed. Although 'August' is a still life rather than a strictly botanical painting, it has an echo of past skills, somehow linking it with the peas found trailing on the narrow borders of illuminated manuscripts. It can be compared with a border in *Master of Cardinal Wolsey*, 1529–30, a breathtaking manuscript from Christ Church Library, Oxford and shown in *A New Flowering: 1000 Years of Botanical Art*.

When Charles Darwin wrote *On the Origin of Species*, which was published in 1859, inheritance of traits from one generation to the next was a critical component of his theory on evolution by natural selection. Yet Darwin did not know how inheritance worked. It wasn't until after Darwin's death that Gregor Mendel working with inbred lines of peas discovered the principles of genetic inheritance. Peas, in the genus *Pisum*, are twining herbs native to Asia. They are predominantly self-pollinating, which allowed Mendel to develop strains of peas with single-colour flowers that he could cross to determine how traits are inherited. Peas provide an important source of protein for human nutrition, especially in the Mediterraneum region, temperate Europe, northeastern Africa, and northwestern India. Archeological evidence shows that dry peas have provided a source of nutrition for humans for at least 7,000 years.

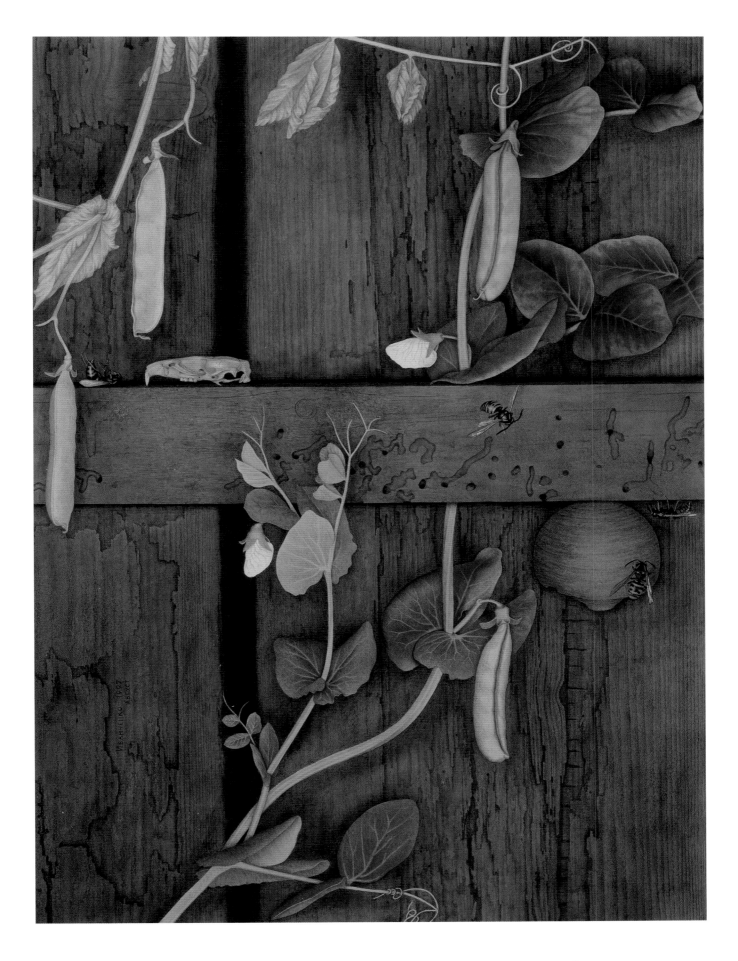

Rosales

The Rosales consist of nine families and are considered to be a strongly supported monophyletic group within eurosid I. Although the various plants within this order are quite heterogeneous in form, the lack of (or small amount of) endosperm in the seeds as well as a specialised floral disk at the base of the flower are two characters shared by many members of the order. The close relationship of the elms, nettles, hackberries, and figs has been recognised by botanists for some time, and these plant families are now understood to be closely allied with the diverse members of the rose family.

65. Tom Putt apple: *Malus* cultivar — Rosaceae

Rosie Sanders, b. Stoke Poges, Buckinghamshire, England 1944

Watercolour on paper, 165 mm x 265 mm
Signed *RJS*

Rosie Sanders went to High Wycombe College of Art and started as a freelance botanical artist in 1974. She has been awarded five RHS gold medals and received the Royal Academy Miniature Award in 1985. Her work has been exhibited in Britain, and appeared in the 7th International Exhibition at the Hunt Institute in 1992. She has been commissioned to do paintings for HM Queen Elizabeth II, HM the Queen Mother, for the RHS, the Royal National Rose Society and commissioned to design a set of wild plant stamps for Barbados.

Rosie is best known for her superlative studies of fruit, apples in particular. She lives in Devon, in cider country, and devoted much of her time to painting old varieties, culminating in her book *The English Apple*, published in 1988. Two apple paintings were acquired for the Shirley Sherwood Collection in 1992, one of them shown here. The trio of red and green apples are superbly three-dimensional.

Recently, Rosie has changed her subject matter and the way she paints dramatically. In 2004 and 2007 she had extraordinarily innovative shows at Jonathan Cooper's Park Walk Gallery of huge carnivorous plants and arisaemas, vastly magnified yet still in watercolour and followed with amazingly translucent iris. She has been called today's Georgia O'Keefe.

The family Rosaceae shows remarkable diversity in their leaves and stems, fruit types, and cell organisation, yet despite this great variation these plants have always been recognised as a very distinctive group of flowering plants. No controversy exists in the recognition of the Rosaceae as a well-supported family and DNA data are concordant with this view. The conspicuous flowers, numerous stamens, and a specialised fleshy tissue in which the seeds are embedded are all traits by which taxonomists recognise this family. The majority of the 3,000 species in the Rosaceae are native to the temperate and sub-tropical regions of the northern hemisphere. Many members of this family have evolved through a two-step process: hybridisation among closely and distantly related species followed by an increase in the number of chromosomes. This two-step process has resulted in the origin of both new species and genera in the Rosaceae.

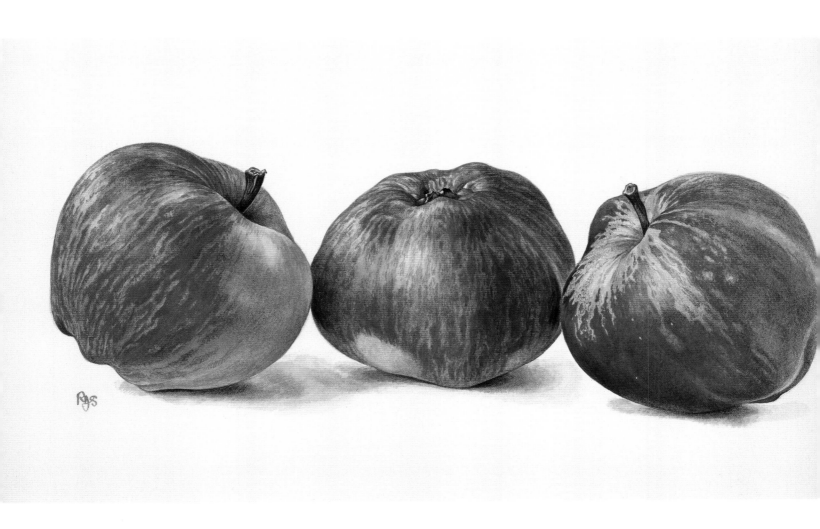

66. **Roses 1: *Rosa* cultivar** — Rosaceae

Regine Hagedorn, b. Göttingen, Germany 1952, works in France

Watercolour on paper, 305 mm x 450 mm
Signed *RH 2001* in square

Regine Hagedorn was educated in Switzerland and France and studied design and jewellery in Ecole des Arts Décoratifs in Geneva. She made jewellery and established a graphic design studio, but also executed botanical paintings and designed a private garden near Geneva.

Regine won three RHS gold medals between 1998 and 2005. Her watercolours have an intense, delicate quality that is hard to convey in reproduction. Some of her rose paintings are lush and detailed, very exquisite and romantic, yet austere.

Her 'Roses 1' must be one of the most beautiful, delicate paintings of the subject, even considering artists from the past like Redouté. It is a superb composition, full of buds, flowers, insects and petals. Her command of watercolour technique is so remarkable one can almost pick the flowers from the page.

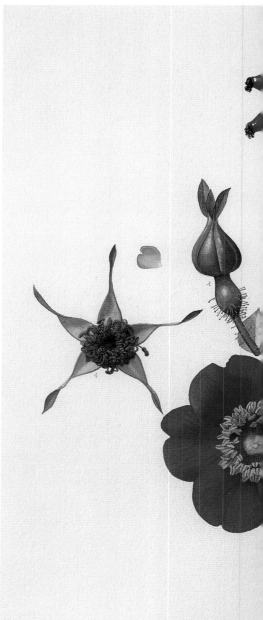

The genus *Rosa* includes more than 100 species. All of the roses have prickles and thorns and most are climbing vines and shrubs. Most species of the genus *Rosa* are native to the temperate regions of the northern hemisphere. Botanists have not satisfactorily deciphered the evolutionary history of the roses and much confusion exists over the classification and correct names for species and cultivars. This confusion in part results from the long history of cultivation and hybridisation of these plants by different cultures. Fossils of roses found in the North American regions of Colorado and Oregon date at least as far back as 32 million years ago, although the actual evolutionary origin of the roses may pre-date these fossils. This long evolutionary history makes the several thousand years that roses have been cultivated by humans seem short.

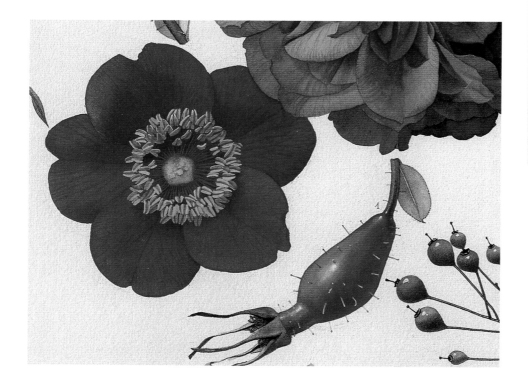

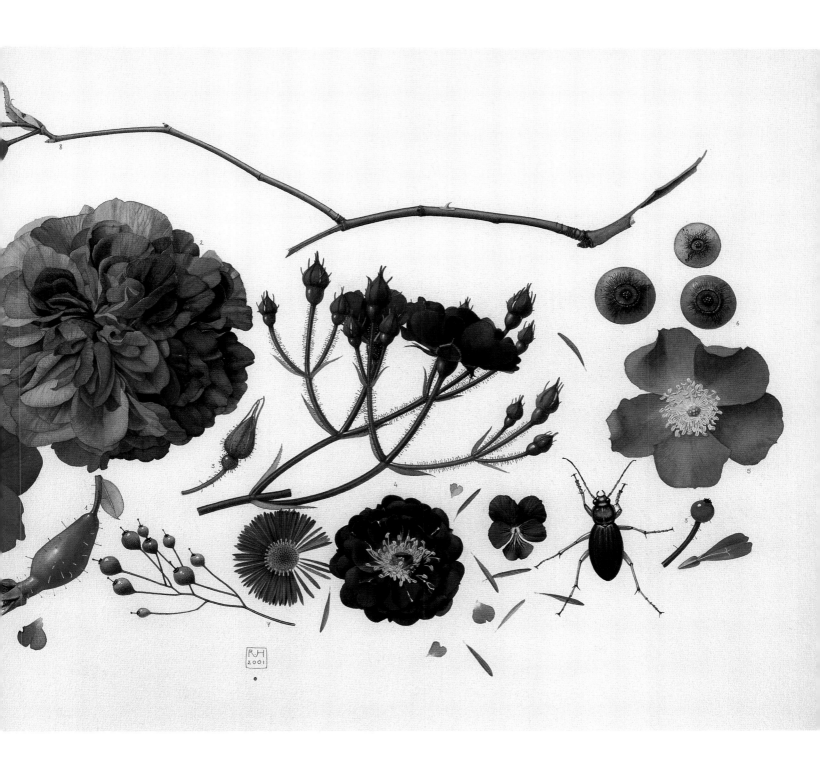

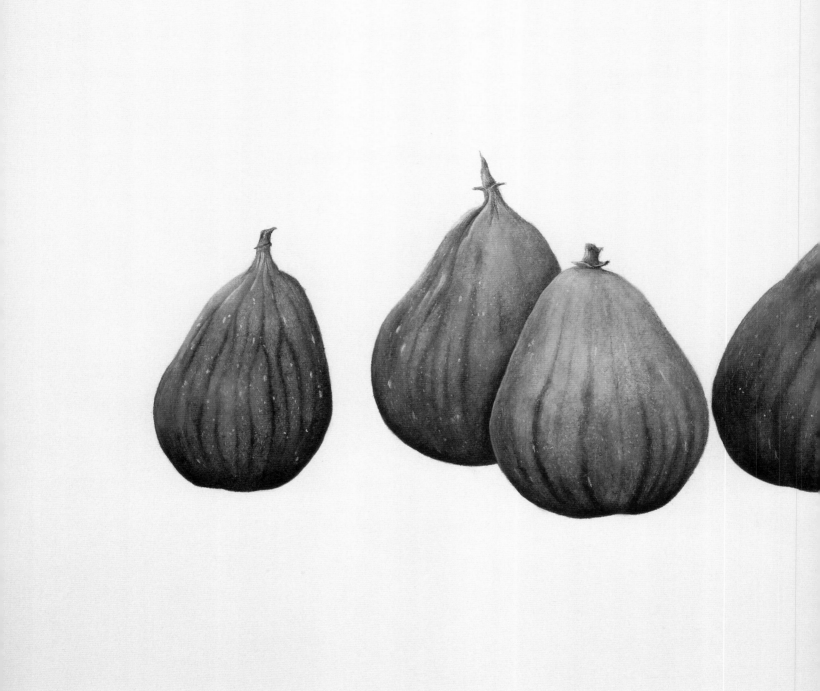

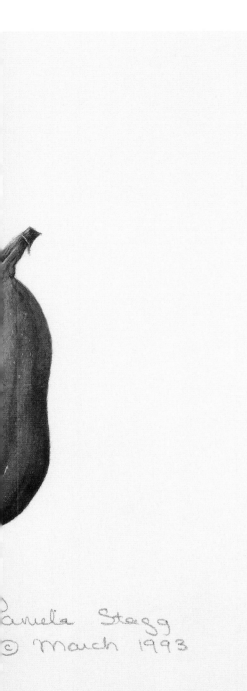

Pamela Stagg © March 1993

67. **Four figs:** *Ficus carica* – Moraceae

Pamela Stagg, b. Nottingham, England 1949, works in Canada

Watercolour on paper, 200 mm x 326 mm

Signed *Pamela Stagg © March 1993*

Pamela Stagg holds joint nationality as both a British and Canadian citizen and lives in Toronto where she teaches and paints. She went to Ontario College of Art in the late 1960s and then read Art History at the University of Guelph. She started botanical painting in 1987 and has had several solo shows in Canada and at Jonathan Cooper's Park Walk Gallery, London. She was awarded a gold medal by the RHS.

Pamela built up a strong reputation as a teacher and lecturer in Toronto and has illustrated numerous articles and books. She is very assured when painting fruit and vegetables while her irises are particularly well executed. This study of figs shows their extraordinary bloom and striped skin very beautifully.

Although no single shared trait is found in every member of the family Moraceae, a number of features, including the milky latex distributed throughout the plant in specialised cells, the number of carpels and the shape of the embryo, unite the members of this family into a coherent evolutionary group. DNA sequence data also show that all of these species are evolutionarily closely related. One of the most distinctive features of figs is the very specialised relationship between the flowers and their wasp pollinators. Fig flowers are unisexual and are grouped inside a sac-like structure. A female wasp enters the floral sac through a tiny hole and lays her eggs inside the female flowers, which are pollinated at the same time. The young male and female wasps that hatch from the eggs become adults after feeding on the developing fig fruits inside the floral sac. When the virgin wasps mate, the male flowers of the figs mature and release pollen onto the female wasps as they exit the tiny opening in the sac. The cycle begins again as the pollen-carrying female enters the floral sac of another fig.

Fagales

Members of the Fagales were formerly grouped with the witch hazels and sycamores, but are now generally agreed to have evolved in the eurosid I group. The eight families that make up this order include the trees and shrubs in the oak or beech family, the walnut family, the birch family, and the bayberry family, among others. All have generally small flowers, which have very reduced sepals and petals, lack nectarines, and are either male or female (unisexual); they are pollinated by the wind. Tannins are present throughout the plant body. Nuts produced by the trees of several families of the Fagales are an important economic crop.

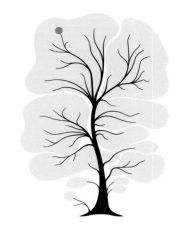

68. **Acorns from the Jura:** *Quercus robur* – Fagaceae

Regine Hagedorn, b. Göttingen, Germany 1952, works in France

Watercolour on paper, 390 mm x 345 mm
Signed *RH 4.10.2000 in square*
Commissioned

This magnified study of two acorns picked up in the Jura is a delight with its quiet elegance and exquisite detail in yet another superb composition from this immensely gifted artist.

Similar to the Betulaceae, members of the family Fagaceae are wind pollinated, but in these species only the male flowers are clustered in many-flowers catkins. The separate female flowers are solitary or in small groups. Many of the nearly 900 species in the family are found in the northern hemisphere where they are a conspicuous element in the hardwood forests that formerly covered much of the land area in the temperate zone. The oaks are also an important component of the tropical evergreen forests of South-East Asia and southern China where a different set of genera to those in temperate North America and Europe are found. Fossil evidence indicates that the Fagaceae may have originated over 90 million years ago.

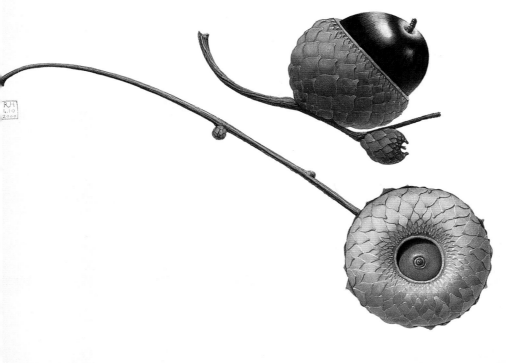

69. Walnuts: *Juglans nigra* – Juglandaceae

Jakob Demus, b. Vienna, Austria 1939

Etching, 265 mm x 380 mm
Signed *Jakob Demus*

Jakob Demus trained as a sculptor at the Vienna Academy where he studied sculpture, anatomy and drawing in master classes under Joannis Avramidis. His passionate love for nature eventually made him decide to concentrate on painting and the graphic arts.

He is an artist who is much influenced by the past. He has not only studied the work of Pieter Breughel the Elder, Claude and the Dutch painters of the seventeenth century, but he also uses their techniques, grinding and mixing his own colours and making extracts of wood smoke to create the warm tones of his bistre. He prints his own work on handmade paper. He draws directly on to the copperplate with a diamond point and makes from two to thirty impressions for each edition.

Demus also draws intensely detailed studies of rocks and stones and delicate landscapes. His work has been exhibited widely in Tokyo, Vienna, Munich and New York and is held in the British Museum, the Victoria & Albert in London, the Metropolitan Museum of Art, New York, the Rijksmuseum, Amsterdam and many other centres. His work was collected for a major retrospective exhibition at the Rembrandthuis Museum in 2005. The Hercules Segers Foundation has recently published a handsome catalogue raisonné.

He is a most satisfying artist with austerity and discipline and an elegant precision, using diamond-point etching, transferred to paper.

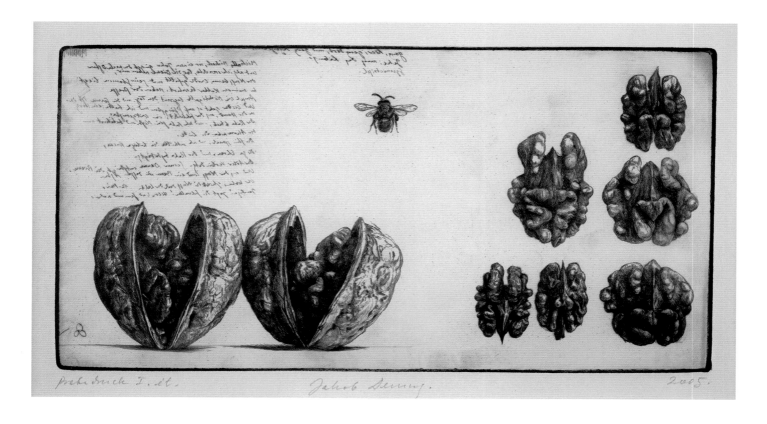

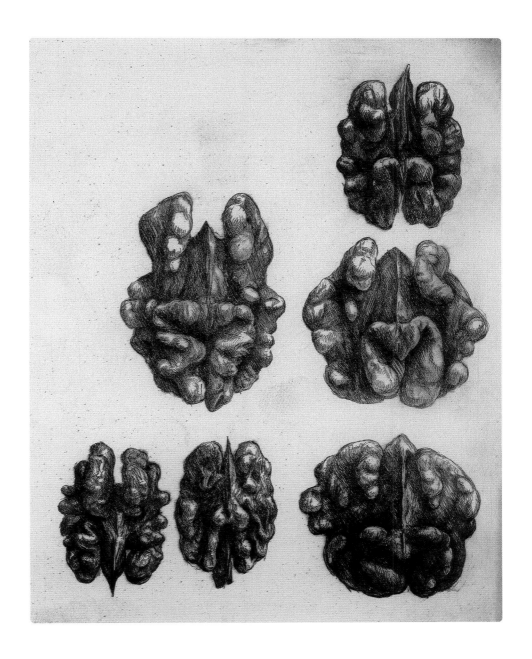

Another small family in the order Fagales is the walnut family, the Juglandaceae, with only 59 species distributed across eight genera. The members of this family have always been recognised as evolutionary close relatives, but their position in the *Tree of Plant Evolution* was not always clear. Earlier botanists had thought that they may be related to the orange family or witch hazels, but DNA evidence indicates their evolutionary relationships to the oaks and birches. Members of the Juglandaceae are large trees, with separate male and female flowers present on the same tree, and are wind-pollinated. In order to ensure cross-fertilisation among trees rather than within the same tree, the male and female flowers of a single tree open at different times over the course of a few days. Cross-fertilisation prevents inbreeding and provides the genetic variation upon which natural selection may act.

70. **Purple filbert:** *Corylus maxima* **'Purpurea'** — Betulaceae

Elizabeth Cameron, b. London, England, 1915–2008

Watercolour on paper, 340 mm x 295 mm
Signed *EC 77*

Elizabeth Cameron trained at the Slade School of Fine Art and St John's Wood Art School in London. Marriage, children and running a business took most of her time until 1972 when she returned to painting. She exhibited in New York, Boston, Johannesburg and at the Hunt Institute as well as in London and was awarded three RHS gold medals. The white gardens at Sissinghurst in Kent and Crathes Castle in Aberdeenshire inspired her to paint a series of white flowers, which she published in *A Book of White Flowers* (1980). To every rhododendron-lover's delight she recently published a beautiful book of magnificent drawings on her favourite plant group. It is a large format collection of excellent plates with superb colour, which she painted some years ago, and is entitled *A book of Rhododendrons* (2005).

This study of a purple filbert is a lovely composition of catkins, stigma, leaves, twigs and nuts executed in 1977.

The family Betulaceae is small with only six genera and a little over 150 species. Formerly the family that included the filberts was recognised as a separate family called the Corylaceae, but DNA data and further study has suggested that the two families should be combined into a single unit. All the members of the inclusive Betulaceae are similar in possessing leaves with margins that have two levels of serrations as well as separate male and female flowers arranged in hanging clusters called catkins. These dangling catkins have evolved to facilitate the transfer of pollen between flowers by the wind. Most species in the Betulaceae are native to northern, cool temperate habitats, but some occur in the mountains of Central and South America.

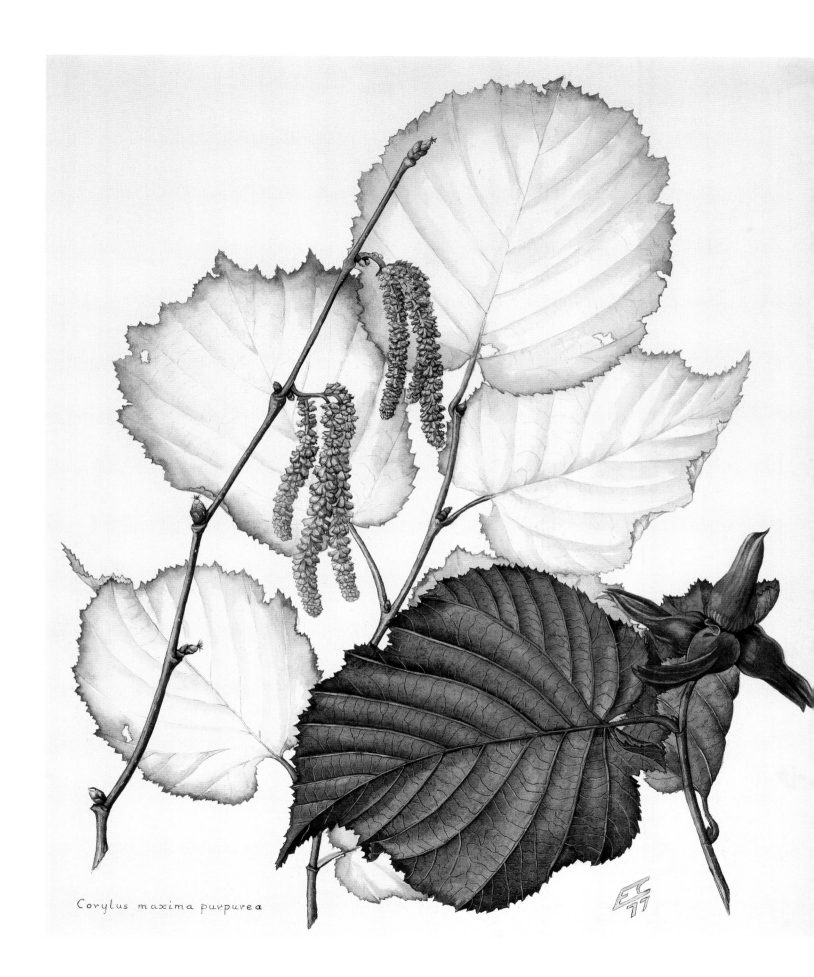

Corylus maxima purpurea

Cucurbitales

The two most well-known families of this order are the cucurbit family and the begonia family. The other five families are smaller and more obscure in their distribution and economic importance. Together, the seven families account for several thousand species. The separate male and female flowers, specialised chemical constituents, and disconnected conducting tissues in the stem are all specialised features of the Cucurbitales.

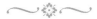

71. **Squash blossom 1978:** *Cucurbita pepo* – Cucurbitaceae

Anne Ophelia Dowden, b. Denver, Colorado, USA 1907–2007

Watercolour on paper, 350 mm x 460 mm
Signed *Anne Ophelia Dowden*

Anne Ophelia Dowden died aged 99, composed and coherent to the end. She can be considered as the 'grandmother' of America's contemporary botanical artists in much the same way that Mary Grierson fills that role in the UK. Both have produced many books and patiently instructed aspiring artists, and both continued to paint until very recently.

Towards the end of her life she lived in her apartment in Boulder, Colorado, close to where she grew up. She was very organised, with her drawings and notebooks arranged meticulously. She used these repeatedly as source material over the years when she was writing, illustrating and publishing her many books. She was worried about her failing eyesight which made it impossible for her to continue painting in the detail that botanical subjects demand.

The American Society of Botanical Artists gave her its annual award for her achievements as an illustrator and author in 1996 and she had another award from the Garden Club of American Zone XII in the same year. In January 1999 she was given the Gertrude B. Foster Award for Excellence in Herbal Literature from the Herb Society of America.

Her 'Squash blossom' painted in 1978 is particularly notable for its excellent composition and the subtly of the greens in the leaves and the fragile, delicate treatment of the tendrils.

The family Cucurbitaceae has always been recognised by taxonomists as closely related to the Begoniaceae. Like the begonias, they are distributed widely around the world and occupy habitats in rainforests and drier woodlands as well as semi-desert areas. The flowers of the family are usually quite conspicuous and some are very large. Many different types of pollinators have been recorded visiting the flowers, including diverse insects, hummingbirds, and bats. The floral biology of *Cucurbita pepo* is somewhat similar to that found in *Begonia*, but with a twist. The flowers are unisexual, occur on the same plant, and are very similar in appearance; both sexes produce nectar, although the female flowers produce more nectar than the males and are open for a longer period of time during the day. The plant deceives the nectar-collecting bees by attracting them to the similar-looking but nectar-poor male flowers, which are much less expensive for the plant to produce.

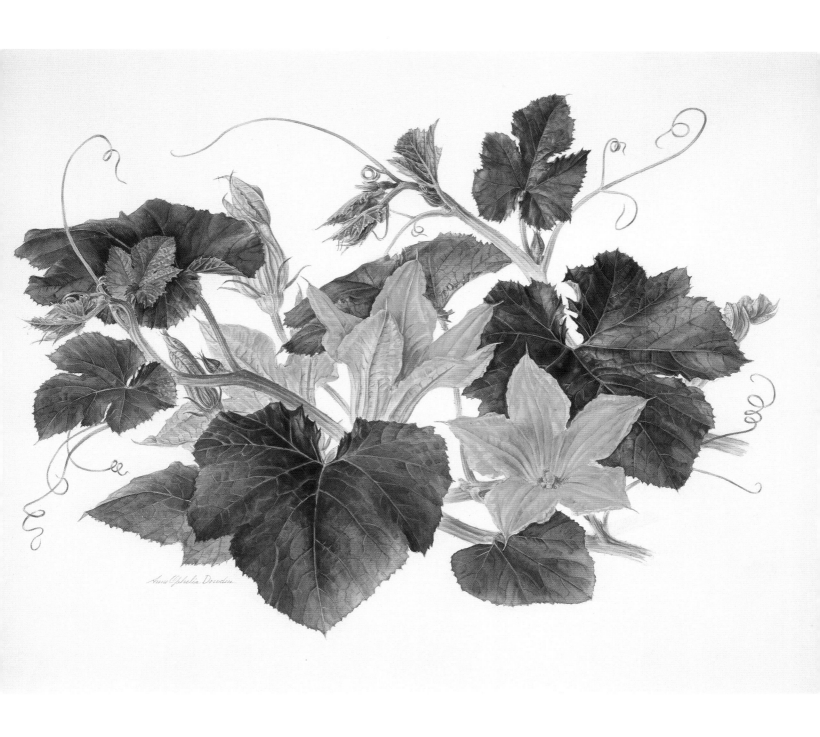

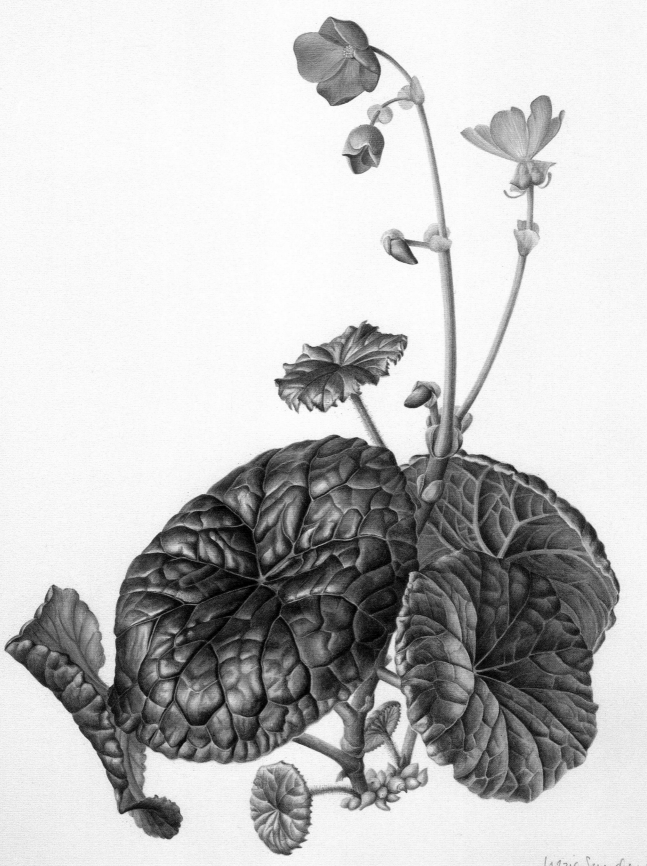

Lizzie Sanders 2000
BEGONIA socotrana

72. Begonia: *Begonia socotrana* – Begoniaceae

Lizzie Sanders, b. London, England 1950, works Edinburgh

Watercolour on paper, 350 mm x 276 mm
Signed *Lizzie Sanders 2000*

Lizzie Sanders lives in Edinburgh. She was the founder partner and director of a graphic design consultancy and is a former Scottish Designer of the Year. She has judged several design awards and been involved in projects for the National Museum of Scotland, British Waterways, Scottish Ballet and the Scottish Tourist Board, among much other creative work. She has lectured widely in Scotland at art schools in Edinburgh, Dundee and Glasgow and has been particularly involved with the Duncan of Jordanstone College of Art, Dundee where she herself qualified.

She showed at the 14th World Orchid Show with other students of the Royal Botanic Garden Edinburgh in 1993, at the Royal Society of Arts, Edinburgh and in a touring exhibition organised by Inverness Museum and Art Gallery, where she won an award in 1998. She has also shown in the Royal Botanic Garden Edinburgh and at the RHS, where she was awarded a gold medal for her paintings of an interesting group of plants from Socotra. She won more gold medals in 2000, 2002 and 2004 and was in the 11th International Exhibition at the Hunt Institute in 2005.

Begonia socotrana was grown at the Royal Botanic Garden Edinburgh, having been brought back from Socotra after an expedition to this isolated, misty island in the Indian Ocean. Her painting is particularly noticeable for the superb lustrous treatment of the domed leaves.

All botanists agree that the family Begoniaceae is a natural evolutionary group. The members of the family are widely distributed in tropical and subtropical regions around the world except Australia. The family contains over 900 species and 99 per cent of them are in the genus *Begonia*; the only other genus, *Hillebrandia*, has a single species endemic to Hawaii. An interesting pollination system has evolved in *Begonia*. The flowers are quite conspicuous, usually white, and are unisexual with both male and female flowers on the same plant. No nectar is produced and the pollinating bees visit the male flowers to collect the very prominent yellow pollen as a reward. The female flowers have bright yellow stigmas much resembling the stamens of the male flowers and deceive the bees into visiting them without providing any pollen reward. The genus is named for the French patron of botany Michel Bégon, who lived from 1638–1710.

Oxalidales

This order includes less than 1,000 species and many are found in the tropical zones. Only the wood sorrels and members of the family Elaeocarpaceae are widely known, although four additional plant families are placed in this order. Some members of the Oxalidales share several flower features, but more investigations of the evolution of the species within this order are needed.

73. *Averrhoa carambola* – Oxalidaceae

Alvaro Evando Xavier Nunes, b. Anápolis, Goiás, Brazil 1945

Watercolour on paper, 430 mm x 317 mm

Signed *Alvaro Nunes* (in Letraset)

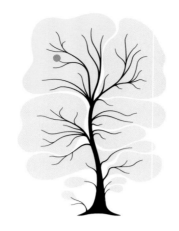

Nunes spends a great deal of time exploring and painting in the tropics and semi-tropical forests of Brazil and has a keen eye for an interesting subject.

This beautifully coloured, luminous painting shows leaves, flowers and fruit on a pendulous branch. Nunes has achieved a wonderful glow on the fruit with a subtle gradation from green to gold and orange, dwarfing the inconspicuous pink flowers.

In the past taxonomists have considered the family Oxalidaceae to be evolutionarily closely related to the family Geraniaceae because of the great similarity in flower structure. However, DNA data have shown that this similarity is due to convergent evolution, which means separate evolutionary pathways have led to this same flower form, and that the two families are not related to each other. Members of the Oxalidaceae are small trees, shrubs, climbers, or often perennial herbs, mostly of the tropical regions of the world. The flowers of species of this family come in two forms: either with long stamens and short styles or with short stamens and long styles. This type of floral dimorphism is called heterostyly and promotes cross-pollination between flowers of different forms. The genus *Averrhoa* is named after a celebrated Moorish physician and philosopher Ibn-Ruschd, who was known as Averroes and lived from 1126–1198.

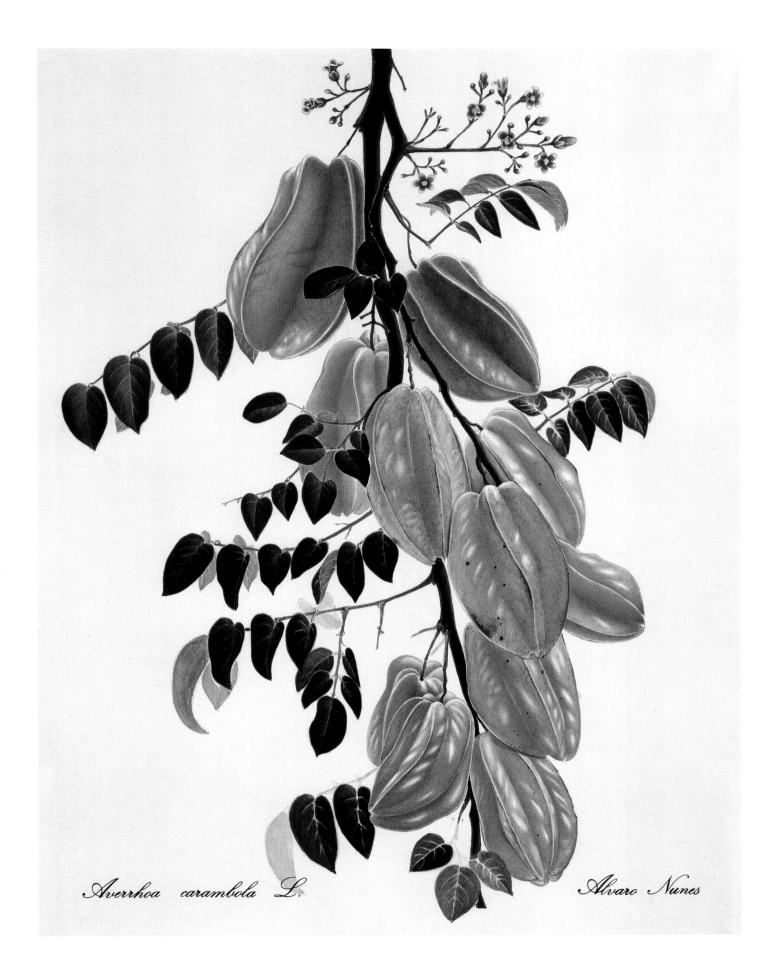

Averrhoa carambola L. *Alvaro Nunes*

BLUE QUANDONG *Elaeocarpus angustifolius*

Margaret A. Saul. 1996.

74. **Blue quandong:** *Elaeocarpus angustifolius* – Elaeocarpaceae

Margaret Saul, b. Brisbane, Australia 1957, works USA and Siena, Italy

Watercolour, gouache and colour pencil on paper, 690 mm x 570 mm
Signed *Margaret A. Saul 1996*
Commissioned

Margaret Saul was born into a family of artists with a keen interest in the Australian native plants that grew around their home in Brisbane, Australia. She had four years of traditional art school education, followed by staff positions as a natural science illustrator at various institutions in Australia. Margaret produced artwork for numerous botanical publications as the Queensland Herbarium's first staff illustrator, a position that led to her interest in botanical art.

During a recent stay in the USA she was instrumental in establishing the Brookside Gardens School of Botanical Art & Illustration, Maryland in 2004 which attracts students from Washington DC and surrounding states.

In 2007 Margaret Saul moved to Siena in Italy. She continues to direct her school in Maryland and is planning to extend the school's programme to Siena. She is currently working in conjunction with the American Society of Botanical Artists (ASBA) developing a resource for botanical art teachers that focuses on drawing – including program design, delivery, drawing techniques and applications. She is the ASBA Chair of Education. Her favourite medium is watercolour with dry colour pencils.

The blue quandong grew on the edge of her garden in Brisbane. The commissioned work is superbly composed with a wonderful range of leaf colour, an exquisite bloom on the berries and a detail of the fruit and the inconspicuous flower.

Evidence from DNA sequence data, floral morphology, and biochemical characters have shown that the family Elaeocarpaceae is a member of the Oxalidales, even though most botanists formerly considered the family to be related to the hibiscus family, Malvaceae. Species of Elaeocarpaceae are tall trees of the rainforests of tropical Asia, the Pacific region, Madagascar, South America, and the Caribbean Islands. As illustrated by the blue quandong, the small- to medium-sized fleshy fruits are often strikingly coloured. They attract small and large animals that eat the fruits and disperse the seeds away from the parent plant. Similar to flowers in the Melastomataceae, the flowers of this family may also be 'buzz-pollinated' by insects that vibrate their bodies causing the pollen to sift out of the anthers, which they then carry to the subsequent flowers they visit.

75. Australian pitcher plant:
Cephalotus follicularis – Cephalotaceae

Christina Hart-Davies, b. Shrewsbury, England 1947

Watercolour on paper, 230 mm x 240 mm
Signed *Christine Hart Davies*

Christina Hart-Davies has held many successful exhibitions and her work is included in collections worldwide, notably in the Hunt Institute.

A committed member of several conservation organisations, Christina travels extensively in Europe, Australia and the Americas to study and paint the native flora. In 1992 she joined an expedition to Sumatra to paint plants of the rainforest and mountain areas, and some of the resulting paintings were included in a three-artist exhibition at the Royal Botanic Gardens Kew in 1994.

Christina was a Founder Member and Honourary Secretary (1985–95) of the Society of Botanical Artists but has now retired to concentrate on illustration. Her delightful Australian pitcher plant gave a lot of pleasure when grouped with other insectivorous plants exhibited in 'Treasures of Botanical Art: Icons from the Shirley Sherwood and Kew Collections'.

The family Cephalotaceae is a small, curious family consisting of a single species of carnivorous plant that is only found in the peaty swamps of the south-western corner of Western Australia. In the past these plants have been classified with the roses and the saxifrages, but are now placed as evolutionary relatives of the carambolas in the order Oxalidales. The small plants are evergreen with leaves of two forms: either entire and slightly fleshy or modified into a pitcher-shaped cup with an over-hanging lid that has patches of light-transmitting cells. Similar to pitcher plants in the families Nepenthaceae and Sarraceniaceae, *Cephalotus* grows in nitrogen-poor soils and must trap insects as a nutrient supplement. However, the Nepenthaceae is a member of the order Caryophyllales (core eudicots) and the Sarraceniaceae is a member of the order Ericales (asterids), both of which are evolutionary unrelated to *Cephalotus* (rosids). This case represents another example of convergent evolution.

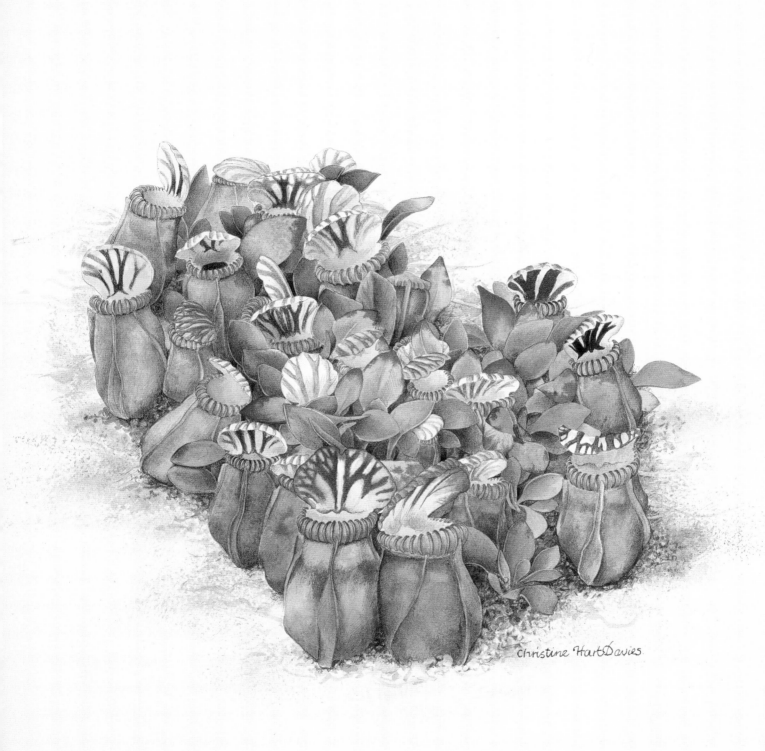

Christine HartDavies

Malpighiales

The evolutionary relationships among the dozens of families and thousands of species (over 13,000 species in all) in the Malpighiales are still under intense debate and study. Like the rosids themselves, DNA data provided the evidence for uniting this heterogeneous assemblage of plants into a single order. Very few flower or fruit traits are shared by all the members of the order, which include the spurges, Saint-John's-worts, red mangroves, Barbados cherries, coca plants, passion flowers, violets, and willows among many other lesser-known species. The largest flower in the world, the parasitic plant *Rafflesia*, is a member of the Malpighiales.

76. *Euphorbia obesa* – Euphorbiaceae

Jenny Phillips, b. Boort, Victoria, Australia 1949

Watercolour on paper, 225 mm x 255 mm

Signed *Jenny Phillips Goode 1993*

Jenny Phillips showed eight euphorbias with the RHS, gaining a gold medal in the 1990s. This small, fat plant is shown in superb detail with its strange little flowers perched on the top of the rotund swollen stem, looking like something from outer space. It is an elegant, detailed study of this character-packed succulent, which is found in South Africa (but which she painted in Australia).

Jenny's exceptional teaching ability has meant that she has been in demand all over the world for master classes.

The large family Euphorbiaceae contains 320 genera and over 6,000 species. Botanists have had difficulty in determining the closest evolutionary relatives of this family. At one time it was considered to have evolved with members of the Malvales, but DNA sequence data have shown it to be better allied with other families of the order Malpighiales. Members of the Euphorbiaceae, which are widely distributed in primarily tropical habitats, are quite different from each other in many features of the leaves, flowers and fruits. Some botanists have cited these differences as a reason to the divide the family into several smaller families. Concerted work on the evolution of the Euphorbiaceae is now underway. The name ' euphorbia' comes from ' Euphorbu,' who was a Greek court physician to Luba II, the King of Mauritania in the first century AD.

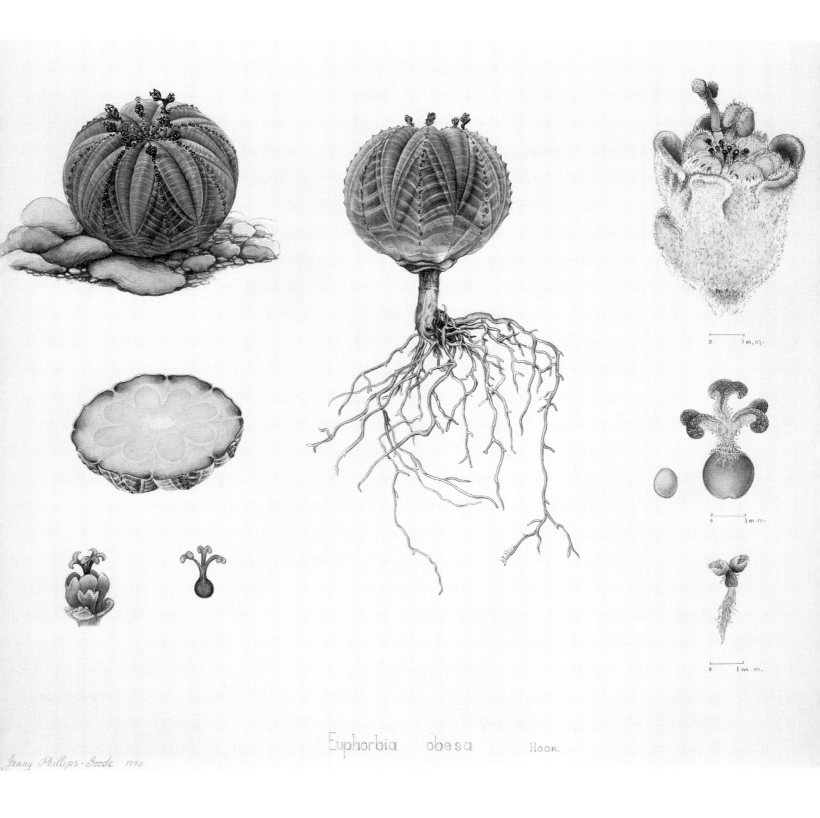

Euphorbia obesa Hook.

Jenny Phillips-Goode 1993

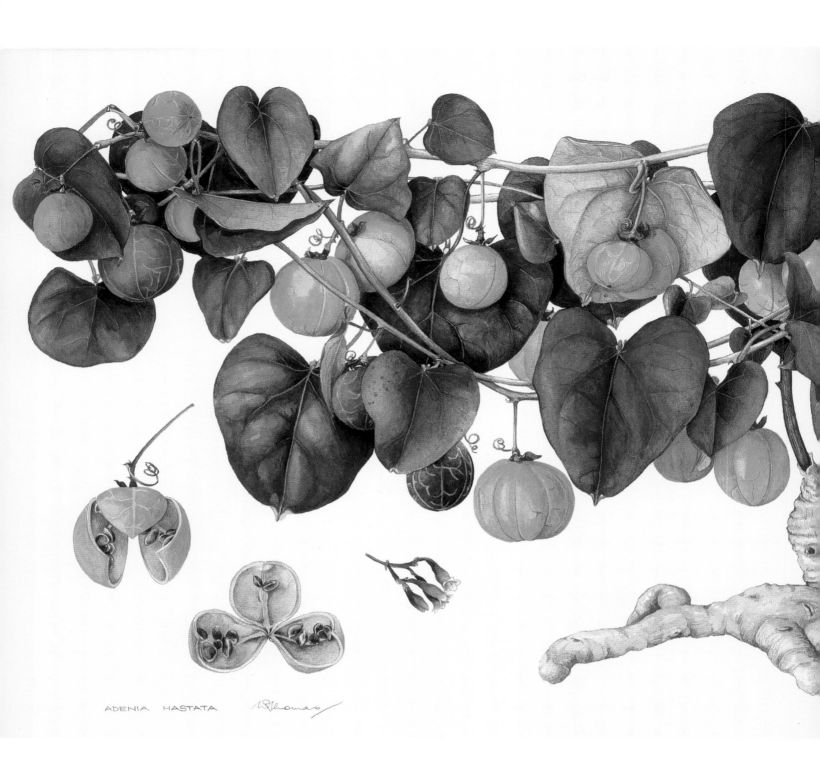

ADENIA HASTATA

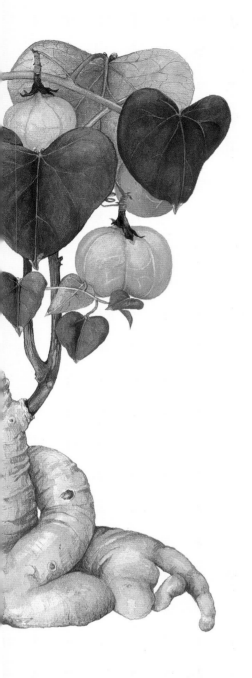

77. *Adenia hastata* – Passifloraceae

Vicki Thomas, b. South Africa 1951

Watercolour on paper, 350 mm x 650 mm
Signed *V Thomas, Adenia hastata*

Vicki Thomas is currently teaching a course in scientific illustration to Stellenbosch University students and has taught botanical illustration through the University of Cape Town's extra mural studies for several years. She regularly holds courses around South Africa. She is a founder member of the Botanical Artists' Association of Southern Africa and a past chairperson.

She painted this interesting work in Kirstenbosch. *Adenia hastata* has very poisonous fruit even if they look like rather tempting golden globes. She has drawn the base of the bush with great skill as well as the delightful golden fruits.

The family Passifloraceae is a characteristic family of the tropics and subtropics around the world with 18 genera and 630 species. An elaborate flower structure with a modified ring of filaments between the petals and stamens shaped like a crown or 'corona' is present in all members of this family and together with DNA data is evidence that this family is a coherent group of plants which have all evolved from a common ancestor. The genus *Adenia* is found in the Asian and African tropics with many species centred in East Africa and Madagascar. This genus is special within the Passifloraceae in that the flowers are either male or female, and only a single sex of flowers is found on one plant. Botanists believe that such a floral sexual system may enhance cross-fertilisation between plants. 'Aden' is the vernacular name in Yemen for the first species described in the genus, *Adenia venenata*, which is native to that country.

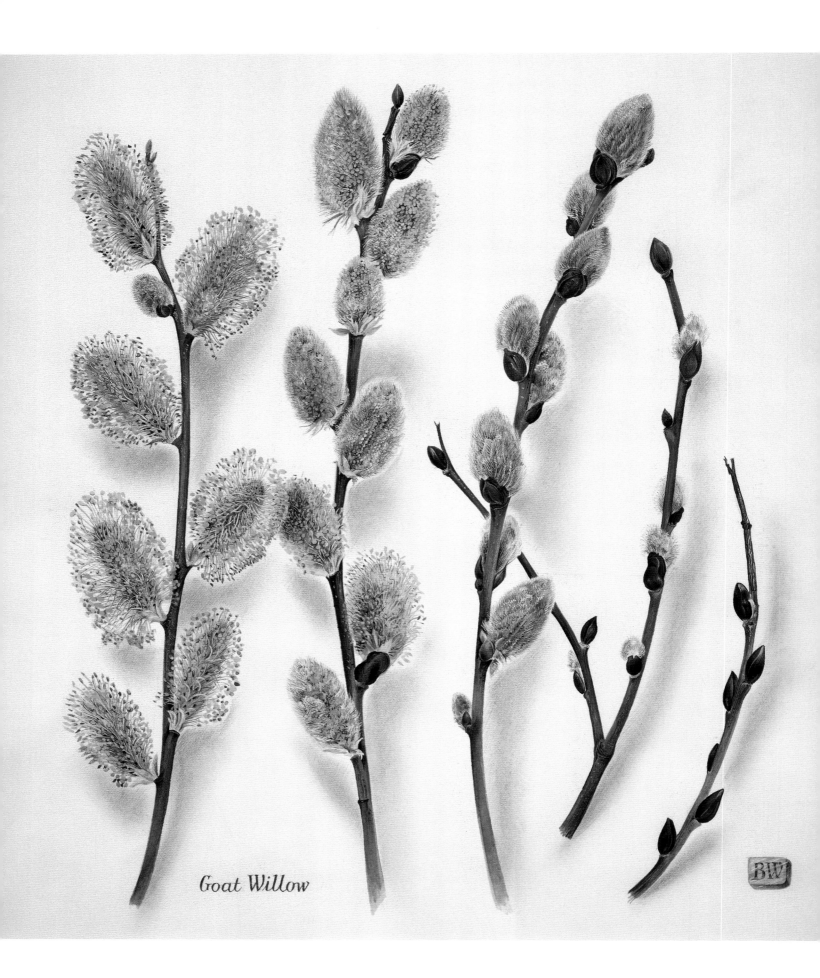

Goat Willow

78. **Goat willow:** *Salix caprea* — Salicaceae

Brenda Watts, b. Ilford, Essex, England 1932
Watercolour on paper, 315 mm x 290 mm
Signed BW

Brenda Watts taught art, craft and design in schools and upon her retirement she plunged into watercolour studies of plants. Working from her home in Surrey, UK, she executes numerous commissions. She paints the most attractive, fresh studies of flowers, fruits and seeds. She was awarded the Certificate of Botanical Merit and also gained the Joyce Cummings award in 1999 at the Society of Botanical Artists.

This delightful watercolour of a sequence of pussy-willow branches shows the development from the tight black bud through the silvery, furry stage to the fully opened inflorescence dusted with sparkling golden pollen. It is a lively painting, beautifully executed with faint shadows projecting it from the page in a rather Victorian style.

The classification and evolutionary position of the family Salicaceae has changed substantially over the last century. Early botanists considered the simple, inconspicuous flowers, which lack petals and are grouped in pendent clusters, as a 'primitive' feature and considered the genus *Salix* and *Populus* (poplars) to be some of the oldest flowering plants from which other plants with more conspicuous and colourful flowers evolved. Later taxonomists, using evidence from DNA sequence data, have shown that these plants are not primitive, but that the 'simple' flowers are highly reduced and have evolved from plants with larger showy flowers. Most recently the taxonomic concept of the Salicaceae has been broadened even further to include tropical species formerly classified in other families. The small flowers of *Salix* lack petals but have nectaries and the hanging flower clusters, or catkins, are visited by insects although wind may also disperse the pollen between flowers on different trees.

79. **Violet:** *Viola* **sp.** — Violaceae

Paul Jones, b. Sydney, Australia 1921–1997

Acrylic on paper, 245 mm x 210 mm

Signed *Paul Jones*

Although Paul Jones considered himself a flower painter he would certainly not have scorned the title botanical artist as well. His camellia paintings, so beautifully published in the two volumes of *The Camellia*, are a lasting testimonial to his ability to observe subtle differences in a lush, romantic way. His romantic side is shown again in the two books he did for the Tryon Gallery, with a variety of coloured backgrounds which he then over-painted with the flower subject in acrylic.

This is a perfect study of a violet with flowers, buds, slender stems and beautifully observed roots. Violets were one of Paul Jones' favourite subjects which he sometimes drew mixed with his great love, camellias. The dewdrops on the leaves were one of his 'trademarks'.

The family Violaceae, although not large in numbers of taxa with 22 genera and 950 species, is quite diverse in its distribution and its life forms. Members of this family range from small temperate zone herbs to tall tropical trees as well as shrubs and vines. The flowers are mostly insect-pollinated by bees, flies, and butterflies, and often have colourful markings on the petals in order to guide the pollinators to the nectar, which is stored in a spur-like structure at the base. Temperate violets have a distinctive spatial separation of the male and female organs in the same flower as a means to prevent self-pollination and inbreeding. It is curious that the same plants also produce much reduced flowers hidden under the soil that never open and are consistently self-pollinated and inbred.

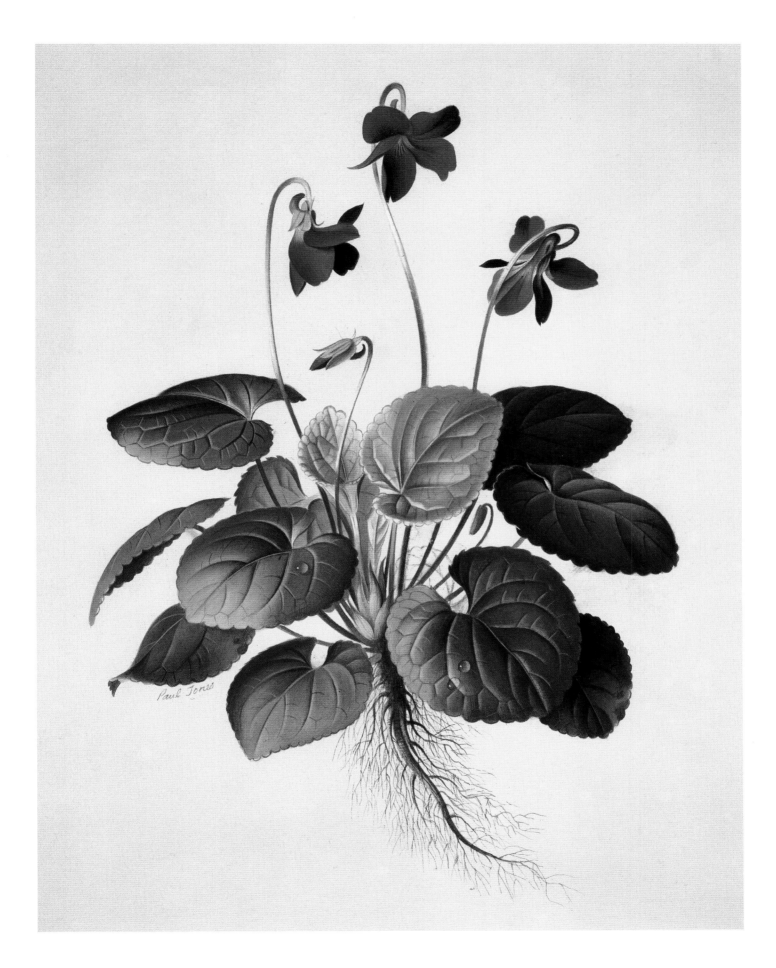

Paul Jones

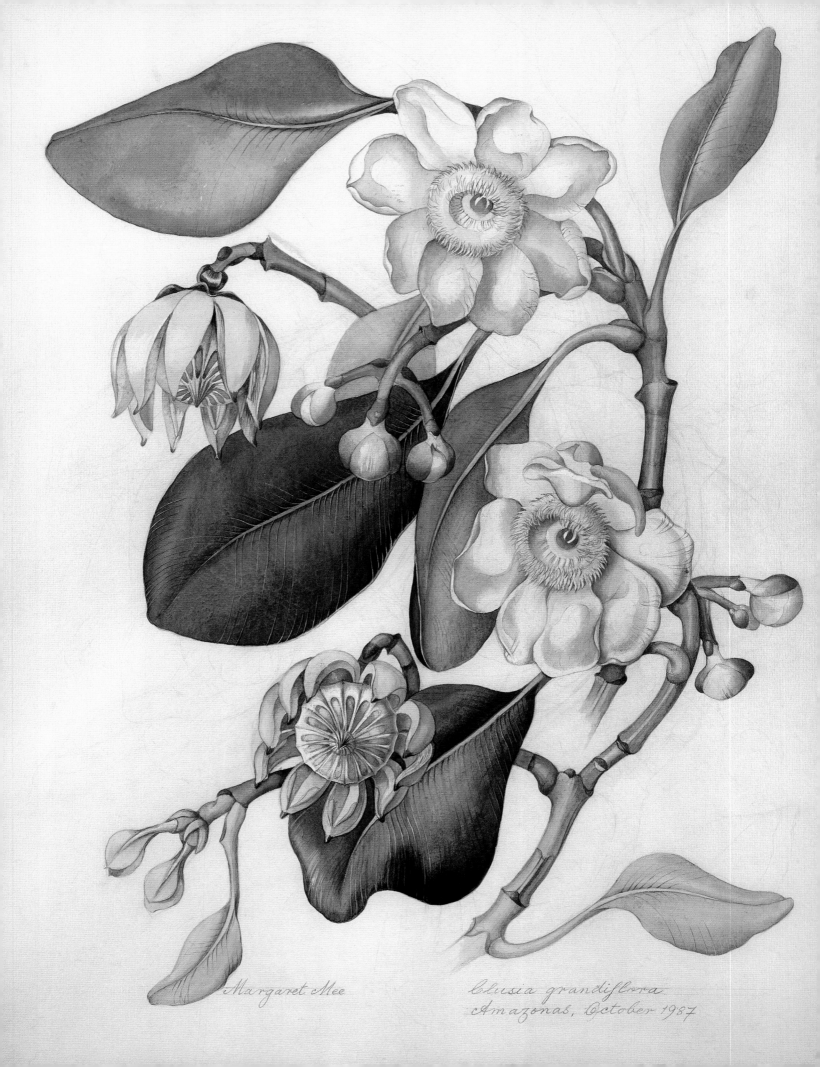

Margaret Mee

Clusia grandiflora
Amazonas, October 1987

80. *Clusia grandiflora* – Clusiaceae

Margaret Mee, b. Chesham, Buckinghamshire, England 1909–1988, worked in Brazil

Watercolour and gouache on paper, 660 mm x 485 mm
Signed *Margaret Mee*

This study by Margaret Mee was acquired in 2002 for the Shirley Sherwood Collection. Painted in 1987, near the end of her life, it is a lovely plant portrait of this beautiful tree with its luscious white and pink flushed blossoms. As usual with Margaret Mee's work it is excellently composed, painted in watercolour and gouache on paper and very fresh.

Margaret inspired many Brazilian artists such as the Demonte family, Marlena Barretto, Patricia Villela and Alvaro Nunes, and the Fundacão Margaret Mee has raised money to finance the exchange of dozens of scholars between Kew and Brazil.

Members of the family Clusiaceae are widespread in the tropics and include 1,110 species in 38 genera. Special cellular and chemical features, including distinctive exudates and saps, are characteristic of all members of this family and together with DNA data provide evidence that all the species in this family are closely related to each other. The flowers of the Clusiaceae are also distinctive in that they have evolved special resins which are collected by the bees that pollinate them. No nectar is produced and the bees use the resin to construct their nests. This relationship between the resin-producing flowers of the Clusiaceae and resin-using bees is a good example of a highly-evolved plant-animal interaction. Clusia was named in honour of the celebrated French botanist and plant collector Carolus Clusius, who lived from 1526–1609.

81. **Koemaroe-njannjan:** *Mourera fluviatilis* – Podostemaceae

Manabu Saito, b. Tokyo, Japan 1929, works in USA

Watercolour on paper, 612 mm x 460 mm
Signed *Manabu Saito Aug '68*

Manabu Saito painted *Mourera fluviatilis* in August 1968 near Stoelman's Island, Surinam, on the north-east coast of South America. The plants were growing on rocks in the rapids of a tributary of the Morowijne River north of Stoelman's Island. He was on an expedition with Dr John Craig who took several photographs of Manabu crouched sketching, perched precariously on partially submerged rocks, surrounded by a fast-flowing river. The leaves can be up to 2 metres long and it is known locally as kumaru-nyam-nyam or 'food-for-fish'.

Mourera fluviatilis is a member of Podostemaceae, the river moss family. Locals in South America use this and other related plants to obtain much needed salt. They harvest it, dry it and reduce it to ashes, then extract the salt with water and evaporate it to obtain crystals. It is used to fight diarrhoea and some tribes use it to restore menstruation. Applied to wounds, especially burns, it seems to expedite healing. Found from Colombia to Bolivia it is not terribly common in collections mostly because it is overlooked, or botanists are afraid of going into the water after it. Looking at the photographs of Manabu Saito in the middle of this raging torrent it is easy to understand that botanists might be too nervous to collect it, let alone attempt to paint it *in situ*.

Members of the family Podostemaceae look like mosses or algae growing on rocks in the fast-moving waters of rivers in tropical and warm temperate areas of the world. These species are among the most bizarre of all flowering plants. Because of the plants' unique features, which may have evolved as a result of the highly specialised aquatic habitat where they live, botanists have had difficulty in determining the exact evolutionary relationship of this family to other plants. DNA sequence data provide strong evidence for the placement of the Podostemaceae in the order Malpighiales close to the Clusiaceae. The species *Mourera fluviatilis* grows in northern South America, including south-eastern Venezuela, Guyana, Surinam, French Guiana, and northern Brazil. Highly modified, claw-shaped roots anchor the stems and cabbage-like leaves to rocks in the river. The tall, erect clusters of pink and purple, sweetly scented flowers produce many stamens and are pollinated by bees.

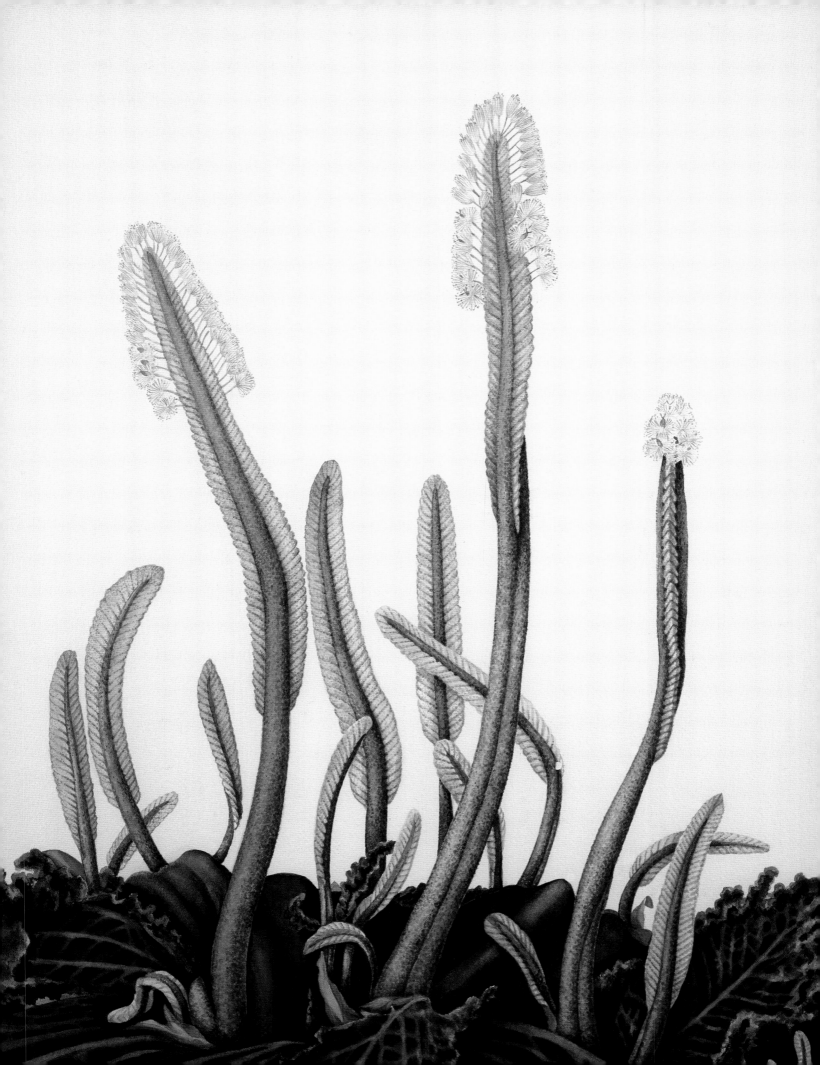

Geraniales

Mostly made up of the members of the geranium family, this order is relatively small with only a few families and less than 800 species. The flower structure (placement of the stamens and nectarines) and specialised leaves with glands are characteristics of these plants. Over the last several decades the classification of this order has changed. For example, the closest evolutionary relative of the family Geraniaceae was formerly thought to be the family Oxalidaceae (the carambolas), but DNA evidence now places the family in its own order Oxalidales.

82. **Pelargonium:** *Pelargonium tetragonum* – Geraniaceae

Ellaphie Ward-Hilhorst, b. Pretoria, South Africa 1920–1994

Watercolour on paper, 480 mm x 350 mm
Signed *E.Ward H 1993*

Ellaphie Ward-Hilhorst had always loved pelargoniums and decided to paint all the known species. She collaborated with botanists at Kirstenbosch, producing the illustrations for three remarkable volumes on the *Pelargonium*, involving 314 watercolours and 160 habit sketches.

Her fidelity with pelargoniums was such that one research worker said she did not need to measure a living specimen, she could get all the information she required from Ellaphie's meticulously accurate and yet beautiful plates.

This particular pelargonium is reproduced in *The Art of Botanical Illustration* by Wilfrid Blunt and William T Stearn (1994).

The family is made up of seven genera and about 750 species, many of which are native to North America. Species in the genus *Pelargonium*, most diverse in the Cape regions of South Africa, have unique flowers in the family with distinctive nectar-producing spurs. The flowers are pollinated by many types of insects. They are directed to the nectar by special colour patterns, called 'nectar guides.' The generic name is derived from the Greek 'pelargos', which means 'stork' because of the resemblence of the fruits to the beaks of these birds.

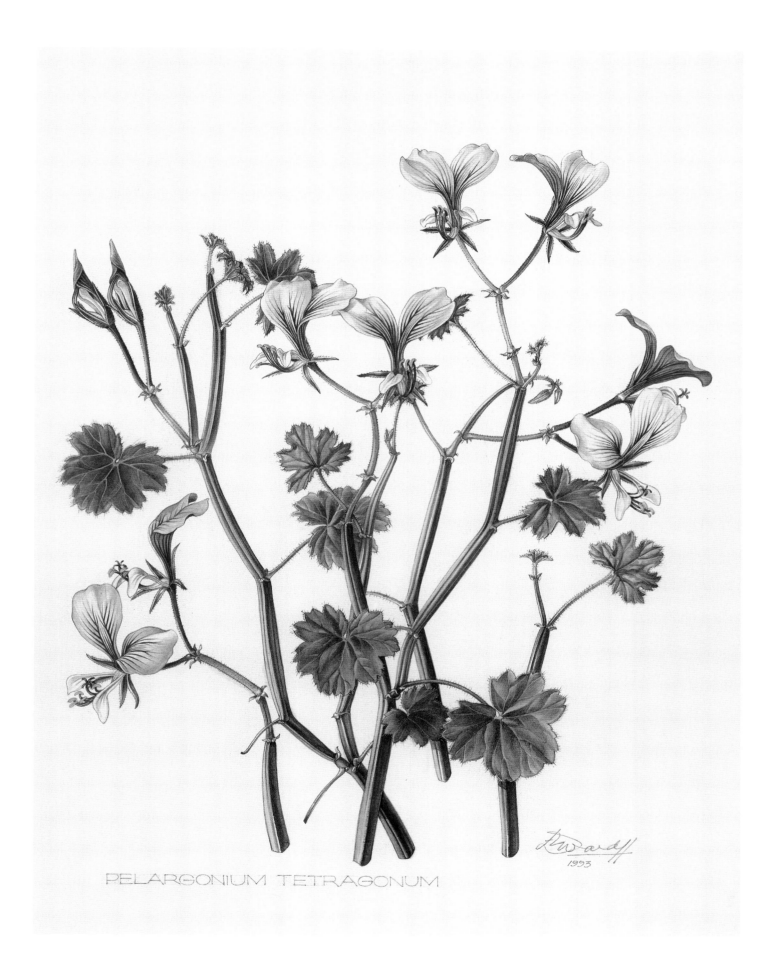

PELARGONIUM TETRAGONUM

Myrtales

The closest relatives of this order in the rosids are still unclear. The Myrtales contain over 9,000 species in total, including such well-known plants as the myrtles, the evening primroses, the loosestrifes, the melastomes, and some mangrove plants. Taxonomists have intensively studied the plants in this order and much is known about their traits and classification. Several characteristics of the wood structure as well as some flower features unite the 13 families of the Myrtales. Many species of myrtles and melastomes are native to tropical zones.

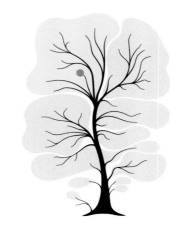

83. **Pomegranates: *Punica granatum*** – Lythraceae

Ann Schweizer, b. Cape Town, South Africa 1930

Watercolour on paper, 420 mm x 520 mm
Signed *Ann Schweizer*

Ann Schweizer caused a sensation in the first Kirstenbosch Biennale Exhibition when she presented a dramatic branch of figs and a spectacular strelitzia.

At a later Biennale she exhibited her still life of pomegranate fruits which show the different stages of young, ripe and burst open, some still on their spiny branches. It has a great deal of the *joie –de vivre* and vitality sometimes seen in Ann Schweizer's work.

The family Lythraceae is one group of plants where all traditional systems of classification as well as evidence from DNA sequence data agree: both on its placement in the order Myrtales, and on its close relationship to the evening primrose family, the Onagraceae. Many members of the Lythraceae produce two types of flowers: one type has long styles and short stamens, the other type has short styles and long stamens. This reciprocal arrangement of floral types promotes the transfer of pollen between flowers of the two types and thus ensures cross-fertilisation between plants. *Punica granatum*, the pomegranate, is native to the Persian region and many of the wild ancestors of cultivated varieties can still be found in the area. The best cultivars of pomegranates were selected artificially thousands of years ago and maintained in some cases through clonal propagation from generation to generation.

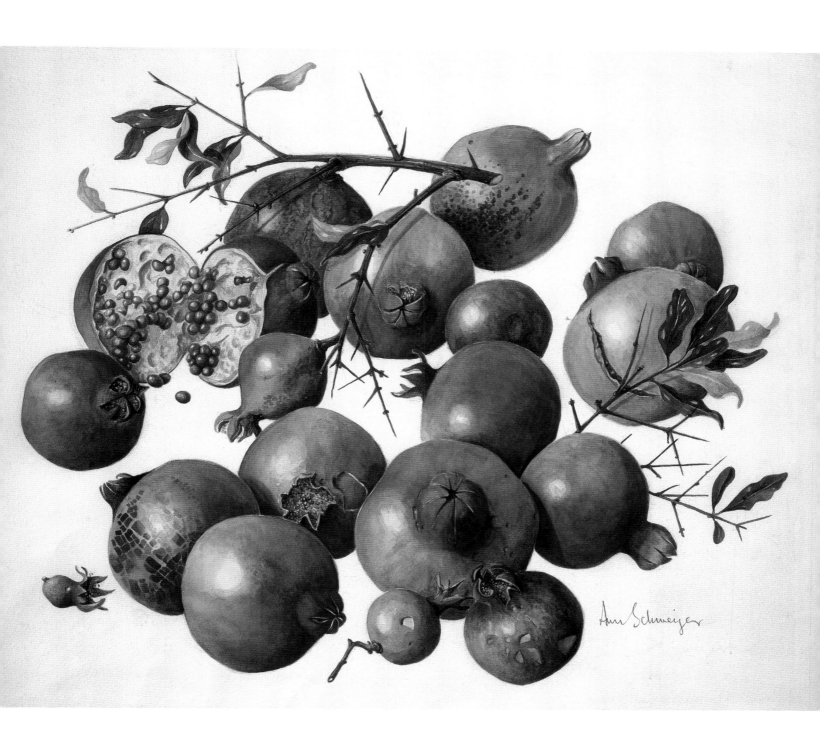

84. Fuchsia: *Fuchsia* cv. 'Corallina' — Onagraceae

Siriol Sherlock, b. Nantwich, England 1954

Watercolour on paper, 430 mm x 370 mm
Signed *Siriol Sherlock*
Commissioned

Siriol Sherlock studied textile design at the Winchester School of Art and then worked in the textile business producing floral furnishing designs. She began exhibiting in 1986 and has continued ever since. Since 1988 she has shown with the Society of Botanical Artists annually, and she also held a solo show at Kew in 1992. She has painted detailed botanical studies for *Curtis's Botanical Magazine* and *The New Plantsman* and has undertaken numerous other commissions. Siriol was a member of the RHS Picture Committee for eight years until 2006 and has taught several of the Master Classes for Orient-Express Hotels.

This fuchsia was commissioned in 1993. Its design is free, yet her unusual technique of using watercolour without preliminary studies in pencil still results in a detailed and accurate painting. This cultivar is an attractive shrub which is hardy in southern England.

Members of the family Onagraceae are herbs, shrubs, lianas, epiphytes, and rarely small trees; many are native to western North America and South America. The family is well-supported as a single evolutionary or monophyletic group. *Fuschia*, which is distributed in Central and South America as well as New Zealand and Tahiti, possesses flowers that are brightly coloured, usually red and pink, can be drooping or pendent, and produce abundant nectar. Hummingbirds in the American tropics and honey-eaters in New Zealand are the main avian pollinators that can easily access the nectar in the hanging flowers. The genus was named in honour of the German botanist and physician Leonhart Fuchs, who lived from 1501–1566. Fuchs described many new species of plants that were being discovered in the Americas, but supposedly never saw a species of *Fuchsia*.

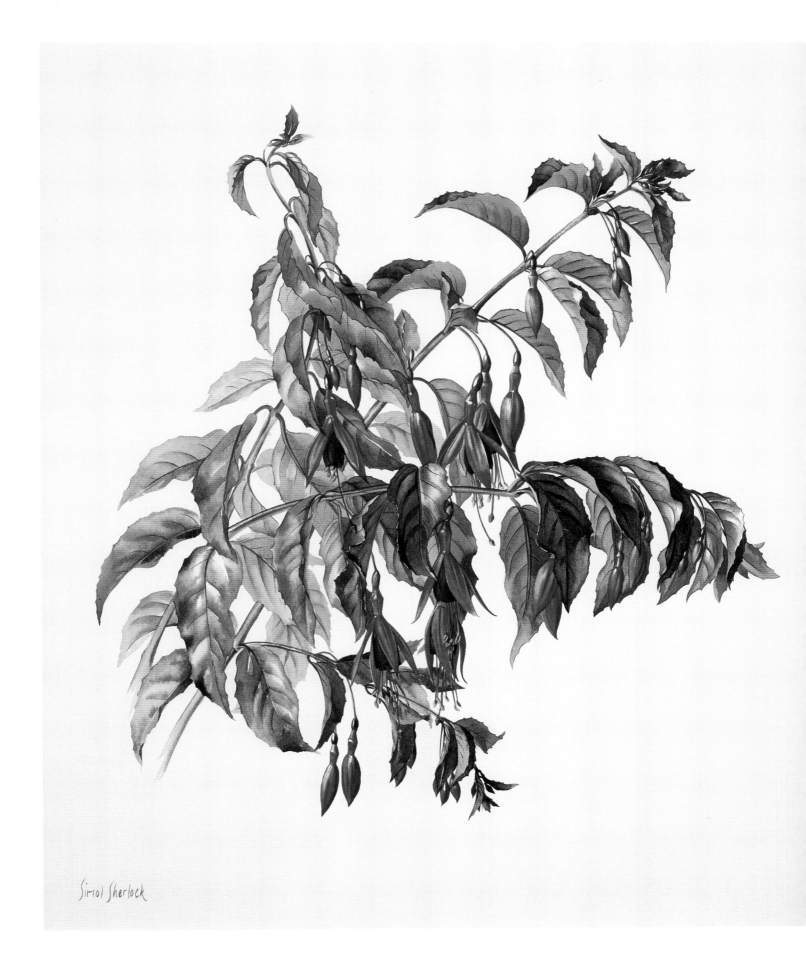

Siriol Sherlock

85. *Corymbia ficifolia* – Myrtaceae

Jenny Phillips, b. Boort, Victoria, Australia 1949

Watercolour on vellum, 530 mm x 390 mm
Signed *Jenny K. Phillips 1998*
Commissioned

Jenny Phillips spent some months studying in Europe, looking at the old masters of the past, stored in the rich libraries and collections of Italian, English and French museums; soon afterwards, in 1993, she showed eight examples of euphorbias at the RHS and was awarded a gold medal. She established her Botanical Art School in Melbourne in the early 1990s and has trained several teachers there. In 1997 she was invited to teach classes in botanical painting for the Orient-Express Hotels, and she has given master classes in Cape Town, Johannesburg, Venice, Sydney and Charleston, where she has been an inspirational tutor, indeed probably the most influential in the world today.

Inspired by the work of Ferdinand Bauer on display in Sydney in 1998 she set to work to do something similar, using vellum for the first time. She chose a pink gum tree, *Corymbia ficifolia*, painting the individual flowers and fruit in the style of Ferdinand Bauer.

The large family Myrtaceae has 144 genera and over 3,000 species. These are mainly distributed in tropical regions around the world including the Americas, Asia, Australia, and sub-Saharan Africa. The family is a coherent evolutionary group recognised by all botanists and supported by numerous lines of evidence, including DNA. The flowers possess many conspicuous, often colourful stamens and the bark has a tendency to flake or peel in a characteristic fashion. The genus *Corymbia* is rare in its native habitats south-east of Perth in the Stirling Mountain Range in western Australia. The name 'corymbia' comes from the Latin 'corymbium' or 'corymb,' which is a type of inflorescence, or cluster of flowers, in which all the stems holding the flowers branch-off from the main axis at different levels, but ultimately open their flowers at the same level.

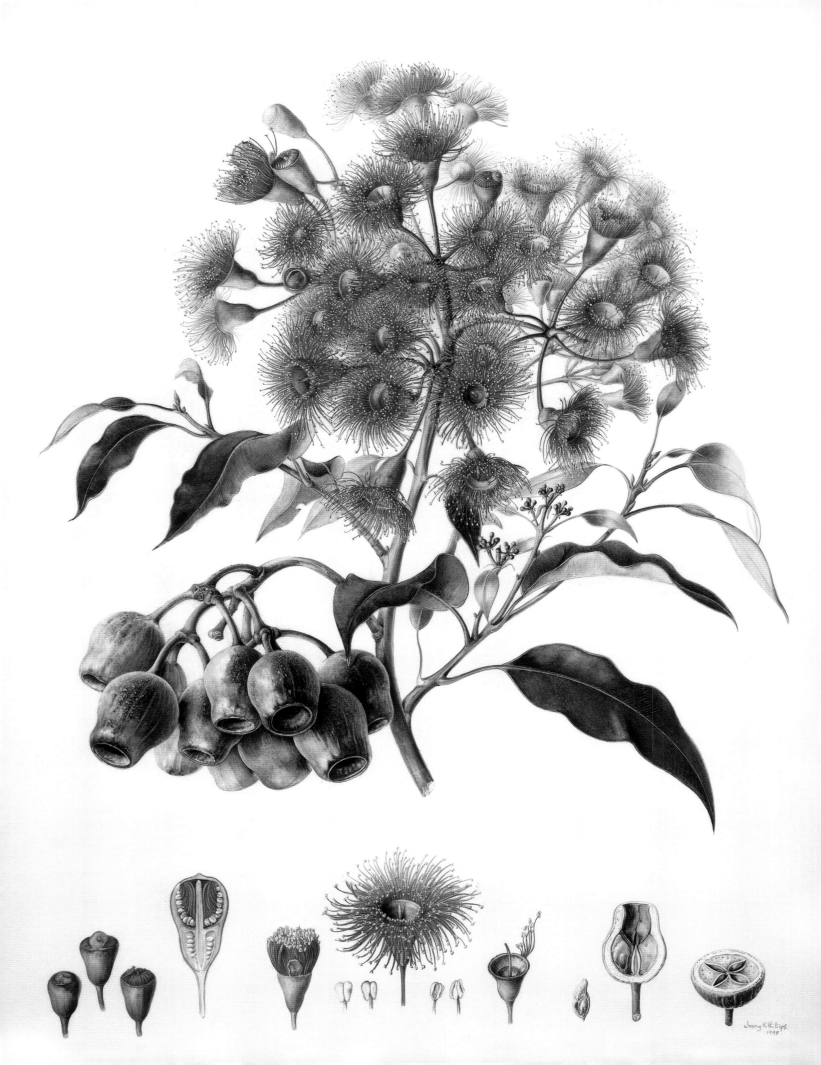

Jenny K Phillips
1998

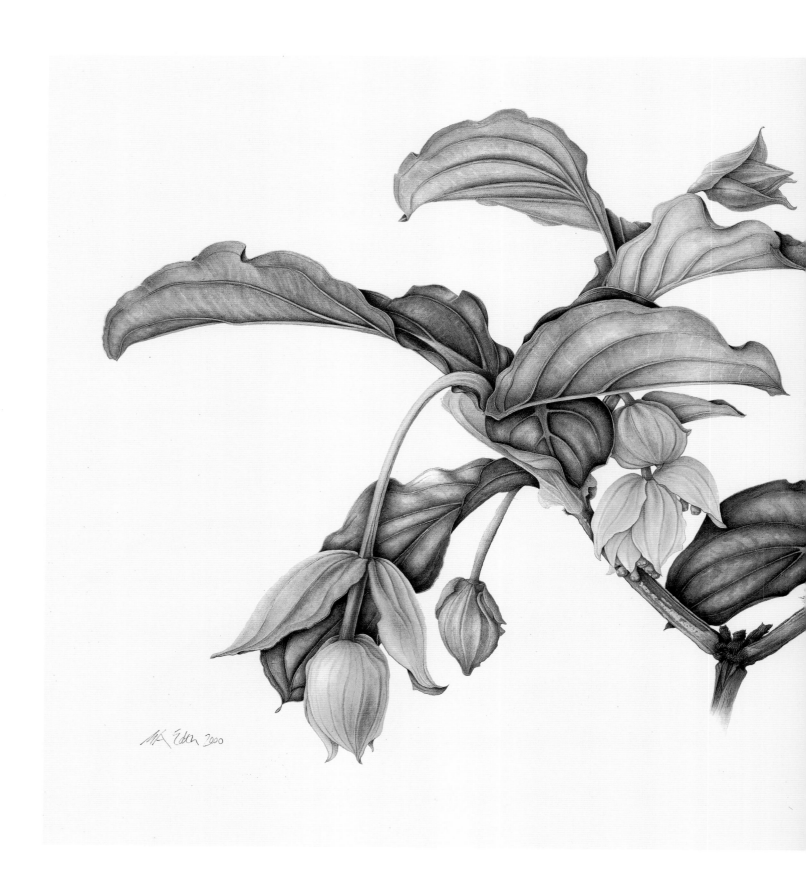

86. *Medinilla magnifica* – Melastomataceae

Margaret Ann Eden, b. London, England 1939

Watercolour on paper, 560 mm x 750 mm
Signed *M. A. Eden 2000*

Lady Margaret Ann Eden studied at the English Gardening School in the Chelsea Physic Garden, at the botanical art classes taught by Elizabeth Jane Lloyd and later by Ann-Marie Evans. These impressive courses have been fine-tuning some of the best of today's British botanical artists.

Margaret Ann Eden spent most of her childhood in Canada and Hong Kong. She started painting early and in 1959 she went to the Byam Shaw School of Art; she later studied portrait, life and still life painting with Bernard Adams. She began painting flowers in watercolours at the end of the 1960s.

She has an unerring eye for an interesting subject. *Medinilla magnifica* is from the island of Luzon in the Philippines. It is an epiphytic plant that can be seen perching on tree-trunks, and it likes warmth and humidity but no direct sunlight. Margaret Ann's watercolour shows each stage of the opening bud and the cascade of flowers. But this is not a laboured exercise in botanical illustration; it has become a work of art, and has been selected for a special series of ceramic plates by Wedgwood commemorating the Shirley Sherwood Collection.

All tropical botanists can recognise members of the family Melastomataceae by their leaves, which have two to eight distinctive primary veins that run parallel to the leaf margins, starting at the base and converging at the tip. Such a universal character, which is found in most if not all members of a plant family, suggests that this feature evolved in the earliest ancestor of the family and has been passed on to all descendents. This type of feature is very useful in tracing the evolution of groups of species and is used by taxonomists to determine evolutionary relationships. Members of the Melastomataceae can be trees, shrubs, herbs, lianas or epiphytes and are distributed in tropical regions around the world. The flowers have special anthers that open by pores. Bees, the primary pollinators, 'buzz' the flowers causing the pollen to sift out of the anthers, which is then collected as a reward to the insect instead of nectar.

Sapindales

Most of the members of this order are trees or shrubs with leaves divided into leaflets arranged along a central midrib. In addition many of the families are characterised by the production of resins and bitter compounds in the leaves, bark, and wood. Many of the trees in this order are native to the tropical and subtropical regions of the world. The nine families making up the Sapindales include the maples, soapberries, horse chestnuts, mahogany, citruses, sumacs, poison ivies, frankincense, and myrrh. Important fruits include the lychee, rambutan, akee, mango, cashew, and orange.

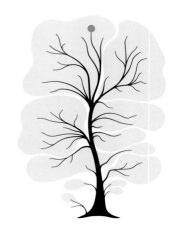

87. **Horse chestnut:** *Aesculus hippocastanum* – Sapindaceae

Pauline Dean, b. Brighton, England 1943–2007

Watercolour on paper, 460 mm x 340 mm
Signed *P. M. Dean*

Pauline Dean was awarded eight gold medals and two further 'joint' ones by the RHS. She had a solo exhibition at the Botanical Garden in Geneva in 1999 and exhibited at the Linnean Society in London, the Hunt Institute in Pittsburgh, the Everand Read Gallery, Johannesburg and also illustrated a number of books. *The New Plantsman* commissioned her to paint a number of plates. Until prevented by ill health she taught Botanical Art at the RHS garden at Wisley in Surrey for eleven years up to 2002, and designed the successful series of 'Winter Flower' ceramic plates for the RHS made by Royal Worcester.

The family Sapindaceae is another family whose taxonomic boundaries have been broadened as a result of new evidence from DNA sequence data. Often non-DNA traits, which were earlier overlooked by botanists, provide additional evidence for making taxonomic decisions after the DNA data are confirmed. In this case the family Aceraceae (maples) and the family Hippocastaneacea (horse chestnuts), which were formerly separately recognised families, are now included in a widely defined Sapindaceae based on DNA evidence. The presence of a unique type of amino acid present in all of these plants is complementary to the DNA data in supporting this new classification. Flowers of *Aesculus hippocastanum* turn from yellow to red after nectar production ceases and the flower is no longer receptive. This change in colour, which is also accompanied by a change in fragrance, signals to the floral visitors that the older flowers should no longer be visited and directs the pollinating insects to newly open flowers.

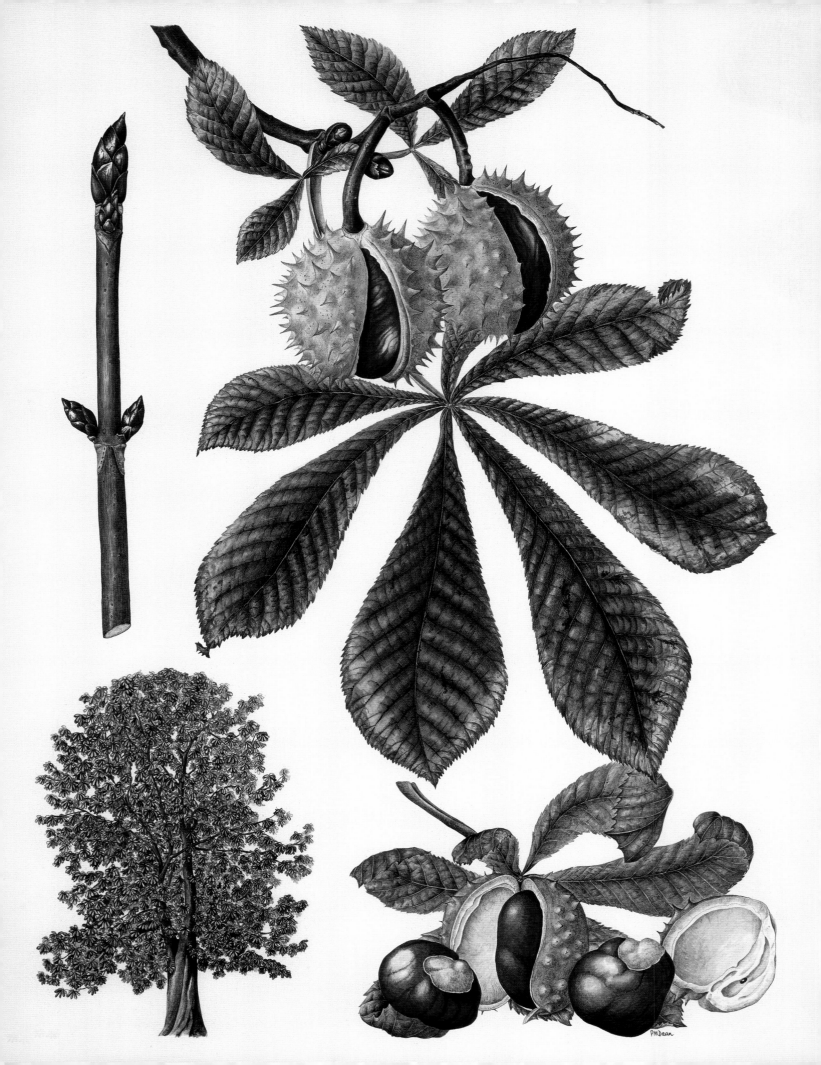

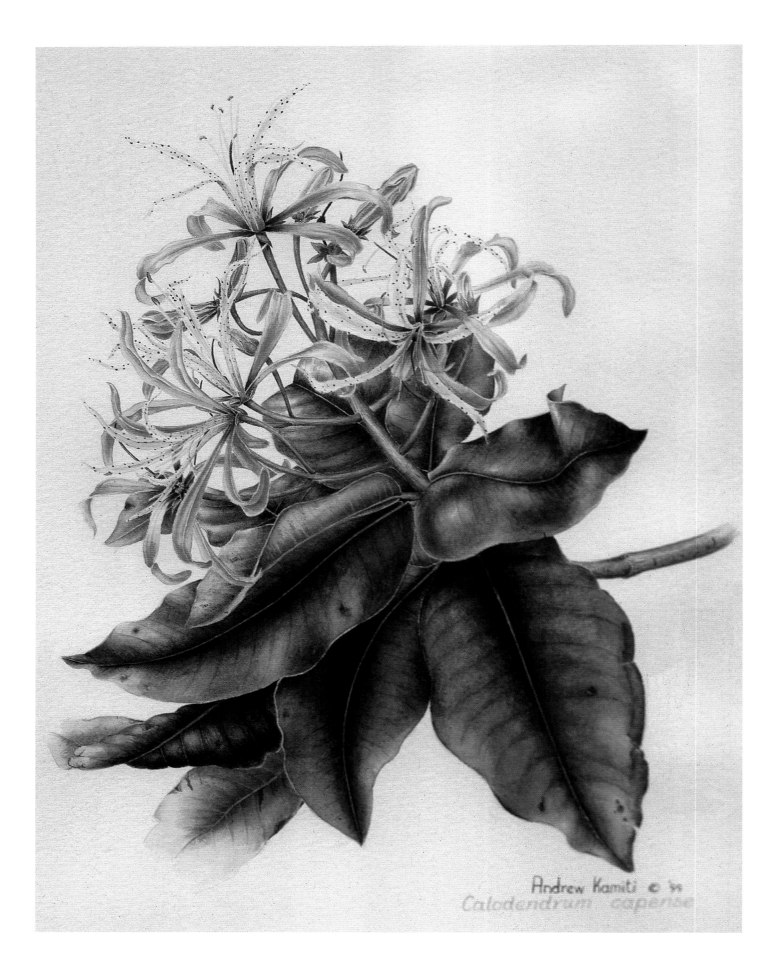

Andrew Kamiti © '94
Calodendrum capense

88. *Calodendrum capensis* – Rutaceae

Andrew Kamiti, b. Nairobi, Kenya 1970

Watercolour on paper, 300 mm x 250 mm
Signed *Andrew Kamiti © 99*

This young Kenyan artist, Andrew Kamiti, made an impressive debut at Kirstenbosch Botanical Gardens in 1999 with an exhibition of paintings of butterflies associated with plants. Merle Huntley, the curator, felt that his plant paintings were of such a standard that he should be invited to be part of the Inaugural Botanical Exhibition in Kirstenbosch a year later, so she organised his entry. Kamiti gained a bronze medal in some distinguished company. While he was in Cape Town he attended classes taught by Jenny Phillips, organised by Shirley Sherwood.

Calodendrum capensis is a spectacular tree flowering in South Africa in the summer, with great trusses of pale pink showing up against the glossy leaves.

Although the members of the family Rutaceae are considered to make up a unified evolutionary group, the internal classification within the family is still not clear. One of the most characteristic traits of the Rutaceae is the tiny cavities present in the leaves and other tissues of the plant that contain ethereal oils and give the oranges and their relatives their special sweet oily odours. The over 900 species in the family are primarily native to the tropical regions of the world, especially in the southern hemisphere. However, a few species also inhabit the temperate zone. The flowers of many species are intensely fragrant and attract various insects as their pollinators. The Rutaceae have evolved many different types of fruits as a diverse means to disperse the seeds by animal (vertebrates) and non-animal (wind) vectors, including fleshy fruits with leathery or hard rinds, winged fruits, and fruits that split open.

89. Klapperboo: *Nymania capensis* – Meliaceae

Barbara Pike, b. Johannesburg, South Africa 1933

Watercolour on paper, 430 mm x 330 mm
Signed *Barbara Pike*

Barbara Pike became a biochemist and medical artist after graduating from the University of Witwatersrand. After a couple of years she moved to the University's botany department as a botanical artist and became freelance in 1959. She has shown in many exhibitions in South Africa, particularly in the Everard Read Gallery in Johannesburg and in congresses devoted to succulents.

Barbara has produced the illustrations for all three editions of *A Natural History of Inchaca Island, Moçambique* by W. McNae and M. Kalk, as well as plates illustrating the flora of the veld and Witwatersrand. She was awarded a silver Kirstenbosch medal for her *Nymania capensis* and other works.

Nymania capensis is commonly known as Chinese lantern or klapperboo in South Africa. This is an unusual shrub or small tree, belonging to the Meliaceae, which is found in semi-desert areas such as the Little Karoo in Cape Province, South Africa. It is quite a bleak area notable for its ostrich farms, the desert studded with cacti and mimetes, where the bright reddish pink 'lanterns' of the balloon-shaped fruits stand out. Buds, flowers and fruit in different stages of maturity can appear together on the same branch. The flowers first appear in the winter and mature to greenish-pink and then deeper pink bells in the spring.

Members of the family Meliaceae are found in most of the tropical regions of the world and grow as small understorey trees in rainforests, mangroves, and even deserts. The 51 genera and 550 species are considered to be closely related evolutionarily to each other based on evidence from DNA and non-DNA characters. *Nymania capensis* is one of the species that favours the arid regions of south-western Africa where it grows in hot, dry habitats. The plants show certain adaptations to desert conditions, including the evolution of a unique form of seed dispersal. When mature, the fruits form balloon-shaped capsules; these contain the seeds, which are blown by the wind across the open dry habitats. The capsules become lodged under small bushes where they are protected until the infrequent rains allow the seeds to germinate and begin to grow. The genus is named after the Swedish botanist Carl Fredrik Nyman, who lived from 1820–1893.

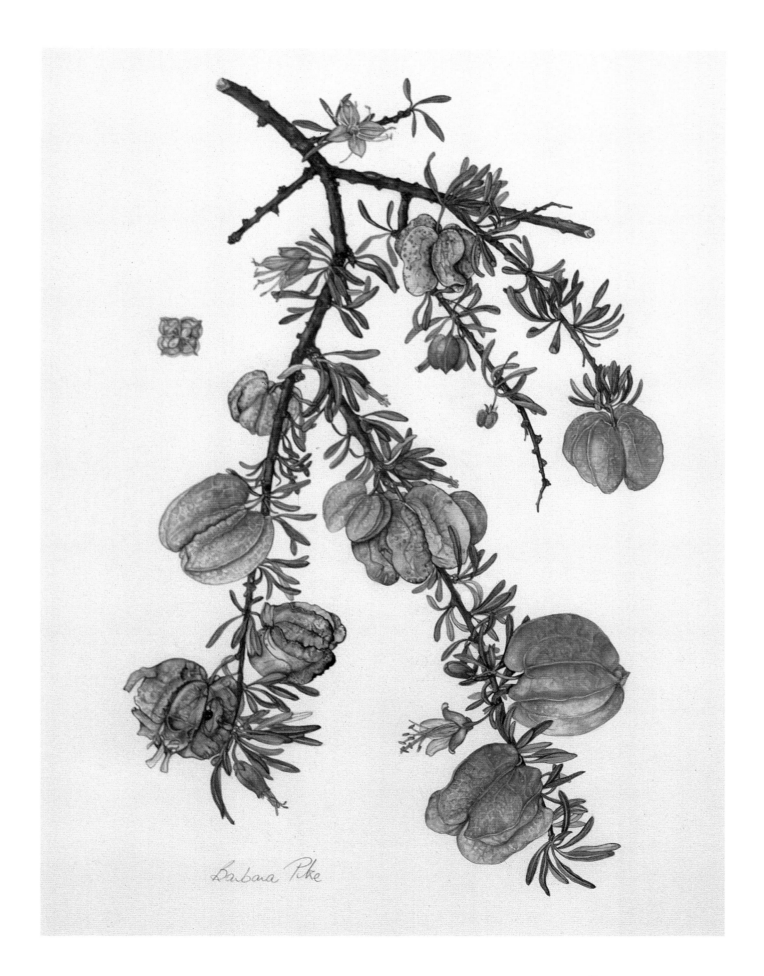

Barbara Pike

Malvales

The nine plant families and over 3,500 species in the Malvales share several unique characters in their wood structure, stamen development and seed coat, and are strongly supported as being closely related by DNA data. Within the order, the definition of the families has significantly changed recently with many genera now placed into a very large mallow family, the Malvaceae. Many members of the Malvales are important tropical trees and the large flowers of a number of them are pollinated by birds and bats.

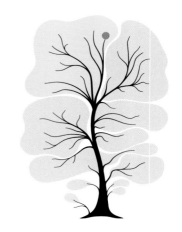

90. *Psuedobombax tomentosum* (**fruit**) – Malvaceae

Alvaro Evando Xavier Nunes, b. Anápolis, Goiás, Brazil 1945

Watercolour on paper, 440 mm x 327 mm
Signed *A Nunes* (in Letraset)

91. *Psuedobombax tomentosum* (**flower**) – Malvaceae

Watercolour on paper, 440 mm x 327 mm
Signed *A Nunes* (in Letraset)

Two studies of *Psuedobombax tomentosum* demonstrate Alvaro Nunes' wonderful skill with subtle detail. His luminous green fruits are suspended on a branch covered with leaf scars while the flower and buds show two equally beautifully painted twigs. He has achieved a convincing flower with its mass of white stamens. Overall the tones of both paintings are superb.

These were both painted some time ago when he used Letraset to name his paintings and 'sign' his name, giving the impression of a print. However, both these works are original, acquired from the artist in 2005, although painted earlier.

The family Malvaceae formerly included only those plants that were closely related to hibiscus. New evidence, primarily from DNA sequence data, has expanded its taxonomic boundaries to include former members of the families Tiliaceae (lindens), Sterculiaceae (chocolate), and Bombacaceae (baobabs). Although some botanists contest this amalgamation, it is justified by what we know about the evolution of these plants and the fact that the traits of the four separate families were always somewhat indistinct. The genus *Pseudobombax*, formerly a member of the family Bombacaceae, is native to central Brazil where it is found in tall forests. The distinctive branches are held horizontally and when the leaves have fallen from the tree in the dry season, the large flowers are well exposed at the tips of the branches. This position makes the flowers accessible to the nocturnally flying bats and the woolly tailed opossum, a non-flying marsupial, both of which are pollinators.

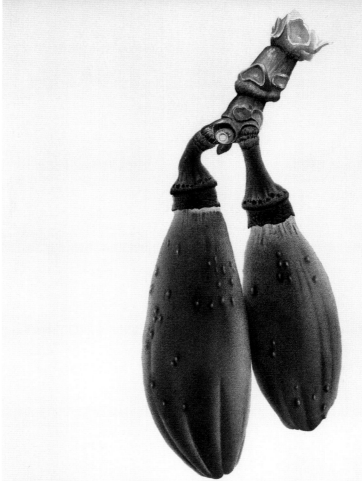

Pseudobombax tomentosum *A. Nunes*

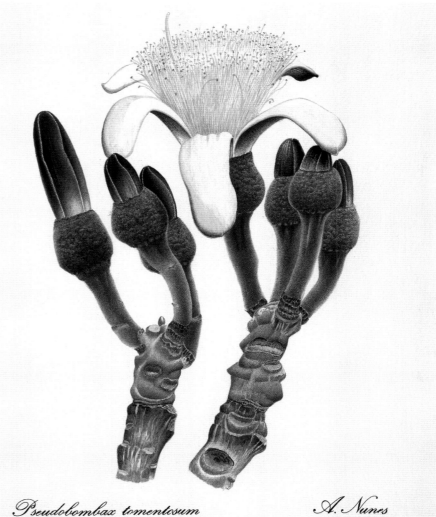

Pseudobombax tomentosum *A. Nunes*

Brassicales

Members of all 15 families of this order produce very distinctive chemical compounds called mustard-oil glucosides (also known as glucosinulates). Prior to the recognition of the importance of this compound in the classification of the rosids, the great diversity of form among these plants suggested that many of the families were not evolutionarily linked. The application of DNA data to this problem suggested that these 15 families should be united into the single order Brassicales. Plants in only one other family of flowering plants (a member of the order Malpighiales) produces the same type of chemical compound.

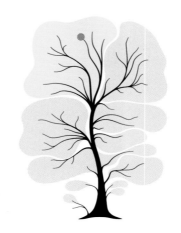

92. **Nasturtium tropaeolum:** *Tropaeolum majus* – Tropaeolaceae

Damodar Lal Gurjar, b. Nahira, Rajasthan, India 1958

Gouache on paper, 160 mm x 125 mm
Signed *Damodar Gurjar*

Damodar Gurjar comes from a farming family living in a village east of Jaipur. He had two years' training at a government art college, the Rajasthan School of Arts. The area abounds with artisans, miniaturists and extremely skilled craftsmen who can copy a photograph or painting. Gurjar reproduced the traditional eighteenth- and-nineteenth-century Jaipur-style paintings and created botanical works influenced by the 'Company' type of study (colonialists working for the East India Company would commission local painters to draw exotic flora for them). He showed at the Hunt Institute in 1992 and later in 'Natural History Paintings from Rajasthan', again at the Hunt. He also had a solo exhibit there in 2001 called 'Enduring Perfection'.

This orange nasturtium is painted on a blue background, providing a vivid study almost certainly drawn from life (in contrast to many of the Jaipur artists who are copyists). The artist favours pale blue backgrounds, a refreshing change from the customary white of most botanical painters. James White, curator at the Hunt Institute, brought it to the Shirley Sherwood Collection from Jaipur.

The evolutionary position of the genus *Tropaeolum*, the only genus is the family Tropaeolaceae, was once considered to be close to the geraniums in the Geraniales. However, DNA data have shown that this family is more closely related to the families that possess mustard oils in the order Brassicales. The glucosinolates are therefore considered to be an evolutionary shared feature between *Tropaeolum* and these mustard families. Members of *Tropaeolum* are herbs and climbing vines native to tropical regions from Mexico to Argentina. The flowers are characterised by a sepal that has been evolutionarily modified into a long tube or spur, which is filled with nectar. Only insect visitors with tongues long enough to reach into the spur will successfully pollinate the flowers. The generic name is derived from the Greek 'tropaion' meaning 'trophy' in reference to the combination of a leaf shaped like a shield and a flower in the form of a helmet.

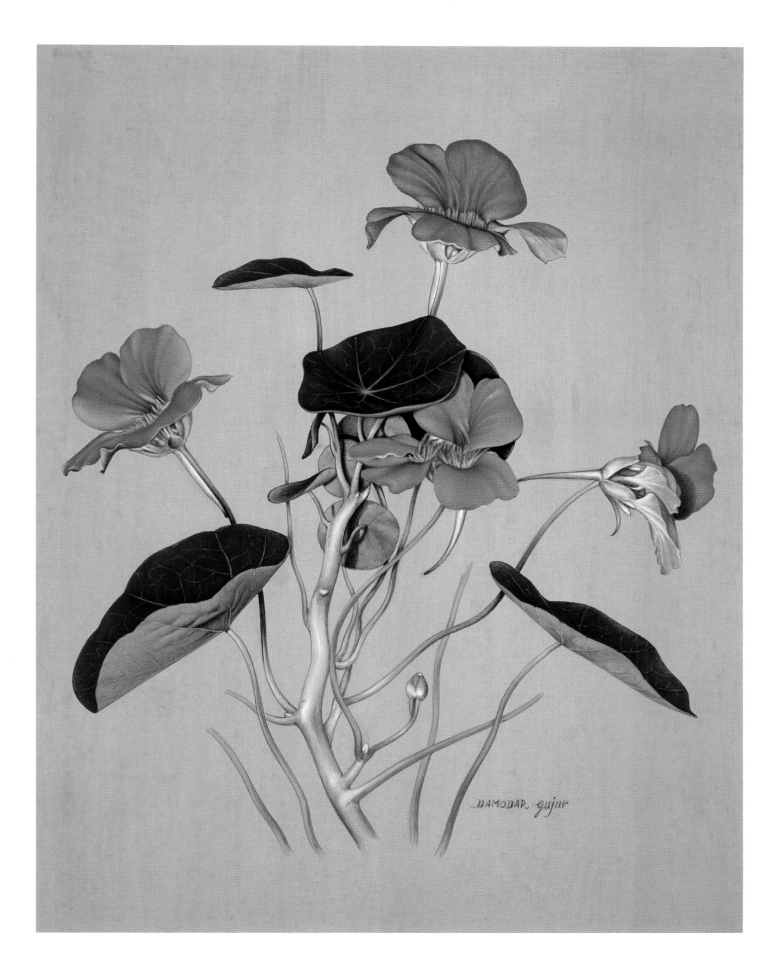

DAMODAR gujar

93. **Savoy cabbage:** *Brassica oleracea* – Brassicaceae

Katherine Manisco, b. London, England 1935, lives in Italy and USA

Watercolour on paper, 445 mm x 445 mm
Signed *Katherine Manisco '99*

This vibrant, lively curly cabbage was the star of Manisco's show in a New York exhibition in 1999. It has such solidarity and strength, yet balances on its weight as it pirouettes on its stumpy stalk, a fat ballerina of a cabbage.

The family Brassicaceae is distinctive in a number of traits, especially the cross-shaped orientation of flowers' four petals. Equally distinctive is the presence of sulphur-containing compounds called glucosinolates, which are present throughout the plant and provide the pungent mustard odours and tastes characteristic of these species. This chemical trait is also shared by members of the plant families Cleomaceae (including cleome) and the Capparaceae (including capers). Some botanists have suggested that these three families should be merged into a more inclusive Brassicaceae, although others disagree and advocate keeping them separate. The traditionally recognised Brassicaceae include mostly herbs found around the world with the highest diversity in North America, Central Asia, and the Mediterranean region. The generic name 'brassica' comes from the Latin name for cabbage.

Katherine Manisco '99

Santalales

The plants in this order are generally defined as being 'hemiparasitic,' that is, they photosynthesize during part of their lives, but obtain nutrients and in some cases water from their host plants upon which they grow. The Santalales include the sandalwoods and mistletoes. Many of these plants are epiphytes and grow on the branches of other species. But unlike orchids and bromeliads, which are also epiphytes, the mistletoes also stress their host plants by stealing their nutrients via modified roots called 'haustoria', which penetrate the vascular system of the host plants. The Balanophoraceae, a plant family made up of parasitic species, has been associated by most botanists with the mistletoes, but DNA data have not been able to determine which member of the Santalales are the closest evolutionary relatives of these plants.

94. *Langsdorffia hypogaea* – Balanophoraceae

Rosália Demonte, b. Niteroi, Brazil 1932

Gouache on vellum, 550 mm x 410 mm
Signed *R. Demmonte* (sic)
Commissioned

The Demonte family live near Rio and jointly published *Flora and Fauna of Brazil*, a mixture of essays and illustrations showing a range of their work. The book was written by Chrystiane Ferraz Blower, one of Rosália's daughters.

Rosália Demonte found the rare *Langsdorffia hypogaea* near the town of Caitité in Bahia. It is a curious root-parasite which had never been found before in this location. She painted this subject from her notes using a large sheet of vellum that had originally belonged to Rory McEwen, which she was given by the Hunt Institute. There is a somewhat similar painting in the collection of Mutis (1732–1808) of Andean plants held in the Archives of the Real Jardin Botanico, Madrid.

Unlike *Phoradendron*, which is a parasite on the branches of trees and has green leaves, members of the family Balanophoraceae are parasites on the roots of plants and do not contain chlorophyll and can not photosynthesize. All nutrients are obtained from the host plant. These subterranean parasites are rarely seen by botanists and are only collected when they produce their above-ground flowers. The lack of chlorophyll also presents a problem in studying the evolution of parasitic plants, such as *Langsdorffia*, because scientists rely on information from the genes controlling the production of chlorophyll and photosynthesis, which are lacking in these underground parasites, to compare evolutionary pathways. However, some floral traits as well as DNA from non-photosynthesis genes show that the Balanophoraceae is part of the order Santalales, which includes other parasitic plants. *Langsdorffia* is named after the German surgeon, explorer, and naturalist Georg Heinrich von Langsdorff, who lived from 1774–1852.

95. **Mistletoe:** *Phoradendron* **sp.** — Loranthaceae

Helga Crouch (formerly Hislop), b. London, England 1941
Watercolour on vellum, 94 mm x 153 mm

After attending school in Sydney, Australia, Helga Crouch trained at the Cardiff College of Art and the Central School of Arts and Crafts as a graphic designer. She moved to flower painting in 1978, often working on a honey-coloured, crinkled vellum. She is known for her meticulous, detailed and very restrained bunches of spring and summer flowers. She has shown her work at the Mall Galleries, London, Guildford House and the Linnean Society in London and is a founder member of the Society of Botanical Artists.

Helga had a solo exhibition called 'Wildly Botanical' at Jonathan Cooper's Park Walk Gallery in 2007, where this work was one of a series of seasonal studies. The subdued tone of the scattered leaves and fruit are very attractive with the scrap of moth's wing and the more vibrant mistletoe.

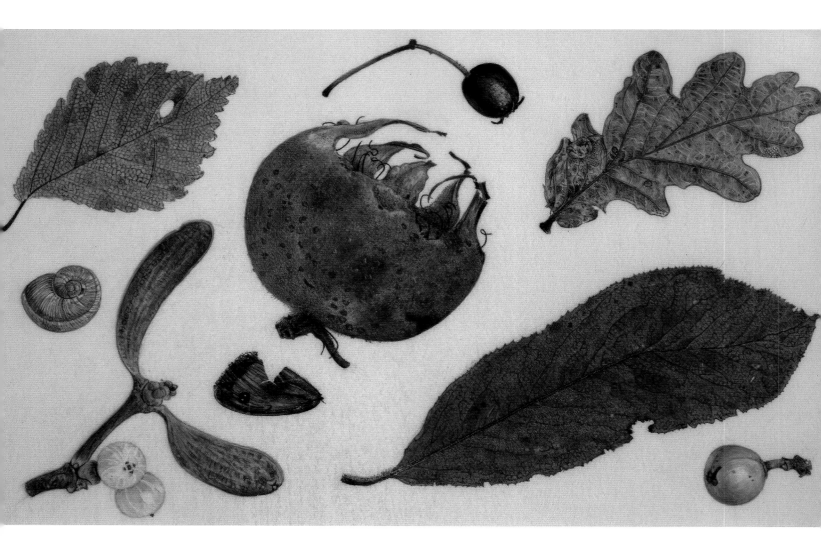

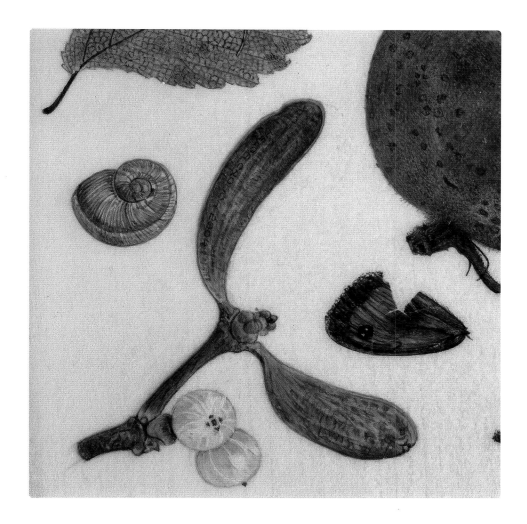

The family Loranthaceae includes seven genera and over 500 species, which are widespread in North and South America, Eurasia, Malaysia, the Pacific region, and tropical Africa. As is true for most of the members of the order Santalales, the Loranthaceae and the genus *Phoradendron* are true parasites on other plants even though they have green, photosynthesizing leaves. Plants of *Phoradendron* are common in the southern part of North America and grow on the branches of both conifers and woody flowering plants. With their modified roots they attach themselves to the vascular system of the host tree and tap into the growing layer of the bark from which they absorb nutrients. The name of the genus comes from the Greek 'phoros' which means 'bearing or carrying,' and 'dendron' referring to 'tree.'

Caryophyllales

The classification of the Caryophyllales is still not agreed upon by all botanists. Some taxonomists have a very broad idea of what plants should be included in this order; others maintain a much more circumscribed concept. From 18 to 29 families are put into this order depending on which botanist is consulted. The boundaries of the order are determined by both DNA features and chemical, anatomical, floral, and seed characters. The Caryophyllales were once called the 'Centrospermae' because many of them possessed a circular embryo inside the seed. Such plants as cacti, carnations, pokeweeds, four o'clocks, purslanes, and stone plants are contained in the Caryophyllales.

96. **Sea grapes:** *Coccoloba uvifera* – Polygonaceae

Katherine Manisco, b. London, England 1935, lives Italy and USA

Watercolour on paper, 475 mm x 406 mm
Signed *K Manisco '98*

A graduate of the Slade School of Fine Art, London, Katherine Manisco studied painting at the Accademia dell'Arte in Florence. She is a member of the American Society of Botanical Artists and the Chelsea Physic Garden Florilegium Society. She also contributes work to the Brooklyn Florilegium Society and her paintings have been included in the first book of the *Highgrove Florilegium*.

Katherine's paintings are included in the permanent collections of the Victoria and Albert Museum, the Fitzwilliam Museum, Cambridge and the Hunt Institute. She has exhibited in New York and elsewhere, including a strong show at Colnaghi, London in 2003 and a delightful display of lemons in the renovated Limonaia in the Boboli Gardens, Florence in 2004. She had a most successful solo show at the W. M. Brady Gallery in New York in 2006 and was elected a Fellow of the Linnean Society in 2004. She divides her time between New York and Rome.

Her beautifully designed sea grapes is a strong, vigorous presentation of a familiar beach-front plant anchoring the sand in warm climes. The spectacular red and green venation of the leaves is balanced by the clusters of hard green grapes producing a solid, sturdy painting.

Members of the Polygonaceae, with 43 genera and over 1,100 species, are easily recognised by their flowers (usually with white to red petals and a peculiar way of opening their buds) and several vegetative characters that are present in the herbs, shrubs, and trees which make up this family. All botanists recognise the Polygonaceae as a coherent evolutionary unit, but only recently has it been agreed that this family is related to the carnivorous plants and the family Caryophyllaceae, primarily because of DNA evidence. Some taxonomists still put the family in its own order Polygonales. *Coccoloba*, one of the few trees that have evolved in the Polygonaceae, grows along the margins of oceans and beaches, and produces bunches of fruits that resemble grapes. The genus name comes from the Greek 'kokkōlōbis', which is an ancient word for a kind of grape.

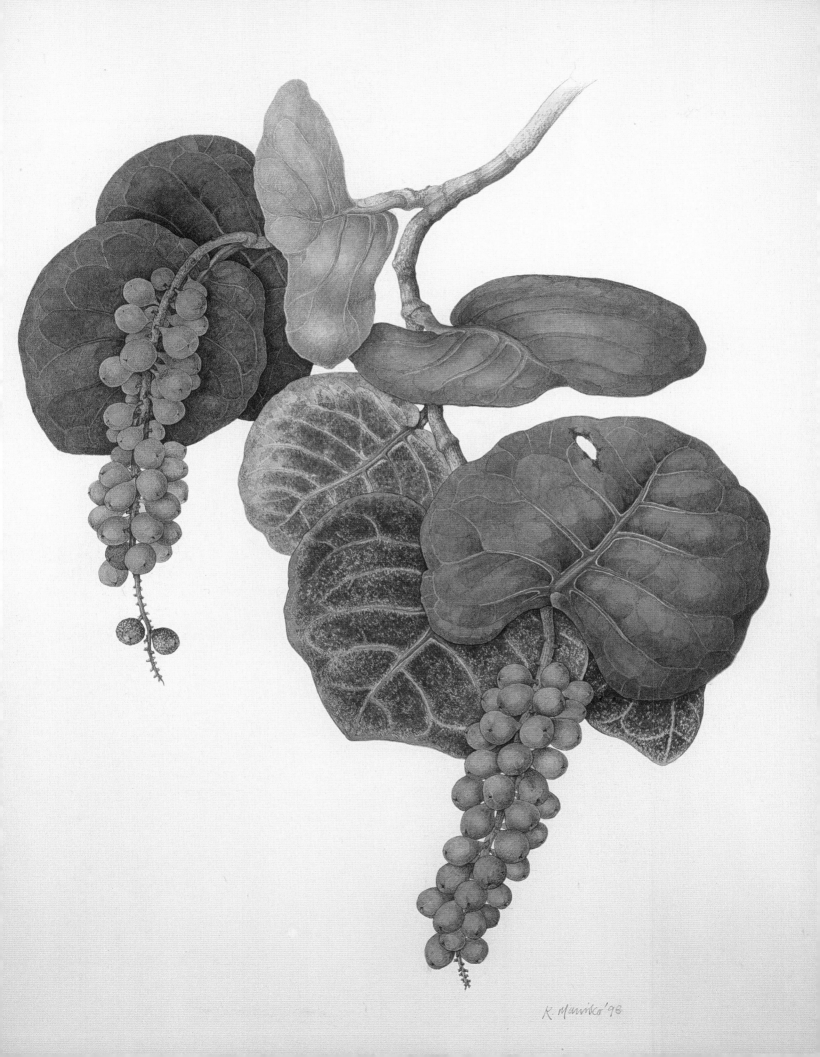

R. Mawiko '96

97. *Nepenthes truncata* – Nepenthaceae

Mariko Imai, b. Kanagawa, Japan 1942

Watercolour on paper, 540 mm x 385 mm
Signed *Imai*

Mariko Imai has had many exhibitions in Japan and Canada, produced the illustrations for several books, some for children, and executed superb covers for the Japanese version of the RHS magazine. There are four of these *Nepenthes* in the Shirley Sherwood Collection. In 1996 twenty-five of her botanical paintings were shown at the 5th Exhibition of 'The World's Precious Plants' at Tobu Department Store in Tokyo; later ten of these were awarded a gold medal at the RHS and were donated to the Lindley Library. One of her major contributions are her superb plates in an important multi-lingual book *Masdevallia and Dracula* by Y. Udagawa (1994).

 Nepenthes truncata is one of her important studies of pitcher plants. Its extraordinary modified leaves have voluptuous glossy lips tempting insects to explore inside. Her style is assured and experienced, making a dramatic painting.

Members of the genus *Nepenthes* produce their 'pitcher' as an extension of the central vein of a drooping leaf. These modified tendrils form a deep, vase-like structure topped by a lid that prevents rainwater from entering the pitcher. Inside the pitchers the plant secretes enzymes, which assist in digesting insects that fall into the trap, and provide nitrogen-rich nutrients important for the growth of the plants. Carnivory has evolved in a number of groups of flowering plants, including the sundews and Venus fly-traps. DNA evidence has shown that all of these plants are evolutionarily related within the order Caryophyllales. Although evidence suggests that carnivory has evolved only a single time in the common ancestor of these plants, the structures for 'eating animals' takes many forms from snap-traps in the Venus fly-trap, to sticky traps in the sundews, to pitfall traps in the pitcher plants.

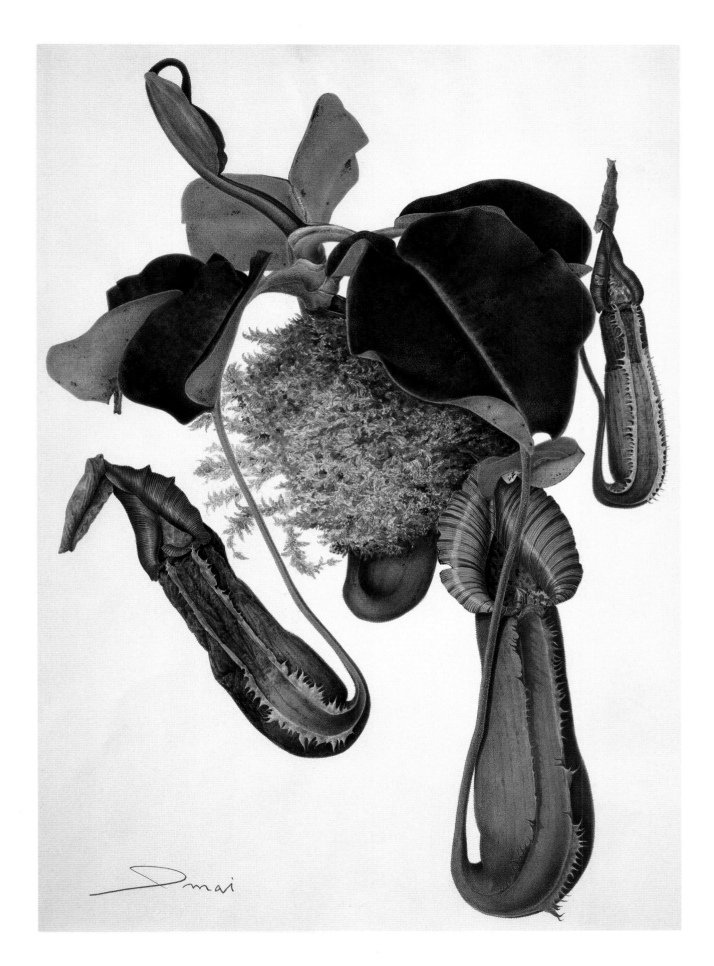

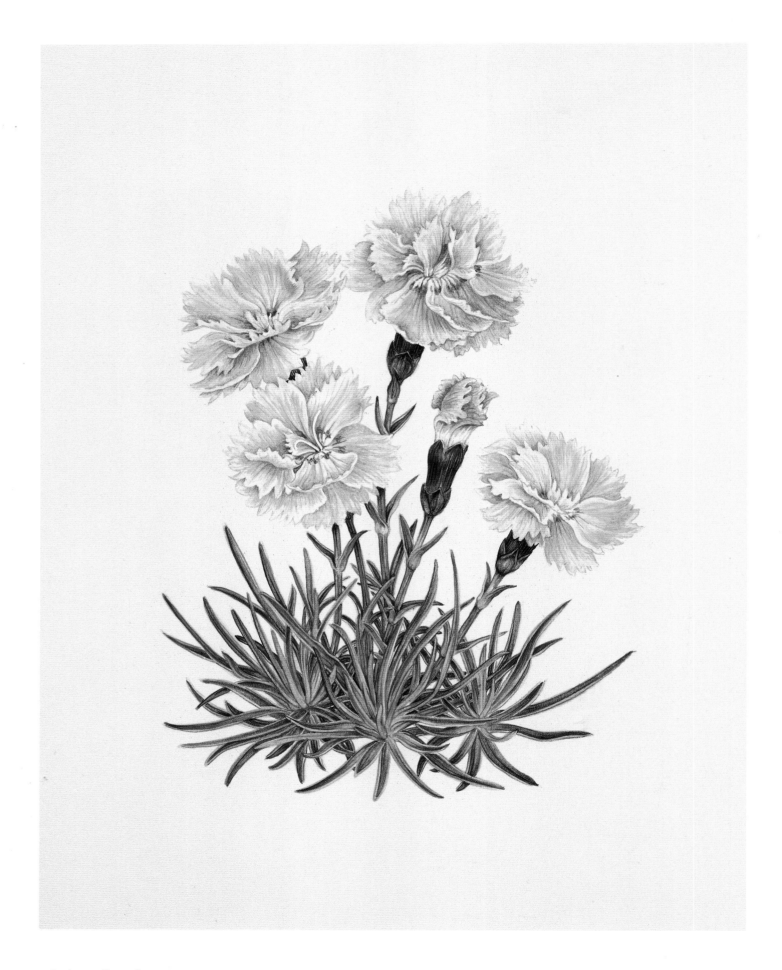

98. **Pike's pink:** *Dianthus* **hybrid** — Caryophyllaceae

Elisabeth Dowle, b. London, England 1951

Watercolour on paper, 222 mm x 182 mm
Signed (on back) *Elisabeth Dowle* 1995

Elisabeth Dowle took a foundation course at Croydon College of Art but otherwise is a self-taught botanical artist. She has illustrated many books, working in watercolour on paper and occasionally on vellum. She most enjoys painting fruit (particularly pears) and crops and has been working on a large series of fruit paintings from the National Collection of Fruit Trees at Brogdale, UK.

This precise, elegant study is a lovely tangle of leaves with a tuft of beautifully painted flowers springing out of them. Dowle's work is always meticulous and well designed and this immaculate study has a special charm.

The Caryophyllaceae is a large family of plants with 70 genera and 2,200 species, which are found in temperate regions around the world, and at some high-elevation sites in the tropics. They are most diverse in the Mediterranean region where they may have first evolved. Members of this family are distinctive in lacking a specific pigment, the betalains, which are found in all of their close evolutionary relatives in the order Caryophyllalles. Many species have flowers that are pollinated by butterflies and moths, and are characterised by sweet fragrances which attract these lepidopteran visitors to the flowers. The generic name *Dianthus* comes from the Greek 'dios' or Zeus, and 'anthos' meaning flower, as in 'flower of Zeus.'

99. Beetroot: *Beta vulgaris* — Amaranthaceae

Susannah Blaxill, b. Armidale, New South Wales, Australia 1954

Watercolour on paper, 480 mm x 640 mm
Signed (Artist's stamp) *SB*

Susannah Blaxill's spectacular beetroot is so arresting that it has been chosen by virtually every exhibition curator when the Shirley Sherwood Collection has been shown around the world. It became one of the favourites in the exhibition 'Treasures of Botanical Art' at the Shirley Sherwood Gallery at Kew. After she finished it she said her family would never eat beetroot again – but this is a painting which makes one look at a familiar vegetable with new eyes, and it has inspired other artists to use vegetables as a subject.

Susannah is currently concentrating on commissioned works, but has also exhibited in the Royal Botanic Gardens, Sydney show 'Botanica' in 2005, 2006 and 2007.

Several families in the order Caryophyllales are similar in their possession of certain traits that allow them to grow in stressful habitats, such as deserts and saline areas high in salt deposits. These traits most likely evolved in their common ancestor and were passed on to the descendents of various families, including the Amaranthaceae, Cactaceae, and Aizoaceae. The Amaranthaceae includes over 2,300 species and is now defined to encompass members of the family Chenopodiaceae, which in the past was recognised as distinct because of differences in the stamens and petals. A number of lines of DNA evidence now support the inclusion of this family in the Amaranthaceae. Around the world members of the Chenopodiaceae inhabit extreme environments that either lack water or have a high concentration of salts. The red colouration found in most of these plants, such as the beets, is due to the presence of betacyanins, a type of betalain pigment common to members of this order.

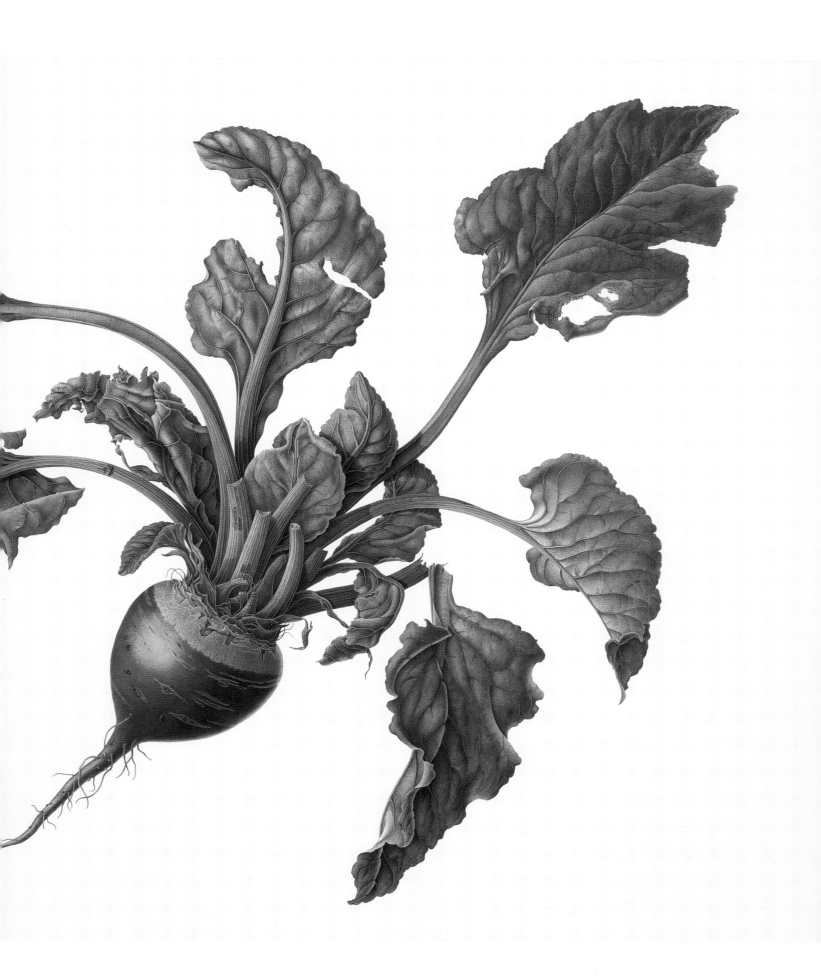

100. Ruschia: *Mesembryanthemum graniticum*– Aizoaceae

Barbara Oozeerally, b. Poland, 1953

Watercolour on paper, 275 mm x 210 mm
Signed *BO 2003*

Barbara Oozeerally glows with her passion for flower painting. She trained as an architect in Warsaw and worked there from 1976 to 1979; she then became a fashion designer and has only been painting full-time in England since 1996. She has exhibited her work several times at the RHS gaining two gold medals, and at the Graphic Fine Art and the Chelsea Society.

Barbara appears at Chelsea Flower Show regularly and her paintings are in the Lindley Library, London and the Hunt Institute in the USA. She exhibits with the American Society of Botanical Artists in New York and has taken part in shows in Melbourne, Australia and Cape Town. She has been awarded two Certificates of Botanical Merit in London and the USA and has been given the prestigious Diana Bouchier Founder's Award for excellence in Botanical Art. She is currently obsessed with magnolias and is travelling widely to paint them.

This small sketch of ruschia was a gift after she had seen it in South Africa growing in the desert sand in the West Coast National Park. It is a charming watercolour but an unusually subdued subject for her when compared with her vibrant tulips, large pine cones and lush magnolias.

The Aizoaceae is a core member of the order Caryophyllales, but the taxonomic boundaries of this family, meaning exactly what plants should be included in it, are not yet settled. For example, some botanists put the genus *Mesembryanthemum* in its own family Mesembryanthemaceae and not in the Aizoaceae. Flower features, such as the structure of the nectaries, as well as DNA data are being used to determine the exact evolutionary relationships within this group of plants. Plants of the Aizoaceae are native to coastal and dry environments in the tropics and subtropics around the world. Several evolutionary adaptations that help the plants to conserve water in these arid habitats include a special type of photosynthesis as well as succulent leaves and stems. Some species produce their leaves at the level of the soil or just below it in order to withstand the intense sunlight and reduce water loss.

2003

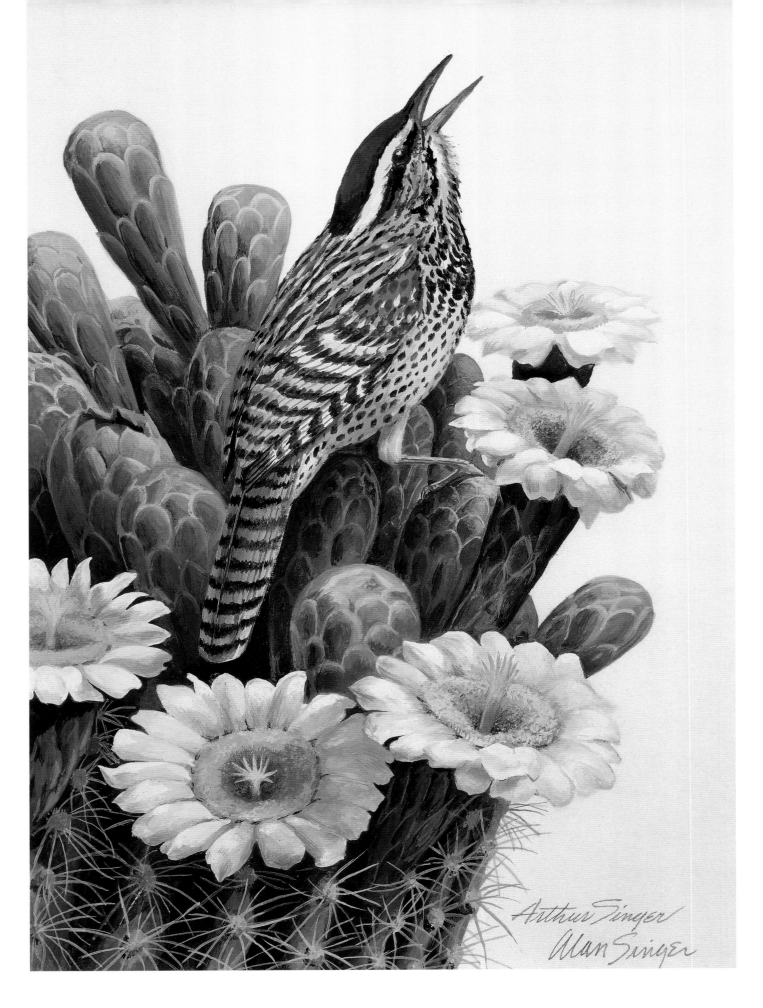

101. Cactus wren on saguaro: *Carnegiea gigantea* – Cactaceae

Arthur Singer, 1917–1990 and **Alan Singer**, b. New York, USA 1950

Gouache and watercolour on paper, 175 mm x 120 mm
Signed *Arthur Singer, Alan Singer*

It is unusual to find a painting signed by two artists but 'Cactus wren on saguaro' was painted by a father and son team, with Arthur Singer drawing the wren while Alan Singer painted the saguaro cactus. It was used as one of the designs for a US postage-stamp set of 'Birds and Flowers of the Fifty States' (1982).

Arthur Singer was one of the best-known bird painters in the United States in recent times with a huge number of exhibitions, publications and awards to his credit.

Like his father, Alan Singer also trained at Cooper Union, New York and then went on to complete a master of fine arts degree at Cornell University. He was an instructor in illustration at the New York Botanical Gardens, lived in Trinidad, West Indies for a while and is currently professor in the department of fine art at Rochester Institute of Technology, Rochester, New York. He has written widely on the visual arts and illustrated for the *National Geographic* and many other publications as well as holding over a dozen solo exhibitions.

This small painting was in the Hunt Institute's 7th International Exhibition in 1992. The American cactus wren, a thrush-sized bird, is much larger than any of the European wrens and burrows its nest in the mighty 'trunk' of the huge saguaro cactus. Saguaros stand isolated in the desert, reaching up to nine metres (30 feet) or more and only branch after a century's growth. They impart an extraordinary quality to these desert regions.

Like the Amaranthaceae, members of the Cactaceae show various evolutionary adaptations for living in dry habitats. They often have much reduced leaves and inflated, water-storing stems that can photosynthesize. A specialised type of photosynthesis has also evolved in cacti, allowing the plants to open their pores at night to take in carbon dioxide and thereby reduce the loss of water. The carbon dioxide is stored in cells as a special form of acid until the next day when sunlight transforms it into sugars. *Carnegiea gigantea* is the only species in the genus and is native to the Sonoran Desert of the south-western United States and northern Mexico. Day-foraging white-winged doves and night-foraging nectar bats visit the flowers of this cactus to sip nectar and pollinate it. The genus *Carnegiea* was named for the American steel industrialist and philanthropist Andrew Carnegie, who lived from 1835–1919.

Asterids

With nearly 80,000 species, the asterids are as diverse and species-rich as the rosids. However, unlike the rosids, this group is characterised by a number of specialised features, such as fused petals, unique chemical compounds (for instance, iridoids and alkaloids) and a distinctive ovule structure, in addition to the DNA sequence data. Within the asterids, botanists are in general agreement about the evolutionary relationships among the major subgroups, for example, uniting the heaths with primulas, brazil nuts and camellias, grouping gentians with potatoes, African violets and mints, and classifying hollies with carrots, viburnums, and asters.

Cornales

This order contains the most primitive member of the asterids and comprises three to seven families, depending on how taxonomists group the genera. The two most important families in the Cornales are the dogwood family and the hydrangea family. In addition to DNA data, which strongly unite these families, all of the members of the order have ovaries placed below the sepals and petals, and a unique nectary disc in the flowers. Most produce fruits that contain pips. The Cornales contain less than 700 species in total.

102. **Dogwood:** *Cornus florida* – Cornaceae

Katie Lee, b. Eldoret, Kenya 1942, works in USA

Gouache on Stonehenge Print, 560 mm x 380 mm
Signed *KT 1993*
Commissioned

Katie Lee is a renowned botanical and wildlife artist and instructor. She graduated from the New York Botanical Garden Botanical illustration programme and has been an instructor there for the past 16 years. She teaches drawing, watercolour, gouache and illustration courses at various programmes worldwide and has exhibited in the US and abroad.

Katie has led numerous sketching safaris in Botswana for Orient-Express Safaris and field sketching trips to South America. She has received the Gold Medal for Excellence and Best of the Show in 2004 at Kirstenbosch Botanical Garden and the Don Harrington Discovery Centre Merit Award for Excellence.

This commission of dogwood was inspired by the enchanting ethereal presence of this lovely tree in the springtime woods of Kentucky.

In the most recent classification the dogwood family has increased in size to include 13 genera and 130 species to it to make it evolutionarily inclusive and coherent. It is widespread in distribution and especially common in the north temperate regions of Asia and the Americas. Members of the family range from perennial herbs to large trees. The genus *Cornus*, has special flower features and chemical attributes, and DNA evidence supports its status as a distinctive evolutionary unit within the family. The conspicuous, white, modified leaves which surround the flowers of *Cornus florida*, attract pollinating insects. The bright red fruits, which mature in late summer, are a important source of food for migrating birds along the east coast of North America.

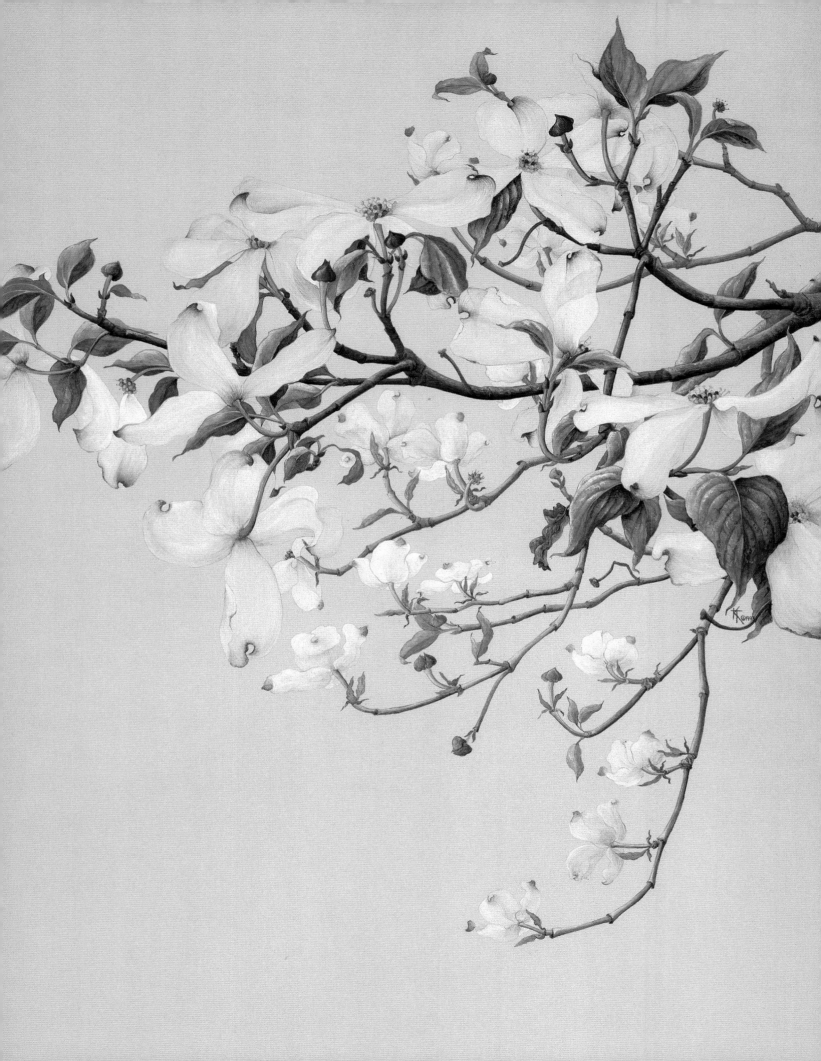

103. *Hydrangea* sp. – Hydrangeaceae

Brigid Edwards, b. London, England 1940

Watercolour over pencil on vellum, 330 mm x 275 mm
Signed *Brigid Edwards 1993*

This subtle, curved hydrangea head is a brilliant study of the fading flower, with its soft tones in the desiccated petals. The exceptionally beautiful treatment of the late-summer leaves is a masterpiece of intense observation, typical of Brigid Edwards at her best.

Earlier classifications of the family Hydrangeaceae placed it as a group within the Saxifragaceae, a family which evolved early in the diversification of the eudicots. More recent analyses, based on DNA sequence data, place this family, which encompasses 250 species in 17 genera, in the more advanced asterids with close evolutionary ties to the family Cornaceae. The flowers of the genus Hydrangea are usually of two types. Flowers of the first type contain stamens producing fertile pollen and carpels with normal ovules. These flowers are usually placed in the centre of the flower clusters and produce nectar, which is a reward for the insects that pollinate them. Flowers of the second type are sterile and produce neither fertile pollen nor viable ovules nor nectar. These flowers, which have enlarged outer sepals and are positioned around the periphery of the flower clusters, signal to insects that nectar is available inside the central fertile flowers.

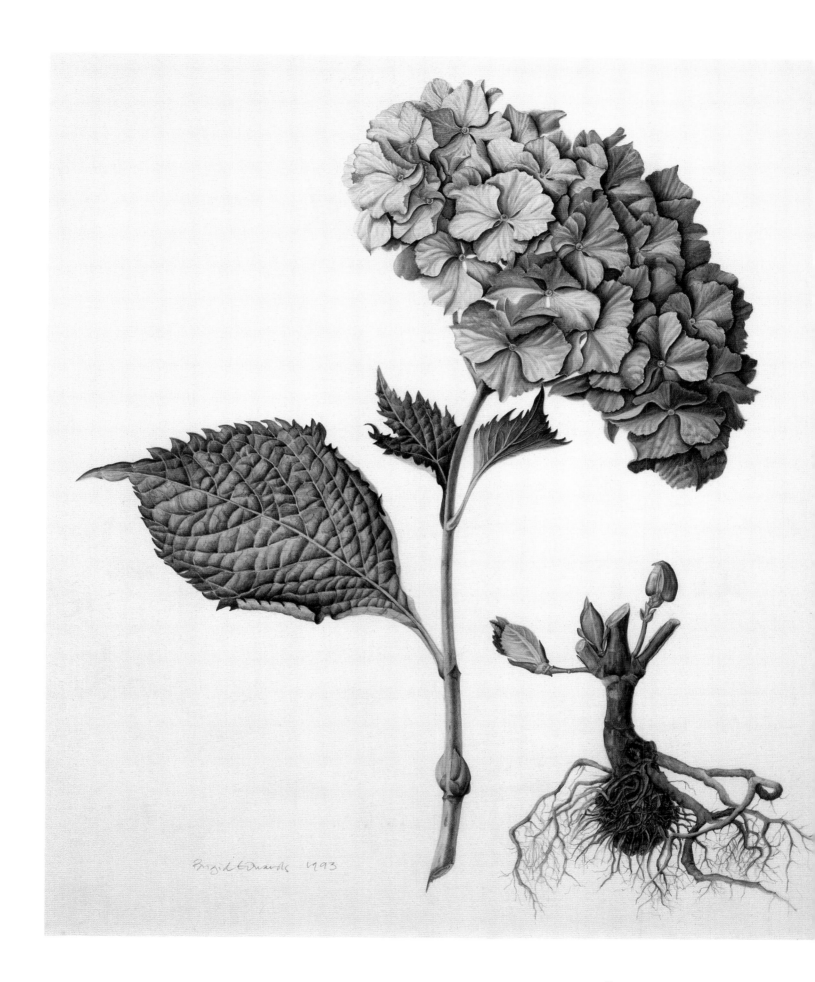

Brigid Edwards 1993

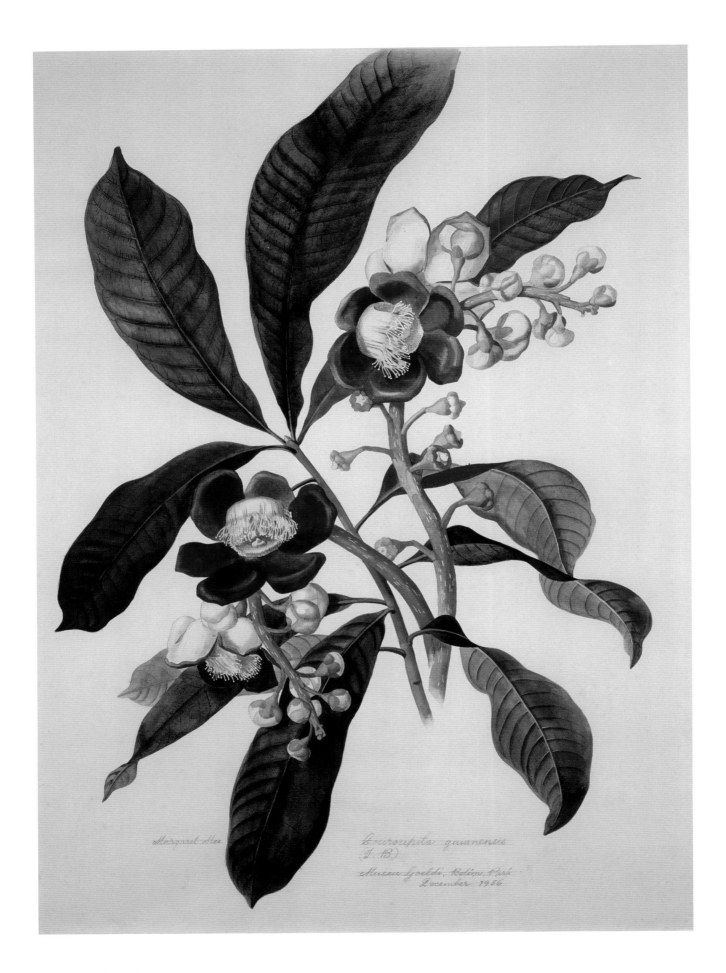

Margaret Mee

Couroupita guianensis
(L. B.)

Museu Goeldi, Belém, Pará
December 1956

Ericales

The Ericales, a large group within the asterids with slightly less than 10,000 species, include the kiwi fruits, sapodillas, ebony, primroses, tea, the heaths, pitcher plants, Brazil nuts, and phlox among others; 23-24 plant families in all. Evidence for the evolutionary relatedness of these diverse groups of plants is provided mainly by DNA sequence data; very few, if any, flower, leaf, wood or chemical features are shared by all the members of the Ericales. Although some of these plants, such as the Brazil nuts, sapodillas, and ebony grow in the tropics, others are mainly found in the temperate regions of the world.

104. **Cannonball tree: *Couroupita guianensis*** – Lecythidaceae

Margaret Mee, b. Chesham, Buckinghamshire, England 1909–1988, worked in Brazil
Pencil and gouache on paper, 640 mm x 460 mm
Signed *Margaret Mee*

This is the first painting Margaret Mee did in the Amazon basin at Belem, in 1956 (according to her late husband Greville Mee). Her diaries describe how someone cut down a branch with flowers for her to paint. She used pencil and gouache on paper. This is a vigorous drawing where she concentrates on the maroon flowers while giving the leaves only perfunctionary attention. Later she would paint leaves in a much more subtle way as seen in her painting of *Philodendron muricatum* and *Clusia grandiflora*.

Both the taxonomic boundaries of the family Lecythidaceae and the identity of its closest evolutionary relatives have been a source of confusion and different interpretations by botanists. Most taxonomists now accept a very broadly-defined family that includes some African and Asian genera, which were formerly put in separate families. And most taxonomists now classify the family in the asterid order Ericales, although earlier it was allied to the myrtle family in the rosids. The nearly 450 species of the Lecythidaceae are all tropical and most diverse in the South American rainforest. The flowers of *Couroupita* are fragrant and have fleshy petals, but they do not produce nectar. They have two types of stamens; the first produces normal pollen and serves to fertilise the ovules of other flowers, the second functions to provide a pollen reward for the visiting insects. The plant has evolved an organisation of stamens that both rewards the pollinator but also makes sure that some pollen is successfully transferred between flowers for fertilisation.

105. *Diospyros kaki* — Ebenaceae

Kimiyo Maruyama, b. Hyogo, Japan 1936

Watercolour on paper, 715 mm x 550 mm
Signed *Kimiyo Maruyama*

Kimiyo Maruyama still lives in Hyogo where she carried out a correspondence course from 1991-1998 with Sogei Education, Japan Gardening Society, Tokyo. Her respected teacher was Hiroki Sato (1925-1998) whose work is also in this book. Soon after that she had a number of solo shows in Hyogo and Tokyo as well as numerous group exhibitions in Hyogo, Sizuoka, Hokkaido, Obaraki, Yamaguchi, Tochigi and Tokyo where she won many special awards.

This work was first shown at the RHS where she has had great success, receiving gold medals at all her appearances since 2001. The Lindley Library bought her superb study of *Pinus sylvestris* in 2005. She is a wonderful painter of pines and all her entries for the RHS that season were breathtaking. This study of *Diospyros kaki* was acquired in 2003. Her work is highly refined and beautifully composed and assured for the relatively short time she has been working in this field. The soft, fleshy fruit glows from this painting with its intensely painted leaf detail.

Members of the persimmon family, the Ebenaceae, are easily recognised by botanists because of their urn-shaped flowers in which the petals are fused together and the green sepals outside the petals persist and enlarge as the fruits mature. The flowers are unisexual with male and female flowers on different plants. Species of the family are widely distributed in the tropics and warm regions of Europe, the Americas, Africa, and Asia. The true persimmons in the genus *Diospyros*, which has over 500 species, are very diverse in Madagascar, North America, Asia, and Australia. The flowers are mostly pollinated by bees. The name 'diospyros' comes from the Greek for 'dios' denoting Zeus or God and 'pyros' meaning 'grain.'

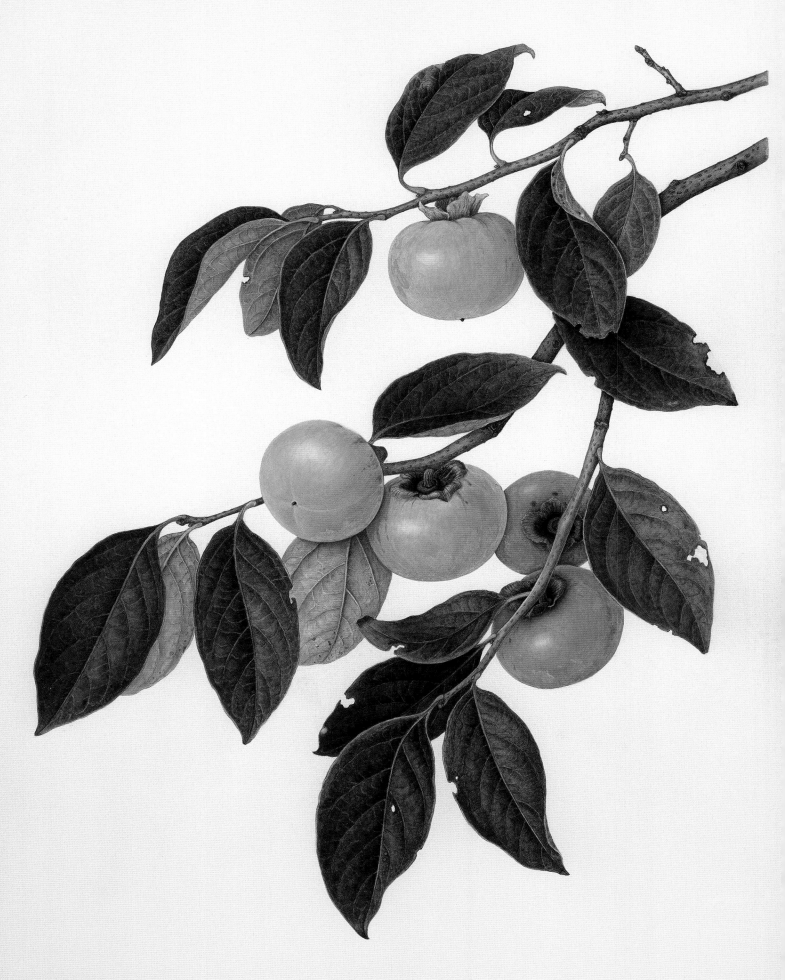

Diospyros kaki

Kimiyo Maruyama

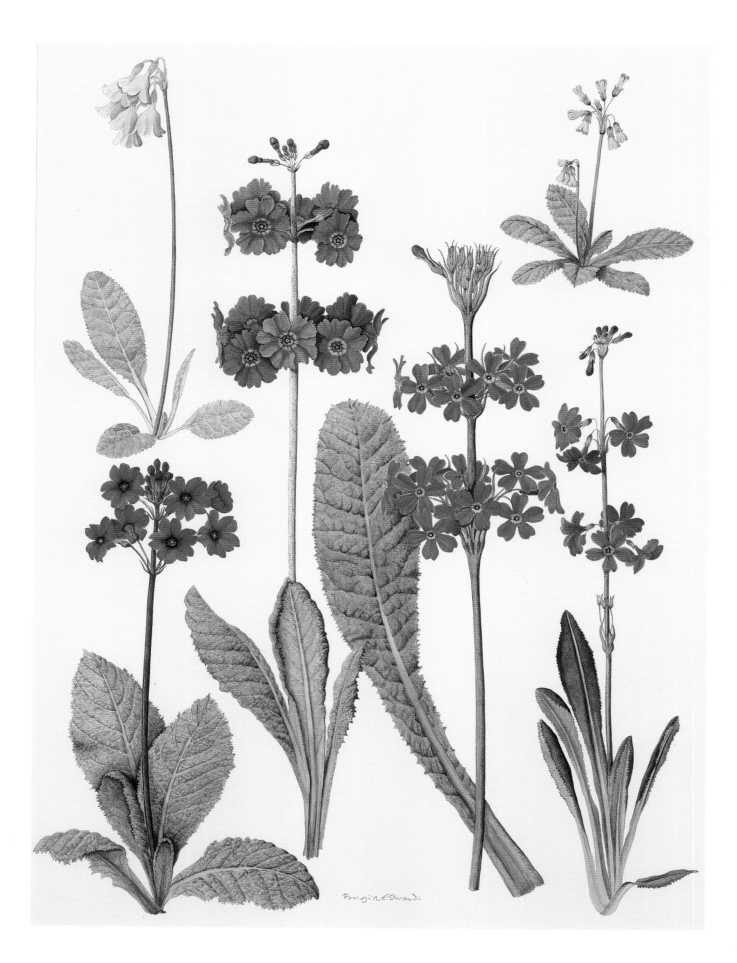

Brigid Edwards

106. **Primulas: *Primula* sp.** — Primulaceae

Brigid Edwards, b. London, England 1940

Watercolour over pencil on paper, 450 mm x 330 mm
Signed *Brigid Edwards*

Brigid Edwards' primulas were painted for *Primulas* by John Richards, published in 1994. This study was placed side by side with a watercolour of primulas by Maria Sibylla Merian (1647–1717) in the first exhibition of 'Treasures of Botanical Art' in the Shirley Sherwood Gallery at Kew in 2008. It was fascinating to see how two great plant painters compare, separated by three centuries. Both showed leaves as well as flowers of different species of primulas, beautifully arranged on the page, both signed at the base.

Although the Primulaceae was long considered to be a clearly defined family because of the consistency of its flower traits, DNA sequence data have shown that without the inclusion of two closely related but distinct families, the Primulaceae is not a coherent evolutionary group. It is now recognised that the unique position of the stamens directly opposite the petals (in other plants stamens usually alternate with the petals) evolved from a single ancestor common to all of the members of the expanded Primulaceae. Species in the genus *Primula* are generally alpine, perennial herbs with a rosette of leaves close to the ground and flowers that are pollinated by bees. The flower arrangement called heterostyly, in which some flowers of a population have long styles and short stamens while other flowers have short styles and long stamens, is present in species of *Primula*. Heterostyly promotes cross-pollination between the two flower types and has independently evolved in many unrelated families of angiosperms.

107. *Cyclamen persicum* – Primulaceae

Francesca Anderson, b. Washington DC, USA 1946

Pen and ink drawing, 730 mm x 580 mm
Signed Francesca Anderson 12/92

Francesca Anderson's work is always full of movement and she chooses large subjects which swirl across her pages. She prefers to work on ten or more similar subjects at a time, like her series of amaryllis, brassicas, poisonous plants, vegetables and bulbs. She is currently drawing birds on scratchboard, a technique that has always fascinated her.

Francesca's drawing of this cultivated cyclamen is lively and strong. She became so involved with the series of poisonous plants she was completing that she felt the cyclamen flowers were spitting at her.

The family Primulaceae as defined by taxonomist in the last century contained species that were mainly native to the cooler regions of the northern hemisphere. However, the uniting of the family Myrsinaceae, which is made up of species found in the tropical regions of the world, (and in which the genus *Cyclamen* was earlier classified), with the Primulaceae to form a much larger family illustrates how the definition of families can greatly change depending on how the taxonomic limits are circumscribed. Species of *Cyclamen* have very colourful, conspicuous flowers that are visited by many different types of insects, including bees, flies, butterflies, and even beetles. However, very little nectar or no nectar at all is produced in the flowers so it is curious as to why the insects bother. Perhaps they are deceived into visiting the flowers because of the bright colours and scents, and only mistakenly pollinate them as they exit the nectar-less blooms.

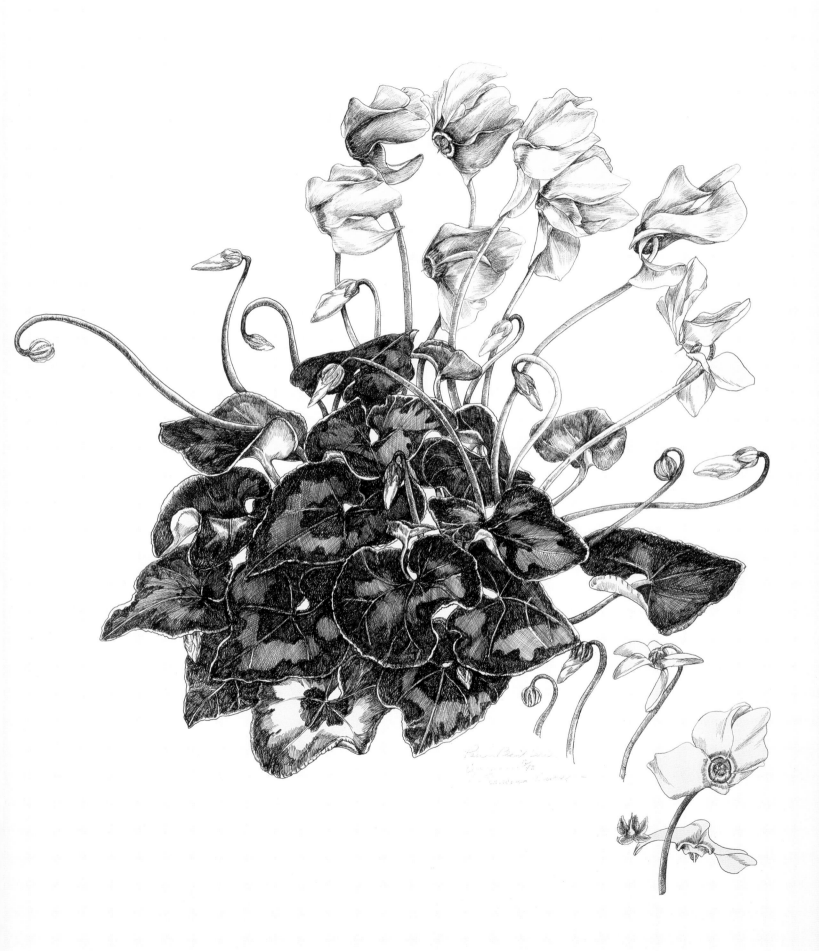

108. *Camellia chrysantha* — Theaceae

Jinyong Feng, b. Yixing, Jiangsu Province, China 1925

Watercolour and gouache on paper, 410 mm x 310 mm
Signed with his name and in Chinese characters
Commissioned

Professor Feng lives in Beijing and he has taught most of the botanical illustrators in China during the course of his long career. He has won major prizes in his own country as well as exhibiting abroad at the Hunt Institute and Missouri Botanical Gardens in the USA, in Sydney, in Japan and at the Everard Read Gallery in Johannesburg. He is now retired from his final position, which he described as 'senior engineer' at the Botanical Institute in Beijing.

Feng's work is exceptionally fine, particularly his older pieces painted some years ago. He has executed some line drawings of great beauty, working with a brush made of just three hairs from a wolf's tail; even under a powerful magnifying glass they were breathtaking. Thousands were done for Volumes I–78 of the vast *Flora Reipublicae Popularis Sinicae* (1959-1989), where every plant is illustrated by a small line drawing on each flimsy page. He also had a number of watercolours, some gouache and some studies that appeared to have been done on paper with oil.

This painting is of the newly discovered *Camellia chrysantha*, executed on Winsor and Newton paper he brought back from a visit to Canada. He had seen this unusual yellow camellia both in its natural setting and as a 'caged' bush in the Beijing Botanical Gardens, protected from the acquisitive fingers of camellia collectors as the Chinese hoped to hybridise it themselves commercially.

In this watercolour he has caught the camellia's dark glossy leaves to perfection and the whole composition is intriguing.

In contrast to the family Ericaceae, which needed to be enlarged by including additional families within its boundaries to make its taxonomy conform to its evolutionary history, the tea family has had to be more narrowly defined by removing some genera. The family Theaceae as recognised today is nearly one-half the size of the family that was accepted thirty years ago. The family now includes 20 genera and about 200 species which are found in tropical and subtropical zones of the Americas and Asia. Species of the genus *Camellia* generally have flowers that range in colour from white to red. The discovery and naming of *Camellia chrysantha* with its golden yellow flowers was therefore an exciting addition to the understanding of the evolution of these plants. *Camellia* was named in honour of the Jesuit missionary Georg Joseph Kamel (1661–1706), who was born in Moravia and was an avid plant collector in Asia.

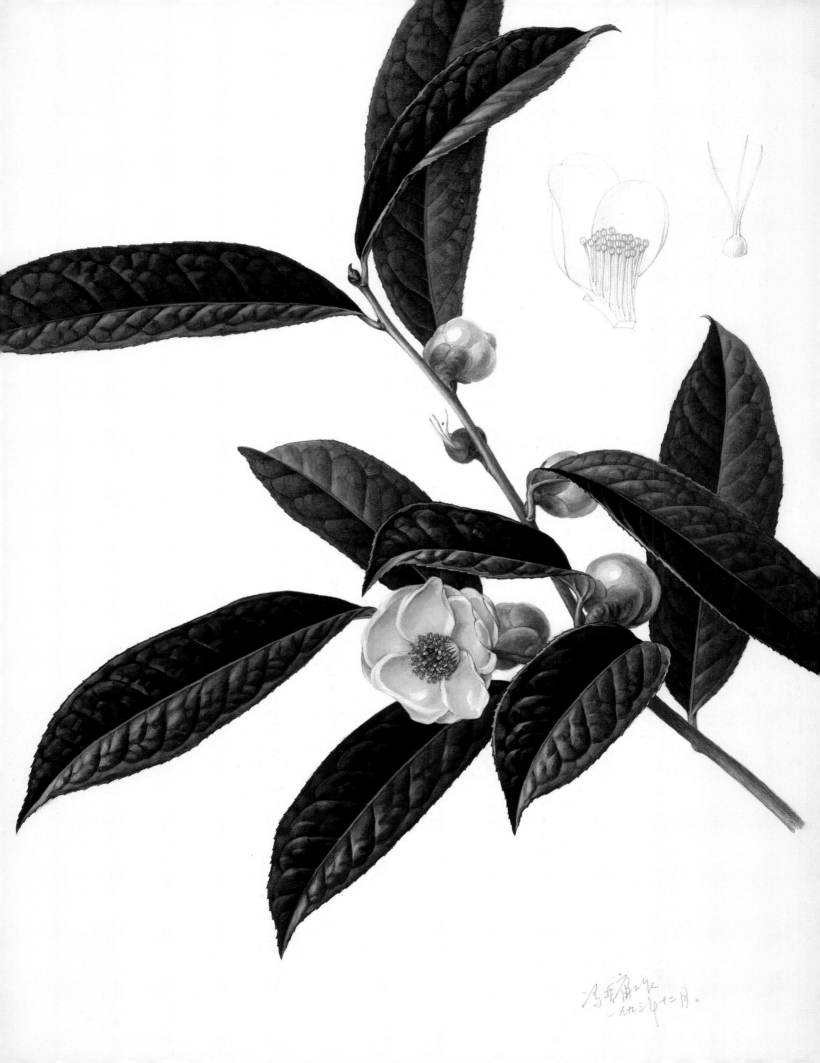

109. *Sarracenia purpurea* – Sarraceniaceae

Mariko Imai, b. Kanagawa, Japan 1942

Watercolour on paper, 360 mm x 280 mm
Signed *Imai*

Imai seems to enjoy painting carnivorous plants and has executed a remarkable series of nepenthes. The *Sarracenia* flowers stand proud above the modified leaves which are adapted to attract insects, supplementing nutrients from the poor soil.

Similar to plants in the families Nepenthaceae and Droseraceae in the order Caryophyllales, and the family Cephalotaceae in the rosids, members of the Sarraceniaceae are carnivorous. However, the ability to capture and digest insects has evolved independently in each of these groups of plants. The similarity of the features associated with carnivory misled some taxonomists at one time into classifying all these plants together in the same order. DNA data provided the important insight that the carnivorous feature of these plants were due to 'convergent evolution' and that these plants were not evolutionarily related to each other. Members of the Sarraceniaceae are native to acidic habitats in peat bogs and open pine lands in North and South America. Their tube-like, rolled leaves are usually brightly coloured, have distinctive odours, and contain enzymes for digesting the insects that become trapped inside. *Sarracenia* was named in honour of the French physician, naturalist, and plant collector Michel Sarrazin, who lived in Québec from 1659–1734.

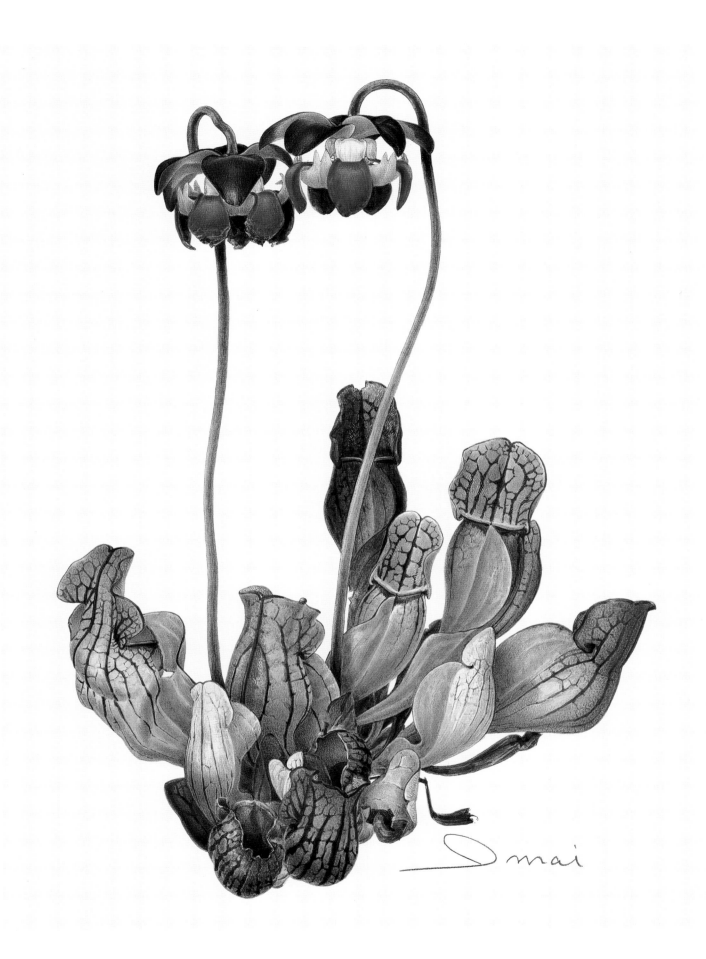

110. Kiwi fruit and prickly pear: *Actinidia chinensis* and *A. deliciosa* — Actinidiaceae

Elisabeth Dowle, b. London, England 1951

Watercolour on paper, 530 mm x 420 mm
Signed *Elisabeth Dowle 1997*

Elisabeth Dowle has won seven gold medals at RHS shows between 1986 and 1998. Her work is well-researched and painted with meticulous attention to detail.

Elisabeth's studies of fruit record the flowering, ripening on the tree, and the picked specimen. She exhibited at the Hunt Institute in 1998 and is also represented in the Lindley Library of the RHS and at Kensington Palace.

The kiwi fruit came into prominence as a 'new' fruit grown first in New Zealand and then worldwide in the 1980s. Peeled and sliced it became a pretty addition to fruit salad and tarts (but with a rather sour taste). This painting shows the flowers, leaves and fruit in a plate painted for *The New Oxford Book of Food Plants* by J.G. Vaughan and C.A. Geissler, which also included a good study of a prickly pear.

The members of the Actinidiaceae are mainly tropical and subtropical trees, shrubs, and woody vines from the Americas and South-East Asia; a few species are also native to temperate regions in Asia. Similar to some species in the Myrtales and Cucurbitales in the rosids, flowers of this family are 'buzz pollinated' by large bees, which collect the pollen as food for their offspring. In order to obtain the pollen the bees activate their flight muscles, which create vibrations of a particular frequency that causes the pollen to be released through special pores in the anthers. This same type of vibration is used by the bees to warm-up when outside temperatures are low, and are also used as a means of social communication. Flowers in the Actinidiaceae have flowers that face down with many stamens, offering a rich source of pollen for the bees.

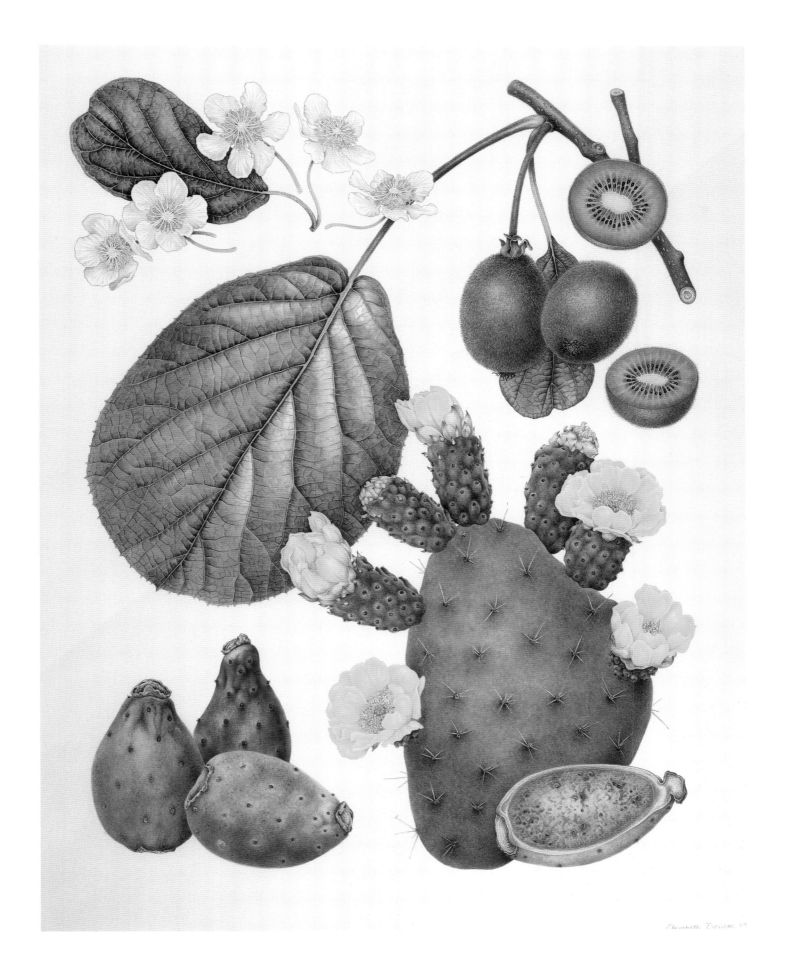

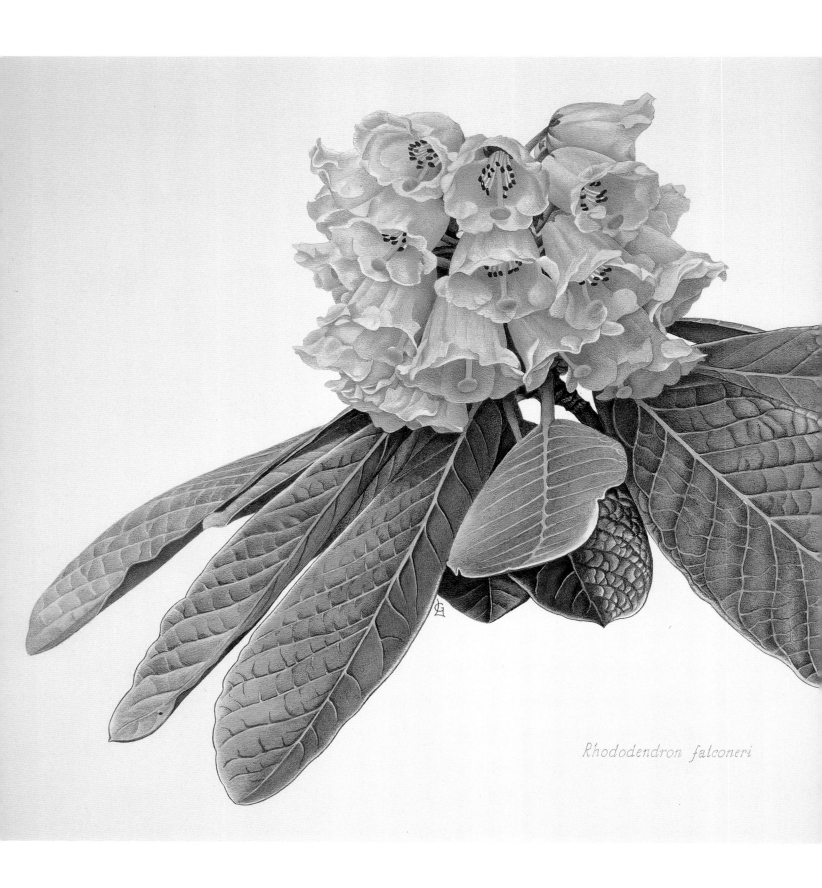

Rhododendron falconeri

111. *Rhododendron falconeri* — Ericaceae

Lawrence Greenwood, b. Todmorden, England 1915–1998

Watercolour on paper, 335 mm x 455 mm

Signed *LG Rhododendron falconeri*

Lawrence Greenwood was one of those unusual painters who was able to produce a painting from a photograph, provided that the latter was of high quality. Because of this skill he was able to paint plants which are not in cultivation by using transparencies taken by botanists on their plant-hunting travels around the world, painting rare and inaccessible species from the Himalaya, Chile and Argentina.

But he also painted more easily obtained subjects like this yellow rhododendron. This is an ambitious painting where he has chosen to display, very successfully, a foreshortened leaf — something most botanical artists avoid.

The large family Ericaceae, with 130 genera and over 2,700 species, was recently expanded by taxonomists to include five additional families that were formerly recognised as separate entities. By excluding these five families, the smaller Ericaceae was not a coherent evolutionary group. A number of lines of evidence from DNA data suggested that combining all of these families into a single larger Ericaceae was the best solution to this taxonomic problem. Within the Ericaceae, the genus *Rhododendron* and its close relatives are similar in possessing bracts that enclose the clusters of bell-shaped flowers, a particular type of fruit, and pollen grains connected by tangles of threads. Rhododendrons are found in the cooler mountain forests of eastern North America, southern Africa, and eastern Asia, especially in semi-tropical regions. *Rhododendron falconeri* was introduced into British gardens in 1850 from Sikkim by Sir Joseph Hooker, past director of the Royal Botanic Gardens, Kew.

Gentianales

The core group of asterids is divided into two main assemblages. The Gentianales, Lamiales, and Solanales make up the first group called the euasterids I. The Gentianales contain five families and are united by the common possession of a number of leaf, flower, and chemical features, including opposite leaves, appendages on the leaves called stipules, and twisted floral buds. In addition to the gentians, this order also is made up of coffee and its relatives, as well as the milkweeds and periwinkles, over 14,000 species in total.

112. Gentian: *Gentiana quinquefolia* subsp. *occidentalis* – Gentianaceae

Marjorie Blamey, b. Sri Lanka 1918, works in England

Watercolour on paper, 210 mm x 160 mm
Signed *Marjorie Blamey 1990*

Marjorie Blamey lives in Cornwall, England and is best known for her illustrations, which have appeared in 27 books, and for the botanical field guides she has illustrated. She did not begin to paint professionally until the mid-1960s. She has the ability not only to work quickly, but also to plan complex lay-outs, fitting species which bloom at different times onto the same plate, using data from her extensive archive of over 10,000 drawings.

She was made an MBE in the 2007 Honour's List for her service to art through her botanical illustrations.

This gentian was acquired in 1990. It is an excellent colour-match of the jewel-like flowers which have always been a painter's joy. Kew has a beautiful rendering by Verelst (c.1644–c.1721) and there is a copy of the Verelst painting by the contemporary Brazilian painter Álvaro Nunes (b.1945) in the Shirley Sherwood Collection. It is a favourite subject for plant painters.

The family Gentianaceae is a medium-sized family with 84 genera and about one thousand species, which are annual or perennial herbs and some small shrubs. The leaves, which are arranged in opposite pairs on the stems, and the radially symmetric flowers with over-lapping petals evolutionarily link members of the Gentianaceae with members of the coffee (Rubiaceae) and milkweed (Apocynaceae) families in the Gentianales. Gentians are found in various habitats around the world and many are associated with open grasslands and alpine meadows in mountainous zones. The tubular flowers have evolved various colours ranging from blue to purple to yellow to white and are pollinated by insects, primarily butterflies and bees. The gentians were named for King Gentius of Illyria (c.500 BC), who was reputed to have discovered the medicinal virtues of the root of the bitterwort (*Gentiana lutea*).

Gentiana occidentalis.

113. *Allamanda cathartica* – Apocynaceae

Ann Farrer, b. Melbourne, Australia 1950, works in England

Watercolour on paper, 340 mm x 260 mm
Signed *Ann Farrer 1990*

When she had completed a series of six plants endangered in the wild Annie
Farrer wanted to keep them together and they were eventually acquired by the
Shirley Sherwood Collection (*Thunbergia* see no. 126 is was also one of the
series). She has painted the golden flowers and glossy leaves of this vigorous
climber with great assurance as part of an excellent composition of a rampant
tropical plant.

The family Apocynaceae is large with 3,700 species in 355 genera. The milkweeds,
formerly in the family Asclepiadaceae, were considered to be the sister-family to the
Apocynaceae, but are now included within it. The members of this large family are
similar to each other in possessing milky latex in all parts of the plant and highly
modified flowers. The species are widely distributed around the world in the tropics and
subtropics with a few taxa also found in temperate regions. Similar to the orchids, the
flowers of the Apocynaceae have evolved very elaborate pollination mechanisms. Both
the styles and anthers have become highly modified to ensure that pollen of one flower
is carefully placed on the stigma of another. Most specialised are the pollen packets
called pollinia, which deliver as a unit all of the pollen grains of a single anther sac that
must be placed in a tiny slit in the stigmatic region of the next flower.

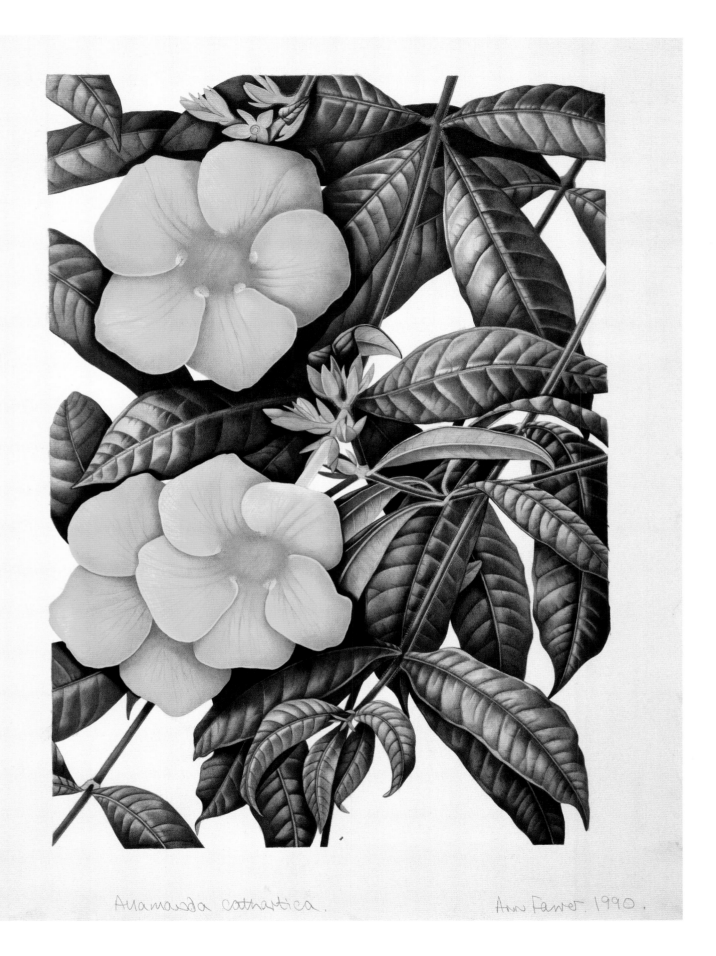

Allamanda cathartica. Ann Farrer. 1990.

Solanales

Members of the five families of the order Solanales all have radially symmetric flowers with the number of stamens being the same as the number of petals. Their leaves are alternate on the stem and lack the stipules present in the gentians. The major plant families in this order include the tomatoes, potatoes, tobacco and relatives as well as the morning glories. The borage family, Boraginaceae, is sometimes considered to be part of the Solanales, although its exact placement in the euasterids I is not certain. Despite the presence of poisonous compounds such as alkaloids, in many members of this order, some of our most important edible fruits, including peppers, tomatoes and eggplants, are contained in it.

114. **Trichodesma scotti** – Boraginaceae

Lizzie Sanders, b. London, England 1950, works in Edinburgh

Watercolour on paper, 552 mm x 368 mm
Signed *Lizzie Sanders 1995*

This was another plant brought back from Socotra by the scientists working at the Royal Botanic Gardens, Edinburgh (see no. 72) and painted by Lizzie Sanders. It is a stunning composition and beautifully executed with subtle colouring of the leaves, stems and white flowers. It grows on the misty hillsides of this isolated island where so many of the plants are endemic to it and found nowhere else.

The determination of the closest evolutionary relatives of the family Boraginaceae has been a problem for taxonomists for decades. The distinctively curled form of the flower clusters has been recognised as a distinguishing feature of the family and DNA data have confirmed the usefulness of this trait in determining the taxonomic boundaries of the Boraginaceae. However, other characters, such as the type of fruit and structure of the ovaries, have misled botanists in their attempts to determine the evolutionary relationship of the family to other members of the asterids. As now defined, species in the Boraginaceae range from large trees in the tropical zones to small herbs in the temperate regions. *Trichodesma scotti* is a small tree only found in the central Haggeher Mountains on the island of Socotra in the Indian Ocean (part of the Republic of Yemen). This exceedingly rare plant holds its leaves and large, drooping, bell-like flowers clustered at the tips of its branches as if reaching out for someone to save it from extinction.

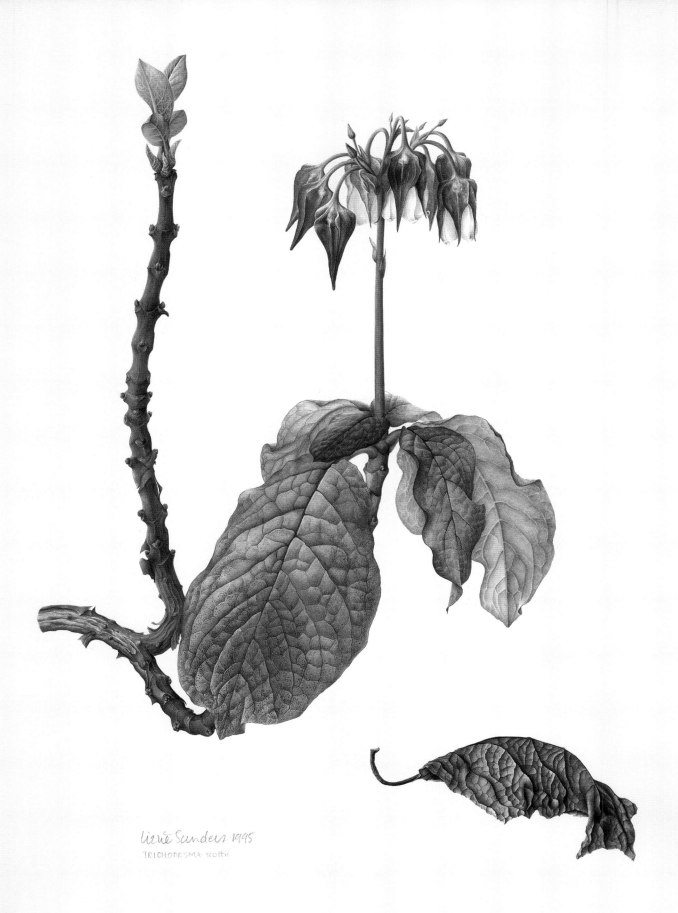

Lizzie Sanders 1995
TRICHODESMA scottii

115. **Morning glory:** *Ipomoea purpurea* – Convolvulaceae

Josephine Hague, b. Liverpool, England 1928

Watercolour on paper, 310 mm x 360 mm
Signed *Josephine Hague 1990*
Commissioned

Josephine Hague recently completed two paintings for the *Highgrove Florilegium*, and one was reproduced as a print for Prince Charles.

Her commission of morning glory became an elaborate design of a popular annual climber and was executed in 1990. She has caught the extraordinary azure of the heavenly blue variety, a true 'heavenly' colour. The painting has great appeal and has always been a favourite when exhibited with the Shirley Sherwood Collection in New Orleans, Sydney, Tokyo, Cape Town, Stockholm, Memphis and Denver.

The family Convolvulaceae has always been considered to be evolutionarily related to the other families in the order Solanales because of the shared arrangement of leaves in an alternating pattern on the stem and the similarly shaped flowers. The family is made up of 1,930 species in 55 genera found in both the tropics and temperate zones around the world. Many species are climbers that scramble over vegetation or are shrubby herbs in rocky habitats. In the deep tropics, some species of the Convolvulaceae are woody vines that reach to the top layer of the forest canopy. In the south-eastern region of temperate North America the species *Ipomoea purpurea* is quite variable in the colour of its flowers, which range from deep bluish purple to white. The main bumblebee pollinators can distinguish the various flower colours and preferentially visit some colours over others. This preference results in differential mating success and natural selection for particular flower colours.

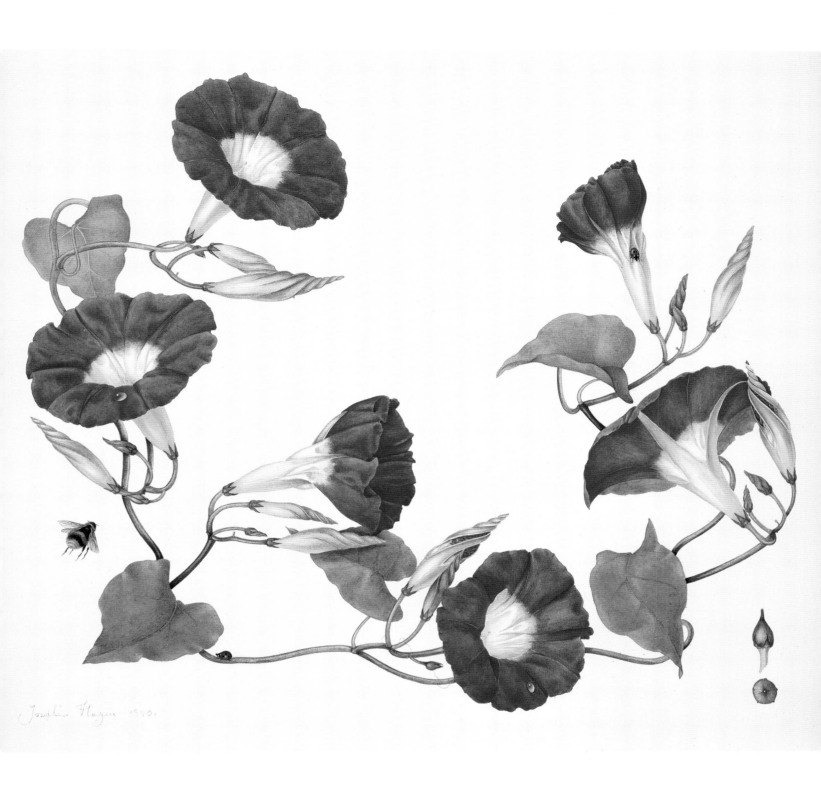

Josephine Hague 1990.

116. Aubergine: *Solanum melongena* – Solanaceae

Susannah Blaxill, b. Armidale, New South Wales, Australia 1954

Pencil and watercolour on paper, 460 mm x 622 mm
Signed *Susannah Blaxill*

Susannah Blaxill's two aubergines suspended in space have the most extraordinary colour and shine while the green caps are exquisitely painted.

Susannah has just finished a camellia, pink and white on a dark background. The background is composed of 32 layers of paint and the flower is in gouache overlaid with watercolour. It was one of the highlights of 'Down Under' in the new Shirley Sherwood Gallery and is an interesting contrast to this dark aubergine on a white background which must also have been painted with many purple layers to get the intensity of colour she achieved.

The family Solanaceae is large with nearly 3,000 species of trees, shrubs, lianas, vines, epiphytes, and herbs. Almost all are widespread around the world, primarily in the tropics. Most botanists agree that the family is a natural, evolutionary unit from evidence based on floral features and DNA data. Flowers of the Solanaceae are conspicuous and are pollinated by a variety of insects. In the genus *Solanum*, flowers produce no nectar and reward the floral visitors with pollen. It is estimated that *Solanum* may contain nearly 1,400 species distributed broadly, but concentrated in tropical America. Many of these species have been selected by humans as foods. The exact origin of the eggplant, *Solanum melongena*, is not clear, but it was probably first cultivated in India and south-western China. From those regions the plant spread to the Mediterranean and is now cultivated around the world.

Susannah Blaxill

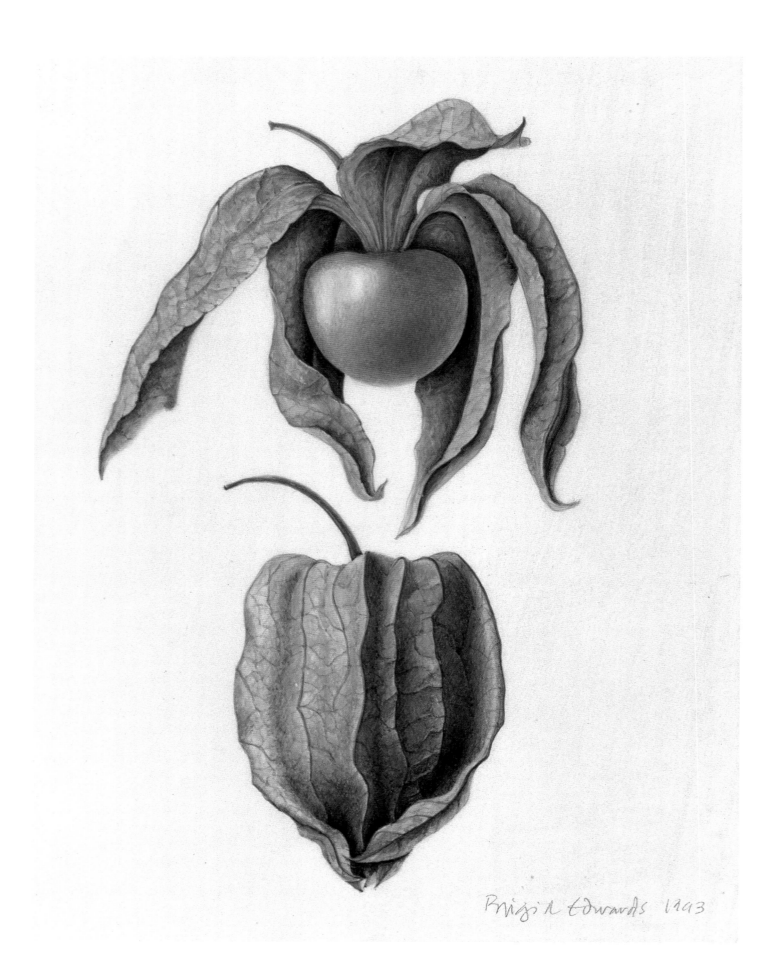

Brigid Edwards 1993

117. Cape gooseberry: *Physalis peruviana* – Solanaceae

Brigid Edwards, b. London, England 1940

Watercolour over pencil on vellum, 190 mm x 125 mm

Signed *Brigid Edwards 1993*

This enlarged image by Brigid Edwards of the glossy, golden fruit with its papery sepals has always been a favourite in the many exhibitions where it has been shown. Soon after it was first published in *Contemporary Botanical Artists* (1996) many other artists started looking afresh at the unusual fruit with its sharp, strong taste and decorative contrasts of texture. The artist has suspended the fruit in space in a strikingly confident way.

Many plants have proven to be evolutionary successful by adapting to the needs of humans. Food plants are a good example of species that have thrived as a result of their cultivation by people. Many members of the family Solanaceae, whose wild relatives are poisonous, have been domesticated over thousands of years as foods and spices that lack these poisons. Members of the genus *Physalis* are annual herbs with grape-like fruits that are enclosed in papery husks when mature. Native to the central region of South America, the plant has been broadly introduced into other parts of the tropical and subtropical world as a vegetable or fruit crop, even though it is not locally cultivated nor appreciated in its native region. *Physalis* was introduced into the Cape Region of South Africa in the early 1800s where it received its popular name 'Cape gooseberry,' even though it was a native of the Americas.

Lamiales

The Lamiales are another large group within euasterids I with 18,000 species spread across 21 plant families. They are distinguished by numerous characters, including exclusive chemical pathways only found in these plants. The special traits, such as unique stomates and hairs on the leaves, embryos and endosperm of a particular type, and proteins in the leaf cells are combined with DNA sequence similarities to provide unequivocal evidence for the evolutionary relatedness of these plants. This order has a long list of familiar garden plants, such as African violets, snapdragons, figworts, trumpet creepers, acanthus, verbenas, and mints.

118. **Studies of streptocarpus: *Streptocarpus* spp.** – Gesneriaceae

Josephine Hague, b. Liverpool, England 1928

Watercolour on paper, 510 mm x 400 mm
Signed Josephine Hague
Commissioned

This work by Josephine Hague was the result of a commission to paint a collection of streptocarpus in the early 1990s. She did one leaf, a twisted seed pod and eleven of the different hybrid flowers, achieving lustrous colour and exquisite detail. The tracery of violet into the depth of the white flower is particularly fine and she has painted an intense, velvety texture in the darkest flower.

The large family Gesneriaceae, with 2,859 species in 126 genera, are considered to be a natural, evolutionary unit. Gesneriads are almost entirely found in the tropics as herbs, shrubs, vines, and small trees; some are epiphytic and grow on the trunks and branches of other trees in the wet forest where they are common. The Gesneraiceae is related to plants formerly classified in the Scrophulariaceae and some taxonomic confusion still persists concerning the relationship of these families. It is difficult to list the specific traits that define the family, but most taxonomists accept the Gesneriaceae as a solid, well-supported family. The genus *Streptocarpus* is found in tropical central and eastern Africa and the island of Madagascar as well as the Asian regions of Thailand, south-west China, and the East Indies. 'Streptocarpus' comes from the Greek words 'streptos' meaning twisted and 'karpos' meaning fruit, which refers to the unique spiral structure of the capsules.

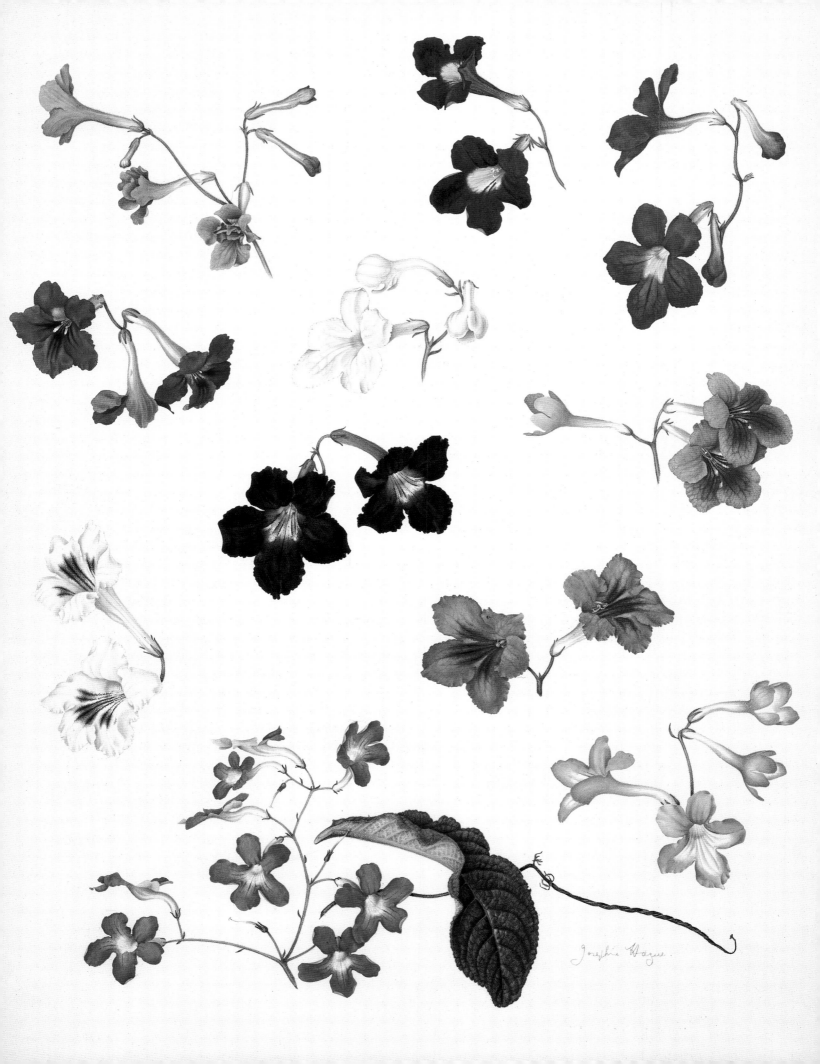

Josephine Hague.

119. 'Rat's tail' spitzwegerich: *Plantago lanceolata* — Plantaginaceae

Sylvia Peter, b. Kaufbeuren, Germany 1970

Acrylic colour on linen and wood, 670 mm x 430 mm
Signed *SP finished June 2002*

Sylvia Peter trained in Germany from 1990–1997 first with a degree in glass and porcelain painting, then studying with Peta Zeiler in Munich and Professor Triebiesch.

She has had several one person exhibitions as well as taken part in group shows and is enthusiastic to start her own gallery in Germany to promote botanical art.

Many of her botanical subjects are vastly enlarged as, for example, her huge 6 feet tall painting of a nettle. She produces strong and vigorous works, unusual and dramatic. Sylvia Peter's study of 'rat's tail' or spitzwegerich is a vastly magnified portrait of the head of this rather inconspicuous inflorescence, painted in acrylic onto linen mounted on wood. It is on a dark background, rather mysterious and perhaps even menacing.

The large group of species that was formerly classified in the family Scrophulariaceae, which included such plants as *Scrophularia, Veronica, Verbascum, Digitalis,* and *Penstemon*, has undergone a radical rearrangement by taxonomists as a result of unequivocal evidence from DNA sequence data. However, because of the historical botanical rules for naming and classifying plants only a portion of these species, including the genus *Scrophularia*, can remain in the Scrophulariaceae. All of the other species formerly in this family are now combined together with the genus *Plantago* into a much larger and evolutionarily coherent family called the Plantaginaceae. The genus *Plantago*, because of its wide-ranging genetic variability in a number of its features, has been widely utilised in studies by botanists to understand the processes of evolution. *Plantago* is an ideal genus for investigating the effects of geographic variation on natural selection and has become one of the ecologically best-characterised of all native, non-cultivated plants.

120., 121. Speedwell: *Veronica persica* – Plantaginaceae

Diana Lawniczak, b. Dabrowa Górnica, Poland 1951

Watercolour on card, 340 mm x 240 mm each (framed together)
Signed *Diana Lawniczak*

Diana Lawniczak was born in Poland but fled to Switzerland in 1981 where she now lives. She took a degree in biology from 1968–1972 at the University of Wroclaw, specialising in ornithology, became a journalist and started work on a doctoral thesis which she did not complete because of her flight out of Poland.

Once settled in Switzerland she became a freelance artist and photographer and illustrated a number of books including *Stone Flies of Switzerland* and a book of plants used for homeopathic remedies. She has had several solo exhibitions in Switzerland, all on natural subjects, in Thun, Konolfingen and Steffisberg.

The study shown here of speedwell was used as an illustration in a charming book *Flora Non Grata* that she published in 2002. She has painted the plant 'close-up', displaying detail rarely perceived by the casual observer, but fascinating with such magnification.

The family Plantaginaceae with 1,800 species in 113 genera encompasses the majority of species formerly classified in the family Scrophulariaceae. Although few floral and leaf traits are shared by all members of the Plantaginaceae, DNA data strongly support the suggestion that this family is a coherent evolutionary unit. Some botanists prefer to name the Plantaginaceae after the genus *Veronica*, one of its most characteristic members, and designate the family as the Veronicaceae. However, many taxonomists are now using the name Plantaginaceae. *Veronica*, similar to *Plantago*, has four petals, most likely due to the evolutionary fusion of two of the upper-most petals into a single petal-like structure. The genus *Veronica* contains approximately 180–250 species (depending on the taxonomist), which are native to a wide variety of habitats from ponds to deserts and from high mountain meadows to suburban lawns. These species are distributed over the entire northern hemisphere as well as East Africa and Australia.

122. *Origanum dictamnus* – Lamiaceae

Anelise Scherer de Souza Nunes, b. Brazil 1961

Watercolour on paper, 705 mm x 500 mm
Signed *Anelise Scherer de S. Nunes 21st August 2000*

After studies with the Federation of High Education of Vale do Rio dos Sinos-FEEVALE, in Novo Hamburgo, Rio Grande do Sul, Anelise taught art in various public and private schools whilst also producing and exhibiting works in a number of different media.

In 1998 on a visit to the Curitiba Botanic Garden, Parana, she met Diana Carneiro, a former Margaret Mee artist fellow. Inspired by the quality of Diana's paintings and realising the important role that an artist could play in helping protect and conserve the flora of Brazil, she took a course in botanical illustration. In 1999, with Diana Carneiro, Fatima Zagonel (a former Margaret Mee artist fellow) and others, she founded the Centre for Botanical Illustration in Parana. In 2000 she returned to live in Rio Grande do Sul where she is working to develop a similar teaching centre.

In 2000 she won the 12th Annual competition for the Margaret Mee Fellowship and studied with Christabel King for five months at Kew. This exquisite, delicate painting was completed at Kew from a plant grown there. The dissections are immaculate and add to the fragile design.

The mint family, Lamiaceae, has undergone an extensive reclassification as a result of evidence form DNA sequence data. The family as now defined contains nearly 7,000 species in 258 genera, and includes some species that were formerly classified in the family Verbenaceae. Taxonomists traditionally classified the Lamiaceae to include all species that had a particular orientation of the style. However, botanists now understand that this trait has evolved more than once, so all species that have it are not necessarily closely related to each other. The new classification of Lamiaceae, which formerly only consisted of herbs and shrubs, now includes tropical trees. Members of the family can be found across many climatic zones, including tropical regions, temperate areas, and even the arctic tundra. The mints are particularly diverse in the seasonally dry habitats of the Mediterranean.

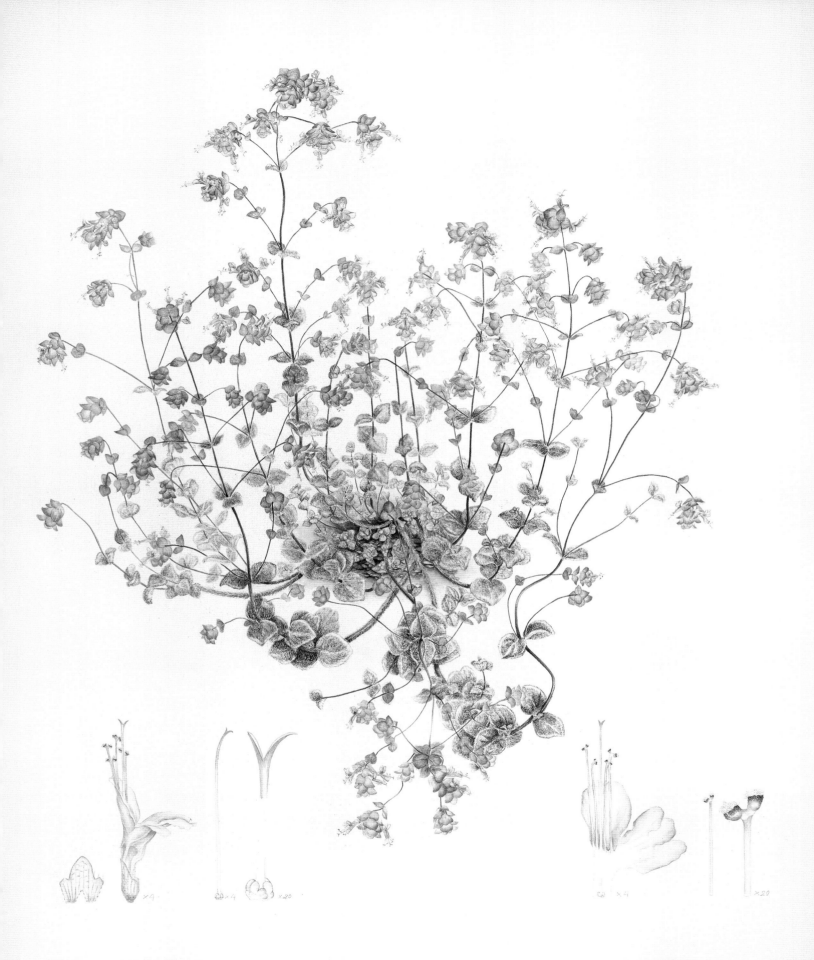

Origanum dictamnus

Cult. Royal Botanic gardens- Kew, England

1952 - 65009 GRAN

Creta

Eveline Scherer de S. Nunes

21st August 2000

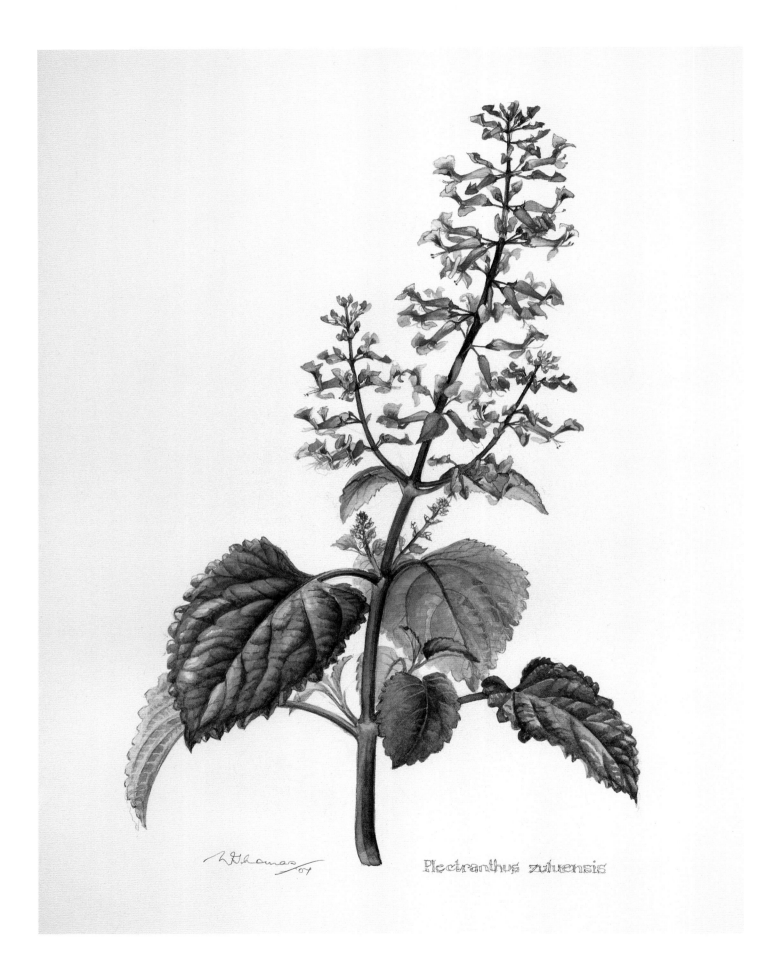

Plectranthus zuluensis

123. *Plectranthus zuluensis* – Lamiaceae

Vicki Thomas, b. South Africa 1951

Watercolour on paper, 360 mm x 260 mm
Signed *V Thomas '07*

A recent book *The Southern African Plectranthus – and the Art of Turning Shade to Glade* by Ernst van Jaavsveld has been published by Fernwood Press (2006), and contains over 60 exquisite paintings of different *Plectranthus* by Vicki Thomas.

Several different indigenous species of *Plectranthus* are being promoted by Kirstenbosch Botanical Gardens, Cape Town as potentially good garden plants, particularly as in general they really like growing in shade. In the UK they are almost frost-resistant but are more safely propagated from cuttings each year. The flowers are usually a beautiful blue and some species have leaves with a green upper surface and a dramatic dark purple underneath.

Plectranthus zuluensis or Zulu spurflower is widespread in subtropical forest from the northern part of the Eastern Cape through to Kwa-Zulu-Natal and Swaziland in the north. This variety is known as Orbi Gorge, one of the best cultivars. Eventually some *Plectranthus* form bushes and need to be pruned.

This fresh, delicate study shows an elegant perspective of the velvety leaves. The fragile small flowers are beautifully painted to make a most delightful watercolour.

Most species in the family Lamiaceae have small flowers primarily pollinated by insects, including bees, butterflies, and flies. The flowers are bilaterally symmetric, meaning that they can be sliced down the middle to form mirror images of the two halves in only one plane. Such flowers are particularly adapted to being visited by insects, which can only enter the flower in a specific orientation. These flowers have evolved specialised floral tubes that are either swollen at the base or modified into a spur; both structures collect a pool of nectar. In the genus *Plectranthus*, the length of the floral tube with the pool of nectar at the bottom has evolved in relationship to the length of the pollinating flies' tongues, which must reach the nectar reward. The name of the genus comes from the Greek words 'plektron,' which means spur, and 'anthos,' which means flower.

124. *Paulownia elongata* – Paulowniaceae

Tai-Li Zhang, b. Jin Zhou, China 1938

Watercolour on paper, 285 mm x 210 mm

Tai-Li Zhang has worked as a botanical painter all her life, training at the School of Botanical Painting, Institute of Botany, Academia Sinica, Beijing from 1958 to 1960 and then working for 35 years for the department of plant taxonomy in the Institute of Botany.

Tai-Li has shown in many exhibitions in China, and in Sydney, Australia, and the Missouri Botanical Gardens in the USA. Her work was represented in the African International Plant Exhibition held in the Everard Read Gallery, Johannesburg in 1992. Over a thousand of her drawings have been reproduced in *Flora Republicae Popularis Sinicae*, in several of the volumes that won prizes.

This beautifully painted *Paulownia elongata* had been previously published so she was prepared to sell it. Paulownia trees are now being planted in southern England but their huge leaves and brittle branches mean they need a very sheltered position.

Paulownia is another plant that has been segregated from the former large family Scrophulariaceae into its own family the Paulowniaceae. Taxonomists had also placed this genus at one time in the family Bignoniaceae. However, the opposite leaves with flowers clustered at the tips of the branches and the dense, brown hairs covering the base of the flowers are traits which distinguish Paulownia as a separate family from both Bignoniaceae and Scrophulariaceae. Scientists classify plants by the shared possession of unique characters that have evolved from a common ancestor. In the case of the earlier concept of a large family Scrophulariaceae taxonomists realised that many of the characters shared by members of the family had not uniquely evolved in those species so it was necessary to divide the species into smaller groups, such as the Paulowniaceae. The genus *Paulownia* includes six species that are native to East Asia and was named after Princess Anna Paulowna (1795–1865), the daughter of the Tsar of Russia.

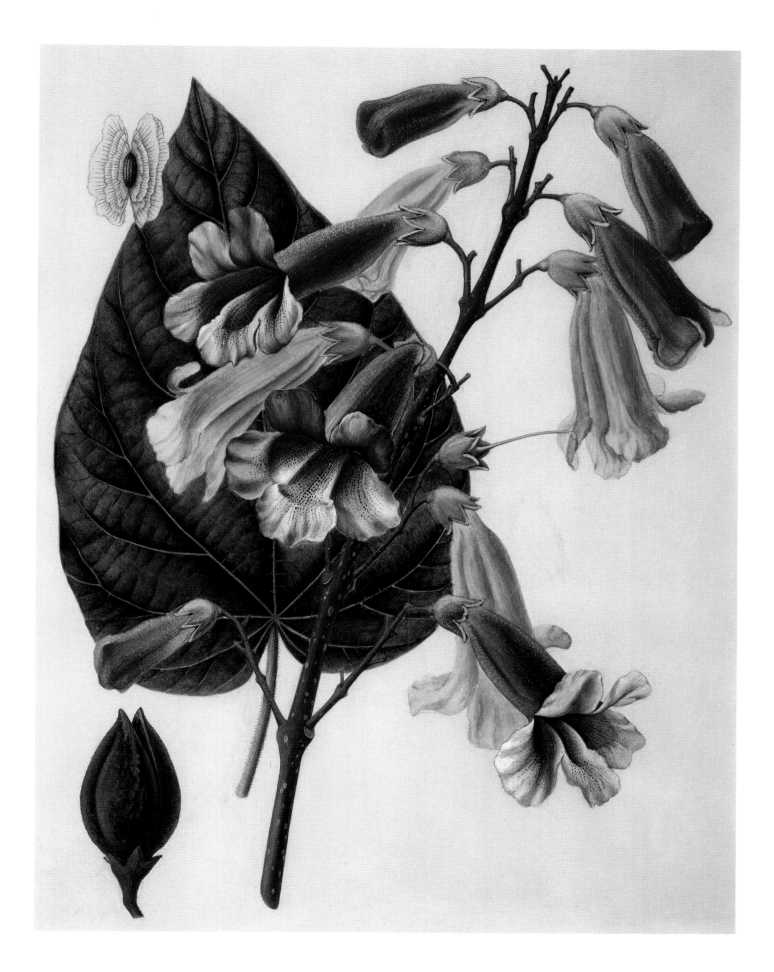

125. *Aeginetia indica* – Orobanchaceae

Mariko Imai, b. Kanagawa, Japan 1942

Watercolour on paper, 270 mm x 190 mm
Signed '79 M. 11.12.2

Mariko Imai is undoubtedly one of the world's most important botanical artists, working for long, sustained periods on a particular plant family to produce a series of definitive portraits.

She teaches botanical painting at Mito Botanical Gardens and has painted a number of plants for the *Endangered Plants of Japan: A Florilegium* (2004) issued by the Japan Botanical Art Association. In 2006 she illustrated a book for children called *The Climbing Plant – Towards the Sunlight* published by Fukuinkan-shoten Japan.

Aeginetia indica is a curious root parasite which grows in wheat fields in Japan.

Members of the family Orobanchaceae, with 61 genera and 1,700 species, are partially to fully parasitic on other plants. This parasitic feature together with several other traits and DNA data provide the evidence that unites these species as a coherent evolutionary unit. The species that are only partially parasitic, called 'hemiparasites,' were formally classified with the genus *Veronica* in the family Scrophulariaceae, but this placement has been shown to be incorrect. Within the Orobanchaceae, species have evolved varying degrees of dependence on their host plants. Some species are green and photosynthesize but derive some important nutrients from their hosts. Others are completely dependent on their hosts for all nutrients and lack the chlorophyll needed for photosynthesis. These plants are called 'holoparasites.' *Aeginetia indica*, native to India, Indonesia, and the Philippines, parasitises sugar cane and other cultivated cereals. This genus was named in honour of Paulus Aegineta, an Egyptian medical doctor in the 7th century, who wrote an early encyclopedia on medicinal plants.

126. *Thunbergia grandiflora* – Acanthaceae

Ann Farrer, b. Melbourne, Australia 1950, works England

Watercolour on paper, 340 mm x 260 mm
Signed *Ann Farrer 1990*

Annie Farrer has painted a lovely plant portrait of this showy climber with its fragile blossoms which drop one day after flowering.

Although it is one of a series of endangered plants in the wild, *Thunbergia* can be seen in cultivation all over the tropics and subtropics. The lovely, prolific powder-blue climber is immensely attractive to huge bumblebees which scratch and tear at the flowers to get at the nectar.

The family Acanthaceae is a moderately large family with 2,770 species in 256 genera. The Acanthaceae is an interesting case in which several lines of DNA evidence support grouping all of the currently recognised species into the family as an evolutionary unit, but taxonomists have not identified any characters of the leaves, flowers or fruits that are shared by all the species. However, the DNA data are strong enough that most taxonomists are convinced that the Acanthaceae should be maintained as a family. The family is primarily tropical and subtropical in distribution with species in Asia, the Americas, and Africa. Within the family, the genus *Thunbergia* and its relatives form an evolutionarily cohesive subgroup sharing similar features found in the leaves, ovaries, and seeds. *Thunbergia* was named by Linnaeus to honour his student Carl Peter Thunberg (1743–1828), who was a plant collector, explorer, and professor of botany and medicine in Sweden.

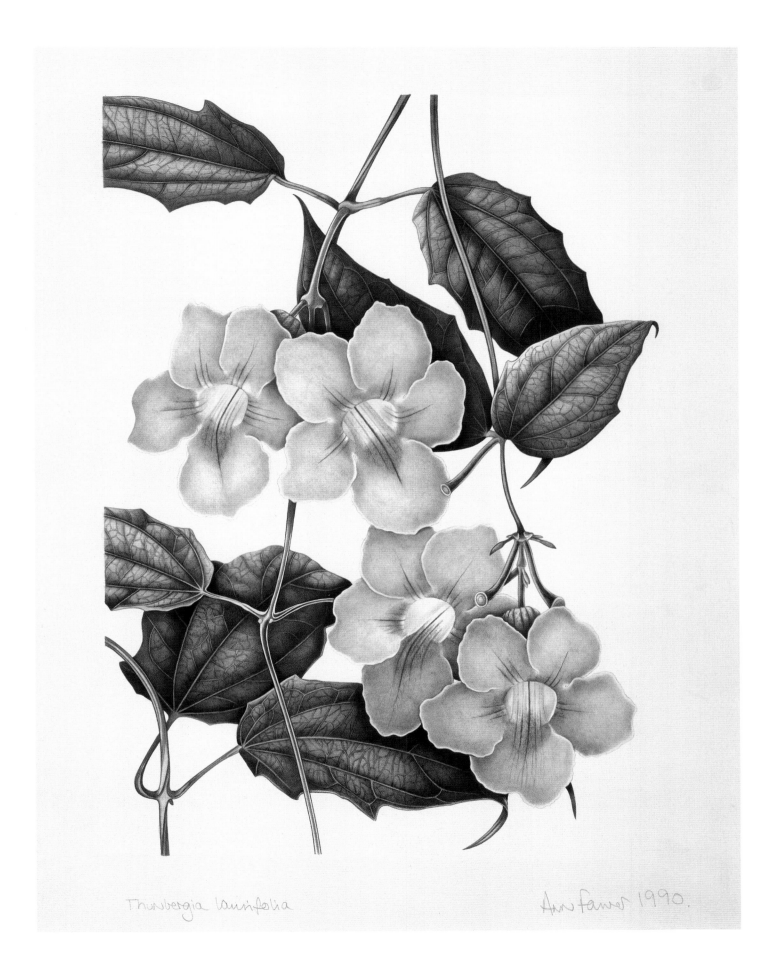

Thunbergia laurifolia

Ann Farrer 1990.

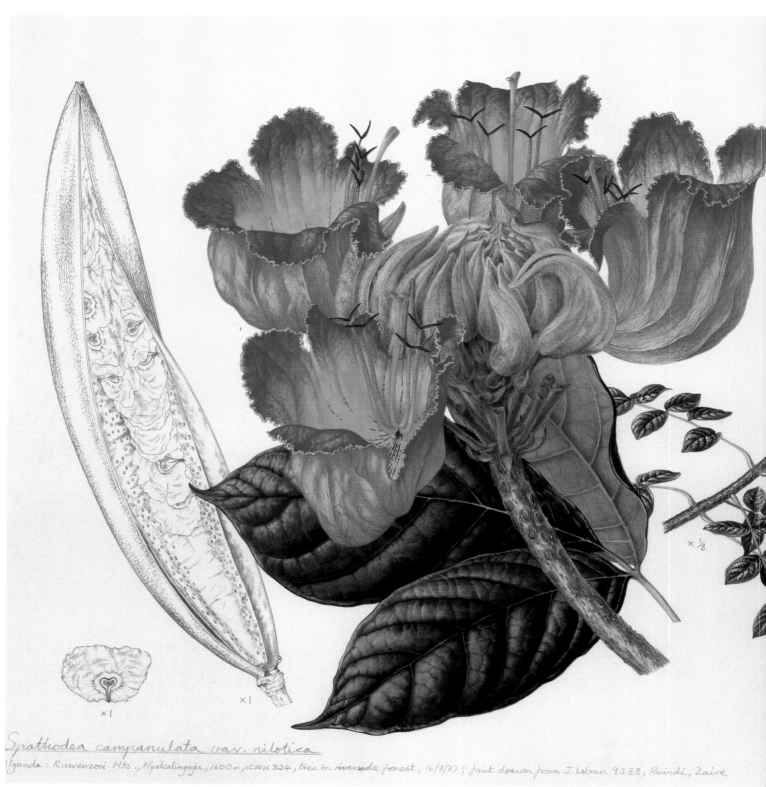

×1

×1

×⅛

Spathodea campanulata var. nilotica

Uganda: Ruwenzori Mts., Nyakalingeju, 1600m, ICFK 324, tree in riverside forest, 16/8/87; fruit drawn from J. Lebrun 9383, Ruindi, Zaire

C F King, Jan. 1993

127. African tulip tree: *Spathodea campanulata* – Bignoniaceae

Christabel King, b. London, England 1950

Watercolour on paper, 265 mm x 365 mm
Signed *C F King 1993*

Christabel King has an honours degree in botany from University College London, and studied scientific illustration for two years at Middlesex Polytechnic, now Middlesex University. Since 1975 she has produced an extraordinary number of illustrations for *Curtis's Botanical Magazine*. She illustrated several books in the 1980s and more recently has painted plates for eight Kew monographs, with more to come. Her latest is *The Genus Roscoea* by Jill Cowley (2007). Her illustration in *All Good Things Around Us* by Pamela Mitchell re-appeared in a new book *Edible Wild Plants and Herbs*, again in 2007. She received the prestigious Jill Smythies Prize from the Linnean Society in 1989.

Her highly professional work is characterised by meticulous handling and subtle colours. She is particularly good at cacti, where she gets a wonderful contrast between their fleshy, succulent, spiny stems and their delicate flowers. Her display of cacti portraits in 'Treasures of Botanical Art: Icons from the Shirley Sherwood and Kew Collections' at the new gallery at Kew was hugely admired.

Since 1990, Christabel King has been an inspiring and memorable tutor to many Brazilian students who come to the Royal Botanic Gardens, Kew under the Margaret Mee Fellowship scheme. In 1994 she visited Brazil and taught courses in Rio de Janeiro, Sao Paulo and, in Pará province, running further courses in 2003 which Brazilian artists still talk about. Since 2002 she has been training botanical artists in Turkey.

Her African tulip tree is painted in glorious colour, showing how good she can be painting a flamboyant subject.

The Bignoniaceae is a family made up of shrubs, trees, and lianas with over 800 species. These plants are all found in the tropics and subtropics, where they form a conspicuous element of the forest because of their usually large colourful flowers. Many diverse pollinating animals have evolved with the diverse floral forms present in the Bignoniaceae. Large bees, birds, bats, and mammals have been recorded to visit the flowers of various genera. The several species which make up the genus *Spathodea* are native to tropical Africa. The open, cup-shaped, bright orange flowers of *Spathodea campanulata* are pollinated in their native habitats by birds that perch on the closed flowers and probe the open flowers for nectar. This species has been cultivated as an ornamental tree in many other tropical regions of the world. In such non-native habitats, local species of birds as well as bats have been reported to visit the flowers even though they have not evolved together.

Aquifoliales

The euasterids II, the second major assemblage of the asterids, is made up of four orders, the Aquifoliales, Asterales, Dipsicales and Apiales. The first order, Aquifoliales, contains the holly family plus four additional rather obscure families. The flowers in these plants are either male or female and are produced on separate plants. The fruits are fleshy.

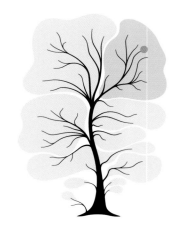

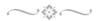

128. **Holly:** *Ilex* **sp.** — Aquifoliaceae

Jenny Phillips, b. Boort, Victoria, Australia 1949

Watercolour on paper, 250 mm x 200 mm
Signed *Jenny K Phillips 2007*

This small sketch shows a masterly grasp of perspective and the clever use of highlights on the scarlet berries and glossy sharp leaves. Jenny Phillips gave this to the Shirley Sherwood Collection in order to complete the paintings in this book.

A number of species of *Ilex*, the large and only genus in the primarily tropical family Aquifoliaceae, produce secondary compounds that are found in the leaves and bark. Some of the species that possess these compounds are used in local cultures as stimulant beverages and hallucination-causing tonics. These secondary compounds evolved in Ilex and other plant families, such as the tomato family, the milkweed family and the willow family, to protect the plants from insects that eat them. These insects, called herbivores, can cause substantial damage to the plants they feed on so any mechanism that discourages these attackers, such as spines or irritating and distasteful chemicals, are favoured by natural selection. The use of these plants and their chemical compounds by people is a secondary by-product of the evolution of these anti-herbivore properties by the plants.

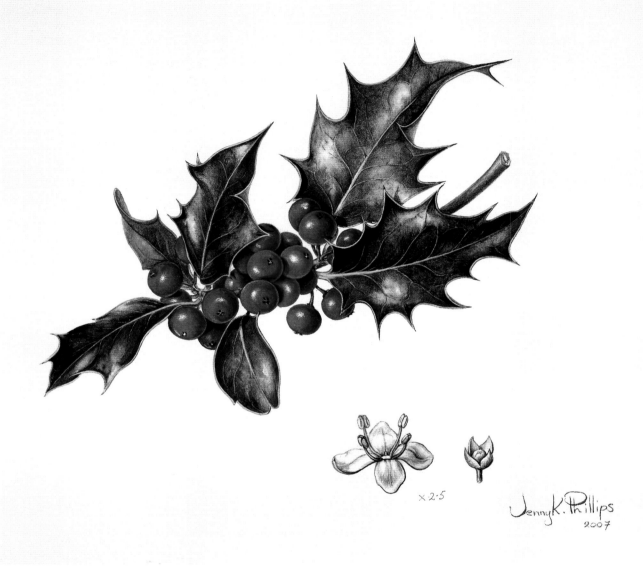

×2·5

Jenny K. Phillips
2007

Asterales

The members of the Asterales contain several special chemical properties and the same chromosome number, and all have stamens that form a tube around the style. Within the order are nearly 25,000 species divided among 12 families, including the asters, sunflowers, campanulas and lobelias. Botanists have intensely studied the evolutionary relationships within the Asterales using DNA data and information on flower structure and chemistry.

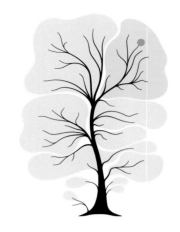

129. *Physoplexis comosa* – Campanulaceae

Rosane Quintella, b. San Paulo, Brazil, 1959

Watercolour on paper, 350 mm x 440 mm
Signed *Rosane Quintella*

Rosane Quintella now lives in Curitiba in the state of Parana, Brazil. After graduating in fine arts from the School of Music and Fine Arts of Parana in 1982 she studied biology at the Catholic University of Parana and graduated from there in 1992.

Rosane studied botanical illustration with Diana Carneiro at the Centro de Ilustração Botânica de Paraná (CIBP) and with Christabel King on her visit to Curitiba in 2003. Her previous work experience included the preparation of large scale diorama displays for various museums in Parana, especially the Iguaçu Regional Museum at the Salto Segredo Hydroelectric Station for which she painted a panoramic series of 21 large paintings (in acrylic on MDF board) depicting the amazing landscapes and ecosystems along the Rio Iguaçu where Paraguay, Argentina and Brazil meet at the most beautiful and dramatic series of waterfalls in the world.

Physoplexis comosa was grown at Kew and painted by Rosane Quintella in 2005 while she was studying on a Margaret Mee Fellowship. It is a quiet and controlled work, worthy of close examination.

The family Campanulaceae is a moderately-sized family with about 2,200 species found principally in the temperate zone and subtropical regions, with a few members in the mountainous zones of the tropics. As defined by contemporary taxonomists, the family also includes those species formerly classified in the Lobeliaceae. In the flowers of the Campanulaceae an interesting mechanism has evolved to place pollen on the animal pollinators that visit them. The five stamens form a tube around the style and as the style expands when the flowers are mature, it pushes the pollen out of the anthers and onto the insect and bird visitors. This mechanism is called 'secondary pollen presentation' because it is the style that secondarily places the pollen directly onto the pollinator and not the anthers themselves. *Physoplexis* grows on limestone rocks and crevices in the Alps of south-eastern Europe.

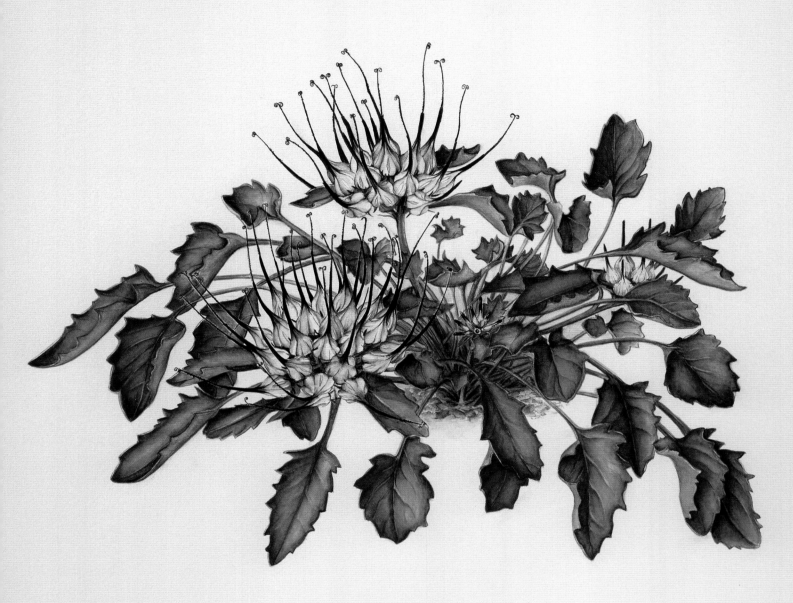

Physoplexis comosa
Campanulaceae
Cult. Alpine Dept., R.B.G., Kew
1959- 80801, Reic

Rosane Quintella
01/06/2005

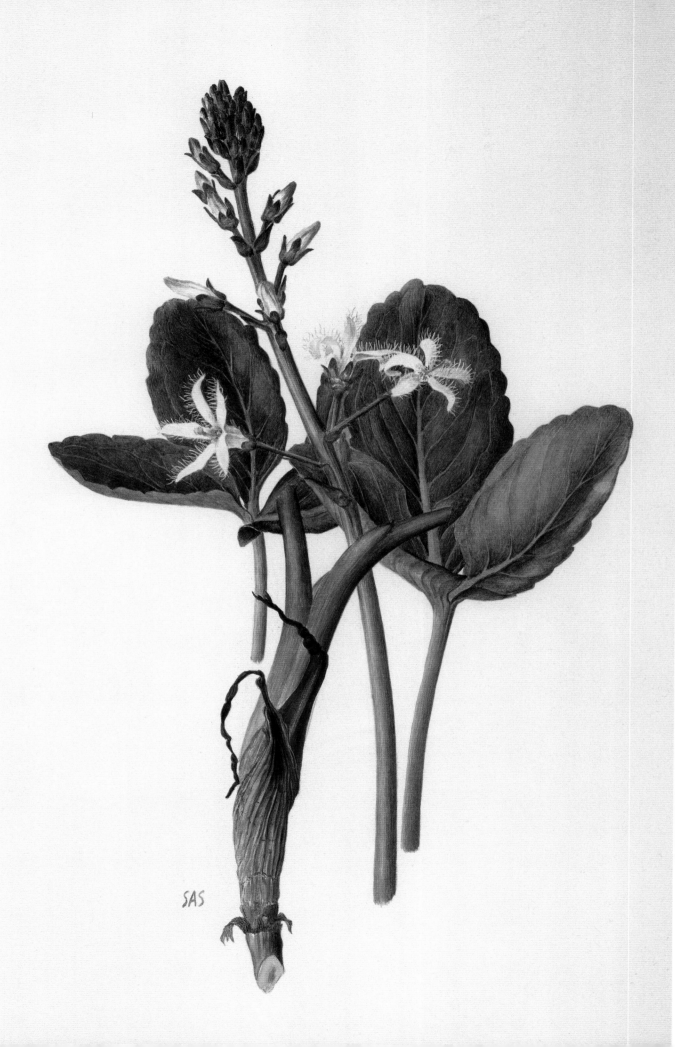

130. **Bog bean:** *Menyanthes trifoliata* – Menyanthaceae

Sara Anne Schofield, b. Twickenham, England 1937

Watercolour on paper, 295 mm x190 mm
Signed *SAS*

Best known for her compositions of seasonal flowers, Sara Anne Schofield also does some delightful studies of isolated specimens. She was commissioned to create eight elaborate plate designs called 'Bouquet for the Queen Mother' executed by Royal Doulton.

Sara Anne studied at Twickenham College of Art, worked at Kew and has had many exhibitions in London and elsewhere in the United Kingdom. She holds two gold medals from the RHS and is a founder member of the Society of Botanical Artists, having shown in all their annual exhibitions. Her work is in the Hunt Institute's collection and she had a solo show at the Tradescant Trust Museum of Garden History, London shortly after it opened.

Her traditional portrait of the bog bean, *Menyanthes trifoliata*, is a quiet, elegant little study of this pretty water plant. She has placed the flowers cleverly in front of the leaves so that their white hairy structure can be seen clearly.

The family Menyanthaceae was at one time considered to be a close evolutionary relative of the gentians in the order Gentianales. This closeness is now not considered to be true and the family is placed in the order Asterales. Members of the Menyanthaceae are adapted to living in wetlands and aquatic habitats around the world and are similar to the water lilies and pickerel weeds to which they are quite unrelated. The genus *Menyanthes* has only a single species, which is distributed widely in the northern temperate regions. Similar to several other groups of unrelated flowering plants, the flowers of *Menyanthes* have two different floral forms that vary in the length of the style and stamens. This condition is called 'distyly' and serves to ensure that pollen is transferred between plants by their faithful insect pollinators. The generic name is derived form the Greek 'mene' meaning 'moon' and 'anthos' meaning flower in reference to the name 'moonflower,' which was the Greek name for aquatic plants.

131. **Dandelion:** *Taraxacum officinale* – Asteraceae

Marilena Pistoia, b. Milan, Italy 1933

Watercolour on paper, 175 mm x 265 mm
Signed *M. Pistoia*

There are more botanical artists in Italy now, but when Marilena Pistoia started she was an exception, with a large body of work in several big glossy books published by Mondadori (Milan) and Calderini (Bologna). The flowers are always most beautifully arranged upon the page, often curved in soft swathes around the centre, and painted in a sensitive and yet decisive way.

Marilena works in an austere studio near Modena. She had specially retrieved her flower paintings from the bank to show them. She said that several years ago a publisher had lost 52 of her original paintings. Then she said, 'I stopped painting flowers, it was a different period of my life and it is completely finished. I only did it to make a living'. She is now drawing only futuristic globes delineated with a fine compass-operated pen. She spends the rest of her time as professor at the Accademia di Belle Arte di Bologna where she has taught etching since 1980.

This dandelion watercolour is one of the most delicate and treasured works in the Shirley Sherwood Collection, with exquisite composition and execution that has been hugely admired when on exhibition.

The family Asteraceae, also called the Compositae, has been considered to be a unified evolutionary group by all botanists. The family is the largest of the eudicots with over 23,000 species and at least 1,535 genera. A number of special traits evolved in the common ancestor of all members of the Asteraceae, such as several unusual chemical constituents, the dense cluster of flowers congested into a 'head' that is subtended by whorls of modified leaves called bracts, and a highly modified envelope of bristles or scales outside the petals. Similar to members of the Campanualaceae, secondary pollen presentation, in which the pollen is pushed out of the anthers by the elongating style, has evolved. Despite the evolution of this elaborate floral mechanism in the Compositae, species of the genus *Taraxacum*, the dandelions, usually reproduce without sex. In this rather rare system the mother plant is able to clone itself and reproduce exact replicates via seeds.

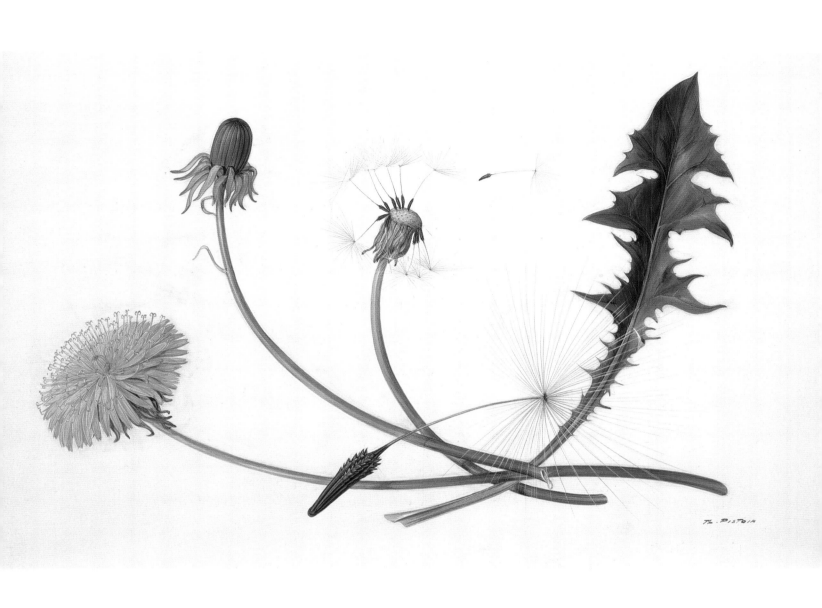

CORE EUDICOTS: ASTERIDS 303

132. **Artichoke flower:** *Cynara scolymus* – Asteraceae

Brigid Edwards, b. London, England 1940

Watercolour over pencil on vellum, 360 mm x 260 mm
Signed *Brigid Edwards 1989*
Commissioned

This painting on vellum was commissioned in the early days of the Shirley Sherwood Collection. Brigid Edwards lived near Oxford and tried to grow good flower heads of artichokes so she could paint them after the huge edible bud had opened to show the purple inflorescence inside. It is a delightful strong and unusual image. The variety of artichoke she painted was the same as one depicted in Bessler's 'Hortus Estenensis' and it was shown with the Bessler plate when comparing old and new botanical studies in exhibitions at the Marciana Library in Venice and in the Ashmolean Museum in Oxford in 2005.

 The striking quality of her work has inspired many artists to paint artichokes and other vegetables, but her work is always original and so strong that she has been a spirited leader, continually breaking new ground.

The family Asteraceae is very large, which makes the classification within the family especially complex and detailed. The taxonomic limits and boundaries of the genera have always been problematic and contemporary taxonomists are now redefining many of the genera based on a combination of DNA evidence and new interpretations of floral and vegetative traits. The artichoke, *Cynara scolymus*, is a member of a subfamily of the Asteraceae that is larger than many other entire families of flowering plants. The artichokes are native to the Mediterranean and the Canary Islands. The shoots are topped by a large, globe-like, cluster of many flowers densely packed together and surrounded by thick and fleshy protective bracts. These bracts are the part of the plant that is cooked and eaten as a vegetable. The bristly, inedible part in the centre of the artichoke, which is avoided by most culinary experts, represents the immature flowers.

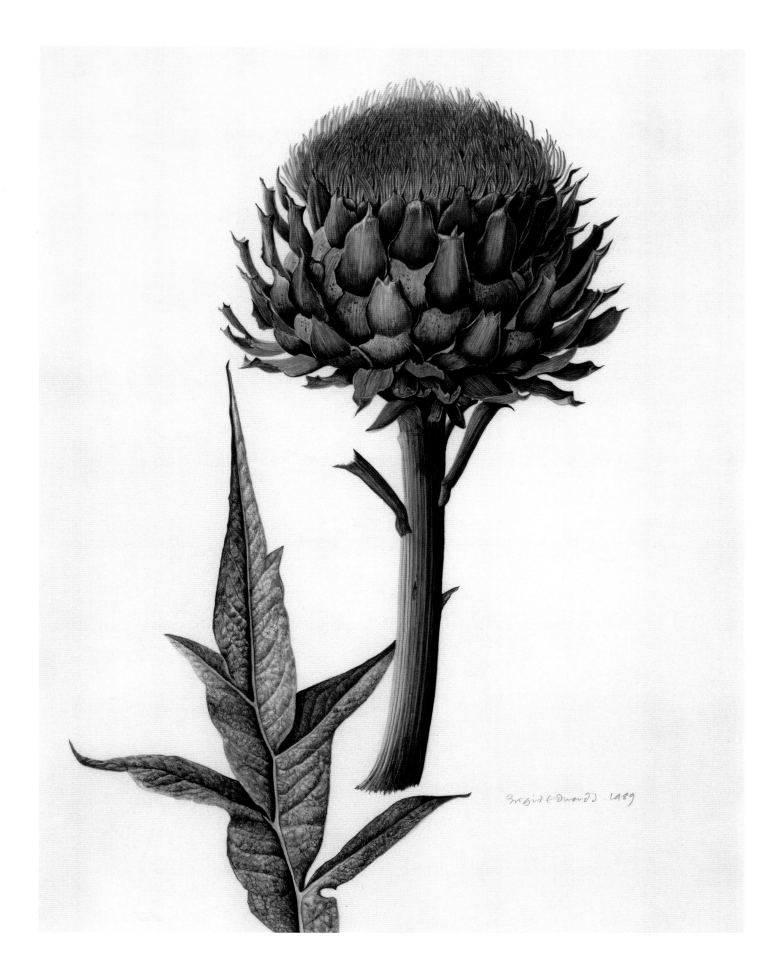

Brigid Edwards 1989

133. Woolly thistle: *Cirsium eriophorum* – Asteraceae

Johann Christoph Dietzsch, b. Nürnberg, Germany 1710–1769

Watercolour and bodycolour, 288 mm x 207 mm

Johann Israel Dietzsch (1681–1754) was an artist whose daughters, Barbara Regina (1706–1783) and Margaretha Barbara (1716–95), and son Johann Christoph (1710–1769) were also all talented painters. Johann Christoph, to whom the painting illustrated in this book is tentatively attributed, worked with his father and sisters at the Court in Nürnberg, and was particularly known for his landscape paintings, although he produced a number of flower paintings, and was also an etcher and engraver. Both he and his sister Barbara Regina, who often worked in gouache, appear to have painted flowers on a very dark brown background, and thistles with butterflies were among their favoured subjects, so it is difficult to be certain who painted this picture.

The woolly thistle is decorated with butterflies, a beetle, a caterpillar, a spider and trails of spiders' webs. Its remarkable three-dimensional quality is enhanced with exquisitely executed leaf prickles. It is a masterpiece from the past and one of the few old works in the Shirley Sherwood Collection.

Members of the family Asteraceae can be found in any habitat almost anywhere in the world. They are most common in the northern temperate zone but can also be found in mountain forests in the tropics. These plants have evolved many adaptations to withstand harsh environments as well as more moderate climates. The genus *Cirsium*, or thistles, includes between 100 and 200 species, most of which are tough and spiny perennial herbs. The spines on the leaves have evolved as a defence to prevent grazing animals from eating the leaves. It is not uncommon to encounter well-grazed cow pastures in which only the thistles remain as evidence of the effectiveness of their thorny leaves. The woolly thistle is common on calcareous soils, open grasslands, and disturbed habitats in Europe and Great Britain. The flowers are pollinated by long-tongued bees and butterflies that effectively probe the heads of flowers while avoiding the spiny leaves.

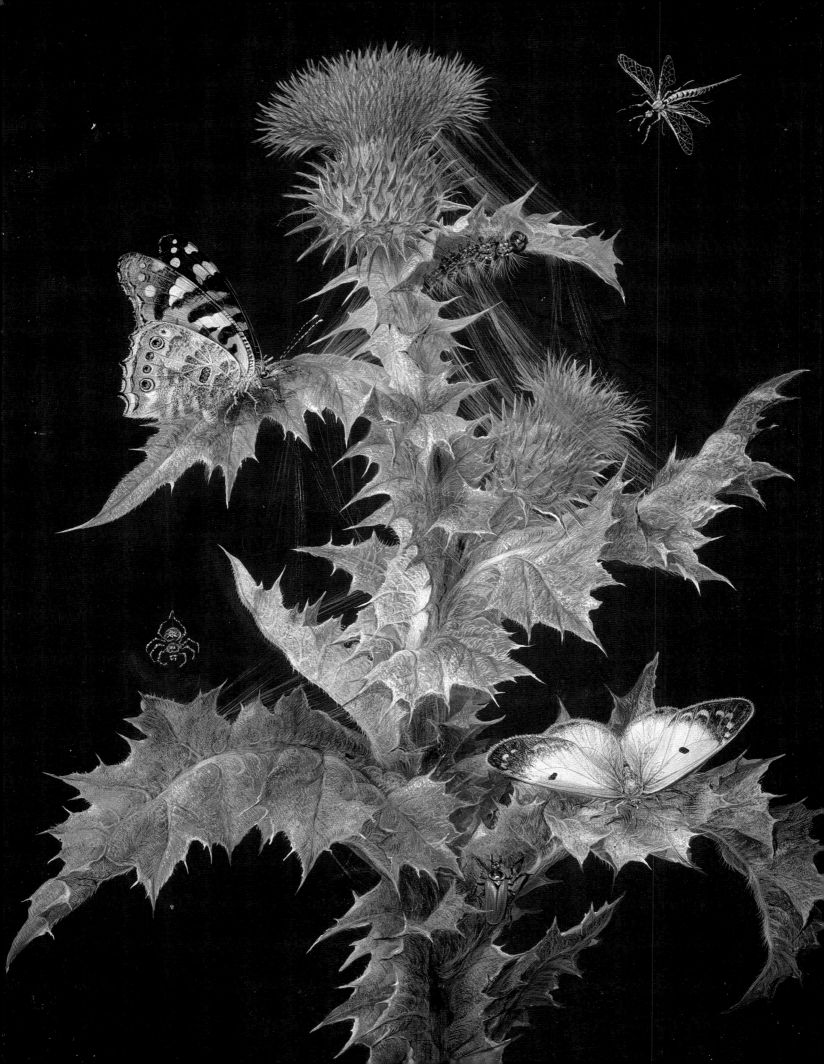

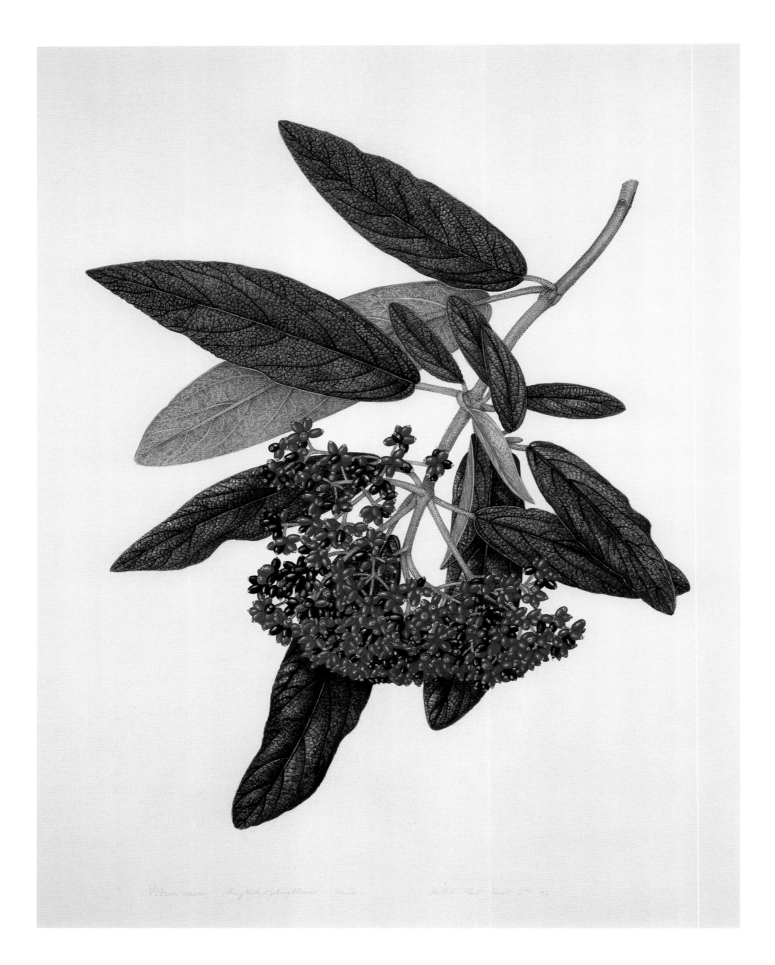

Viburnum rhytidophyllum Hemsl.

Dipsicales

One of the most specialised groups of flowering plants, the Dipsicales include only two plant families and about 100 species. They are distinctive in having opposite leaves and a unique form of endosperm development in the seeds. Plants such as honeysuckle, viburnums, and teasel are found within this order, which has members distributed widely in cooler temperate zone regions.

134. *Viburnum rhytidophyllum* – Adoxaceae

Margaret Stones, b. Victoria, Australia 1920
Watercolour on paper, 482 mm x 370 mm
Signed *Margaret Stones*

One of Australia's most celebrated botanical painters, Margaret Stones spent a great deal of her life in England, living close to Kew. She has now returned to her homeland.

She has illustrated many books including the massive *The Endemic Flora of Tasmania* by W. Curtis (1962–77) whose six volumes contain 250 of her watercolours. She painted a collection of wild flowers from Louisiana which have been shown widely throughout the United States and which were published in *Flora of Louisiana* (1991). She has received two honourary degrees as well as an MBE. Her work has been selected for many collections ranging from the Natural History Museum in London, the Ashmolean in Oxford, the British Museum, Cornell University and National Gallery of Victoria to the National Library of Australia.

Her painting of *Viburnum rhytidophyllum* shows her skill with leaves as well as with the dramatic black and scarlet berries. Her innate sense of design is evident as well as her superb technique. She found this specimen early in the autumn at Kew.

The family Adoxaceae is closely associated with the family Caprifoliaceae, which includes the honeysuckles. The Adoxaceae is well-supported as a separate family by both DNA sequence data as well as features of the flowers, nectaries, and pollen. The largest genus is *Viburnum* with 175 species of shrubs and small trees. It is often inluded in the Caprifoliaceae, but it is now evident that it is more properly classified in the Adoxaceae. Species of *Viburnum* are distributed throughout the northern hemisphere and many are recognised by their flat-topped clusters of fragrant flowers. The flowers around the margins of the clusters are often non-fertile and have enlarged and very conspicuous petals that have evolved to attract insect pollinators to the flowers inside the clusters. These attractive marginal flowers in the Adoxaceae are very similar in appearance to the marginal flowers found in the family Hydrangeaceae. However, in the hydrangeas, the outer sepals of the flowers have evolved the conspicuous display, rather than the inner petals as in *Viburnum*. Natural selection has achieved the same function in two groups of unrelated plants in very different fashions.

Apiales

The ten plant families in this order were thought to be more closely allied to the rosids in earlier classifications by botanists. DNA data has now shown that these plants have most certainly evolved with families in the euasterids II, but it is not clear which of these plants are the closest relatives of the Apiales. Many of our cooking herbs, such as dill, caraway, coriander, cumin, fennel, parsley and anise, are in this order.

135. **Ivy:** *Hedera helix* – Araliaceae

Diana Lawniczak, b. Dabrowa Górnica, Poland 1951

Watercolour on card, 340 mm x 240 mm
Signed *Diana Lawniczak*

Here, Diana Lawniczak has produced another fascinating close-up study, this time of ivy (see also speedwell no. 120–21). She shows a selection of varied leaf shapes, the magnified flower and different stages of fruit development. She wanted to display the variety and detail usually missed by the casual observer and this, like her previous study, was published in *Flora Non Grata* in 2002.

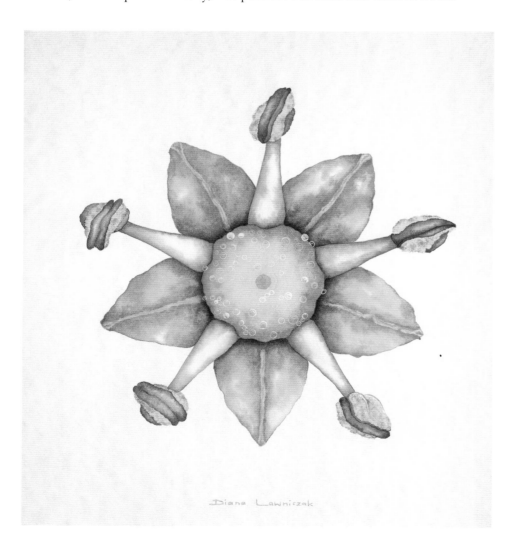

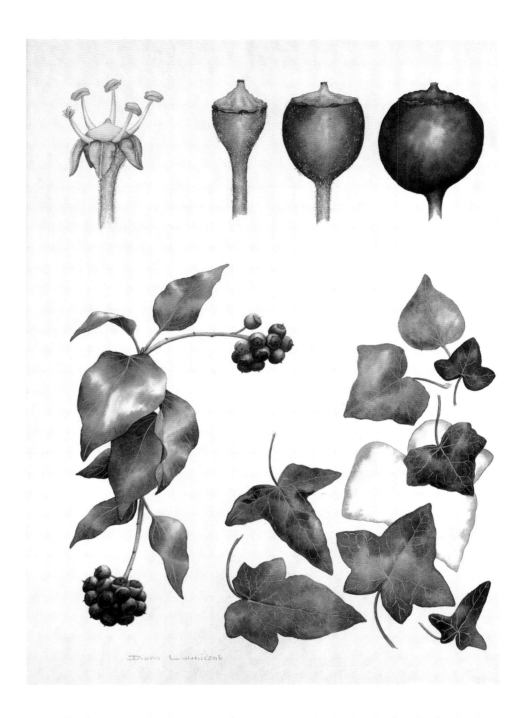

Diana Lutwiniczak

For those taxonomists who recognise the Araliaceae as a separate, distinctive family from the Apiaceae, three taxonomic subgroups are recognised within the family that correspond to the geographic distribution of the species in South-East Asia, Eastern Asia, and the Pacific Ocean. The taxonomic boundaries of some of genera in the Araliaceae are also at present under intense scientific study. The genus *Hedera* is allied with other species in the Araliaceae that have evolved globose fruits containing several pips inside. The flowers of *Hedera helix* produce a strong and, to some, disagreeable fragrance, which attracts a number of types of insects to the flowers, including caddis-flies, crane-flies, blow-flies, and mosquitoes. Some of these insects also feed on carrion, which may account for the evolution of the flowers' unpleasant odour, which mimics that of rotting flesh.

136. **Sand thistle:** *Eryngium maritimum* – Apiaceae

Viet Martin Kunz, b. Stuttgart, Germany 1941

Watercolour on paper, 390 mm x 340 mm
Signed *V M Kunz*

Kunz started his career as an art teacher after graduating from Stuttgart. He has concentrated on botanical illustration in watercolour since 1972, showing solo in Filderstadt Municipal Gallery in Bad Wörishofen and Wilhelma Zoological and Botanical Garden in Stuttgart in 1990.

He showed at the 7th International Exhibition at the Hunt Institute in 1992. His illustration of an *Eryngium* thistle was painted on the Atlantic shores when he was on holiday; he called it 'Sand thistle'.

Some taxonomists have chosen to combine the family Apiaceae, which are mainly herbs, with the family Araliaceae, which are mainly shrubs and trees. Together this very large taxonomic group constitutes over 4,250 species. Good reasons exist to combine these families, including DNA sequence data as well as the distinctive fruit type and chemical compounds that are shared by their members. However, other taxonomists, who believe that the same evidence points to the distinctive nature of the two families, prefer to keep them as separate Apiaceae and Araliaceae. As more evidence accumulates from the study of DNA as well as morphological traits of the plants, a consensus on the appropriate taxonomy will undoubtedly emerge. The genus *Eryngium* is traditionally placed in the herbaceous Apiaceae. The species *Eryngium maritinum* is shrubby in its growth habit and grows in the sand dunes bordering the ocean where it is adapted to the low salinity of this maritime environment.

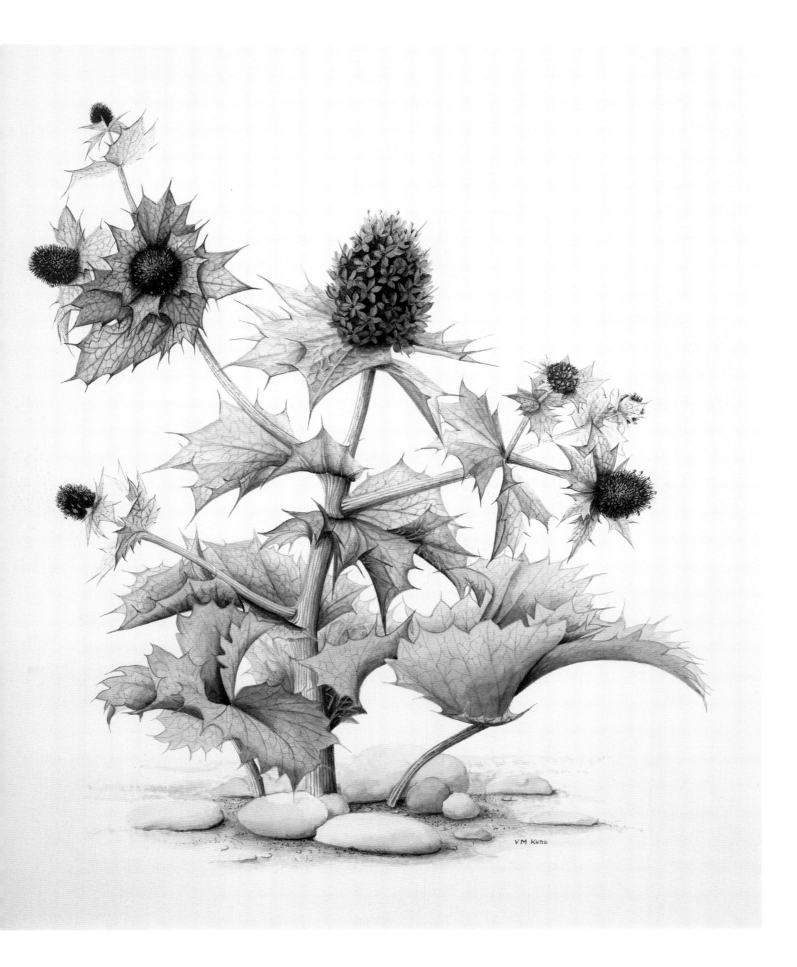

VM Kunz

Select bibliography

General books

Arnold, Marion. (2001). *South African Botanical Art: Peeling Back the Petals.* Fernwood Press in association with Art Link, South Africa.

Blunt, W. and Stearn, W. T. (1950). *The Art of Botanical Illustration.* Collins, London, UK.

————— (1994). *The Art of Botanical Illustration* (2ⁿᵈ edn). Antique Collectors' Club, Woodbridge, in association with Royal Botanic Gardens, Kew.

De Bray, L. (1989). *The Art of Botanical Illustration.* Christopher Helm, Bromley and Wellfleet Press, NJ, USA.

Kenrick, P and Davis, P. (2004). *Fossil Plants.* Natural History Museum, London

Rix, M. (1981). *The Art of the Botanist.* Lutterworth Press, Guildford & London, UK. (Published in the USA by the Overlook Press as *The Art of the Plant World: the Great Botanical Illustrators and their Work.*) Reprinted 1989 by Bracken Books, London as *The Art of Botanical Illustration.*

Sherwood, S. (1996). *Contemporary Botanical Artists: The Shirley Sherwood Collection.* Weidenfeld & Nicolson, London, UK.

————— (2000). *A Passion for Plants.* Cassell & Co, London, UK.

————— (2005). *A New Flowering: A Thousand Years of Botanical Art.* Ashmolean Museum, Oxford, UK.

Sherwood, S. and Rix, M. (2008). *Treasures of Botanical Art: Icons from the Shirley Sherwood and Kew Collections.* Royal Botanic Gardens, Kew, UK.

Snow, C. P. (1960). *The Two Cultures and the Scientific Revolution,* The Rede Lecture 1959. Cambridge University Press, Cambridge, UK.

Scientific publications

Angiosperm Phylogeny Group (2009). An update of the AGP classification of families and orders of the flowering plants. *Botanical Journal of the Linnean Society,* in press.

Heywood, V. H. et al. (2007). *Flowering Plant Families of the World.* Royal Botanic Gardens, Kew, UK, and Firefly Books, Toronto.

Judd, W. J. et al. (2002). *Plant Systematics: A Phylogenetic Approach.* Sinauer Associates, Inc. Sunderland, MA, USA.

Mabberley, D. J. (2008). *Mabberley's Plant-book: A Portable Dictionary of Plants, their Classifications, and Uses.* 3rd Edition. Cambridge University Press, Cambridge, UK.

Soltis, D. E. et al. (2005). *Phylogeny and Evolution of Angiosperms.* Sinauer Associates, Inc. Sunderland, MA, USA.

Books illustrated by contemporary artists with works in this publication

The artists are listed alphabetically by surname, listing only books which have been illustrated wholly or partly by the artist.

Coombs, Jill

Chatto, Beth (1985). *Plant Portraits.* Dent, in association with the Telegraph Sunday Magazine, London, UK.

Grey-Wilson, C. (1987). *Herbs for Cooking and Health.*

Illustrations for *Curtis's Botanical Magazine, The Crocus* by Brian Mathew, *Flower Artists of Kew* by William T. Stearn, *The Natural History of the British Isles, Country Life* and *The Origin of Plants* by Maggie Campbell-Culver.

Dean, Pauline

Dean, George. (2009). *Flowering Legacy: The Biography of a Botanical Artist – Pauline M Dean.* Botanical Publishing, Guildford, UK.

Dean, P. (2004). *Portfolio of a Botanical Artist.* Botanical Publishing, Guildford, UK.

Stearn, W. T. (2002). *The Genus Epimedium and other Herbaceous Berberidaceae.* Royal Botanic Gardens, Kew, UK.

Demonte, Etienne

Ferraz Blower, C. D. (1990). *Fauna e Flora do Brasil – Fauna and Flora of Brazil.* Salamandra, Rio de Janeiro.

White, J. J. (comp.) (1985). *For Love of Nature: Brazilian Flora and Fauna in Watercolour by Etienne, Rosália and Yvonne Demonte.* Hunt Institute, Pittsburgh and Wave Hill, NY.

Edwards, Brigid

Richards, J. (1993). *Primula.* Batsford, London, UK and Timber Press, OR, USA.

Farrer, Ann

Boyce, P. (1993) *The Genus Arum,* Royal Botanic Gardens, Kew, UK.

Fomicheva, Dasha

Musselman, L. J. (text), watercolours by Dasha Formicheva. (2000). *Jordan in Bloom: Wildflowers of the Holy Land.* Jordan River Foundation, Amman.

Dowle, Elisabeth

Huxley, A. (ed.) (1999). *The New Royal Horticultural Society Dictionary of Gardening.* Macmillan/The Folio Society, London, UK.

Morgan. J. and Richards, A. (2002). *The New Book of Apples.* Ebury Press, London, UK.

Vaughan, J. G. and Geissler, C. (1997) *The New Oxford Book of Food Plants.* Oxford University Press, Oxford, UK.

Guest, Coral

Guest, C. (2001). *Painting Flowers in Watercolour: a Naturalistic Approach.* A and C Black, London, UK.

Imai, Mariko

Udagawa, Y. (1983–84). *The Story of Orchids.* K. K. Shin Kikaku, Tokyo, Japan.

————— 1994. *Masdevallia and Dracula.* Nigensha Publishing, Tokyo, Japan.

Jones, Paul

Blunt, W. (1971). *Flora Superba.* Tryon Gallery, London, UK.

————— (1976). *Flora Magnifica.* Tryon Gallery, London, UK.

Urquhart, B. L. (ed.). (1956–60). *The Camellia.* 2 volumes. Leslie Urquhart Press, Sussex, UK.

King, Christabel

Cowley, Jill (2007). *The Genus Roscoea.* Royal Botanic Gardens, Kew, UK.

Cribb, P. & Butterfield, I. (1988). *The Genus Pleione.* Royal Botanic Gardens, Kew in association with Christopher Helm, Bromley and Timber Press, OR, USA.

Davis, A. P. (1999). *The Genus Galanthus.* Royal Botanic Gardens, Kew in association with Timber Press, OR, USA.

Heywood, V. H. (ed.) (1978). *Flowering Plants of the World*. Elsevier, Oxford, UK and Mayflower Books, NY, USA.

Mathew, B. (1989). *The Genus Lewisia*. Royal Botanic Gardens, Kew in association with Christopher Helm, Bromley and Timber Press, OR, USA.

Michael, P. (1980). *All Good Things Around Us*. Ernest Benn, London, UK and Holt, Rinehart & Winston, NY, USA.

Taylor, N. P. (1985). *The Genus Echinocereus*. Royal Botanic Gardens, Kew in association with Collingridge, Middlesex.

Yeoman, G. (1989). *Africa's Mountains of the Moon*. Elm Tree Books, London, UK and Universe Books, NY, USA.

Lee, Katie

Armour, M. C. (1994). *Orca Song*. SoundPrints, Norwalk, CT, USA.

Bailer, D. (1993). *Puffin's Homecoming*. SoundPrints, Norwalk, CT, USA.

Chandra, D. (1995). *Who Comes?* Sierra Club Books for Children, San Francisco CA, USA.

Fear, S. (1999). *Go Away Bugs*. Addison-Wesley Educational Publishers Inc, New York, USA.

Jay, L. A. (1995). *Sea Turtle Journey*. SoundPrints, Norwalk, CT, USA.

Lee, K. (1994). *A Visit to Galapagos*. Harry N. Abrams, NY, USA.

Lind, A. (1994). *Black Bear Club*. SoundPrints, Norwalk, CT, USA.

Meachen Rau, D. (1996) *Undersea City*. SoundPrints, Norwalk, CT, USA.

Nash, O. (1996). *Underwater with Ogden Nash*. Bulfinch Press, Boston, MA, USA.

Ring, E. (1996). *Monarch of Aster Way*. SoundPrints, Norwalk, CT, USA.

McElwain, Dianne

Mairose, M. A. (2008). *Our First Family's Home*, Ohio University Press, Ohio, USA.

McEwen, Rory

Blunt, W. (1977). *Tulips and Tulipomania*. Basilisk Press, London, UK.

McEwen, R. (1988). *Rory McEwen: the Botanical Paintings*. Royal Botanic Garden, Edinburgh in association with the Serpentine Gallery, London, UK.

Moreton, O. C. (1955). *Old Carnations and Pinks*. George Rainbird in association with Collins, London, UK.

———— (1964). *The Auricula*. The Ariel Press, London, UK.

Mee, Margaret

Mayo, S. (1988). *Margaret Mee's Amazon*. Royal Botanic Gardens, Kew.

Mee, M. (1980). *Flores do Amazonas – Flowers of the Amazon*. Record, Rio de Janeiro, Brazil.

———— (1968). *Flowers of the Brazilian Forests*. Tryon Gallery, London, UK.

———— (ed. T. Morrison). (1988). *In Search of Flowers of the Amazon Forests*. Nonesuch Expeditions, Suffolk, UK.

———— (2004). *Margaret Mee's Amazon. Diaries of an Artist Explorer*. Antique Collectors' Club in association with the Royal Botanic Gardens, Kew, UK.

———— (2007). *Margaret Mee*. Fundacio Botanica Margaret Mee

Sanders, Rosanne

Sanders, R. (1988). *The English Apple*. Phaidon, Oxford, UK, in association with the RHS. (American edition published as *The Apple Book* by The Philosophical Library, NY, USA.)

Sellars, Pandora

Boyce, P. (1993). *The Genus Arum*. HMSO, London in association with the Royal Botanic Gardens, Kew, UK.

Cribb, P. (1998). *The Genus Paphiopedilum*. 2nd Ed. Natural History Publications, Borneo, in association with the Royal Botanic Gardens, Kew, UK.

Sherlock, Siriol

Sherlock, S. (1998). *Exploring Flowers in Watercolour: Techniques and Images*. B. T. Batsford Ltd, London, UK.

Speight, Camilla

Has contributed to many books including recent RHS manuals by Macmillian, London.

Green, P. (1997). *The Flore de la Nouvelle Calédonie et Dépendances*. Muséum National D'Histoire Naturelle, Paris, France.

Radcliffe-Smith, A. (1997). *The Euphorbiaceae*. Royal Botanic Gardens, Kew, UK.

Stones, Margaret

Curtis, W. and Stones, M. (1967–78). *The Endemic Flora of Tasmania*. The Ariel Press, London, UK.

Stones, M. (1991). *Flora of Louisiana*. Louisiana State University Press, Baton Rouge, USA and London, UK.

Tangerini, Alice

Ayensu, Edward S. (1978). *Medicinal Plants of West Africa*. Reference Publications Inc., Michigan, USA.

———— (1981). *Medicinal Plants of the West Indies*. Reference Publications Inc., Michigan, USA.

Judziewicz, Emmet et al. (1999). *American Bamboos*. Smithsonian Institution Press, Washington, USA and London, UK.

King, Robert M. and Harold Robinson. (1987). *The Genera of the Eupatorieae (Asteraceae)*. Missouri Botanical Garden, Lawrence, Kansas, USA.

Read, Robert W. (1979). *Flora of the Lesser Antilles: Monocotyledoneae: Palmae*. Harvard University, Massachusetts, USA.

Tippo, Oswald and William L. Stern. (1977). *Humanistic Botany*. W. W. Norton & Company Inc., New York, USA.

Wagner, W. L. et al. (2005). *Systematic Botany Monographs*. Vol. 72 & 83. American Society of Plant Taxonomists, Michigan, USA.

Ward-Hilhorst, Ellaphie

van der Walt, J. J. A. (1997). *Pelargoniums of Southern Africa*. Purnell & Sons, Cape Town, South Africa.

———— & Vorster, P.J. (1981 & 1988). *Pelargoniums of Southern Africa*. Vol. 2 & 3. Juta, Kenwyn & National Botanic Gardens, Kirstenbosch, South Africa.

van Jaarsveld, E. J. (1994) *Gasterias of South Africa*. Fernwood Press (Pty) Ltd, South Africa.

Woodin, Carol

Cribb, P. (1998). *The Genus Paphiopedilum*. 2nd Ed. Natural History Publications, Borneo, in association with the Royal Botanic Gardens, Kew, UK.

Glossary of terms

Adaptation. Any morphological, physiological, developmental, or behavioural character resulting from natural selection that enhances the survival and reproductive success of an organism.

Angiosperm. A plant that produces seeds which are enclosed in an ovary, i.e. a flowering plant.

Arborescent. Appearing like a tree in structure and size.

Basidiomycete. A class of fungi, which includes some 25,000 described species such as mushrooms, toadstools, stinkhorns, puffballs, shelf fungi, rusts and smuts. The Basidiomycetes are distinguished from all other fungi by the production of a particular type of spores called basidiospores.

Bryophyte. Non-vascular terrestrial green plants including mosses, hornworts and liverworts collectively.

Carboniferous. A geological time period within the Palaeozoic (c.365–290 million years BP).

Carpel. A unit of the female reproductive organs in a flower. Each carpel is comprised of the stigma, style and ovary, which contains one or more ovules.

Caryopsis. A small, indehiscent, dry fruit with a thin outer covering that is fused to a single seed. A common fruit of the grasses.

Chlorophyta. The green algae, which are the most diverse of all types of algae in both form and in life history. Green algae are widely accepted as the plant group ancestral to the bryophytes and vascular plants because of their similarity in biochemistry and cell structure.

Chloroplast. The cellular organelle found in photosynthetic organisms, such as land plants and green algae, which contains chlorophyll and is the site of photosynthesis.

Clade. A monophyletic group of taxa that is made up of a single ancestor and all of its descendants.

Cladogram. A branching diagram or 'tree' representing hypothesised phylogenetic or evolutionary relationships of a group of organisms.

Coevolution. The reciprocal evolutionary change, driven by natural selection, between two or more interacting species with a close ecological relationship.

Convergent evolution / parallel evolution. The independent evolution of similar structures or forms of life that are unrelated (convergent) or more distantly related (parallel) resulting from similar forces of natural selection.

Corm. A short, swollen, underground storage stem in which food is accumulated, usually in the form of starch.

Cotyledon (s). The first leaf, or pair of leaves, of an embryo within the seed, that may store food reserves for the developing seedling.

Cretaceous. A geological period of the Mesozoic era (c.140–65 million years BP).

Cultivar. A variety of a plant produced through hybridisation, artificial selection or any other cultivation process.

Cyanobacterium (pl. Cyanobacteria). Specialised photosynthetic bacteria, also known as the blue-green algae, which were 'captured' by early plants and became the chloroplasts inside the cells.

Deciduous. A type of plant that sheds its leaves during an unfavourable season of the year.

Diatom. A unicellular organism that occurs in both fresh and salt water environments, and an exceedingly important component of phytoplankton. Diatoms have finely-patterned double shells of opaline silica arranged in intricate formations.

Dicotyledon (Dicot). A plant whose embryo has two cotyledons, i.e. a pair of seed leaves. The dicots comprise one of the two former classes of angiosperms, but are not considered to be monophyletic and hence are no longer recognised as a valid category by taxonomists.

Dinoflagellate. A group of algae comprising more than 1,000 known species, many of great importance in the food webs of marine ecosystems. Some species of dinoflagellates are responsible for poisonous red tides and others are symbiotic with corals.

Dioecious. The presence of female and male flowers on separate individual plants of the same species.

Distyly. A floral system for promoting transfer of pollen between plants in which flowers from different individuals of the same species may have one of two different style and stamen lengths.

Diversification. The formation over evolutionary time of two (or more) separate lineages from one common ancestral lineage.

DNA. Deoxyribonucleic acid, the primary genetic material of a cell, is a large molecule made up of four nucleotides (adenine, guanine, cytosine, thymine), that appear as chains in the form of a double helix. Analysis of the sequence of nucleotide pairings in the two chains provides information on the evolutionary history of organisms.

Ectomycorrhyzal. One of the major types of mycorrhizal relationships between plants and fungi. Most trees of temperate and tropical regions form ectomycorrhizae, in which the plant roots are enveloped by a mantle of fungal hyphae.

Endosperm. The triploid (3 sets of chromosomes), fleshy tissue that protects and nourishes the growing embryo in angiosperm seeds.

Epiphyte. A plant which grows on another plant for support, but not to obtain water or nutrients.

Family. A rank within the hierarchy of taxonomic classification that falls between the higher rank of order and the lower rank of genus.

Gametophyte. The generation of the plant reproductive cycle in which gametes (reproductive cells) are produced. This plant structure is usually multicellular and haploid (each cell nucleus contains one set of chromosomes).

Genetic drift. The random changes in gene frequencies in small populations that are not due to natural selection or mutation.

Genus (pl. genera). A rank within the hierarchy of taxonomic classification that falls between the higher rank of family and the lower rank of species.

Gymnosperm. A seed plant with seeds that are not contained within a closed ovary, i.e., a non-flowering seed-bearing plant.

Hemiparasite/Hemiparasitic. A plant that is able to produce some of its own carbohydrates, but also derives water and some nutrients from its host plant through special root attachments.

Heterogenous. Having a non-uniform and variable structure or composition.

Heterostyly. A floral system for promoting transfer of pollen between plants in which flowers of different individuals of the same species may have one of two or three different style lengths and stamen lengths.

Holoparasite. A plant that lacks chlorophyll and is not able to produce any of its own carbohydrates, but derives all water and nutrients from its host plant through special root attachments.

Hybrid. The offspring of two organisms that belong to different species.

Hydroid. A specialised water-transporting cell found in some mosses.

Inflorescence. An arrangement or aggregation of one or more flowers.

Jurassic. A geological period of the Mesozoic era (c. 210–140 million years BP).

Labellum. A modified, usually expanded, petal, sepal, or other floral structure, such as the 'lip' in the Orchidaceae.

Leptoid. A specialised nutrient-transporting cell found in some mosses.

Linnaean System. The systems of hierarchical classification and binomial naming of species that was first established by Carl Linnaeus. The Linnaean system classifies organisms according to ordered ranks, such as kingdom (largest), phylum, class, order, family, genus, and species.

Mesozoic era. A geological era (c.245–65 million years BP) comprising the Cretaceous, Jurassic and Triassic periods.

Mitochondrion (pl. Mitochondria). The organelle found within cells where respiration occurs. Mitochondria have their own genome separate from the nucleus that is made up of a circular DNA molecule.

Monophyletic. A group of taxa that are all derived from of a common ancestor and are defined by shared characters possessed by that ancestor.

Mucilage. A gummy substance produced in special cells by some plants.

Mycorrhizae. The symbiotic association between a fungus and the root system of a plant in which nutrients are supplied to the plant.

Nectary (pl. nectaries). Glands in a flower that produce nectar, a sugary liquid, as a reward for visiting pollinators.

Neotropics. The biogeographic region that includes South America, the West Indies, and Central America south of the Mexican plateau.

Order. A rank within the hierarchy of classification that falls between the higher rank of class and the lower rank of family.

Pedicel. The stalk that attaches a single flower to an inflorescence.

Peltate scale. A specialised hair, or trichome, that traps and absorbs water and minerals in epiphytic plants, such as the bromeliads (Bromeliaceae).

Perianth. The collective term for the combined outer whorl of sepals (calyx) and the inner whorl of petals (corolla) in a flower.

Permian. A geological period of the Palaeozoic (c.290–245 million years BP).

Petiole. The stalk of a leaf that attaches it to the stem.

Phaeophyta. The brown algae, which include about 1,500 species, are almost entirely found in marine environments. The giant kelp is a well-known brown alga.

Phloem. A plant tissue made up of several specialised types of cells that transport food materials throughout the plant body. In woody stems it is the innermost layer of the bark.

Photosynthesis. The biochemical process in plants that uses light energy from the sun to synthesise carbohydrates from carbon dioxide and water in the presence of the green pigment chlorophyll.

Phylogeny. The evolutionary history of a group of organisms that indicates the pattern of ancestor-descendant relationships.

Pistil. The female reproductive organ of a plant that consists of one or more carpels, which are made up of the ovary, style, and stigma.

Pollinium (pl. Pollinia). A mass of connected pollen grains produced by an anther sac that is transported as a single unit during pollination, as in the orchids and the milkweeds.

Rhizomatous. Possessing a horizontal stem, often underground or on the surface of the ground, that lives over from season to season and which bears roots and leafy shoots. Plants that have underground rhizomes include ginger, bamboo and turmeric. Plants that have above ground rhizomes include some iris species and ferns.

Rhodophyta. The red algae which includes about 4,000 species, most of which are found in marine environments. The red algae are the largest group of seaweeds.

Sapogenin /saponin. A group of toxic, soap-like compounds present in many plants.

Saprophyte. A plant that is not free-living and so requires decaying organic material as a source of nutrition.

Sepal. A member of the outer whorl, or calyx, of the floral perianth. Sepals protect the unopened flower and are typically green and leaf-like.

Spadix. A spike-like inflorescence with a thickened, fleshy axis with many congested flowers as is characteristic of members of the family Araceae.

Spathe. A large leaf-like bract that surrounds or subtends an inflorescence, as is characteristic of the conspicuous inflorescence bract of members of the family Araceae.

Speciation. The evolutionary process by which phylogenetic lineages split to form new species, often as a result of reproductive isolation between populations.

Species. The basic unit of biological classification. By one definition, a distinct lineage of sexually-reproducing organisms forming interbreeding populations that are reproductively isolated from other such lineages.

Speciose. Comprising a large number of species.

Sporangium (pl. sporangia). The spore-producing reproductive organ of the sporophyte.

Sporophyte. The multicellular, diploid (two sets of chromosomes) generation of the plant reproductive cycle that produces spores.

Stamen. The pollen-producing male reproductive organ of a flower composed of a filament (stalk) and anther (pollen sacs or sporangia).

Stolon. An elongated, slightly underground stem with long internodes that form new plants at the tips.

Stoloniferous. (see under Stolon).

Stomate. A small opening between two cells in the outer cellular layer of the leaves of vascular plants (and mosses). The size of the opening is controlled by the plant and allows diffusion of gases and water vapour into and out of the photosynthesizing leaves.

Strobilus (pl. strobili). A cone-like cluster of modified spore-bearing leaves or ovule-bearing scales that are grouped at the tip of a stem.

Symbiosis. The close ecological relationship between two or more species. Three types of symbiosis are found in nature: mutualism (both organisms benefit from the relationship), parasitism (the relationship is harmful to one organism and beneficial to the other), and commensalism (one organism benefits and the other is unharmed by the relationship).

Symbiotic association / symbiotic relationship.
(see under Symbiosis).

Taxon (pl. taxa). A group of organisms, which in principle are monophyletic, treated at a particular rank in the taxonomic hierarchy.

Taxonomist. A person trained in the discipline of identification and classification.

Tepal. A segment of the perianth of a flower that is not clearly distinguished as either a sepal or a petal.

Terpenoid. A structurally-diverse class of plant compounds that have aromatic qualities.

Triassic. A geological period of the Mesozoic era (c.245–210 million years BP).

Trichome. An external, hair-like plant structure usually made up of either one or several cells.

Tristylous. A floral system for promoting transfer of pollen between plants in which flowers of different individuals of the same species may have one of three different style lengths and stamen lengths.

Xylem. Tissue inside the plant body comprised of several specialised types of cells that transport water from the roots to the rest of the plant.

Zygomorphic. A term used for flowers which are divisible into equal halves by only one plane of symmetry.

Acknowledgements

I am particularly grateful to Professor Paul Kenrick, Research Palaeobotanist who introduced me to the wonderful plant fossils housed in the Natural History Museum, London and who helped Kew to borrow a remarkable selection of them for the exhibition at the Shirley Sherwood Gallery.

Next my thanks go to Linda Rudd for collating the Shirley Sherwood Collection and to Andrew Donaldson for preparing the works for the exhibition.

I would also like to thank the artists whose paintings are published here for their enthusiastic response to using their works.

Shirley Sherwood

For assistance with science and classification: Mark Chase, David Mabberley, James Wearn, Jann Thompson, Chip Clark, Paul Rhymer, Paul Kenrick

For assistance in compiling the taxonomic information: Jamie Whitaker, Maribeth Kniffin, Tarja Yvanka de Soysa.

For assistance in preparing the publication: Gina Fullerlove, Michelle Payne, Guy Allen, Jeff Eden.

For general assistance: Ida Lopez, Alice Tangerini.

John Kress

Index